ALSO BY PATRICIA BOSWORTH

Montgomery Clift: A Biography
Marlon Brando: A Biography
Anything Your Little Heart Desires: A Memoir

DIANE ARBUS

DIANE ARBUS

A BIOGRAPHY

With a New Afterword by the Author

Patricia Bosworth

W. W. Norton & Company New York London

Grateful acknowledgment is made to the following for permission to reprint previously published material:

Howard Nemerov: Excerpts from *Journal of the Fictive Life* by Howard Nemerov (Rutgers University Press, 1965; reprinted by University of Chicago Press, 1982). Excerpts from *The Collected Poems of Howard Nemerov* (University of Chicago Press, 1977). Reprinted by permission of the author.

Newsweek, Inc.: Excerpts from an interview with Diane Arbus appearing in *Newsweek*'s March 20, 1967 issue. Copyright © 1967 by Newsweek, Inc. All rights reserved. Used by permission of Studs Terkel.

Picture Credits appear on p. 373.

Library of Congress Cataloging-in-Publication Data
Bosworth, Patricia.
Diane Arbus : a biography.
Includes index.
1. Arbus, Diane, 1923–1971. 2. Photographers—United States—Biography. I. Title.
TR140.A73B67 1984 770'.92'4[B] 84-737
ISBN 0-393-32661-6 pbk.

W. W. Norton & Company, Inc.
500 Fifth Avenue, New York, N.Y. 10110
www.wwnorton.com

W. W. Norton & Company Ltd.
Castle House, 75/76 Wells Street, London W1T 3QT

6 7 8 9 0

For Mel

In memory of my late husband Mel Arrighi
without whom this book could not have been written

Contents

Preface ix

Russeks Fifth Avenue 1

The Fashion Years 65

The Dark World 155

Afterword 323

Notes and Sources 329

Index 355

Illustrations follow pages 114 and 274.

Preface

Diane Arbus' unsettling photographs of freaks and eccentrics were already being heralded in the art world before she killed herself in 1971. Then, a year after her death, the Venice Biennale exhibited ten huge blowups of her human oddities (midgets, transvestites, nudists) that were "the overwhelming sensation of the American Pavilion," as the *New York Times* art critic Hilton Kramer wrote. Soon afterward, a large retrospective of her work opened at the Museum of Modern Art in New York and was both damned for its voyeurism and praised for its compassion; 250,000 people crowded in to see such haunting Arbus portraits as "The Jewish Giant" and "The Man in Hair Curlers." Later the show toured the United States to acclaim and controversy and another retrospective was similarly received when it traveled throughout Western Europe, Australia, Japan, and New Zealand. Arbus gained an international reputation. Subsequently a book of eighty of her photographs was published by Aperture. Its overriding themes—sexual role-playing and people's irrevocable isolation from each other—seemed to express the rebelliousness, alienation, and disillusionment that had surfaced in the sixties and flowed into the seventies. The book has since sold more than 100,000 copies.

It is possible that Arbus would not have received such concentrated attention had she lived, although it is generally acknowledged that her rough uneasy style (which combined snapshot technique with the conventions of heroic portraiture) did in any case have a seminal influence. She drastically altered our sense of what is permissible in photography; she extended the range of what can be called acceptable subject matter. And she deliberately explored the visual ambiguity of people on the fringe and at the center of society.

Back in the fifties her images were strictly one-dimensional. I met her then. When I was eighteen I modeled for her. In those days Diane Arbus was a fashion photographer in partnership with her husband Allan. They worked constantly for *Glamour* and *Vogue* and various advertising agen-

cies. They hired me to pose for a Greyhound bus ad. It was my first big booking.

I remember thinking, on that hot summer morning so long ago, that my carefully applied pancake makeup might streak my neck. I was terrified that even in my falsies, waist-cincher, crinoline petticoats, and shirtwaist dress—the standard uniform for a John Robert Powers model—I would be told that they'd made a mistake, that I was wrong for the job. However, the moment I entered the Arbus studio on East 72nd Street—a huge, cool echoing place decorated with an enormous green tree—a barefoot Diane ran over to me with outstretched arms. "Good!" she declared. "You don't look like a model." And then in a conspiratorial whisper: "That's why we hired you."

The rest of the day passed swiftly. We went "on location" (another first for me), driving to Ardsley Acres, a small town less than fifteen miles from Manhattan, and stopping at a dead-end road where weeping willows surrounded a pond. Until it got dark I posed, together with a male model who played my "date," in front of an empty Greyhound bus, while between takes Diane fussed with my hair and murmured encouragement. It was Allan who took all the pictures (I learned later that he and Diane alternated shooting). She addressed him as "boy" and he called her "girl," and they had an assistant, Tod Yamashiro, a young Japanese photographer from Chicago, who kept loading their cameras. The three of them seemed to have a warm, joking relationship, and by the end of the afternoon I was laughing and joking, too. Driving back to the city, I felt exhilarated as Diane plied me with gentle questions and then listened to my answers with such intensity I believed I had never spoken so articulately or been so well understood. (Later I discovered that Diane consistently had this effect on people. "When you were talking with her, she made you feel as if you were the most important person in the world," says her old friend Stewart Stern.)

I worked for Diane twice after that, I think, and then when I became a journalist I continued to see her occasionally. We'd run into each other on the street and have long, rambling conversations. Once we sat in a coffee house while she told me she'd left fashion and was "doing her own thing," photographing strangers on Coney Island. Another time, riding together on the up escalator in a department store, she informed me that she'd won a Guggenheim, which would enable her to travel around the country photographing "events" and "celebrations." She had just photographed a beauty contest at a nudist camp in Pennsylvania, she said. I subsequently recognized one of the pictures from that take when I saw it along with other of her portraits—a woman with a cigar, kids dressed as grownups, grownups dressed as kids—at the Museum of Modern Art. They were part

of a 1967 show called "New Documents," a crucial exhibit because it marked the end of traditional documentary photography and introduced a new approach to picture making, a self-conscious collaborative one in which both subject and photographer reveal themselves to the camera and to each other. The result is a directness that pulls the viewer smack into the life of the image.

By 1978 Diane Arbus' stature as a preeminent photographer was unquestioned—she was linked to Walker Evans and Robert Frank in importance—and yet nothing had been written about her life, although it was obvious that behind her pictures lay a strange and powerful person.

She once said, "A photograph is a secret about a secret. The more it tells you the less you know." I set out to probe this secret—to explore her mystery—to illuminate if I could the sources of her vision. However, when I met with Doon Arbus, Diane's oldest daughter and the executrix of the Arbus estate, she told me she could not contribute to any biography that touched on her mother's life—"that the work speaks for itself." Diane's former husband Allan decided not to contribute, as did their younger daughter Amy and certain close friends including the late Marvin Israel.

I did find a great many people who were more than willing to help me piece together Diane's worlds—the mercantile world of Russeks Fifth Avenue (her family's department store), the glittering world of fashion, and the dark world of freaks and eccentrics she was so irrevocably drawn to.

From the very beginning Diane Arbus' brother, the distinguished poet Howard Nemerov, gave me his complete cooperation and support. I visited him at his home in St. Louis and we corresponded regularly. I have also gathered copious reminiscences from the rest of Diane's family: her mother Gertrude Nemerov, her sister, Renée Nemerov Sparkia, her brother-in-law Roy, her sister-in-law Peggy Nemerov. I interviewed cousins, aunts, uncles, and many of the people who worked at Russeks; I talked to Diane's school friends from Fieldston, Phyllis Carton (now Contini) and Eda LeShan, as well as to teachers like Elbert Lenrow and Victor D'Amico who first recognized her special visual talent.

Some of the most significant conversations I had were with the women who were close to Diane Arbus, like her god daughter May Eliot and her photography teacher Lisette Model. I owe a special debt to Charlie Reynolds, a photographer who shared Diane's love of circuses and magic, and to Neil Selkirk, who has printed all of Diane's work since her death. With regard to her work, although the Arbus estate did not give me permission to reproduce any Diane Arbus photographs, I was able to document in my book the evolution of many of her images, often by speaking to those subjects still alive. My gratitude to them for their time and recollections. And thanks to those collectors who have kept some of Arbus' earliest un-

published attempts with a camera and allowed me to study them. Special thanks to gallery owner Lee Witkin who directed me to much source material and who also lent me a rare Arbus portfolio to pore over.

I would like to thank John Szarkowski, the former head of the photography department of the Museum of Modern Art, curator Walter Hopps, and Studs Terkel, who gave me permission to quote from his tapes of Diane Arbus. And thanks as well to Philip Lopate who allowed me to draw from his extensive interviews with Lisette Model.

Of the close to two hundred people I interviewed or corresponded with, I am especially indebted to: Alex Eliot, Jane Eliot, Loring Eutemay, Dorothy Evslin, Frank Parker, Liberty Dick, Tina Fredericks, Rick Fredericks, Robert Meservey, Cheech McKensie, John A. Williams, John Pauker, Bill Ober, Rudi Wurlitzer, Larry Shainberg, Gay Talese, Walter Weinstein, Hope Greer Eisenman, Robert Benton, David Newman, Harold Hayes, Nancy White, Barbara Goldsmith, Ilya Stanger, Jim Hughes, Bernard Malamud, Gail Sheehy, Pat Peterson, Tom Morgan, Peter Crookston, Joseph Mitchell, Hiro, John Gossage, Clay Felker, Bob Adelman, Bruce Davidson, Joel Meyerowitz, Garry Winogrand, Seymour Krim, Ralph Gibson, Arthur Weinstein, Peter Beard, Frances Mclaughlin Gill, Lee Witkin, Henry Wolf, and the late Chris von Wangenheim, to name only a few. Dale McConathy, Emile de Antonio, and the late John Putnam were particularly generous with their time and memories.

For the last two years I was given strong moral support by Aileen Ward and the Biographers Seminar at New York University's Institute for the Humanities. The New York Society Library and the Mercantile Library have been unfailingly helpful, as has the photography department of the Museum of Modern Art; Anne Tucker, curator of photography of the Museum of Fine Arts, Houston, Texas; and T. Hartwell, curator of photography at the Minneapolis Institute of Art. Thanks to my researcher Judy Rehak and to Martha Kaplan. I would like to single out my husband, Mel Arrighi. He gave me the idea for this book; he helped me shape the material.

A final note of deep gratitude to my editor Robert Gottlieb for his guidance, his enthusiasm, and his supreme clarity.

PART ONE

RUSSEKS FIFTH AVENUE

As a teen-ager Diane Arbus used to stand on the window ledge of her parents' apartment at the San Remo, eleven stories above Central Park West. She would stand there on the ledge for as long as she could, gazing out at the trees and skyscrapers in the distance, until her mother pulled her back inside. Years later Diane would say: "I wanted to see if I could do it." And she would add, "I didn't inherit my kingdom for a long time."

Ultimately she discovered her kingdom with her camera. Her dream was to photograph everybody in the world. This meant developing tenacity, this meant taking risks, and Diane was always very, very brave; some people even called her reckless. But it seemed perfectly natural, since in her own imagination she believed she was descended from "a family of Jewish aristocrats"—given her definition that aristocrats possess a kind of existential courage. As far as she was concerned, aristocracy had nothing to do with money or social position. Aristocracy was linked to a nobility of mind, a purity of spirit, as well as inexhaustible courage. These were qualities Diane Arbus believed to be of utmost importance in life.

Actually, her maternal grandfather, Frank Russek, a short, mild-mannered man, had traveled to the United States from Boleslawiec, Poland, in 1880 and as a teen-ager kept from starving by selling peanuts on trains going from St. Louis to Kansas City. Then he and his brothers Simon and I.H. moved to New York, where they became successful bookies. The only reason they decided to trade furs, they used to tell Diane, was that it gave them something to do in the winter when the racetrack closed down. By 1897 Frank and I.H. had opened Russeks Furs in a tiny storefront at 14th Street and University Place in Manhattan. Minks from Michigan, chinchilla from the Andes, squirrel, beaver, and fox furs were all displayed in their tiny shop.

In 1900 Frank married Rose Anholt, a tough, husky-voiced young woman. Rose worked in the fur shop, too, before the birth of her daughter, Gertrude, in 1901 and her son, Harold, in 1902, who later joined the fur business.

The Russeks were so successful at creating fashionable, reasonably priced furs that by 1913 they were able to move their business to Fifth Avenue, although to equally cramped quarters (the store measured twenty-five by ten feet). Some said the small size was conducive to selling; lines of customers stood outside the shop waiting to get in.

Chorus girls and presidents' wives came to Russeks; the architect Stanford White had a black broadtail coat, lined with mink and collared with otter, made to order. Occasionally, to boost sales, Frank Russek locked a less famous customer into a fitting booth until he or she agreed to buy.

In 1915 a poor grocer's son from Crown Heights named David Nemerov started working at Russeks as a window dresser, at a salary of $25 a week. Within two years he impressed the sixteen-year-old Gertrude Russek with his saturnine good looks, his ambition, his sense of style. He was an excellent tailor, and while they were courting he whipped up a fashionable evening gown for her that was, in her word, "gorgeous."

By now the Russeks were living in splendor on Park Avenue and they did not approve of the romance between Gertrude, their beautiful daughter, and the impoverished David. But their disapproval didn't stop David, and he continued his ardent pursuit of Gertrude, even taking her to meet his father, Meyer Nemerov, a frail but tyrannical man who spent most of his days praying at a Brooklyn synagogue.

Long ago in Kiev, Meyer had run off and married his secret sweetheart, Fanny, against his parents' wishes—he'd been promised to somebody else. Then he enraged his parents even further by deciding to come to America. "It will be an adventure!" he cried, never imagining the misery awaiting him in New York. He left Russia in 1891 and Fanny followed a year later carrying their first baby, Joe, a pair of candlesticks, a blanket roll, and a samovar, which always stood in a place of honor in their various tenement apartments.

In the wretchedly crowded Jewish ghetto of Manhattan's Lower East Side, Fanny bore six more children, including twin brothers (one of whom died), while Meyer grubbed and scrambled, working in sweatshops and selling real estate. He was eventually able to open his own basement grocery store, but without much success. Homesick for Kiev, uprooted from his culture and his language, he felt himself doomed. Still, he clung to his heritage. Orthodox Judaism for him embraced politics, religion, diet, a set of values, a way of life. After work, even though he was exhausted, he would go to the synagogue and study the Talmud. Eventually he moved his family to Brooklyn, where he founded a yeshivah in Crown Heights to help preserve the Faith.

As time went on, he staked everything on the destiny of his four sons, exhorting them to work hard, keep clean, and get an education. "I can't

make it, but you can. You know English. The American tempo—it's in your blood."

Growing up, the sons sold pencils and shined shoes on street corners to help Meyer pay the rent. And they all studied late into the night. Ultimately Willy and Meyer, the youngest sons, became "cloak-and-suiters" (much to their father's disappointment). But Joe, the eldest, became a "big Broadway lawyer," and when David Nemerov married Gertrude Russek, he reached the pinnacle—he would be a "merchant prince."

At Passover, David was fussed over the most. "Uncle David was Meyer's favorite because he'd done everything right, including marrying into a wealthy family, which none of the older brothers had been able to do," said a cousin, Dorothy Evslin.

Even David's slender elegance (he often wore a blue shirt with white collar and cuffs) was in direct contrast with his three brothers as well as his sister Bessie. They were squat and roly-poly as pumpkins—like their mother, Fanny, a kind, generous woman who painted pretty watercolors and was an expert seamstress. "She taught David to sew " his sister Bessie said.

At Passover, out of respect for their father, the Nemerov brothers tried to hide their differences, their feelings of resentment and competition. Even so, David and Joe could barely be civil to each other. This was because Joe, a bachelor, lived openly with his chorus-girl mistress. Once or twice David voiced disapproval. Later his cousins would say that David had no right to pass judgment when his own marriage was so compromised: Gertrude Russek Nemerov had borne their son, Howard, who was to become one of America's most distinguished poets, three months after the wedding.

Still, Gertrude and David's first years together were happy ones. They lived in a large apartment on West 73rd Street with plenty of servants, even including a strict German nanny for the baby. Meanwhile David, who was determined to be very rich, was working long hours at the fur shop, gaining the respect of the entire Russek clan. David had a flair for retail and promotion—and he could spot fashion trends. After attending the Paris collections in 1920 he became so excited by the opulence and style of the clothes, by the braids and buttons and embroidery of haute couture, he realized that selling furs alone would never be enough to hold his interest.

He began dreaming of having a specialty shop of his own. Russeks Furs was so successful financially—the Russeks were now millionaires—David saw no reason why the store couldn't expand to include dresses, suits,

lingerie, hats. But to do that would require more space. Russeks would have to move.

Frank and I.H. didn't particularly want to move or expand; they were content with their thriving business as it was. What they really cared about was playing the horses. But David went on trying to convince them that he could turn Russeks into a specialty shop to end all specialty shops. He would make it a showplace, he promised—a glittering spectacle with the finest possible merchandise. Russeks' windows would be veritable theater—the various departments, fantasy lands . . .

In time the Russek brothers discussed the project with Max Weinstein, a former coat manufacturer who ran a bank in the old Waldorf-Astoria Hotel on 34th Street. He thought the idea of a specialty store was great— he put up half a million dollars and the Russek brothers put up another half (David still another). Weinstein would be president of Russeks, Frank and I.H. would handle the fur business, and David would be merchandising director.

In 1923 a very grand Russeks opened at Fifth Avenue and 36th Street. The outside of the seven-story building (formerly Gorham Silversmiths, designed by Stanford White) was imposing; with its balconies and marble columns, it resembled a Venetian palazzo.

Inside, on David's orders, purple velvet carpets covered the floor, and salesmen and salesladies behaved obsequiously. Furs remained the foundation of the store's financial success (furs were displayed on the main floor as well as the second, partly because Nemerov believed that furs, in some mysterious way, were a primitive symbol of strength: "Fur creates a protective image," he told one of his buyers once), but there were dress departments, too, both moderately priced and expensive; there was a millinery department and a boutique devoted to lingerie; there was a beauty parlor and a bridal salon.

From the beginning David proved to be a fashion innovator (to this day he is remembered by people like Ben Zuckerman, the dress manufacturer, as one of the most creative retailers in the business). In the 1920s he pulled together Russeks wardrobes for movie stars like Mae Murray and Norma Talmadge; he was the first to design a silver-fox fur, the first to introduce fur cardigans. For ten years he published a Russeks fashion-furs booklet which was bought and followed by more than two hundred fine stores throughout the country. It was his idea to make copies of Paris originals—other stores followed his lead. Rip-offs of Chanel suits and Paquin coats were sold at Russeks. In 1928 you could buy a copy of a Vionnet pleated afternoon dress for $23.50 at Russeks—"not extravagant but smart."

Nemerov also spent a fortune in newspaper ads extolling Russeks chic.

He ran ads every day, alternating photographs with illustrations (also an innovation—nobody used photographs in newspaper ads), and his copy was, according to Andrew Goodman, president of Bergdorf Goodman, "the snappiest of all of retail."

Sometimes, however, Frank Russek would read an ad and then throw it on the floor and stamp on the elegant copy. He believed Russeks' identification with high style would ultimately kill its mass fashion potential. He and Nemerov never stopped arguing about Russeks' ambivalent merchandising policies. On the one hand, it was a high-fashion fur and specialty shop, its quality comparable to that of Henri Bendel on West 57th Street. On the other hand, flanked by Lord and Taylor and B. Altman, Russeks was in the heart of the 34th Street market and presumably trying to reach that market. Yet, unlike Lord and Taylor or B. Altman, which were spacious, well-designed stores, Russeks suffered from its physical situation. Soon after they moved into the Gorham Building, the Russeks realized—too late—that the seven floors were overly narrow and that selling space was hampered by the design of the rooms: their old-fashioned columns and bays, although lovely to look at, restricted traffic and display areas. The extreme narrowness of the main floor stifled the potential of a bustling main-floor operation, which Frank Russek believed was the mainspring of retail profitability.

Ben Lichtenstein, advertising director of Russeks for thirty years, says, "Russeks survived as long as it did mostly due to David's enthusiasm and drive. He was a fantastic promoter—a showman like Bernie Gimbel and John Wanamaker." He never created exploitation wars with his arch competitor, I. J. Fox (across the street)—the kind of war Gimbels cultivated with Macy's. "No—David did classy promotion which made Russeks *seem* successful all the time, even when we were going through rough periods. He knew fashion was theater, that fashion was ephemeral—it kept changing. Fashion kept David in a state of perpetual excitement, and his excitement was contagious."

And he seemed clairvoyant. He knew that one season baguette jewelry and lace fans would be the thing, along with fur-trimmed coats. He always could sense what women wanted; he could tell husbands what to give their mistresses for Christmas—French perfume, gold mules, satin lingerie, bunches of artificial violets—and he'd be right. Eventually Russeks got the reputation of being the store for "kept women" and chorus girls. "There was always something a little bit excessive about Russeks," Eleanor Lambert, a fashion press agent says. "A little bit vulgar."

By 1935 Nemerov had established a bureau (with Ruth Waltz, a fashion economist) equivalent to the couturier laboratory in Paris to determine fashion trends. He found that suits sell in cycles—that invariably a

peak suit season followed a peak bright-color dress season. And as a creator of Russeks furs—which were the Russeks trademark; "We were the largest buyers of raw fur pelts in the world," Ben Lichtenstein says— "David Nemerov had a particular genius." He knew women would always pursue furs because they were so soft and luxurious. So he labored in the Russeks workroom along with the designers to create the first black-ermine afternoon coat, the first full-length badger coat, shawls of mink and fox. He was the first to try to bleach mink.

He understood that both the shape of the fur and the shape of the woman must be carefully considered when cutting a fur coat, otherwise both would look ridiculous. And he was famous on Seventh Avenue for his long discussions with dress manufacturers on the pros and cons of a particular fabric such as silk jersey. Occasionally he wore a scarlet jacket in the office to prove that men didn't have to wear brown or gray or blue.

According to Lichtenstein, David Nemerov had only one glaring fault: "With money he was hopeless." Figures bored him. He had no idea how much money Russeks was making or losing—or if he himself had any money. "I don't think he ever stepped into a bank or wrote out a check," Lichtenstein says. "He had Russeks' accountant pay all the household bills for Gertrude, and he'd often borrow little sums of money from me. If he wanted cash right away, he'd just scrawl '$50' on a piece of paper and hand it to the Russeks cashier."

Max Weinstein—a man utterly at home with figures (he not only ran Russeks, he was now chairman of the First National Country Bank, which he had built, complete with marble floors and gold tellers' boxes, at 38th Street and Seventh Avenue, on the very site where he'd sold candy as a penniless immigrant boy)—was bothered by Nemerov's casual attitude toward money. "My father and David Nemerov did not get along," Max's son Walter recalls. "They disagreed about practically everything, but never openly. My father was always very polite with David, and David was always very polite with him." Meanwhile the Russek brothers and the Weinsteins continued to be close friends. The two families often vacationed together at Colorado Springs, and Frank Russek particularly enjoyed it when Max's wife, Bertha Arbus, played the piano.

On March 14, 1923, the Nemerovs' second child and first daughter was born. Later Diane would be told that she had been named after the sublimely romantic heroine in the movie *Seventh Heaven*. Actually, her mother, Gertrude, had seen the Broadway show from which the film was made while she was pregnant, and, sitting in the warm, dark theater, she'd been so impressed by the character of the "virgin woman Diane, so vulnerable and strong at the same time," she vowed that if she had a daughter she would call her "Dee-ann" ("They pronounced it that way in the play," Gertrude Nemerov would explain).*

According to Gertrude, Diane was a large (nine pounds), beautiful baby with thick golden hair, translucent skin, and huge green eyes that held curious powers of observation. "Even as a baby she didn't just look at you —she *considered* you." At first a fierce, unspoken tenderness and mutuality existed between mother and daughter. On her nanny's day off, Diane seemed to find pleasure and reassurance from literally clinging to Gertrude. "She'd never let go my hand."

Diane's description of early childhood is slightly different. In an autobiography she wrote at Fieldston School when she was sixteen she recalled that she was "cranky—always crying, yelling, screaming. I can always remember the feeling I had. I always felt warm and tired and there was warm sun on me and I didn't want to wake up . . ."

During this time (except for trips to Palm Beach) Diane lived with her parents and brother at 115 West 73rd Street. When she was around four, the family moved to an apartment at Park Avenue and 90th Street. Thick drapes hung across the windows. "It was almost always dark," Howard recalls.

There were two maids, a chauffeur named Scott, a cook named Eva, as well as Helvis, the German nanny for Howard, and a French nanny who

* To certain people Diane insisted she be addressed as *Dee-ann*, but she answered to "Dy-ann" as well. Howard shifted back and forth. In a letter he began "Diane—DEEANN?" Usually he called her "D."

took care of Diane for the first seven years of her life. "Mamselle," as she was called, was a cool, undemonstrative young woman who wore her hair in a bun. "She had a hard sad quite lovely face and I adored her," Diane wrote. "She always looked as if she had a very sad secret." Whenever Mamselle went on vacation, Diane would cry and cry and try to keep her from leaving. When they were together, the two rarely spoke, but Diane seemed very happy with her. When they did converse, it was in French and Diane enjoyed that, although she "didn't know" she was "speaking French."

One of her most vivid memories was being taken by Mamselle to the dried-up cavity of what had once been a reservoir in Central Park, where they peered down on a Hooverville shanty town made up of tin shacks. "This image wasn't concrete, but for me it was a potent memory," Diane told Studs Terkel years later. "Seeing the other side of the tracks, holding the hand of one's governess." Diane asked to go down into the cavity to investigate the shacks, but Mamselle wouldn't let her. "She was very strict," Diane said.

Whatever discipline or direction Diane and Howard received came not from their parents but from their various nannies and later from Kitty, the maid, "who had a terrific sense of humor," Howard says, and who took them to the dentist and to their dancing and music lessons.

Gertrude Nemerov, an imperious, beautiful woman nicknamed "Buddy," was proud of her little son and daughter although she sometimes seemed baffled by them. Early on she began apologizing for Diane and Howard's "strangeness" because, unlike "most kids," their noses were pressed in books. She once said she had "a hard time figuring out what they were talking about."

Most mornings when the children were little, Mrs. Nemerov would lie in bed drinking coffee and smoking. She might phone her best friend, May Miller, the vivacious wife of the shoe tycoon Meurice Miller, who was filled with curiosity about everything; then at around 10:30 she would discuss the dinner menu with the cook, Eva. Although Eva exasperated everybody in the Nemerov family (she was rude and chewed incessantly on a toothpick), Mrs. Nemerov refused to criticize her because she didn't want to lose her. "But she makes such marvelous pot roast," she'd exclaim when Diane would cry out that Eva had been nosing through her dresser drawers again.

At around eleven, Mrs. Nemerov would rise and begin slowly creaming her face in front of a mirror. Sometimes Diane would watch, wondering at the self-absorbed reflection in the glass. Her mother often seemed to her to be cultivating an air of supreme indifference.

By 11:45 she was dressed and settled in her limousine, telling the chauffeur, Scott, to take her to Russeks.

Gertrude Nemerov went to the store several times a week for browsing and pricing and trying on the latest styles. She only window-shopped at Saks and Best's—never bought there. Everybody on both sides of the family was supposed to get her clothes only at Russeks. "You can look at De Pinna and Bonwit's or Tailored Woman—but just *look*," the children were warned.

As soon as Diane was old enough to walk, she would accompany her mother in her treks through the store. Dressed in a reefer coat, white gloves, and tiny patent-leather slippers, she would toddle solemnly after her mother as Mrs. Nemerov swept through the narrow main floor across the purple velvet carpet and into the fur department.

Even before she started investigating a new shipment—it could be the latest sealskin coats, some ermine ball-wraps—the fur salesmen were bowing and scraping and "rubbing their hands together like shoe salesmen," Diane said. "It was like being in some loathsome movie set in an obscure Transylvanian country, and the kingdom was humiliating." Of this experience Diane said to the photographer Frederick Eberstadt, "I was treated like a crummy princess." (Years afterward, as a photographer, her precise, unjudgmental eye would confront an entire series of grief-stricken "crummy princesses.")

However, on those late mornings long ago, Diane would merely follow her mother into the elevator and up to the dress-and-suit department, or to the millinery salon to try on hats. Mrs. Nemerov greeted all the personnel by name. As the daughter of the founder of Russeks, she knew everybody. Russeks was a home away from home. She loved the store.

The last stop would always be David Nemerov's wood-paneled office on the seventh floor. From that office with its ever-ringing phone and the secretaries and buyers hurrying in and out, Nemerov ran the store, okaying all merchandise, all ad copy, all window displays.

Preoccupied with Russeks, Nemerov showed little warmth or interest in his children, although in public he would always put his arms around them and make a great show of affection. In or out of the office he chain-smoked, and he suffered from a nervous stomach.

As a young man he'd been in two car accidents, so he never drove himself; instead he went everywhere by limousine. Chauffeurs came and went because he was such a demanding employer. One driver—the very handsome one named Scott, whom Mrs. Nemerov liked—quit in a huff over a mix-up about his day off and then wrote the Nemerovs a letter implying that they were "crude" and listing the abuses he thought he'd

been subjected to. Diane never forget the effect of that letter on her—his words "were both insulting and hurtful to me, because I was somehow implicated in the criticism, but I was equally critical [of my parents], which meant I played both sides." She secretly thought of her father as "something of a phony. A lot of his friends were richer than he was, but he was the most flamboyant."

At Russeks he could be charming and ebullient when business was going well, but much of the time his challenging, often brutal manner terrified personnel. "If you got in his way, he'd walk all over you," a buyer said. At his angriest, either in the store or at home, he would appear infinitely reasonable; his voice would sink to a whisper. This would madden Gertrude and Diane and Howard, because they often couldn't hear what he was saying but were afraid to tell him so.

Howard remembers his father as "an overtly powerful, power-using sort of guy. Diane and I were rarely punished, but everything in our house was based on approval, not love. This made us feel rather helpless because we never knew whether Daddy would approve or disapprove of something we did." He gives as an example: "I once bought my father a postcard from a little trip I'd taken with my nanny to Van Cortlandt Park. Daddy lectured me very sternly on how much it cost, which must have been three cents."

Until Howard was enrolled at the Franklin School in 1926, he and Diane were inseparable. It was as if they had passed through some secret experience together, and although it might not interest any of the other Russeks or Nemerovs, it bound them close together.

If they took a walk together in Central Park, they were accompanied by their nannies. Howard remembers that whenever he and Diane played in the park sandbox, they were forbidden by their nannies to take off their white gloves.

Once home, they ate their meals together, usually in silence, occasionally bickering. Both possessed powerful, quirky intellects, both read voluminously, absorbing knowledge and myths with ease, and they created rich fantasies which they shared with each other and no one else.

Their giftedness made them feel separate and alone. "We were protected and privileged as children," Howard says, "but we were watched over incessantly. It made us fearful." Their sense of themselves and their situation was reflected in the gravity with which they sat or stood, not looking at each other, but close as twins. Their eyes rested on their parents, the servants, weighing each situation, each event.

One July they traveled to Europe with their parents on the ocean liner *Aquitania.* While the Nemerovs stayed in Paris to view the collections, Howard and Diane were taken by Mamselle to Le Touquet, Proust's favor-

ite vacation spot in the north of France, where they gorged on wild straw-
berries and Diane was frightened by a goat.

Diane and her brother fought a lot. Howard says they once struggled
over a china doll that broke in their hands, and he believes Diane got a
scar on her face as a result. "In early life, my sister and I used to blame
one another, get one another punished quite a lot." When it rained, they
played football in the living room, and "the ball left the marks of its nose
and seam on the ceiling so that we got found out," Howard writes. "One
Christmas morning we came into the living room secretly and managed
to knock the tree over." He doesn't remember whether they put it back on
its feet or not.

For the most part, however, they were obedient, well-behaved little
children, with the same watchful, shining eyes, the same intense remote-
ness.

"Howard doted on Diane," says a Nemerov cousin. "He kept a photo-
graph of her in his wallet until she died. He was certainly in awe—because
even when she was tiny, she never behaved like a little girl. She had innate
sophistication—wisdom about things—and she was gorgeously intuitive.
Howard turned into a highly critical, precise intellectual. It was some
combination in one family."

Since they were three years apart, Howard and Diane never attended
the same classes, but for one year they were both at Fieldston, a private
school in Riverdale. Teachers said they were the most gifted brother and
sister who'd ever attended that institution. They hated being compared.
Later, when Howard became a poet and Diane a photographer, they never
discussed their work with each other. In fact, each rarely told anyone of
the other's existence. "And I for one have no theories as to how or why we
became what we became," Howard says now.

"My motto was already 'Do what you're told and they'll leave you
alone,' " he continues. "I didn't like being bothered by people."

Diane's motto was "In God We Trust." She had read it on a nickel and
would repeat it every night before going to sleep. She yearned to have
something or somebody to be faithful to, to believe in. She believed in
Howard. He was strong and quiet and so handsome she liked to just look
into his face. And he didn't pester her as many relatives in the family did
—Howard left her alone with her dreams. Except when they fought—
pinching and mauling and tickling each other. Then she was briefly and
tantalizingly his equal—sharing the pain and pleasure of fighting. And
Diane always remained close to her brother in a primitive, non-verbal
way. "We didn't 'explain' or 'reveal' things to each other—we always
respected each other's privacy," Howard says. "We were both very private
people—even as kids."

That feeling of privacy, of having an inner life, disturbed the other Nemerovs and Russeks—all the aunts, uncles, cousins who thrived on intrigue and talk. They would comment on Diane's detachment, her moods, on Howard's dour silences. Howard says, "My mother used to tell me, 'You'll never get on in the world—you're much too uncommunicative.' "

When they were four and seven respectively, Diane and Howard posed for an oil painting. Although the portrait has been lost, Howard recalls that "[we sat] together on [a] red settee, she in a white dress . . . [my] hair, still blond . . . and brushed back into a pompadour . . . [Diane's] expression [was] an indescribable compound of sullen and shy, [mine was] bolder, perhaps a trifle insolent, perhaps somewhat defensive. No smiles . . . [and] the artist's difficulty with perspective made us appear to have shoed stumps instead of feet."

Many years later Howard alluded to that portrait in a poem entitled "An Old Picture."

Two children, dressed in court costume,
Go hand in hand through a rich room.
He bears a scepter, she a book;
Their eyes exchange a serious look.

High in a gallery above,
Grave persons frown upon their love;
Yonder behind the silken screen
Whispers the bishop with the queen.

These hold the future tightly reined,
It shall be as they have ordained:
The bridal bed already made,
The crypt also richly arrayed.

"The anecdote of the poem stressed the helplessness of these children under the traditional impositions of scepter and book, their fates already arranged by the parents (in the poem, the bishop, the queen)." Howard adds, "The poem ends with some considerable bitterness toward these grownups."

On Oct. 13, 1928, when Diane was five and a half, Renée Nemerov, Diane's younger sister, was born. As she had with her two previous children, Gertrude Nemerov delegated the care of this latest offspring to a nanny. Diane was very excited about Renée's arrival. She began showering her with the affection she craved but had not found in her mother. At the slightest provocation she would pick her tiny sister up in her arms and rock her back and forth, kissing her over and over.

Diane would always feel a special kinship with small children. She saw herself in them—isolated creatures, secretly raging. Some of her earliest and best photographs are of little boys and girls confronting their energy and despair. One of her most famous, entitled "Exasperated Boy with Toy Hand Grenade," she took in Central Park in 1961, part of a series she planned on rich children "[since] I was a rich child more or less myself."

As time went by, Diane would accompany Renée and their nanny across Central Park, identifying trees and statues along the way. "Diane was my idol," Renée says, "my point of reference for everything."

When Renée got older, Diane read her *Grimms' Fairy Tales, A Child's History of the World, Gulliver's Travels, Peter Pan*, the Oz books, and especially *Alice in Wonderland*. Diane marveled over Alice as giant, Alice as midget, Alice fat and Alice thin, and she would often run to the bathroom and stare at her reflection in the glass. Am I really big . . . am I really small . . . am I in any way imperfect . . . am I just right? Like most children, Diane was fascinated by her mirror image.

Meanwhile, Howard had taken up the piano and at home he practiced diligently. Diane (who'd refused to go on studying music after her brother started) would sometimes plop down next to him on the piano bench and correct him. "No, no, it shouldn't be played *that* way but *this* way," and she'd demonstrate, her fingers flying over the keys. Then she'd run off to fuss over Renée.

Howard invariably dismissed Renée as "the baby," but he seemed

briefly annoyed that Diane was no longer focusing her attention on him alone. For her part, Diane possessed a certain command over both her brother and her sister, making them do what she wanted, says a Nemerov cousin who used to observe them playing together.

Since there was such an age difference, the siblings rarely went anywhere together except to the dentist. "There was this dentist—a friend—who'd come to Daddy with a hard-luck story," Renée says, "a hard-luck story that his business was going bankrupt and he was so in debt he was going to kill himself. Daddy lent him money (as he often did with friends) and got him patients. He used to send Diane, Howard, and me to him constantly, almost every month for years. We were constantly being X-rayed, drilled, worked over, chiseled at . . . When we grew up, we all had terrible trouble with our teeth."

Howard writes: "It frequently crossed my mind that [the dentist] wanted my teeth to outlast me, that I was his monument, those fillings would still be there when the last Pyramid had been worn down to the desert . . . Ideas of death and eternity in connection with teeth appear thus early in my life, and it comes to me now that behind 'lux aeterna' is the dentist's overhead light which I described in a short story (about a man who tried to kill himself) . . . ('Looking down your throat' is an expression of triumphant aggression and hostility, chiefly in poker games)."

In 1930, when she was seven, Diane began attending Ethical Culture School on Central Park West. Most of the couples the Nemerovs knew were sending their children to this school, which was part of the Ethical Cultural system, based on the religious humanistic philosophy, also called Ethical Culture, which had been developed by Felix Adler in New York around 1867. Adler, who'd been trained as a rabbi, maintained it didn't matter whether you believed in God; in life what mattered was "deed, not creed." At Ethical Culture emphasis was placed on "a love of learning," one of its finest English teachers, Elbert Lenrow, says. Lenrow, who was also Howard's first mentor, adds, "The artistic development of each student was stressed and particular value was placed on the creative arts as both an intellectual discipline and a means of nourishment."

Other teachers at Ethical Culture remember Diane as subject to occasional tantrums but otherwise well behaved and "powerfully bright." "Diane Nemerov demonstrates a large vocabulary, the ability to read and concentrate better than her peers and she has a marked talent for drawing," stated one third-grade report.

David Nemerov had already recognized his daughter's mental agility, her specialness. He was proud, but he was fearful, too. After reading the school report he remarked to his sister Bessie Shapiro that maybe Diane was too bright for a little girl. What should they do? He subsequently

contacted Ethical Culture by letter and asked that Diane be given extra homework. They did so and she rapidly completed it.

Now she was growing tall and slender, and her thick brown hair hung down her back in tangled curls. Mamselle had left the Nemerovs the previous summer and Diane "loathed" her new nanny (and all subsequent ones). In rebellion she became a "grubby kid" for a while. "I refused to keep clean," she said. Her father was furious "because I was the apple of his eye and he wanted me to be the most possibly beautiful that I could possibly be."

Excruciatingly shy, she lived in a state of constant fear. For years cruel and wily kidnappers pursued her in her fantasies—panting, haunting her steps. From an early age she was beset by shadows of herself as persecuted victim and courageous heroine—products of her rage and longing to be noticed. But, like most imaginative children, she told no one of her secret terrors—nor would she admit for the longest time that she preferred darkness to light—loved, in fact, to stay in a pitch-black room where she could wait for monsters to come and tickle her to death. Her sister, Renée, insisted that a lamp be kept burning in her bedroom all night. Once the lampshade caught on fire and Mr. Nemerov had to run and beat out the flames. It was around four in the morning. Diane stayed curled up among her pillows in the purple darkness, listening to the scuffling and the cries.

In her autobiography she confided, "The teachers always used to think I was smart and it would torment me because I knew that I was really terribly dumb."

At around this period of her life the family moved from the apartment on 90th Street to another at Park Avenue and 93rd. Then during the Depression they moved again, settling at 146 Central Park West in an apartment house called the San Remo, where Diane was to live until shortly before she got married.

The San Remo apartment was huge—fourteen rooms with wood-paneled walls and decorated with French and English antiques. "It was essentially dreary," Diane said. The only detail Howard remembers about the San Remo apartment was "Rodin's 'Le Baiser' reproduced in bronze on the edge of a jade ashtray in the living room."

Diane's bedroom overlooked Central Park and it was cluttered with books. She didn't enjoy collecting toys, as Howard did; his closet was crammed with toy soldiers and expensive sports equipment from Abercrombie and Fitch. Diane treasured a strange speckled rock she had discovered on a path near Sheep Meadow in the park. For a while she kept goldfish in a bowl, but when they died, she flushed them down the toilet and said, "Please, no more."

On weekends when she was seven and eight years old, Diane and her

cousin Dorothy Evslin would play together. They'd throw bags of water from Diane's bedroom window onto pedestrians walking up Central Park West. Or they'd take turns talking into Howard's "phone"—two Dixie Cups connected by a piece of string. Every so often they'd wander around the apartment, which to Dorothy (who lived in Brooklyn) seemed "gigantic and somber." Once Diane showed her Gertrude Nemerov's dressing room. "I ohhed and ahhed over Aunt Gertrude's collections of cut-glass perfume bottles. 'Most of them are filled with tea,' Diane told me."

During the early years of the Depression, things got so bad that Gertrude Nemerov sold some of her jewels and for a while her parents moved into the San Remo and the living room filled up with Frank Russek's cronies from the track. Diane recalled: "I remember vaguely family conferences which took place behind closed doors . . . like loans negotiated and things like that . . . but the front had to be maintained . . . in business, if people smelled failure in you, you'd had it."

At Russeks, David Nemerov worked longer hours, exhorting his buyers to order less merchandise but "don't lower the quality." To save money, he didn't cover the Paris collections; anyhow, he knew from the fashion grapevine that Schiaparelli was experimenting with synthetic fabrics that disintegrated when cleaned; that Chanel's entire line was a study in cotton and piqué.

Every week, in an effort to attract business, Nemerov changed Russeks' windows. Sometimes he would work all night with his assistant, Miss Christ, a beautiful little woman whose energy and imagination were similar to his. Together they displayed the styles of the period (flowing lounging pajamas, "tea gowns" with horse-halter necks) against all manner of exaggerated backgrounds: driftwood, whitened tree branches, Chinese lanterns, white-on-white paper decorated with fishnets. "Once they displayed Russian cossack costumes against what looked like snowdrifts," says George Radkai, who was a Russeks illustrator. "Another time they hung tapestries and placed dozens of mannequins in front of them dressed in the most opulent furs and jewels. It was a daring thing to do at the height of the Depression. None of the other Fifth Avenue stores were doing anything in their windows—they looked dead—and here was Russeks exploding with rococo glitter and surrealistic fashion excitement. David's windows were like stage sets—like George Platt Lynes or Hoyningen-Huene photographs—specially lit so you could see the sheen of fur against the bloom of a little flowered hat. The Russeks windows drew crowds."

Even so, the store was losing a great deal of money because Nemerov refused to do what Saks and Best's were doing—turning their main floors

into a mass of accessories bars with cosmetics, jewelry, handbags, scarves. The fur department was still what you saw the instant you entered Russeks. "It was quiet as a morgue," Dorothy Evslin says. Nevertheless the Nemerovs "kept up the front" (Diane's phrase), entertaining a great deal in the San Remo. At least once a week an extra maid would be hired to help serve a dinner party of twelve which invariably included the Millers, who were still the Nemerovs' closest friends (when you asked Miller how his shoe business compared with other shoe businesses, he'd always answer, "We're predominantly dominant"). There were also cigar makers and theater owners, and dress manufacturers like Ben Zuckerman, who often came to the Nemerovs. "It was like being part of a closed corporation," says a childhood friend of Diane's, whose real-estate tycoon father was part of the group that dined there regularly.

These men, mostly immigrant Jews from Poland or Russia whose parents had fled the pogroms and worked their way up from the Lower East Side slums to the "gilded ghettoes of Central Park West," displayed the same kind of snobbism as the uptown German Jews—bankers like Seligman, Warburg, Schiff. The Seligmans and the Schiffs would never entertain the Russeks or the Nemerovs; it was a question of class. And, carrying snobbery a step further, the Russeks would never entertain David Nemerov's parents, who lived in Brooklyn—David Nemerov rarely if ever invited his father and mother to the San Remo. In that mammoth apartment any suggestion of superstition or poverty had been blotted out.

Diane and most of her friends were brought up to have all the accomplishments of the well-bred eighteenth-century English lady—painting, piano, languages, manners, a thorough familiarity with art. "Our upbringing was a cultural phenomenon," a classmate of Diane's says. "It never would have happened if our parents hadn't made a great deal of money very quickly and hadn't known how to deal with it. The kind of money our families had magnified their feelings of inadequacy, of personal failure. We grew up in an emotional desert of shame—never affirmation—and those of us who were taught to be assimilated were filled with self-loathing."

Another childhood friend remembers that in spite of the Depression she and Diane and Renée and others like them were raised as "Jewish princesses." They had the "kvelling mamas" who almost daily told them they were special—they had the lessons at Viola Wolff's dancing class, the orthodontia, and, for several of them, later the nose job. "We were isolated, we were pampered, we were spoiled, we knew nothing else but that world on Central Park West, so we took it for granted."

She then recalls Diane's reaction when the two of them were taken as teen-agers to Arthur Loew's vast estate at Oyster Bay. They swam in the

outdoor swimming pool and later watched a screening of *The Little Colonel*. "We compared notes on the afternoon and suddenly Diane looked at me and said, 'I'm Jewish!' As if she'd forgotten."

"I never knew I was Jewish when I was growing up," she said. "I didn't know it was an unfortunate thing to be! Because I grew up in a Jewish city in a Jewish family and my father was a rich Jew and I went to a Jewish school, I was confirmed in a sense of unreality. All I could feel was my sense of unreality." (In 1967, after her first major exhibit at the Museum of Modern Art, Diane commented to *Newsweek*: "It's irrational to be born in a certain place and time and of a certain sex. It's irrational how much you can change circumstances and how much you can't. The whole idea of me being born rich and Jewish is part of that irrationality. But if you're born one thing, you can dare—venture—to be ten thousand other things.")

While "Jewishness" was never central to her life or Howard's (they attended Temple Emanu-El only on Holy Days and they went to Sunday school grudgingly), their "Jewishness" was still a fact. And always dramatized when, every other year, they celebrated Passover at Meyer and Fanny Nemerov's apartment in Brooklyn. It was practically the only time they ever saw their paternal grandparents, and they found the experience strangely consoling. Surrounded by immigrants and the sons and daughters of immigrants who all shared a common past, the awareness that they were Jewish had residual significance.

Later, at Harvard, Howard toyed with the idea of converting to Catholicism (for "silly aesthetic reasons"). But he didn't, and in his poetry* he frequently reaffirms his Jewishness. Perhaps his clearest statement is in the poem "Debate with the Rabbi," part of which goes:

> Stubborn and stiff-necked man! the Rabbi cried.
> The pain you give me, said I.
> Instead of bowing down, said he,
> You go on in your obstinacy.
> We Jews are that way, I replied.

Later Diane would take dozens of photographs of Jewish matrons in which she explored not only their collective memories but the relationship between role-playing and cultural identity. And she was to find an affinity with the famous fashion photographer Richard Avedon because his Russian immigrant father had also owned a Fifth Avenue dress shop; she

* Howard admits that some of his earliest poetry, which has a despairing, almost rabbinical quality, was probably inspired by his grandfather Meyer, whom he calls "one of the wisest men I've ever known." Meyer Nemerov, the Biblical scholar who often wept when he read the Old Testament, instilled in Howard a love of and dedication to words.

would laugh when she heard Garry Winogrand shout, "The best photographers are Jewish!"

Still later she would go with Ben Fernandez to photograph the American Nazi Party in Yorkville. Loaded down with her cameras, she would listen while the leader of the party made vicious anti-Semitic remarks. She did not react; she just listened intensely—watching, watching. And she arranged to photograph the Nazis. And they were charmed by her.

"To Diane the real world was always a fantasy," said a friend.

4

By the age of thirteen Howard was on his way to being a first-rate athlete
—an excellent swimmer and tennis player and on the second-string foot-
ball team. He was pursuing proper names—through bird books, flower
books, tree books, star books—"to make some mind of what was only
sense," he recalled later. He was also discovering Freud by reading the
entire Basic Writings in the Modern Library edition, "even though a friend
of my mother's told me 'reading Freud will make you sick.'"

He and Diane still took walks together and went to museums, but they
no longer roller-skated since he'd been robbed by a group of toughs right
across the street from the San Remo with Diane as terrified witness. After-
ward Howard had tried to fight with the boys, which was difficult since
he was on roller skates and Diane was, too, but she attempted to stop him
"à la Lillian Gish in some silent movie." For several minutes they wheeled
around on the sidewalk "like nutty performers." Diane would repeat this
anecdote over and over again to friends, and she was to have a nightmare
about the experience; in fantasy it became a much more violent confron-
tation.

Now Howard spent most of his free time with his schoolmate John
Pauker, whose father, Edmond Pauker, was Ferenc Molnár's agent. The
Pauker home in Riverdale became Howard's home away from home. Pau-
ker, Sr., was deeply involved in show business. "He got every Hungarian
artist a job in Hollywood," John Pauker says, "including, I believe, Ernst
Lubitsch."

Howard was intrigued by the energy and ebullience that radiated from
the Pauker household, and John Pauker had it, too. Red-haired, pixie-
faced, highly theatrical, he wore a green cape when he and Howard took
their walks through Central Park singing, arguing, vowing to become
"heroes."

For a while Howard toyed with the idea of becoming an opera tenor,
but as his voice changed he realized he'd have to be "a basso if anything."
Then he thought that perhaps he'd be a psychoanalyst, until "Mommy

ridiculed me, saying, 'How could you ever be an analyst when you're incapable of talking with people!' "

In 1934 Howard caught typhoid fever. He remembers he had "a nurse who taught me dirty songs . . . I am said to have been some time in delirium." While he was convalescing, he broke out in red spots, which "the doctor circled in blue ink."

Their brother's fever was so contagious that Diane and Renée were moved to the Hotel Bolivar, on Central Park West at 84th Street, where they lived with their nanny for three months. Every so often they would be trotted back to stand opposite the San Remo and wave up to their mother, who stood at their apartment window waving back.

During that period, Renée recalls, "Diane and I were as intimate as we'd ever be, I suppose." She remembers coming back to the hotel and Diane helping the nanny bathe her and Diane coloring in her coloring book or drawing pictures for her and reading to her from *Jane Eyre* or *Wuthering Heights*. Diane enjoyed Gothic novels in which fantasy predominates over reality; the strange overshadows the commonplace, the supernatural prevails over the natural. "I had the feeling Diane likened herself to Jane Eyre, who was a talented, superior girl deeply romantic and full of dreams," Renée says.

At school she was a font of creativity—particularly in art class, where she sketched, painted in oils, sculpted, and made collages. "Obviously Diane possessed a gift which gave her a sense of separateness, from the very beginning," her art teacher, Victor D'Amico, says. "She wasn't *aware* of her talent then, but her talent—her imagination—compelled her to live in a state of internal crisis, of excitement, which must have been disturbing to her. I remember how impatient she was with easy solutions."

He recalls, "Once I gave her class an assignment to design a dream house. Everyone else drew up very traditional plans, mainly mock Tudor three-story jobs with fireplaces and balconies. Diane's house was completely round with windows on different levels so she could study the stars in the sky as well as watch the grass grow. There was little furniture in her fantasy house, just the essentials—bed, table, chair—because she wanted to be free to walk around in the dark without bumping into things. In spite of her fears about so many things, Diane felt safer, more comfortable in the dark."

However, in school, invariably surrounded by a group of children who looked to her for leadership, she was beginning to show signs of independence. After class she would organize treks and games in Central Park with her friends. Whenever there was something a little daring or dangerous to do, like jumping over a wide crevice between rocks or playing a trick on a teacher or teasing one of the younger girls, Diane would be the

leader, "the first one to do it." As a result she was considered one of the boldest students at Ethical Culture, but privately she was sure "I was more afraid than the others." She forced herself to be brave, "even though I hated to and was all hot and frightened."

She became very popular and was able to move in and out of cliques, which she defined as being "based on exclusion and feeding on the misery of non-members." She fluctuated between wanting to desert one clique and be close to another. She was never sure which clique she liked best.

Even at the age of eleven she was aware of the duplicity in herself and her classmates, and she would write about it angrily in her autobiography —labeling both herself and her friends as "mean" and "stupid" because they all pretended they knew everything when they knew nothing. She realized she was supposed to act excited and silly about boys and clothes and dances, too, but often she found she could not react. She felt still and empty inside and then she would go off by herself to the Metropolitan and stare at the El Grecos. A classmate remembers how "Diane would float away from a group of us—suddenly—no explanation. Later we'd see her sitting by herself reading a book of poetry in Central Park. She did that a lot."

She was always being disappointed in people. They were not what they appeared. The grown-ups were falsely sophisticated and hypocritical— they played roles, projecting different images in order to compete and be loved. And the kids imitated them. For a while she was best friends with a rich European—a striking, arrogant girl who seemed to have invented herself. At parties they would amuse each other with half-smiles and whispered sarcastic remarks. They found they both liked watching people in peculiar situations, people under stress—a Schrafft's waitress with hiccups, a deaf-mute child making bird sounds to attract his parents' attention. But Diane had a falling out with the rich European girl and would no longer speak to her and would tell no one why and the stillness inside her got bigger and bigger.

In 1934 Diane's grandparents Meyer and Fanny Nemerov were given a party at the Hotel Tower in Brooklyn to celebrate their fiftieth wedding anniversary. The party was attended by the entire Nemerov clan. Diane and Renée went, but Howard was still at home recovering from typhoid. When they posed for the family portrait, Diane held a photograph of her brother in her lap.

Diane never forgot her grandparents' genuine attachment to each other. "They were married lovers," she told a friend. Every morning Meyer went to the synagogue and Fanny would sit in the window of their

apartment all day waiting for him to come back. There was a mysterious closeness about these grandparents that fascinated Diane, perhaps because her own parents seemed so inscrutable.

Later Diane composed an entire series of photographs on people and their love objects, including a woman holding a pet monkey in her arms (the monkey is dressed in a baby's snowsuit). And she wrote: "Love involves a peculiar unfathomable combination of understanding and misunderstanding."

"But, darling, what is it—being married?" David Nemerov once asked a relative. And then he answered, "Being married is just lying in bed back to back."

Howard remembers listening to his parents "quarreling" behind closed doors and being terribly shocked. Their behavior seemed "secret, invisible." Once, impulsively, he peeked into their bedroom, was caught and scolded for it. Ever after, he says, he has connected "seeing with the sexual act and guilt; with the forbidden and punishable and photography as the antithesis (guilt) of writing (innocent)."

When they were growing up, Diane and Howard had little chance to know their mother and father, who at home spent much of their time playing cards. "That's my most vivid memory of the Nemerovs—smoking and playing bridge for hours," John Pauker says. "But Diane and Howard always treated them with the most exquisite respect. They would always kiss them very dutifully on the cheek before they went out, even if it was just for a chocolate malted."

Their mother seemed the more impenetrable—Gertrude, the beautiful chain-smoker who ran the elaborate apartment, directed the servants, sat at the long dining table in the evenings. "Gertrude was deep down very shy, a woman of few words," explains her old friend Lillian Weinstein. "Her life revolved around her husband—she was crazy about him. But she was concerned about Howard, Diane and Renée—like any good mother, she wanted them only to do the 'right thing,' the 'correct thing,' and to have all the advantages."

As for David Nemerov, one presumes he wanted the best for his family, too, but neither Gertrude nor the children saw much of him. He was at his office up to fourteen hours a day—helping keep the various Russeks afloat (aside from the Fifth Avenue store, there were now branches in Brooklyn and Chicago). Away from the store, he devoted his energies to the Home and Hospital of the Daughters of Jacob and later to United Jewish Appeal. And he gave advice. "He was fantastic at giving advice," Diane said. Relatives, most of whom worked at Russeks at one time or another, and

friends and children of friends would drift in and out of the apartment at the San Remo and Nemerov would listen to their problems—emotional, sexual, philosophical—and he would dispense (occasionally lofty) solutions.

Sometimes he betrayed confidences. A Nemerov cousin who wishes to remain anonymous says, "I idolized David—thought he was a god. When I was sixteen, I fell in love with a boy and we eventually had sex—a terrible thing to do in the 1930s when you're not married. My parents disapproved of him. Anyway, I ran to David for advice. I told him how crazy I was about this boy, how much in love and so forth. David was so gentle and sympathetic—near the end of our talk he whispered, 'I won't tell anyone, I promise, but have you gone to bed with this boy?' I nodded. That night David informed my parents I was no longer a virgin; it was a humiliating and awful time for me. I never spoke to David again."

In the evenings Nemerov would go either to the theater or to night-clubs with friends like Nate Cummings, the Canadian industrialist who later became a billionaire art-collector and head of Consolidated Foods (Fuller Brushes, Sara Lee frozen baked goods, Chicken Delight). Nemerov admired Cummings almost slavishly for his ability to make money. "A businessman must be ruthless, otherwise he's not a good businessman," Cummings was quoted as saying. "Too many people are afraid of making decisions—I know how to make decisions."

Every so often Nemerov and Cummings would take a train to Florida and hole up in a hotel suite with their cronies. "We'd play cards in our underwear for twenty-four hours straight," Cummings recalls. "We had one hell of a time."

Throughout the 1930s a family rumor circulated but was never proved that Nemerov was under particular pressure because he was attempting to pay off an enormous debt his father-in-law had incurred. A compulsive gambler, Frank Russek had supposedly "lost the entire chain of Russek stores in a wild game of roulette at Monte Carlo." Nemerov had been with him and it was only due to his fast talking that the Russeks empire remained in family hands. (Years later Walter Weinstein, Max's son, disputed the story vehemently. "Frank loved to gamble, but he couldn't have gambled the stores away without our knowledge—our family owned fifty percent of the stock.")

Be that as it may, at home Nemerov often talked anxiously about the future of Russeks. Howard, acutely aware of what his father expected of him, kept out of the discussions. As the only Nemerov son, it was assumed that he would take over the store as merchandising director, but he had no interest in retail or making money for money's sake, "so I kept quiet."

Diane said nothing either, but she sensed her father's concern and imagined a terrible fate for him. In her autobiography she wrote, "I was ashamed . . . I thought my family must do things wrong . . . I was afraid that my father's business was really being run badly and that one day everyone would find out and he would be put in jail."

Although their relationship continued to be a formal one ("We were a family of silences," Renée says), Diane felt an ambivalent attachment to her stern, handsome daddy "because he was there if I really needed him."

Judy Freed, who knew the Nemerovs when she was a child, recalls attending Howard's eleventh-birthday party at the San Remo. "Mr. Nemerov dropped in and he and Diane flirted outrageously with each other. They were obviously taken with one another."

As she grew older, Diane fantasized about committing incest with her father; she thought he preferred her to her mother. She alternated between loving her father and feeling contempt for him because "he was always putting on an act." He bought expensive French art books, which he displayed prominently in the living room, pages uncut. He often greeted guests in a smoking jacket. He smiled continuously in public. Phyllis Carton, one of Diane's closest friends in school, says, "Diane didn't seem to belong to him, and yet the power and talent in herself she may have inherited from him."

In general, when she was a little girl, Diane's affinity to painting drew her to Nemerov, who had secret dreams of becoming a painter himself. (He always took a sketch pad with him to Europe when he covered the collections for Russeks, and he would fill it with his visual impressions of Paris—the streets and the kiosks and cafés.) He was proud and protective of her ability, and when he could, he gave her special attention ("Diane was definitely his favorite child," her cousin Helen Quat says). Sometimes he would take her along on his rare weekend expeditions to museums or galleries. Gertrude did not enjoy staring at paintings.

For several summers the Nemerovs rented houses in Deal, New Jersey, the so-called "Jewish Newport," where families like the Guggenheims and the Strausses owned sumptuous mansions and gardens landscaped like Versailles. (Elaine Dundy, whose parents also summered in Deal, recalls being brought to the Nemerovs' lavish home and watching Diane frolic barefoot on a wide, rolling green lawn. Behind her, Howard stood very stiffly, conducting an imaginary orchestra.)

Every August until the outbreak of World War II, David and Gertrude Nemerov traveled to Paris and the south of France, so during much of

their adolescence the three Nemerov children were sent away to camp. Howard enjoyed going to the mountains, where he swam and played tennis; Renée says she was "always homesick."

Diane's experiences in camp were fraught with savagery and drama; these were some of the first adventures she ever had. They remained vivid memories to her and she would occasionally re-create them for friends—how, for example, at Camp Arden in Maine the summer she was fourteen she had staged a veritable revolution against the older campers and in the process had been beaten up and had fainted for the first time in her life.

After that she had remained aloof from the other girls, although she hiked with them through the pine woods, played tennis and went swimming in the lake—she loved swimming because it was a mysterious activity and faintly sinister. Toward the end of summer she found one girl she thought she could trust—a girl rather like herself, shy, imaginative, who hated camp as much as she did. In between basketball games and flag ceremonies they would sit under the trees and tell each other how unhappy they were. Theirs was the paradox of being both spoiled and ignored by their parents, leaving a residue of anger and giving them a sense of omnipotence.

They spoke haltingly of their futures—could they possibly be devoted wives and mothers? How many children should they have? (Diane wanted at least four.) They had been taught to be compliant and ornamental, so they had little sense of self—they were valued for their looks and charm, for their ability to please their fathers, their beaus. But a tiny secret part of them longed to discover and assert themselves, and when they alluded to that yearning (Diane shyly confided she "dreamt and wished" she could be a "great sad artist"), nothing seemed good enough for them—nothing could fill their huge, undefined capacities. Somehow, somewhere, there must be a way to satisfy those inchoate adolescent longings.

And Diane would ask questions of this girl in a confidential whisper—she wanted to know *exactly* how she *felt* about everything, and she made the girl feel important because she seemed so interested in her. And finally Diane liked her "very much, even though every so often I would feel something she said rub against me. She seemed a little afraid of liking me and I was so unafraid I acted as if I liked her much more than I did. Because she held part of my secret and I couldn't bear that."

When the girl left two weeks early, Diane cried, but in her teenage autobiography she confided she "almost hated her because she was too much like me. We both wanted to tell and neither one of us wanted to hear . . ."

In the fall Diane returned to Fieldston School, which she attended from the seventh through twelfth grades and which to some extent shaped her life. (Fieldston is located in the wooded Riverdale section of the Bronx, just off the Henry Hudson Parkway; it is the continuation of the two Ethical Culture elementary schools: the midtown school on Central Park West, which Diane had attended, and the Fieldston lower school.)

At the time, in the mid-1930s, ethical orientation was a big part of the curriculum, and Fieldston had inspired teachers like Algernon Black, a fierce, handsome man who believed that humanity was at once civilized and primitive. To illustrate philosophical points that had ethical consequences, he would recount symbolic anecdotes from Dante, Homer, the Greek myths, and Shakespeare to his students. He was a dynamic story-teller and Diane developed a crush on him.

From Black she learned that myths are not invented but inspired; that they come from the same source as dreams, below the level of consciousness. A dream is personal, Black said; a myth is a dream of society and concerns the mysteries of life. You can't interpret images concretely—if you try, you've lost their significance. Certain myths concerning heroes and quests belong to nearly all societies.

For the rest of her life, Diane savored words like "quest," "aristocracy," "rituals," "legends," "kingdom," and she began to view the world in mythic terms. Later she would see the ritual, the myth, in visual spectacles such as parades, contests, circuses, dances, and weddings, and such backgrounds would be a source for her photography. And as she pursued her dwarfs and giants, her eccentrics and extremes, she would explore the winding paths of self-dramatization, contradiction, and ambivalence in her subjects—between what men and women are and what they wish they could be.

Sometimes on a school field trip to a museum or a zoo she identified with *Alice in Wonderland* (a favorite book about growing up which she would read and reread as an adult, having memorized the riddles, the

endless kingdoms of freaks). Like Alice, Diane constantly wondered what was normal? What was not? What was animal and what was human? What was real or make-believe? She was never quite sure.

She couldn't understand why when she and her class visited the Ethical Culture settlement house (an immaculate building set amid decaying slums) they weren't allowed to speak to the outcasts and derelicts who lounged in the doorways while mangy cats skittered across garbage-strewn sidewalks. Diane longed to talk to these strange people—find out their thoughts. She sensed that the cultural gap between them and herself was enormous, but still she identified with these strange, sad people's isolation—their aloneness. They were the same in some basic way—exactly the same.

Years afterward she confided, "One of the things I suffered from as a kid was I never felt adversity. I felt confirmed in a sense of unreality which I could feel as unreality, and the sense of being immune was, ludicrous as it seems, a painful one."

The secret pain of being kept immune stayed with Diane until she began photographing experimentally by herself in New York during the 1950s. Throughout her adolescence her immediate frustrations centered on the fact, as far as she was concerned, "the world seemed to belong to the world. I could learn things, but they never seemed to be my own experience."

To counteract this, she and Phyllis Carton would periodically create little adventures for themselves. They would ride all over the subway system, observing the strange passengers—the albino messenger boy, the little girl with the purple birthmark. These were visual, sensual experiences for Diane, and they frightened and pleased her just as later on photographing freaks and extremes frightened and pleased her, too.

Often she and Phyllis would get off the subway "impulsively—in the Bronx or Brooklyn or the Lower East Side—we never planned anything," and would simply follow a person who interested them. It could be someone like an old lady, barefoot but otherwise dressed in bedraggled finery, and they would trail her for blocks, watching terrified and fascinated as she rummaged through garbage cans, babbling to herself, before she disappeared into a tenement building's dark hall. Diane would have noted that the old lady's ankles were swollen and red but that she had a tiny diamond in her ear—she was undoubtedly a countess in disguise. But what was it like inside her tenement building? Diane would wonder. She was dying to explore the old lady's room.

Finally, just as it was growing dark, she and Phyllis would drag themselves back to the subway and home to their luxurious, gloomy apart-

ments on Central Park West. Later they might phone each other to go over again what they had seen and experienced that day. "Because *everything* in life was extraordinary to Diane," says Phyllis, "even the most ordinary details. She would use the word 'extraordinary' to describe the old lady," but she would use the same word to describe the way her mother played cards. Most afternoons the shuffling sound of cards echoed through the ornate living room. "I got the feeling that Diane was as terrified of re-entering the bourgeois world of her parents as she was of exploring the world of freaks and eccentrics. Both worlds fascinated her because they seemed one and the same to her."

Diane's clique lived near one another on Central Park West, so they took the bus, and then the subway up to Fieldston School in Riverdale in those early mornings. "We'd crowd into the Eighth Avenue express sharing chewing gum and secrets," Hilda Belle Rosenfield says. "Stewart and Phyllis and I talked a lot more to Diane than she did to us—often she seemed far away." "And so beautiful!" Stewart Stern adds. "I was madly in love with her, but she never knew."

(Unbeknownst to her clique, Diane was forcing herself to obseíve the men on the subway who exposed themselves. Some sat quietly, news-papers covering their genitals. Others stood between the swaying cars opening and closing their coats quickly, convulsively, and Diane would catch a glimpse of pinkish-brown swollen flesh and she would force herself to stare very hard. Terror aroused her. Later she said, "I must have counted thirteen exhibitionists on the subway during high school.")

Once on Fieldston's grassy campus, the quartet of friends attended fire drills in the rain, they raced to history class or the library, and, along with the rest of the student body, they voted to discredit cheaters. And they went on field trips: to the coal mines of Pennsylvania, to the Taystee Bread factory near Newark. There was talk of inviting a few of the factory work-ers' children to lunch at Fieldston, but Diane argued against it as "gro-tesque" and the plan was abandoned.

Later she auditioned for a school production of Shaw's *Saint Joan*. Everyone said she had the perfect spiritual quality and she was sure she would get the part of the peasant girl—she saw herself leading armies, hearing voices. But the teacher gave the role to someone else—an earthy, voluptuous type. Diane was devastated—both angry and upset. If she had had any dreams about going on the stage, she now abandoned them.

She started devoting more time to art class. Friends remember her bold paintings, the confrontational way she sketched the naked models relaxing, smoking in life-study class. She also made bizarre little pencil sketches—caricatures of people she saw on the street. She helped Stewart

Stern complete a huge mural in the school dining room. Her advisor and art teacher, Victor D'Amico, encouraged her to think seriously about becoming a painter after she graduated.

"She had a talent and I think she was responding to it negatively and positively," D'Amico says. "She found it both a burden and a blessing, but she was what she was. She was special. I remember her hands—she had powerful, capable hands with great manual dexterity—she could put puzzles together, build models, concoct *objets trouvés*. She particularly enjoyed working with clay because she could control the material—she would knead and push and change the shape and she could feel herself doing this. She liked working in creative situations where her hands *controlled* the result. Maybe that's why she ultimately shifted to the camera. She could capture the unguarded naked moment quicker on film than with a brush."

D'Amico recalls how often she would come to his little office at Fieldston to discuss something. "Maybe about Käthe Kollwitz, who was a favorite of hers—or Paul Klee. 'May I talk to you, please?' I can still hear her hushed little voice. She was always bursting with ideas. She had such a superior intellect it was sometimes hard to follow what she was saying, she thought so quickly—so imaginatively. I remember her participation on a student panel at the Museum of Modern Art along with Phyllis Carton and Stewart Stern where she talked about what it would be like if Goya painted in the Impressionist style—afterwards Alfred Barr said, 'That girl's mind is terrifying.' "

She would wince every time D'Amico called her talented. Phyllis Carton recalls, "We felt like phonies. We told each other we couldn't be as talented as D'Amico said."

Frequently in class Diane appeared catatonic. "Not for long periods. We all got used to it," D'Amico said. "Diane would be talking about something and then pfft! she'd go off into a kind of trance. It was when an idea or image seized her—it was as if she'd stepped out of the room to glance into a book for research—then she was back with us, talking away as if nothing had happened. I never in all my seven years of teaching her found her melancholy. She was endlessly curious, funny, decent, good."

Diane kept on showing her paintings to her father; he was impressed. Although he had mixed feelings about any of his children becoming an artist ("How can you make a living at it?" he would ask Howard, who was then thinking of a career as a tenor), he was still pleased that Diane and her brother were so "creative." When Gertrude complained that the children were growing even more distant with her—that she simply could not talk to them and whose children were they anyway?—David would laugh

and say, "They're *my* children, Buddy. They take after *me*." After all, the Nemerovs were artistically inclined. His mother, Fanny, had done watercolors—and didn't he have a fabulous sense of design and color? "I could be a painter," he would murmur.

In the spring of 1935 Diane's father arranged for her to come down to the store after school and take sketching lessons from Dorothy Thompson, who was Russeks' illustrator.

"Dorothy was probably the first beatnik type Diane had ever met," Ben Lichtenstein says. "She was an independent lady who didn't wear makeup, had studied painting with George Grosz, lived in a rustic place upstate with a guy who made carved gun handles. Anyway, Dorothy gave Diane sketching lessons in anatomy twice a week. And she'd take Diane to museums like the Met and talk to her about art."

Dorothy Thompson introduced her to Grosz's watercolors—harsh, unforgiving images which depicted the world as an evil, phantasmagorical place. Grosz became one of Diane's favorite artists (and a future inspiration for her photographs). She was particularly fascinated by the subjects he explored: lechery, drunkenness, and overeating.

Lichtenstein notes that at fourteen Diane was still "painfully shy, withdrawn—proud of her lustrous hair, which she liked to brush." The impression of fragility which she always gave was in her manner, her fluttery gestures, her voice. She spoke softly and in rapid, convulsive bursts. When she was at ease, she would punctuate her conversation with giggles.

Also in the Russeks art department, working with Ben Lichtenstein as a copy boy, was Allan Arbus, a slender, handsome, curly-haired nineteen-year-old who was going to City College at night.

Allan had got the job through his uncle Max Weinstein, who was still very much president of Russeks. Weinstein's second wife was Bertha Arbus. Her youngest brother, Harry Arbus, was Allan's father. Harry had helped run the family business, I. Arbus & Sons (which featured ladies' coats), before he began selling mutual funds.

The Arbuses were originally from Warsaw, Poland. "As a clan they were musical, secretive, emotionally cold," says a cousin, Lureen Arbus. "Allan was bright and strong-willed," says another cousin, Arthur Weinstein. "He was interested in everything to do with the arts." His mother, Rose Goldberg, was a schoolteacher (her most famous pupil was Harold Clurman). Rose's brother was an actor. Her sister Jenny Goldberg was a classical pianist and married to Philip Horowitz, Enrico Caruso's doctor.

"Allan wanted to be an actor. We'd go to all the Broadway shows together," Weinstein continues. "He could mimic anybody." A classmate at Bronx High School of Science, Seymour Peck, remembers him as "the

best actor in the school and president of the Drama Club." He'd already won several prizes on Major Bowes' Amateur Hour. Apart from acting, his main obsession was playing the clarinet. His idol was Benny Goodman.

Diane took one look at Allan and he took one look at her and, according to Ben Lichtenstein, "they fell madly in love." Later Diane would say Allan was "the most beautiful man she had ever seen" and their romance had been "like Romeo and Juliet."

Not long after they met, Diane told her parents she wanted to marry Allan Arbus right away—immediately—at fourteen. The Nemerovs were flabbergasted by this turn of events. As far as they knew, Diane had never shown much interest—let alone excitement—about anybody or anything. They said no, absolutely not, and they did everything they could to discourage the young couple.

Arthur Weinstein, then eighteen, remembers being ordered by his parents to "take Diane Nemerov out—which I did and I was completely captivated by her. We became close friends." She immediately told him she was in love with Allan and he ended up being "like a beard." "I'd pick Diane up at the San Remo and we'd appear to be off to a movie, but instead I'd take her straight to Allan. They were very stubborn and determined to see each other as often as they could." For the next four years they carried on a courtship fraught with clandestine meetings, secret phone calls, rendezvous in Central Park, letters delivered by hand.

"Allan became the most important person in Diane's life, the crucial relationship," Renée says. "She had never been that close to anyone before except to Howard—and at fourteen she was restless, impatient. She longed to experience things, and Allan brought beauty and passion into her life. He became her guide, her mentor, her reason for being."

He called her "girl"—she called him "swami." They tried to see each other every day, although that was difficult with Diane at Fieldston and Allan working at Russeks and then attending college at night. Still, they managed. Diane told only a few of her clique at Fieldston about her involvement with Allan. Naomi Rosenbloom recalls that she did say she was "crazy about him" and that he made her feel "shivery," but she never introduced him to any of her friends.

"And then the oddest thing," Naomi goes on. "Months went by—Diane turned fifteen and one day she advised me not to wear a bra or panty girdle and that I should do breast and stomach exercises instead. Allan had taught her to do this," Naomi says. "He made her very aware of her body. Her body didn't scare her and she wasn't ashamed like most of us— she carried herself proudly." Diane told another friend that she had started to masturbate. After everyone was asleep in the apartment, she would go into the bathroom, lock the door, turn on the light, and undress

slowly in full view of the neighbors. She would caress herself, aware that men in other apartments were watching her. She *wanted* them to watch her, she said. She did this night after night, and with abandon, for several years, she told her friend. Her parents never caught her. Howard meanwhile regarded masturbation "with a religious guilt and seriousness." His secret word for it was "worship." "My father once caught me at it and said he would kill me if it ever happened again."

During this period (1938–9) Diane and Hilda Belle Rosenfield would go to one of the lounges between classes at Fieldston and practice foxtrotting. Diane's mother, a beautiful ballroom dancer, was always taking lessons to master the latest variations in the rhumba and the samba; she once even took a special course at some resort in the Catskills. Diane envied her grace and suppleness.

Diane invited Hilda Belle to dinner with her parents off and on through 1938. "I thought it was a proud, odd household," Hilda Belle says. "The Russeks and the Nemerovs were such a powerful combination when they were together in one room. Not much communication—but reverberations. And a great many servants. Lots of antiques. I remember someone exclaiming over a tabletop of inlaid wood. Howard was made much of—he had just begun at Harvard and he spoke about it in a slow, thoughtful way. Mrs. Nemerov never stopped looking at herself in the mirror."

After one of these dinners Diane confided to Hilda Belle that she'd seen her mother sitting on her father's lap and crying—something about how she could no longer run the country house they'd rented in Westchester along with their New York apartment. Diane wondered if her mother wasn't really crying about the perilous state of her marriage.

Just as David Nemerov's style and presence pervaded the apartment in the San Remo, so, too, did stories of his constant philandering. Diane first heard these stories from Paris, the new chauffeur, who confided to her that he frequently drove the "boss" to various assignations. At one point during the 1930s Nemerov was rumored to be involved with Joan Crawford*; he used to visit her at her suite in the Beekman Tower Hotel. And Ben Lichtenstein recalls taking flowers to a girl who ran a bike rental place on 59th Street. "It was David's way of telling the girl he didn't want to see her anymore."

Gertrude meanwhile held her suffering deep inside. Most afternoons she stayed in the apartment, chain-smoking and doing exquisite embroidery or playing bridge. She seemed to accept what was happening in the profoundly passive way so many women accept life and their men. "Diane and I learned how to be submissive from Mommy," Renée says.

* He encouraged the design of a mink coat with the "Joan Crawford look"—full, swinging collar and cuffed with an overabundance of fur "in which every pelt suggested a dollar sign."

If Gertrude confided in anyone, it was in her mother, Rose, a heavy-set, good-natured woman who spoke in stentorian tones (a habit both Gertrude and Howard imitated). "Gertrude was closer to her mother than anyone else in the world," Bessie Shapiro said. "They saw each other most every day, especially after the Russeks moved to the Hotel Lombardy. When they were together, they behaved like schoolgirls."

Sometimes Diane would observe her grandmother and mother whispering together and she would imagine her family being close like that—"united." She knew about her father and his women and was confused. Diane in particular hated seeing her mother in pain although she didn't understand *why* she was in pain. "I could tell Diane was very sensitive to my moods, although she never said anything," Gertrude Nemerov recalls.

By 1938 Gertrude Nemerov's feelings of inadequacy and melancholia had increased and a deep depression set in which she couldn't shake.

Forty years later she said: "All I know is I had everything in life that a woman wants and I was miserable. I didn't know why. I simply could not communicate with my family. I felt my husband and children didn't love me and I couldn't love them. I stopped functioning. I was like a zombie. My friend May Miller had to take me shopping and help me try on clothes. I wasn't able to take them off the hangers I felt so weak."

She would sit in silence at the dinner table night after night, until finally her husband asked Kitty, the maid, to help get the children off for camp in the summer. "Mrs. Nemerov is sick."

Eventually she consulted psychiatrists, gynecologists, nerve specialists, "but nobody could diagnose what was the matter with me. My depressions continued. Finally one doctor told me I wasn't neurotic—I wasn't crazy—I should just live my life as planned and go off to Europe with Daddy as we did every year to the south of France and then to Paris to see the collections."

So they did. As always, they went by ocean liner. The first night on board, "Daddy wanted me to go to dinner, but I couldn't, I was in such a state of depression, of anxiety, so he went up by himself and I had supper in our cabin. Later when he came back he said he'd met a famous analyst from Chicago—I can't remember his name—at the captain's table and he'd told him about me and the doctor said, 'Look—I'm on vacation, but as a favor I'll treat your wife. Have her meet me on deck tomorrow morning at eleven o'clock.' "

For the next couple of mornings Mrs. Nemerov had sessions with the analyst on deck while couples played shuffleboard or drank coffee from trays and the sea pitched and rolled around them. Mrs. Nemerov said the analyst made her uncomfortable. "He was oily—and he had hot, piercing

black eyes and I didn't see the purpose of his questions." The sessions did no good. "I felt exactly the same—no lifting of the depression."

After the third or fourth session the analyst arranged "to treat me in our cabin—but I was alone. I remember I was wearing very short shorts. He asked me to lie down on the bunk and then he began asking me all sorts of intimate, probing questions about my sex life. I was embarrassed and I refused to answer them. He did not react, he just kept staring at me with his hot, piercing black eyes. I was so unnerved I decided I wouldn't see him after that, and I told my husband that I didn't need to see the analyst anymore—that I was much better—even though I still felt terrible, almost crippled with anxiety. That night I remember putting on my prettiest evening gown and we went up to the dining room. I forced myself to laugh and act as if I was having a marvelous time—inside I was absolutely choked. Panicked. *Because I could not define my depression.* All the while I could see the analyst lounging at the bar, watching me with his hot, piercing black eyes. I was terrified of him. I never wanted to see or talk to him again!

"He got off at Naples—we were going on to Cannes. Before he left, he presented Daddy with a bill for a thousand dollars. But I felt no better and remained depressed the entire summer and into the fall. Then slowly, very slowly, I came out of it. I don't quite know how. A year went by and I was all right again. I was exhausted. I felt as if I'd recovered from a hideous disease and had finally healed.

"I tell you this because Diane, I think, was concerned for me; she observed me during those painful months. We never talked about what was troubling me, of course, but years later when she contracted hepatitis and had to go into the hospital, she fell into a ghastly, unending depression that went on for three years—until her death. Periodically she would call me on the phone in Florida and cry, 'Mommy—Mommy—tell me the story of your depression and how you got over it.' And although I had no real answer—no solution—I would repeat my story and it seemed to reassure her. That if I had gotten well, so could she . . .'"

6 _____

Diane's romance with Allan Arbus went on unabated during her sopho-more and junior years at Fieldston. Her friends were beginning to know of Allan's existence, but she never brought him to the campus. Secrecy was always important to her—as it was to Allan. They were a scrupulously private couple who revealed themselves to few people.

Gertrude kept saying that in time Diane would change her mind about Allan and marry a man with money and social position. Allan was bright and attractive but poor in comparison to the Russeks and the Nemerovs. "It never occurred to Aunt Gertrude that she, too, had fallen in love with a bright, attractive, but impoverished man and married him against her parents' wishes," Dorothy Evslin said.

To placate her mother, Diane went out with a few boys at Fieldston, among them Adam Yarmolinsky. "There were a lot of boys in love with her," another classmate, Eda LeShan, recalls. "She was irresistible," Stewart Stern says. "I used to stand outside her apartment looking up at her window, hoping I'd catch a glimpse of her. When you were with her, she made you feel like you were the only person in the world." But she wanted to be with Allan—only with Allan. When she went to Russeks to try on clothes, the salesladies said, she would be wearing Allan's under-pants "as a sign of love."

Periodically Diane also worked at Russeks in the stockroom. A cousin, Helen Quat, who worked with her, says, "I've never seen anyone hate a job as much as Diane hated the stockroom." Later Diane said: "I abso-lutely hated furs; I found the family fortune humiliating." But as a teen-ager she suffered in silence.

So did Howard, who also worked in the stockroom during Easter va-cations. By this time he and his father were having arguments about How-ard ultimately taking over the store. He knew that if he didn't make a career at the store, it would seem as if he was deserting his family, and he wasn't yet sure he could redeem himself by success elsewhere. "And I would cry," Howard says. "I was terrified of Daddy and I wanted him to

love me, but I knew I would never be interested in running Russeks and I would never change my mind."

Russeks meanwhile was flourishing. Nemerov kept tabs on the increasing popularity of mink coats (mink represented eighty percent of Russeks sales—there were an estimated 250,000 mink coats and jackets in American closets). He noted each new fur trend—now women wore fox-fur jackets over their bathing suits in Palm Beach, unflattering to short figures and mature silhouettes; he predicted the demise of the fox-fur jacket and he was right.

He had created a series of boutiques within the store proper—among them a college shop and a bridal boutique, innovative merchandising touches in 1938. He also organized weekly fashion shows at Russeks—very popular with the customers—and they helped boost sales. "David did everything," the fashion illustrator George Radkai says. "He chose the clothes, he accessorized the models, he was a magician when it came to putting the right scarf with the right earrings and shoes." As added promotion for the store, Nemerov was also supplying Russeks outfits for Broadway shows. "He'd dress bit players free and then get Russeks credited in *Playbill*," Radkai says. "David loved being involved with show business."

By June of 1938 Diane's romance with Allan had grown even more intense. "A lot of yearning and frustration," her sister Renée says. She remembers going into the kitchen late at night for a glass of ice water "and there they'd be—Diane and Allan—kissing passionately in the dark." When Allan wasn't around, Diane hung on the phone with him, and in conversation with others she referred to him constantly. " 'Allan says this' —'Allan believes that'—Allan's word was gospel," says Hilda Belle Rosenfield.

Under Allan's influence Diane began creating her own style—her own look. She often refused to put on the elaborate dresses her mother chose for her at Russeks—nor did she wear silk stockings and her legs were bare and unshaved. When she visited her brother at Harvard, his friend Clara Park recalls: "Diane's thick brown hair hung almost to her waist. She wore a blouse of heavy ivory silk, tweed skirt, no makeup, no jewelry, and white ankle socks and sandals—you know the kind one bought at Best's for children? Howard kept repeating how exquisite his sister looked, but to me she was making a statement—and it was an utter rejection of the way she'd been raised."*

* Diane always believed in female naturalness. Although she'd been taught that hairiness, menstruation, and body odors made one "impure," she rebelled against her parents' preoccupation with cleanliness. She couldn't understand why women were kept in a state of innocence about their flesh and blood and denied their sensual animal selves. In time Diane chose to wear no deodorant, and as she grew older, people—particularly men—would comment in

That summer Allan took a photograph of Diane lying in the grass in Central Park. "It was the most rapturous portrait of young love I've ever seen," Dorothy Evslin says. "Diane seemed thrilled with it and showed it to everybody in the family." David Nemerov refused comment. While he never told Diane to stop seeing Allan, he disapproved of their involvement and he expressed his disapproval by being "as cold as ice," Renée says. "Diane retaliated by ignoring Daddy, which frustrated him terribly. He was used to people wilting under his disapproval, but Diane wouldn't budge. And to make matters worse, she wouldn't accept the fur coat he'd given her—all our friends were wearing little fur coats that year, but Diane wouldn't even try hers on. It was the final blow as far as Daddy was concerned."

Eventually Nemerov phoned Victor D'Amico at Fieldston and pleaded with him, "Make Diane stop seeing this Arbus fellow. I'll pay you any amount of money if you can persuade her. She respects you more than anybody in the world. Please do something."

D'Amico refused. Subsequently he and Diane talked briefly about Allan, "but I never met him. Diane said she was determined to go through with the marriage in spite of her parents' opposition. 'I'm going to wait until I'm of age,' she told me, 'and then I can go off by myself.' I got the impression that, while she may have cared for Arbus, he was principally the way for her to leave home and be independent."

During their talk D'Amico suggested to Diane—and later to Mr. Nemerov—that she go to the Cummington School of the Arts for the summer. Cummington, set on 170 acres in the hills above Northampton, Massachusetts, was considered a "very progressive" school. The students (aspiring poets, writers, painters, dancers) baked their own bread, made their own shoes, literally tilled the fields on the school property, "in order to get close to nature and themselves." At one time or another the faculty members included Marianne Moore, Archibald MacLeish, and Allen Tate.

These names meant nothing to David Nemerov, but when D'Amico told him about the school, he thought that a protracted separation from Allan might break up Diane's romance, so he packed his daughter off to the school in July of 1938.

It was very hot in Cummington. The grass on the hills was golden and brittle. Diane worked sporadically in class on an oil painting she called "The Angel Gabriel" (it was really Allan Arbus), and together with the

embarrassed tones about her "funky body odor." However, she enjoyed her smell. She carried herself proudly—shoulders squared—totally accepting it.

other students she sang songs while washing the supper dishes. But she spent most of her time with nineteen-year-old Alexander Eliot, the great-grandson of Charles W. Eliot, president of Harvard. Alex, a genial six-footer, was to become the art editor of *Time* magazine, but at the time Diane first met him, he was, according to a friend, "a beaming wunderkind—messy, red-haired, always smoking, always talking."

Born in Cambridge, Massachusetts, and raised in Northampton, where his father, Sam, Jr., taught drama at Smith College, Alex was nurtured by his mother, Ethel Cook, a plump, gentle woman and a writer of children's books, among them *Wind Boy*, which was a best-seller in the 1930s. Ethel encouraged Alex to be an artist rather than an educator. "She thought everything I did was great," he says. As a boy Alex scribbled short stories, painted "all kinds of painting—from realism to complete abstraction." He attended Loomis prep school, but refused to go to Harvard and instead went to Black Mountain College for two years, and then to the Boston Museum school of painting. He had opinions about everybody and everything, from philosophy to art. One of the first things he told Diane was a quote from Goethe which she never forgot: "Every form correctly seen is beautiful."

Alex says he fell in love with Diane the moment he saw her. "Her physical presence was so extraordinary, she startled me—took my breath away. It was like coming upon a deer in a forest." "There was this meeting opening night of Cummington," he goes on. "Katherine Frazier, the founder of the school and quite a remarkable woman—a musician, an aesthetician—was giving us students an inspiring talk as to how we could develop into a real artistic community.

"Meanwhile I noticed Diane moving in the background—weaving in and out among the other students. She was dressed all in black. Her thick, lustrous, fragrant hair was hanging down about her shoulders. She was quite voluptuous—beautifully shaped arms, exquisitely formed legs . . . She kept moving back and forth very deliberately as if she was dancing out what Miss Frazier was saying, with beautiful, thoughtful motions. I couldn't take my eyes off her. I fell in love. She was the first great love of my life."

The following day Alex asked Diane to take a walk with him and she said, "Sure." "I told her, 'I noticed you last night,' and she said, 'I know you did.' 'I loved the way you moved,' I said, and she said, 'I know you did —it was all very much for you.' She was completely aware. It was her nature. She had that instantaneous intuition coupled with a cherishing slowness of response. She always knew what was up, but she took her time about reacting."

Diane and Alex went off on many walks alone that summer. "Walking

with her took on special significance because she would stop and notice everything along the way. All artists collect images and Diane was no exception. She noticed everything—the changing colors of the sky, the way the clouds formed on the horizon, the peeling paint on a barn, the *textures*, wrinkles, feel of the peeling paint . . . Once, I remember, we were sitting in a meadow and a fly alighted on her arm and she watched it move across the hairs . . . with the utmost concentration." Years later when Alex was studying Zen in Kyoto, he was in the temple meditating "and there were flies in the temple and they buzzed around me and one burrowed into my cheek as I knelt there. I remained very still on my knees, remembering Diane's large, dreaming eyes on that fly, her almost trance-like concentration."

When he met her, Alex was attempting to be a painter. He showed Diane his painting of the burning of Boston. She showed him her portrait of Allan/Gabriel. "The minute I saw it, I knew she was going to be a great artist. The painting of Allan [which Alex now has in his home in Northampton] was an extraordinary work for someone so young." (In the painting Allan is stripped to the waist, arms clenched. He resembles a soul locked in despair. His head is bald, although in person he has a headful of thick, curly hair. His eyes are sad and bulging, the color of his skin is pale —almost dead-looking. There is an eerie, ghostly quality about the painting—a primitive quality.)

"The emotion, the colors, the textures—the proportion—it was all there. I thought it was museum quality," Alex goes on. "I got very excited about it and told Diane how I felt, but the fact that she was talented couldn't have mattered less to her. She was bewildered by people who made much of her talent. It was simply a part of her like her fingernails and so what?

"It's something that's commonly understood now, what we've learned from the East is that *product is not the point*. That it isn't a question of doing art, it's a question of making art of what you do . . . This attitude didn't hold in the 1930s. It was a severe and hungry time for artists, musicians, poets—you were supposed to *produce*, do something that would startle and amaze the world . . . Diane was far ahead of her time . . . she'd already in her heart made the leap—that it was not the end result that mattered, it was the doing, and if the doing was too easy—as in painting—she'd try something else, something more difficult . . ."

That summer Diane and Alex cut most of their art classes and spent hours wandering together through the hills. They had a favorite place— the town graveyard of Cummington, which, oddly enough, was in the center of the school grounds and high on a hill. "It was a tiny, eerie place

full of strange vibes," the poet Louise Bernikow recalls. "Very spiritual but ominous, too—one could imagine having an out-of-body experience in this graveyard; one could imagine miracles happening, snakes appearing; one could imagine men turning into bears, vampires, or mountain gnomes." Diane and Alex went often to that graveyard, usually lingering until dusk—sometimes they would try to decipher the ancient tombstones, sometimes they would just talk.

"It was a sweaty Sunday afternoon," Alex writes. "Diane and I were giving each other back rubs in the long grass behind the cemetery. I first sensed with my fingertips the snake of light, the delicious serpent hidden within her spinal cord." Several times that summer she laughed and cried in Alex's arms. Nobody understood her except Allan Arbus, she confided. Her mother phoned her every day, wanting to know her every thought, her every move. She said her mother wanted her to have an operation. "Diane had a funny breastbone. It stuck out and was very obvious whenever she wore a bathing suit or a dress with a round neck. Mrs. Nemerov wanted her to have corrective surgery to repair it—she found it ugly, disfiguring. I told Diane, 'Don't do it! That breastbone is your antenna!'"

To the other students at Cummington "Diane was wondrously strange," Alex says. "She was beloved by everyone." This was proven when she lost the inscribed silver slave bracelet Allan had given her. "We had gone to the meadow one afternoon and Diane had taken it off and left it behind in the tall grass," Alex says. "When she realized she'd lost it, she was beside herself. The entire student body searched the meadow until the bracelet was found. There was great rejoicing," Alex says, "and then Diane and I were summoned to the principal's office—we'd cut so many classes we were sure we were going to be expelled. But instead Miss Frazier said that although most of the teachers thought we should be kicked out, she had decided to let us stay. She then added something like 'There is more than one way to learn about life and art.' She even told us to keep on cutting classes if we wanted to."

They cut no more classes after that, although Alex did take Diane down to meet his parents in nearby Northampton and they spent the afternoon with Ethel Cook and Sam Eliot, a tall man with a terrible stutter, who showed her his pride and joy: a huge book he'd written—the definitive book on the birds of the Connecticut Valley. Afterward Diane likened Alex's family to the pattern in their living-room carpet. She said, "Your father reminds me of the middle of the rug—worn, walked over; you're the bright patch under the chair—you haven't been touched yet."

Toward the end of the summer Allan Arbus came up on the bus to visit

Diane and she introduced him to Alex as "my fiancé." Alex says, "She had told me she was planning to marry this Allan Arbus, but she was only fifteen. I kept hoping she'd change her mind."

He found Allan handsome, slight of build, and amazingly self-contained. When he spoke, his voice sounded deep, almost fruity. Alex was surprised at the way Allan treated Diane, "tender but dominating; he'd keep telling her, 'Finish your sentence, girl, don't let your thoughts hang.' Diane never finished sentences—that was part of her charm. It had never bothered me."

After that summer Diane wrote to her brother, Howard, at Harvard about Alex and urged them to meet. The two young men eventually had lunch in Cambridge and, says Alex, "talked a blue streak." Later they attended Ezra Pound's controversial lecture during which Pound made some anti-Semitic comments. Howard said nothing, although he was very conscious of being Jewish; a definite quota sysem existed at Harvard and in most Ivy League universities, and Harvard was a conspicuously Brahmin establishment. Howard was aware of this and believed the best thing to do was keep his mouth shut. Nevertheless he was intent on making a name for himself and he did by excelling in everything—top grades, swimming, high jumping, tennis. He got into the prestigious Signet Society; he published short stories in the *Harvard Advocate.* "Howard was a golden light on campus. He was brilliant," says Clara Park, who was at Radcliffe at the time. "He was rich, he was good-looking. He got sixty dollars a month allowance—astronomical in those days." Dryly witty and courtly with people he liked, he could be arrogant and contemptuous of anyone less bright than he. He chose his friends carefully: there was Clara, there was Bill Ober, an aspiring music critic, and Reed Whittemore from Yale, who was just about to start a little poetry magazine called *Furioso* with James Angleton.

Howard and his friends read T. S. Eliot, his archenemy William Carlos Williams, and Archibald MacLeish, and Howard began scribbling poetry, competing with his first-year roommate, Billy Abrahams, who'd already won awards for his poetry and been published in *The New Yorker.* "Howard wasn't going to be a poet—he *was* a poet," Clara Park says. "He had a grandiose vision of himself—to many girls he became a darkly Byronic figure. God, he took himself seriously! I've never known anyone to take himself so seriously! He gave himself a goal to write three thousand words a night and he kept it up for quite a while. But he didn't think he improved."

Howard explains: "Writing was for me at the beginning sinful and a transgression . . . the emphasis I place to this day on work, on being indus-

trious for the sake of being industrious, contains a guilty acknowledgment that I became a writer very much against the will of my father, who wanted me to go into his business, or, as it used to be called, go to *work*." He adds, "In retrospect, one of the reasons I worked so hard at Harvard was to prove to my father that even though I wasn't going to take over Russeks I was still a man of good character—that creating art—writing poetry—could be as much *work* as working in a department store."

At the time, Howard identified with Thomas Mann (one of his "spiritual fathers"). Mann's persona—that of a lofty, elegant recluse—appealed to him. He may have also identified with this great writer because, despite his talent for defining character, Mann was privately not very interested in people. In his junior year at Harvard, Howard won the prestigious Bowdoin Prize for an essay on Mann's *The Magic Mountain* and how the novel embodied the quester myth. He had tea with Mann at Princeton and later spent the $500 prize on a secondhand Buick. When he realized he wouldn't have enough money for the insurance, he phoned his father and asked if he would give it to him. Mr. Nemerov chastised him severely for not having considered this detail before buying the car. "Howard was absolutely crushed by Daddy's disapproval," Diane said.

During the 1938 winter holidays Alex Eliot attended the Nemerovs' annual Christmas party. "A crowded affair—lots of rich eggnog in silver bowls." As far as the Nemerovs were concerned, Alex Eliot was Howard's friend, but Alex spent most of his time with Diane, "although it was difficult because Howard never left us alone." Diane got so annoyed at her brother's continued presence that she finally stuck her tongue out at him and he burst out laughing. "It was one of the few times I have ever seen Howard laugh."

That same Christmas, Alex accompanied Diane when she sneaked off to a rendezvous with Allan at an East 86th Street delicatessen. Alex sat with the couple for hours over their coffee while they recounted the drama of their romance, explaining in graphic detail how the Nemerovs disapproved of it and how they planned to marry in spite of the opposition; how they loved each other passionately and well. Suddenly Alex, swept up in the emotion of the moment, blurted out *his* feelings for Diane— extolling her talent, her sensitivity, her beauty—while Diane giggled with delight.

By New Year's the three had become inseparable—wandering into art galleries, roaming through Central Park knee deep in snow. They went to Russeks, too, and Diane took Alex on a tour of the entire store, ending up in David Nemerov's wood-paneled office. Nemerov, knowing that Alex wanted to be a painter, gave him an assignment to do some fashion illus-

trations. Alex sketched a few rapidly on big sheets of paper and then he and Allan and Diane pasted them up along Fifth Avenue opposite B. Altman and near the Empire State Building.

By themselves, Allan and Alex talked for hours—discovering they shared many interests in art and in books. They both wanted to be artists —Allan an actor, Alex a painter. And they shared the same Renaissance idea—that friendship, even more than sexual passion or romantic love, was the essential ingredient of a good life. Eventually they told each other a great deal about themselves and "we became as close as brothers," Alex says, "which was funny because, looking back on it, we were the exact opposite. Allan was cautious, cool, a perfectionist, while I tended to excess —I drank too much, talked too much, ate too much, smoked too much. Allan never did too much of anything."

Over the next year Alex would periodically come down from the Boston Museum art school to New York and see Allan. The two young men developed a strong and affectionate friendship, but it was Diane who made them feel alive. "Because, no matter how well we thought we knew her, she was elusive—an enchantress." Anything could happen when they were with her; she was a catalyst, a troublemaker, a source of joy and despair. "She was such a profoundly feeling being—we were both deeply touched by her," Alex says. "Her emotional, feeling life was the dominant part of Diane; her intuition, her emotions were extraordinarily developed by the time she was fifteen. The intellectual life was brilliant, too, but secondary to that; and the life of the will—the drive to accomplish something—was very much a third."

Alex was sure she was a genius. "Always surprising. Like the *objet trouvé* she'd made for Allan that he had framed in his room. What Diane had done was place a worn and polished stone on top of two twigs—one bent and one straight—and it became a composition and one I found strangely moving. I asked Allan, 'What is it?' and he told me that Diane had fashioned it for him during one of their walks through Central Park, and I said, 'What does it mean?' and he said, 'I think it's meant to be us.' " Allan knew how greatly gifted she was, and although he was gifted himself, I think he was afraid he couldn't hold her—that she was too much for him, that he simply wasn't on her level. At some point in 1939 he confided to Alex, "I'm just going to hold her back, you know."

Alex says that his "heart leaped because I wanted to marry her so terribly, so I asked, 'Why are you marrying her, then?' thinking I might stand a chance." Allan replied that Diane wanted to and he wanted to because he believed he could give her the security she needed. Desolate, Alex returned to Boston.

At that time he was renting rooms in a Beacon Hill house on Pinckney Street that belonged to Evans Dick. Dick and his wife had once been extremely wealthy. Now they took in boarders, and their four daughters —a beautiful, eccentric brood—lived jammed together on the top floor. Anne, the eldest, was a fashionable, high-strung blonde who had just broken off her engagement to the poet, Robert Lowell.*

Jean Stafford, who married Lowell soon after, used to cry, "If you say that Anne Dick looks like Bette Davis one more time, I'll do you violence!" Anne did have slightly protruding eyes and a seductively caustic manner, and she was very bright, having already had poems published in *Hound & Horn*. "An aura of glamour surrounded her," her cousin Frank Parker says, "because she had been psychoanalyzed for her depressions. Her parents were afraid of her—her beaus were afraid of her—she and her sisters fought like cats and dogs. She could get very edgy."

Anne was thirty when she met Alex Eliot; he was nineteen. She was terrified of becoming a spinster. "Getting married was essential to Anne," Parker goes on. "Having a man to depend on—to live through—was of prime importance. And Alex was intelligent and charming and sexy—and he came from a distinguished family."

So Alex and Anne "courted" for the next six months while he painted furiously but without much success. He had very little money. In fact, from time to time Allan Arbus would send him $5 a week from his meager Russeks salary to help pay for groceries. Then Alex managed to scrape enough funds together to start an art gallery in his rooms, which he called the Pinckney Street Artists Collective. He showed friends' experimental work, including Diane's, and he was extremely enthusiastic about the venture, but it failed in less than a year. In his distress he phoned Diane, who was properly sympathetic. At the close of the conversation she said that she and Allan wanted him very much to be the best man at their wedding.

After that Alex continued to see Anne Dick and they decided they were in love and he would give boisterous parties in his rooms and serve iced Russian vodka while some of his friends made charts of the novels they were going to write. Early in 1940 Alex and Anne got married.

Later he would tell people he'd been totally unaware of Anne's violent mood swings—one day she would be euphoric, the next so despondent she became physically ill and took to her bed and the only thing that seemed

* Lowell's parents had forbidden their son to leave college and marry Miss Dick. They had bitter arguments about it and Lowell had become so enraged he knocked his father to the floor, breaking his glasses. Throughout his career Lowell returned obsessively to this incident in his poetry—expressing continued anguish and remorse.

to soothe her was warm tap beer that Alex used to fetch from the local bar.

When they met, Diane responded instantly to Anne's struggle with depression since she suffered from bouts of deep depression herself. As their friendship grew, they were to spend much of their time together cheering each other up.

Until she reached her senior year at the Fieldston School, everyone thought Diane would go on to college. She had the reputation of being such a singular student, and nobody else took herself as seriously. She was solemn, she was dedicated. Naomi Rosenbloom can still see her "trotting over to me during recess—I'd been goofing off, and she let me have it. 'You can be much better than you are,' she chided. 'You should always strive to be as good as you can possibly be.' "

She was certainly striving. In her autobiography she had scribbled: 'For about four years I had visions of being a great sad artist and I turned all my energies toward it." This was evident not only in her painting, but in Elbert Lenrow's Great Books course, "because," Lenrow says, "she wouldn't accept other people's ideas of composition." The essays she wrote on Flaubert and Sophocles predict her work with a camera; she was already preoccupied with ambiguity, with contradictions. She was examining rather than interpreting the world.

"We talked—we argued together," Phyllis Carton says, referring to the group of bright students she and Diane belonged to. They would meet in the cafeteria and hold long discussions about what they were being taught. "We were passionate about the school, our futures, ourselves," Eda LeShan says. "We wrote letters to each other—'I can't live without you' kind of thing." As if to prove it, LeShan and Carton gathered up a bunch of twigs to symbolize their clique and buried it under the foundation of a new building going up on campus. "We laughed a lot," LeShan goes on, "but we took ourselves very seriously."

They all planned to go to college, and although Diane didn't say anything, everyone assumed she'd be going to college, too. That is, until Shirley Fingerhood asked where she'd applied—Radcliffe? Bennington?—and Diane answered that she hadn't applied anywhere; she wasn't going to college, she was getting married to Allan Arbus and that was that.

"Falling in love with Allan had made Diane feel very grown-up," Phyllis Carton says. "To her, marriage would mean a huge life experience, and

college was dry—it meant more education. That wasn't life for her. She was preoccupied with anything physical—any physical sensation that made her believe she was alive. Her menstrual cycle fascinated her—after she fell in love with Allan, she talked to me about her longing to conceive and bear a child. We discussed the mysteries of conception; she thought childbirth must be the most extraordinary experience in the world."

One of the last things she did in art class was to create a weird collage of a mother and child out of different-colored paper towels; it was three-dimensional—a woman with a fetus swelling inside her womb. "It was very strong—very powerful," Phyllis remembers. "And the mother's eyes were so sad. It was so different from the stuff the rest of us were doing—I was sketching the Cloisters, for God's sake." Everyone in class was impressed by Diane's collage, but "spooked by it, too. There was something about it that was downright scary."

"Her talent was very special," D'Amico says. But being thought of as different made her feel self-conscious. "In some ways Diane wanted people to think she was like everybody else."

So in a way it was a relief when her father, after praising her gift for painting, dismissed it as a "hobby." Her true goal, he said, was "to live under the wing of a man." Yet he was very disturbed about her continuing romance with Allan Arbus. Allan Arbus wasn't proper "husband material" —couldn't she see that? With all the advantages she'd been given, with all the expectations, how could she possibly want to spend her life with a would-be actor? She should go to college first. To which Diane would reply that she was in love with Allan and intended to marry him.

Throughout her senior year at Fieldston, despite her father's anger and disapproval, she continued seeing Allan as often as possible. None of her friends ever met him, but she talked about him constantly, telling Phyllis Carton that she was "madly in love." Every so often, looking grimly determined, she would bring him home. "Mommy and Daddy were going to have to accept them as a couple," Renée says. "Diane wouldn't budge." It finally became a battle of wills between father and daughter, and David never stopped carping, criticizing, mocking. Diane kept quiet.

Now suddenly it seemed more important than ever to believe she could escape from her family—Allan would take her away and they would create a life together free from all memories of the gloomy, oppressive Nemerov apartment so thick with useless experience, so cloudy with cigarette smoke. She told Phyllis that she felt she had never belonged there ("I'm an orphan," she said). In fact, she felt it was impossible to be herself at all. She was conditioned to please—to do what her parents wanted, what Allan wanted, and it was always extremely hard for her to make up her mind about the little things. Should she go to the movies? Or the theater?

What about the ballet? And should she wear her pink cashmere sweater or her pale silk blouse with the pearl buttons? She would grow overwrought trying to decide. For much of her life she would be like this. Only when she began photographing on her own did she turn decisive.

In the meantime, crazily, she concluded that if she got married and became a wife (even Allan's wife), she would somehow win her father's approval—since he did expect her to play out that role. Then she would enjoy the rewards of being a "good girl" (whatever that meant). Married, she would fulfill the demands of others—the demands of her willful, striving self would have to wait; and at least if she was married her parents would finally leave her alone. But she was ambivalent about whether or not she was doing the right thing.

In an essay she wrote on *Medea* she alluded to her conflict, describing "the deep selfish slowness of woman who closes her eyes to everything," including the restlessness of woman whose dreams then become a defense against awareness. "Such women were like sleepwalkers." She questioned female passivity even as she exhorted herself to be passive. "A woman wants to be one thing," she wrote, and then she is told to be another. If she doesn't fulfill her destiny, should she hate herself? "I don't think so."

Abruptly she phoned Alex Eliot in Boston and told him she would marry Allan the moment she turned eighteen. When he asked about her painting, she replied sullenly that she had begun to hate painting—hate the squishy sound of paint on paper, the smell, the mess, the time it took. It had been the greatest pretense in the world, she said, to visualize herself as a "great sad artist" when she wasn't an artist at all. She sounded as if she was trying very hard to convince herself that she didn't enjoy the act of creating. "Diane was simply scared stiff of her talent," Phyllis Carton says. "It terrified her because it set her so apart."

During the spring of 1940 she began slowly withdrawing from her friends, and she refused to help with the art work on the *Fieldglass*, the school yearbook, having denounced all her paintings to D'Amico as "no good." Nor would she pose for a group class portrait, although the photographer did take a picture of her alone which documents her wistful, faraway quality. Under the picture is the prediction: "Diane Nemerov—to shake the tree of life and bring down fruits unheard of."

Now when anyone asked her plans she would say she had no intention of pursuing a career or of attending college; all she wanted to become was Mrs. Allan Arbus. As proof, she never took off the silver slave bracelet he'd given her as proof of his love. Nevertheless her depressions grew more pronounced, and everyone in her class noticed. "She dragged herself around in a daze," Elbert Lenrow says.

When Howard came to visit Lenrow at Fieldston during Easter vaca-

tion, the teacher commented on Diane's dark moods. "She seems very troubled," he told her brother. "Don't you think you should do something?" Howard didn't answer. He himself was so often depressed that he thought he should go into analysis. The only thing that saved him, he said, apart from his excitement at being at Harvard, was his writing. He'd had his first short story (about a friend's suicide) published in the *Advocate*, he'd just got into the exclusive Signet Society, and he was getting to know instructors like Delmore Schwartz and writers like Wallace Stevens and fellow classmates like Norman Mailer. He told Lenrow that he'd decided he was going to be an artist, no matter what his father's plans were for him to take over Russeks. He hoped to be a very great artist someday, he declared; he would write plays and novels and epic poems, and he would write essays, too, and criticism, and he would contribute to *The New Yorker* and all the scholarly journals.

Of Diane's mood he remembers that at home they would sit around the living room and she would tease him about his tendency to intellectualize everything. "She told me she was very glad she wasn't going to college, because she didn't want to be like me."

In May the senior class spent a weekend at Ethical Culture's Hudson Guild farm in Netcong, New Jersey. Diane didn't join in the walks through the woods or the Ping-Pong games. A teacher, Spencer Brown, remembers seeing her sitting by herself on the porch staring into space "while the kids screamed and played around her. Some of her friends would go over and try to talk to her. Most of them addressed her as 'Miss Diane.' She was very beloved." Another teacher said, "I thought she was peculiar. Peculiar but nice."

In the weeks just before graduation Diane stayed late on the Fieldston campus, wandering the grounds. It was as if she didn't want to go home.

One afternoon—it was after five—Elbert Lenrow came upon her in his office gazing up at some prints of African masks he'd tacked up on his bulletin board. The masks were tragic images—huge, hulking, almost grotesque—and Diane seemed drawn to them. She looked at each one close-up for five to ten minutes—just staring very hard, as if memorizing them. Then she reached up and stroked them. "I've never seen such an intense physical response to anything," Lenrow says. "Those masks obviously had a powerful emotional effect on her."

Diane did not seem to notice that Lenrow was in the office. Neither one of them spoke, and finally she wandered off into the dusk.

. . .

After Diane graduated from Fieldston, the Nemerovs sent her with her cousin Dorothy to a farm in Morrisville, Pennsylvania, for the summer. They were driven there by Paris in the limousine. Along the way they listened to news of the London blitz on the radio. "We were supposedly going to get lots of fresh air and sunshine and learn about farm animals," Dorothy said, "but the real reason was to keep Allan and Diane apart." It didn't do any good. As soon as Diane arrived at the farm, she telephoned Allan, and a few days later he came down by bus to visit her.

The Nemerovs spent the following months trying to convince Diane to change her mind about marrying Allan, but Diane was adamant. Nothing could sway her. Exhausted from talking, the Nemerovs agreed to the marriage, and the engagement was announced in the *New York Times* on March 3, 1941: "A. F. ARBUS TO WED MISS DIANE NEMEROV. Mr. and Mrs. David Nemerov of 888 Park Avenue have announced the engagement of their daughter Miss Diane Nemerov to Allan Frank Arbus, son of Mr. and Mrs. Harry Arbus of 1225 Park Avenue . . . Mr. Arbus attended the College of the City of New York and is now in the advertising business."

The Nemerovs threw an elaborate cocktail party, "everything in aspic," to celebrate the engagement. Designers like Mollie Parnis and Hannah Troy came and I. Miller and Andrew Goodman. Everybody stood around the elaborate, gloomy apartment while Diane and Allan whispered to each other in a corner.

Afterward Diane wrote to Alex Eliot describing the party in detail. She had been corresponding with him regularly since his marriage, and over the past year their romantic attachment to one another had intensified, partially because Alex absolutely doted on Diane—idolized her, championed her in his boisterous, emphatic way. Everything she said and did delighted him. And there was a strong sexual attraction between them, too, that had never been consummated. This both excited and worried Diane. She kept asking Alex, "Is it evil that I want both you and Allan?" He would assure her that it wasn't evil. He was positive that the four of them would remain dear and trusting friends—possibly better friends after she and Allan got married. Certainly nobody would ever get hurt. "At the time, I thought Diane and I were like brother and sister. She confided in me as a sister confides in a brother . . . I kept telling myself our relationship was harmless."

On April 10, 1941, less than a month after her eighteenth birthday, Diane Nemerov and Allan Arbus were married in a rabbi's chambers; Diane wore a pale blue suit. Only the immediate families were present: Gertrude

and David Nemerov, Mr. and Mrs. Harry Arbus, Allan's sister Edith, grandparents on both sides. Alex Eliot couldn't be present—his wife didn't feel well enough to travel.

As a wedding present Gertrude Nemerov guaranteed Diane a five years' supply of clothes from Russeks and the services of a lady's maid for a year.

Since they had no money for a real honeymoon, they took the train to Boston and spent their wedding night at the Eliots' apartment on Pinckney Street. "First we walked around the Commons Garden and I showed them all around Beacon Hill." Alex adds that he kissed Diane chastely on the cheek just before she and Allan retired for bed. The next morning Diane told Alex that Allan had joked, "Now, why do you suppose he didn't kiss *me?*"

The day after the wedding Diane wrote to her best friend, Phyllis Carton, assuring her, "Everything is going to be all right."

8

Shortly before Pearl Harbor, Alex came to the conclusion that he couldn't make a living as a painter in Boston, so he got a job assisting Louis de Rochemont on *The March of Time* and he and Anne moved to New York and rented an apartment across the hall from Diane and Allan's on West 38th Street. "The building was next to the Lincoln Tunnel, so it was very noisy," Alex says.

The two couples saw each other every night and often spent entire weekends together. Alex's exuberance, his optimism, his insistence on seeing only the good and positive in life seemed to enhance the quality of their friendship, so that for a while it was infinitely pleasurable for everybody.

Sometimes Allan would entertain the others by playing his clarinet. "He sounded exactly like Benny Goodman." Sometimes he would do imitations of Maurice Evans. They all laughed a lot. They were determinedly cheerful. Alex called Anne and Diane "Sun and Moon" because when blonde Anne was happy, her face positively shone, whereas the dark Diane seemed to have a mysterious silvery sheen to her cheeks.

Together they discussed art and literature and sex—"but not much," Alex says. "We were inhibited talking about sex." And they discussed their own feelings, their own emotions in regard to one another. Rather, Allan and Anne and Alex did—Diane did not. "Nobody ever knew what Diane felt about anything," Liberty Dick, Anne's sister, says.

In time Alex decided they should become an extended family, and he likened them to the four legs of a table. "If one leg collapses, the entire table collapses." They would share everything, he declared—food and money—and nothing would ever be hidden between them and there would be no betrayals, no deceptions.

To make sure of this, Alex announced that he was still in love with Diane. He would repeat this over and over, adding, in the same breath, that he was in love with his wife, too, of course. And they seemed to accept this as a fact of their life together and Allan didn't seem to mind—he was

used to men falling in love with Diane; it flattered rather than irritated him. As for Anne, she suffered from it a little because, much as she enjoyed his company, she wasn't the least bit in love with Allan. "I frankly don't know what Anne ever got out of that four-way friendship except a lot of pain," Marian Wernick, a former *Time* magazine researcher, says.

Diane, meanwhile, floated above the situation—detached, remote, never commenting or making judgments. She concentrated on being Mrs. Allan Arbus and she seemed totally committed to the man, to his desires, his dreams. She had been taught to believe that there is no greater destiny for woman than to glory in her femininity, and she was obsessed with doing just that.

Phyllis Carton recalls watching her "make the marriage bed"—caressing the mattress, tucking in the sheets, pulling the blankets very tight. "It was an act of supreme devotion and I was much moved by it," Phyllis says.

Diane was trying hard to play the 1940s housewife to perfection, taking out the laundry and shopping at the grocery store—these were duties she'd never had to perform at home, where servants took care of everything. Liberty Dick, who was then living in Greenwich Village with her husband, remembers how "Diane would follow me around our apartment trying to 'learn homemaking,' as she called it. She didn't know the first thing about planning a meal, let alone cooking it. Whenever she'd visit me, she'd ask endless questions about this and that—she was actually quite a pest."

Diane had become a practicing vegetarian; she had little interest in *haute cuisine*. However, she worked very hard in the kitchen, and eventually cooked well. But she didn't try out her culinary skills on her parents right away since they rarely visited the Arbus apartment on West 38th street. They were aware that "the kids" were struggling financially (Allan had two jobs—at Russeks and somewhere else as a salesman; he was also trying his hand at fashion photography with Diane acting as his assistant). But the Nemerovs didn't give them any money.

"We [Howard and I] never benefited from our parents' wealth," Diane said. "There was no sense that you could ever do something glorious with the money." It was used for the Nemerovs' lavish life style, "which we inherited as long as we lived with them, but it was temporary." There was no money or promise of money when Howard and Diane tried to be independent and lead their own lives.

Russeks was going through a boom period. "It was the era of the fur-trimmed coat and suit and we did a landslide business," Ben Lichtenstein says. "Something like two million dollars' worth of sales in 1941."

But there were problems. When World War II broke out in Europe,

Norway disposed of its fox furs on the American market; many furriers were caught with huge supplies, and millions were lost. Furriers, Russeks included, hated talking about the fox collapse and turned vague when pressed for details as to how many fox pelts were being kept on ice in warehouses, where uncured skins could be stored indefinitely.

Just before Pearl Harbor, Howard enlisted in the United States Air Force, but he flunked out. Undaunted, he enlisted in the Royal Canadian Air Force. Charles Lindbergh had been a boyhood hero, and he'd always had a romantic urge to be a pilot. Somehow it was a fierce gesture of independence against his father, a way of testing himself.

In training in Ontario, Canada, he would vomit every time he took a plane up. He wrote long letters to John Pauker ". . . wishing the war would be over soon I am in another damn depression . . . am reading an early work of one V. Nabokov *Laughter in the Dark* . . . good . . . went to a dance last night and saw two sargeants dancing with each other. Seems like dear Berlin . . . flying solo . . . landed plane badly but anyway I was alone for the first time in nine months so that was a relief . . . got the highest marks in meteorology class 50 points out of 50 still the good boy of Fieldston ain't I? . . ." and finally this telegram to Pauker: "ROLL OUT THE BOTTLE I AM COMING HOME SUPPER SATURDAY NIGHT AM PILOT WITH OBSERVER RATING SECOND HIGHEST IN CLASS. MUST DRINK MORE . . ."

He went on to win his wings and serve fifty missions with the RAF; later, with the United States Eighth Army air force, he flew fifty-seven bombing missions over the North Sea. "I was finally on my own," he says. "I was still frightened, but I was frightened in a different way."

Allan joined the Signal Corps in September of 1943. He stayed briefly at the induction center of Fort Dix, New Jersey, before being shipped out to Camp Crowder, Neosho, Missouri, for basic training. According to Hope Eisenman, whose husband, Alvin, was there, too, "Allan was miserable." By November Allan was shipped back to New Jersey, to the photography school near Fort Monmouth. Diane moved to Red Bank and lived in one room. She set up a darkroom in the bathroom and every night Allan would come back from photography school and teach her what he'd learned. Often in the afternoons she would baby-sit for Hope Eisenman (Alvin was stationed at the Publications Center, working on army manuals). "Diane loved our baby daughter, Suzy. She would push her around the camp in a doll's carriage. It's all we could afford."

Hope says Diane was snapping pictures all the time. "She carried her cameras in a black sack. I would ask her, 'What did you photograph today?' She once told me she'd been trying to photograph the bare light-bulb hanging from their ceiling." When a dead whale was washed up on the Jersey shore, Diane took a bus to the beach and spent hours photo-

graphing the whale from every angle. She returned to Red Bank that evening with rolls of film and a piece of the whale's carcass for Allan.

Every so often the Eisenmans and the Arbuses would have supper together. "But they almost resented being around other people—you got the sense they preferred being by themselves, they were so close! And Diane never stopped talking about Allan when she was away from him."

In May 1944 Allan was transferred from Fort Monmouth to Astoria, Queens, for more photographic training. Diane told Hope she was excited because they would be moving to her "favorite spot in New York—Lexington and 54th Street." They rented an apartment there and spent their evenings printing and framing their best pictures. Diane eventually sent Hope a portrait she'd taken of her in which, Hope says, "I look quite cross." Diane had written on the back of the print: "not complicated enough."

In late 1944 Allan was shipped off to Burma with a photographers' unit. Diane discovered she was pregnant not long after he left. She subsequently took a nude self-portrait which she showed to Alex before sending it to Allan. And she took another self-portrait a little later—clothed—in the mirror of her parents' bathroom. This haunting image (which Alex still has) reflects the dreamy, faraway quality she would later capture in almost all of her subjects' expressions.

With Allan away at war, the Nemerovs were insisting that Diane move into their new apartment at 888 Park. A nice, freshly decorated room awaited her; everything would be taken care of—meals, maids, her bills. And she could talk on the phone as much as she wanted. "Diane had telephonitis," a friend said. So she returned, a bit sullen, and within a few days she and her mother were arguing. She told Naomi Rosenbloom, "Mommy keeps telling me to wear my galoshes in the rain and I don't want to anymore."

For Renée, Diane's return home was a godsend. At Fieldston, where she was now a sophomore, she was constantly being compared to Diane scholastically. Known as "Diane Nemerov's 'little sister,'" I was miserable. Mommy and Daddy kept saying I was the normal one—they seemed to be pinning their hopes on me; that, unlike Diane and Howard, I would turn into a conventional person. I wanted to please them because I wanted them to love me, but I wanted to please Diane, too. I felt under huge pressures."

It was Diane who supported her when Renée decided to switch to the Dalton School in her junior year "so I could find my own identity." At Dalton nobody asked her about being Diane Nemerov's sister, and at Dalton she was the first student to graduate with a "distinction in sculpture."

She went on to study with Rufino Tamayo and the Swiss impressionist Hansegger.

Renée was fascinated by the changes in Diane since her marriage to Allan. "She seemed more sure of herself. She still looked like a little girl, but she walked like a woman—I remember how her hips undulated under her skirts. She was sexually very aware. I was still innocent, so I was jealous of her sophistication. We talked a lot about life."

During this period Diane was constantly visiting the Eliots in their new apartment at Lexington and 73rd. Anne had just had a daughter, May, who'd been a "blue baby" and was now suffering from a heart defect; she would eventually have an operation. Diane was godmother, so she felt very responsible and spent as much time as she could caring for her little godchild. And she tried to comfort Anne, who'd become increasingly despondent; she was very upset about her baby's condition, and New York made her uneasy—other than the Arbuses, she had no friends. She decided to take May for a visit to the Dicks' shambling estate, Appleton Farms, in Ipswich, Massachusetts. She said the visit would be temporary, but it stretched into weeks and months while Alex remained in New York most of the time. It was quiet and peaceful at Appleton Farms; the other Dick sisters were back and forth from Boston, herded about by their indomitable mother.

Diane's own daughter, Doon, was born on April 3, 1945. Afterward Diane told Naomi Rosenbloom that she had forbidden her mother and sister to accompany her to the hospital. She hadn't wanted anyone close to her to witness her personal drama of "dread, guilt, and expectation." Diane was terrified of being alone, but she believed she had to be alone to really experience something. *Only then would it count.*

As soon as she got back to the Nemerov apartment, she bustled about, trying to act very grown-up, very much the little woman. "She became a wonderful mother," Renée says. "Tender, gentle, loving—she absolutely adored Doon and felt magically connected to her." When the baby was only a month old, Diane entwined her bassinet with fresh flowers and pasted postcards on the walls—prints of Roman ruins, Greek statues, English landscapes—"things for the baby to see and absorb when she wakes up."

She loved showing her tiny daughter off. Ben Lichtenstein dropped by the Nemerov apartment and Diane woke Doon up and put her on the floor, ordering, "Now crawl for your Uncle Ben, Doonie." And Doon wriggled across the carpet and Diane beamed. She was very proud.

By this time, Lichtenstein says, "The Nemerovs' place was overflowing with women." Aside from Diane and Renée, there was a European refugee

girl (the daughter of a friend of David's), there was Gertrude and her mother, Rose, and Peggy Russell Nemerov, Howard's nineteen-year-old English bride, who'd arrived on a troopship from London in May 1945.

Peggy, a pretty brunette, was, in her own words, "gauche, timid, and hideously dressed." She was also extremely self-conscious, knowing that the Nemerovs disapproved of her because she wasn't Jewish. (David Nemerov had, in fact, written Howard a twelve-page letter denouncing his choice of a Gentile wife, and Howard had fired back an eloquent defense which had been gone over and over at the dinner table. It was "like a family conference," Diane reported to her brother in a note. She ended with, "Don't worry, there is nothing our parents can do. It is your life. D.")

And, of course, the Nemerovs did nothing—they tried to be welcoming, but "they never ever accepted me," Peggy says. She was unprepared for their wealth—their power. Howard hadn't told her that his family owned department stores. "Why didn't you tell me your parents had money?" she demanded months later, and he replied grouchily, "I didn't think it had anything to do with me."

("We never *felt* rich," Diane said. "Oh, we had the most expensive clothes and the finest educations, but the benefits redounded to the family's credit—the money would never pleasure [Howard, me, or Ren] personally in any way.")

After the austerity of wartime London, Peggy was staggered by the waste in the Nemerov home "of everything—food, clothes, liquor." She couldn't get used to so many servants underfoot. There was a cook, a maid, a chauffeur, a laundress, a seamstress, and "someone who came in just to do Mr. Nemerov's Sulka shirts." She remembers "trembling with fear" during Passover and Chanukah. "I didn't know what was going on."

A month or so after Peggy arrived, her mother, Hilda Russell, appeared at the Nemerovs' apartment. Hilda was fragile, seemingly timid, and very pretty ("I wanted to be an actress when I was a girl"). She had recently been divorced in London and decided to come to America, "where the money was." After meeting her, David Nemerov gave her a job at Russeks selling the more expensive dresses. "He loved my English accent. He said it helped sales."

Hilda stayed with the store for more than a decade and waited on people like Doris Duke and Vivien Leigh and Mrs. Bob Hope. Occasionally when a really big customer like Eleanor Roosevelt came in, Nemerov would ask Hilda to "get some hot tea across the street at Schrafft's and then I'd serve it to the celebrity in a silver pot on a silver tray." Hilda

recalls Mrs. Roosevelt wanting a "very cheap fur-lined coat and I sold her one for sixty-five dollars."

Sometimes, Hilda says, Diane would wander into Russeks. "She was so dear, so sweet—so kind to me—but I always thought she behaved as if her head were in the clouds. She was never quite 'there,' if you know what I mean. She would always squeeze my hand when she saw me and whisper, 'Oh, Hilda, I love you!' Diane was a great comfort to me."

Peggy says, "Diane tried to be so nice to me, too, although we had nothing in common—it was hard for us to have an extended conversation. But she was going through her own personal hell at home, so maybe that's why she reached out."

Gertrude Nemerov had decided to take over the care and feeding of her granddaughter, Doon, and without consulting Diane she had hired a German nurse and insisted that Doon be bottle-fed, even though Diane had been breast-feeding her baby. Arguments ensued. Diane held her ground. Finally a compromise was reached: before every feeding the nurse would put Doon on the scales to be weighed and then Diane would attempt to breast-feed her, after which Doon would be weighed again to see if she had gained any nourishment.

Peggy says, "I felt so sorry for Diane. She was under such scrutiny that often the milk wouldn't flow. She was trembling with nerves—with the German nurse and Gertrude hovering over her." Peggy remembers that once after the feeding-and-weighing procedure Diane suddenly burst into the hall and ran up and down crying triumphantly, "Doon gained five and a half ounces!"

When Howard came back from England trimly handsome and charged with the rank of second lieutenant, the Nemerovs gave him a lavish party. Diane and Alex and Anne Eliot were there, and all the Russek and Nemerov relatives—aunts, uncles, cousins, the people from the store. "I was not at my best," Howard says. "Everyone around me was complaining about gas rationing and not getting enough steak to eat. I'd seen blood and crushed bones—death. I clammed up and refused to talk. Mommy was furious."

Not long after coming home, Howard told his parents he'd decided to become a writer, something he'd already confided to Peggy and Diane in many letters from London. David Nemerov listened to his son's plans in silence; there was no question now that Howard would ever take over Russeks, so he didn't bring up the subject, but he was bitterly disappointed. Supposedly he confided his disappointment to his close friend I. Miller, whose son Jerry had followed his father into their shoe empire. Jerry recalls, "If you didn't make a career out of the family business, it

was like deserting the Armed Forces or something. You could redeem yourself by being very successful in another field—but to be a writer, to be a poet, well, it was considered a terrible failure, particularly if you were the only son."

Nemerov said none of this to Howard; he only begged him not to use the word "artist" when describing what he was going to do with his life. "What about 'man of letters,' Daddy?" Nemerov liked that phrase and used it often when telling his colleagues of his son's choice of occupation.

Howard realized that in order to survive he must remove himself from his family's apartment, so he and Peggy immediately rented a tiny flat on 25th Street which the Nemerovs rarely visited. "What made the whole thing incomprehensible to me," Peggy says, "was David Nemerov's unawareness of the suffering he'd inflicted on Howard. Howard wanted to write all the rich fantasies crowding his head—he wanted to push his intellect to the furthest reaches possible, because he believed that to use the mind passionately and well was the true test of aristocracy in the modern world. David Nemerov seemed indifferent to Howard's dreams. Nor did he have any notion of his power—the power a father has to irrevocably hurt his son."

Every so often Diane would escape from the vast Nemerov apartment and take Doon to Central Park. She would meet Jill Kornblee, who now owns an art gallery on 57th Street, and the two women would wheel their baby carriages down to the sailboat lake at 72nd Street. "The park was almost Edwardian then," Jill says, "sweet-smelling—clean—no litter—no violence. Even the sunlight on the grass seemed pure, almost distilled.

"We felt suspended in time. We'd read our husbands' letters or just sit and talk. Doon was breathtakingly beautiful. She'd be tugging on my son John's rattle. Diane and I complained about being back with our parents. We were both women of the world. Wives. Mothers. We were twenty years old."

Jill remembers "Diane's bony bare feet thrust into Capezio ballet slippers—nobody in those days wore ballet slippers on the street. When she walked, she sort of plodded flat-footed—like an Indian surveying the land. And she would have on some little nothing smocklike dress—no jewelry, no powder or lipstick, and leg makeup. She looked terrific. She had this great, thick hair. Oh, and funny teeth. When she smiled wide, she looked faintly wolfish."

Sometime in 1946, Hilda Belle Rosenfield ran into Diane on Fifth Avenue. The two old school friends stood on the corner and talked. "Diane told me that her husband, Allan, had come back from the wars and that

they were going to become fashion photographers. 'We're going to be a team,' she said."

Hilda Belle was about to be married, "so I didn't care about Diane's career—I wanted to know how it felt to be a wife and mother. Was it as she anticipated? Was it fulfilling and marvelous?

"Diane listened to my questions without answering, scrutinizing me with her huge green eyes. Suddenly she interrupted me almost violently. 'When I look at my baby, I get a funny feeling!' she cried. The tone of her voice sent shivers up and down my spine. I had the sense that although she'd tried to do all the right things, the traditional things a woman is expected to do—get married, have a child—she still felt separate and alone. She said nothing more, just mumbled goodbye and plodded off. I never saw her again."

PART TWO

THE FASHION
YEARS

In 1946 Ben Lichtenstein gave Diane his Speed Graphic and she tried experimenting with it. But it was heavy to carry and the flashgun attachment scared her; the images produced were chaotic and came too fast. She stopped using it. Later she would say she found the camera "recalcitrant—it's determined to do one thing and you want it to do something else." A photograph suggested alternatives—choices. The act of photography was ambiguous and contradictory, like herself.

For a short while she studied with Berenice Abbott, who photographed New York and James Joyce and collected Atget. Abbott thought photography was the ultimate art form of the twentieth century because it demands speed and science, and she was fond of quoting Goethe: "Few people have the imagination for reality."

Some of Diane's first pictures taken after her classes with Abbott were candids of Howard and Peggy in their cold-water flat on Third Avenue. "We never saw them, but Diane seemed to have fun taking them," Peggy says.

Diane would develop the pictures in the darkroom set up in her parents' Park Avenue apartment. She liked escaping into the little cubbyhole lit only by a red bulb. There were trays holding strange-smelling chemical solutions, and she would place a negative with a sheet of photographic paper under a piece of glass and expose it to white light for a few seconds, then place the paper in a tray of dark solution, and slowly the image would swim into view in the ruby glow of the lightbulb.

There was a magic in the process that never failed to amaze her, and the chemical smells, the continual sound of running water soothed her.

She developed more pictures, one of Anne Eliot clad in a white slip and seated on the floor of the Eliots' Lexington Avenue apartment. She looked very sad.

"I thought it was the most revealing portrait Diane had ever taken," Alex says, "but then Diane did a funny thing. She backed Anne's portrait with a nude portrait of herself that Allan had taken. She tried to scratch

out much of her image with pencil, but you could still see the outlines of her body."

Meanwhile Allan had been discharged from the Army, and he and Diane moved into a railroad flat on 70th Street between Broadway and West End Avenue. Their landlady had rented out all the floors of her converted brownstone at exorbitant rates—$225 a month in 1946 was a lot to pay for a one-bedroom apartment, but there were thousands of ex-GIs in the city saddled with new families and no place to live.

"Our building was never well tended," says Dell Hughes, a neighbor. "There were mice and cockroaches and hardly any heat in the winter." Hughes tried fighting the landlady in court about the heat and about rent reductions. "Although we talked about it, the Arbuses didn't involve themselves in these disputes," he goes on. "They were a shy, retiring couple, especially Diane." Allan, as he remembers, worked in a frame shop on Sixth Avenue; Hughes would hear the sound of a clarinet drifting out from the Arbus apartment most evenings. Allan was practicing his music while scheming and dreaming about becoming an actor—that's all he wanted to be.

He and Diane had long talks about whether or not it was too risky, since he almost certainly couldn't support a wife and child on what he might make in the theater. They discussed it with their parents and with Howard and with Anne and Alex Eliot, too, although they frequently got sidetracked with them and would wonder instead over the adjustments they were having to make—the adjustments of living together again as a married couple after two years apart. They'd both tasted independence— they were no longer used to compromise. They seemed to feel better after they voiced their discomfort to the Eliots. After a while they forgot they'd ever been separated and grew very close again. By that time Allan had decided to give up—at least temporarily—his dream of being an actor. Trained as an Army photographer, he finally decided to go back into that work—into fashion photography—with Diane as his partner. They had dabbled in it briefly in 1941 and had been rather successful, although neither of them had any interest in fashion; it seemed too frivolous, too ephemeral.

Once again David Nemerov helped them out. He agreed to pay for all their new camera equipment, but at the last minute reneged on his promise and paid for only a fraction of it. However, he did give them their first regular account—photographing Russeks fashion and furs for newspaper ads.

Postwar fashion photography was almost painterly in tone and line, influenced by the elegant studio work of Steichen, Louise Dahl-Wolfe, and John Rawlings as well as the bold German émigrés Erwin Blumenfeld and

Horst P. Horst, all of whom believed that color combinations carry emotional weight.

These particular photographers came to the fore in *Vogue* and *Harper's Bazaar* with the resurgence of Paris styles and the explosion of original American designs such as the wraparound dresses of Claire McCardell.

Then in contrast there was Munkacsi, the Romanian sports photographer, who revolutionized fashion photography with his exuberant "snapshot realism." Munkacsi was the first photographer to photograph clothes as they were worn—in action—and outside on location.

As far back as 1934, Munkacsi had been photographing models for *Bazaar*, swimming, running, playing golf—in other words, women enjoying themselves. This innovative way of shooting fashion has since been reinterpreted by countless photographers, the most famous being Richard Avedon, who papered his bedroom walls with Munkacsi images when he was a little boy.

At the beginning of their career Diane and Allan Arbus worked only inside the Russeks studio, sharing it with Harold Halma. "They were very particular," Ben Lichtenstein says. "They wouldn't let the Russeks stylist or the art director interfere. Diane would model the clothes first. They were usually miles too big, but she'd pose barefoot in, say, a Nettie Rosenstein black dress, looking like a kid fooling around in her mother's wardrobe."

Allan meanwhile would be fiddling with the lights, setting them up, and then together he and Diane would try to figure out what the picture should look like before booking the models through Eileen Ford, a former stylist who was operating out of her father's law office, taking calls for four top models (among them Dorian Leigh) at $75 a month.

Recalls Carole McCarlson, a Ford model who worked frequently for the Arbuses up to the 1950s: "As soon as I'd come out of the dressing room, maybe in one of those satin suits and awful pointy slippers, Diane and Allan would duck under the focusing cloth of their heavy eight-by-ten view camera and start whispering together conspiratorially. It got to be a big joke in the business—Diane and Allan huddling under the focusing cloth —because, no matter how many people you get under that cloth, only one person can click the shutter. I had the feeling they were playing a game— waiting for me to do something surprising. They'd egg me on—I'd strike various poses. Sometimes I'd feel like a dancing dog. Then Allan would shout, 'Hold it!' and I'd remain motionless for what seemed like hours— I'd often have to count to a hundred and twenty before they clicked. Then they'd pop up from the cloth and Allan would always say to Diane, 'Well, what do you think, girl?' and then they'd go off and confer in a corner."

Sometimes he'd shoot half a session and she'd shoot the other half, and

when the models were gone, they'd take photographs of each other. The models often gossiped about their behavior. No other husband-and-wife photography team worked the way they did—so tenderly, so closely, in complete collaboration. Not Lillian Bassman and Paul Himmel (and Lillian Bassman had married Paul Himmel when she was very young); not Leslie and Frances Gill, nor the Radkais.

Paul Radkai was a top fashion photographer, but his wife, Karen, was just beginning, and she often annoyed the models by insisting they pose free for her after they'd done a sitting for her husband. "She was building up her portfolio for *Vogue* and she wanted to use top professionals," Dorian Leigh says.

While Diane and Allan knew the Radkais and Lillian Bassman (who saw their portfolio when she was art director of *Junior Bazaar*), they did not spend time with them or with any photographers, for that matter.

"We weren't a very friendly bunch," reports Francesco Scavullo, who had just begun to photograph for the fashion magazines in 1947. He recalls, "Diane had the most terrible teeth—funny-looking little brown teeth—odd for someone so young and otherwise attractive. She and Allan *always* kept to themselves." Scavullo adds, "Fashion photographers have always been unfriendly to each other because we're all basically after the same job."

He recalls that the only photographer in the forties who gave parties for other photographers was the highly original George Platt Lynes. Celebrated for his portraits of Gertrude Stein and Somerset Maugham (gazing longingly at a male nude), Lynes also did surrealistic, almost hallucinatory fashion shots, experimenting with bizarre poses, offbeat props, shadowy lighting. Lynes destroyed most of his fashion work before his death in 1955 because he secretly despised fashion. He believed that those in it were interested only in the immediate effect of creating something that would reflect the present—the now.

Diane and Allan felt that way about fashion, too, but they didn't voice their dissatisfaction. Instead, along with the Russeks account, they began shooting a series of one-column ads for Bonwit Teller. (Robert Frank and Louis Faurer were shooting Bonwit ads then, too.) Barbara Lamb, who was assistant ad director for Bonwit, recalls: "Diane always wore beige on beige and spoke in a whisper. Allan was so considerate—he'd run out and get me a container of chocolate-chip ice cream in the mornings. For some reason, chocolate-chip ice cream cured my hangovers."

According to Betty Dorso, a model turned boutique owner, "Everybody in fashion drank." After a shooting, the models and photographers would go into P. J. Clarke's and down lethal martinis and there'd be a lot of dashing to the bathroom while cigarettes smoked in the ashtrays, and then

around midnight everyone would go on to jam sessions where musicians like Dizzy Gillespie and Lester Young were playing. And on Friday nights there would be wild car rides out to the Hamptons. "It took hours—no freeways then," Dorso says, "so along the way we'd stop at some roadside bar and get plastered. It was a miracle we never got into any accidents— we were always drunk, always laughing. Postwar New York was golden and exciting and affluent . . ."

The Arbuses did not join in the merrymaking at P.J.'s or the Hamptons. They didn't drink or smoke—they were considered by everyone who knew them a shy young couple who seemed almost symbiotically close. In fact, strangers frequently mistook them for brother and sister, since they did bear a striking physical resemblance—they were roughly the same height and had thick, wavy hair and identical watchful expressions. For a while a rumor persisted in the fashion business that Diane and Allan Arbus were blood relations—first cousins who'd fallen passionately in love and married in spite of family opposition. That story got started because Russeks president Max Weinstein's wife's maiden name was Bertha Arbus (her brother was Allan's father). It was also incorrectly assumed that Weinstein was a member of the Russeks clan because he headed the store and was therefore Diane and Allan's grandfather. In truth, he was Allan's, not Diane's, uncle, but no blood relative at all. Another incorrect assumption was that Diane was so rich she and Allan didn't have to work. Nothing could have been further from the truth. She and Allan never received any financial help from her father, and throughout their marriage—particularly in the early years—they were always worried about money.

Neither the Russeks nor the Bonwit account was very lucrative (Bonwit paid only $50 a column), so Diane and Allan would periodically take turns going from advertising agency to fashion magazine with their portfolio of photographs in the hope of getting more assignments. (Art Kane, then an art director, says, "They reminded me of two little mice scurrying around and acting furtive.") Afterward Diane might describe her adventures on Madison Avenue to one of their new friends, a lanky young photographer named Bob Meservey from New Hampshire. He was earning $21 a week as Ferdinand Fonssagrives' assistant. Meservey says that, despite her shyness, Diane was starting to be quite an anecdotist. "Actually, Allan would act out the stories and Diane would narrate them," he says. "She sounded like the explorer Stanley describing his adventures in Africa. Diane could make a documentary out of going to the corner deli for a quart of milk."

Finally in January 1947 the Arbuses got an appointment to see twenty-six-year-old Tina Fredericks, the youngest art director ever at Condé Nast. (Tina was to become one of Diane's closest friends.) "Diane and Allan

came into my office at *Glamour* and there was hardly any fashion in their portfolio," she says. The only photograph she can remember was "of a cracked ceiling with a lightbulb hanging from it." Nevertheless, after talking with them, she decided that they both had a sense of style and taste, and she passed on their book to her boss, Alexander Liberman, now a legend in fashion journalism (as Condé Nast's supreme editorial director, he oversees *Vogue, Glamour, Mademoiselle, House and Garden, Self*, and the new *Vanity Fair*).

As Liberman remembers it, the Arbus portfolio was full of rigid images, moody double exposures, a kind of affected artiness that was characteristic of the late forties, but he felt that a few of the photographs showed "a flair—a talent for observation." He told Mrs. Fredericks to give them some work.

Their first assignment for *Glamour*, published in May of 1947, was entitled "The New Sweater Is a Long Story." For it they shot sweaters—striped cardigans, chenille pullovers, bouclé turtlenecks—in close-ups of the neck, arm, and so forth. "It was difficult to lay out, but it was effective," Mrs. Fredericks says.

Their next assignment was less successful because they photographed a dozen shirtwaist dresses in Central Park's Sheep Meadow, but from such a distance that the models looked like stick figures and you couldn't see the clothes. Fredericks had them reshoot it and it was better.

From then on Diane and Allan worked steadily for *Glamour* magazine, and the cramped Condé Nast offices in the Graybar Building on Lexington Avenue became like a second home. Before they got their own place, they would shoot assignments in the *Vogue* studios—pages and pages of accessories: scarves, dark glasses, purses, gloves. They photographed ruffled lingerie and extraordinary sequined hats. Once they photographed rainbow-bright bathing suits against a backdrop of painted clouds. Afterward they might drop by the art department to show off their contact prints. "They were so well liked, those two," says Miki Denhoff, another art director there. "They were so in love, so interdependent."

Eventually they shot covers for *Glamour* and beauty features on location in the Caribbean and the Hamptons. They became adept at arranging groups of models—models on bleachers, models draped around phone booths. They liked everybody "in action"—models in bouffant Jonathan Logan dresses playing Ping-Pong or powdering their noses in the spacious, mirrored ladies' lounge of the Plaza Hotel.

The Condé Nast booking department complained about how expensive the Arbus sittings were because Diane and Allan worked so slowly and carefully that the sessions took hours, sometimes days, and the model fees ran way up. "But the results were worth it," Tina Fredericks says, "even

though we fought a lot. We would disagree over the concept of a layout and then would behave as if they were doing me a favor if they ended up shooting it my way." But she enjoyed working with them "because they were so creative and such perfectionists—slaving over the smallest detail to get it right."

At home their collaboration was just as intense—it was almost a way of surviving. They were like twins, sharing secrets, forbidden pleasures, little indulgences. And they did everything together—even cooked meals together. Rick Fredericks, Tina's husband, who was a reporter on the *New York Times*, thought they were "like kids acting out a storybook marriage. The whole thing didn't seem quite for real. They would hold hands constantly and then Diane would bat her eyes—at Allan and then at me. She was a great one for batting her eyes at men and she could be very seductive —whispering to you almost conspiratorially in her little-girl voice. I found her quite manipulative." There were other occasions when she refused to speak at all. When Allan was out of the room and Rick would try to talk with her, she would stare him down, leaving him feeling exceedingly uncomfortable.

Their central fact was the marriage itself. "It seemed—in 1947–48— unshakable," Betty Dorso says. Diane and Allan complemented each other, backed each other up. Diane would tell people what a great fashion photographer Allan was turning into, and Allan would talk about Diane's mystical way of seeing. He was always encouraging her to take photographs on her own—long before anyone else. Diane gave him credit for that. "He was my first teacher," she would say.

He cared for her, watched over her, seemed to dominate and almost guard her. "Sometimes he seemed more at ease when he was away from her," Rick Fredericks says, "although it was obvious he doted on her." For a long time their collaboration was on one level a matter of survival.

As with many couples, it seemed a marriage of opposites: each needed what the other had. Diane was a shadowy creature—slow-moving, receptive, given to protracted fits of daydreaming. Allan, on the contrary, was brisk, rational, organized, anxious. The life they envisioned for themselves would ideally be full of exotic new experiences which they would somehow collaborate to bring into being. Already they had created a visually pleasing setting in their little home; the West 70th Street railroad flat was immaculate and painted all white—walls, floors, furniture. "Your eyes opened up when you entered the Arbus apartment," May Eliot says. And Diane's artistic clutter stood out—the Henry James novel she might be reading; the wrinkled brown paper bags she insisted on using instead of purses because she loved the color, shape, and texture of paper bags. You could stuff so much into a paper bag—copper pennies found on the side-

walk, shells from the beach, an old green bottle, weirdly formed rocks. So many objects to finger and stroke and dream over . . .

But sometimes it must have been exasperating, not her clutter but her lethargy, her inexplicable melancholia. When they weren't photographing, she might withdraw into a depression and sit dazedly in the apartment for hours. Her black moods came and went, but she fought them, rarely giving in to despair in front of her daughter, Doon, or her goddaughter, May. In fact, she usually hid her depressions from most people; only with Allan would she let down her guard, and then after a while he would gently tell her to take their portfolio up to Condé Nast or that it was time to buy groceries—anything to focus her concentration elsewhere. "Allan would get very upset by Diane's depressions," her sister, Renée, says. "He was pulled down by them and he didn't want to be."

To raise his spirits, when he relaxed with their friends he would often do imitations of David Nemerov walking ducklike around Russeks, or he'd tell stories about his war experiences in China and Burma in his deep, mellifluous voice and describe the strange types he'd met, from English officers to spies, and then he'd create entirely new characters. "He could be very, very funny," Rick Fredericks says.

But he had his dark moods, too, which caused him to go off and play the clarinet compulsively—for hours; and then the music he made, whether it was classical or jazz, sounded like an appeal. He yearned to act —to be in the movies; he talked about this to everybody. As time went on, he felt increasingly frustrated because he was certain he'd never fulfill his dreams.

As for Diane, dreaming remained her best defense against awareness. Part of her existence was spent rearranging her expectations—adjusting what she saw to what she hoped to see and feel. Her inner reality was her most valuable possession—it constantly challenged the assumptions of the world outside. On her own she led an exceptionally rich life of the mind. She read widely—Jung, Willa Cather, Kafka, Emily Dickinson. She saw movies, theater, attended concerts, went to galleries—asked a thousand questions, few of them ordinary. But mostly, Alex Eliot says, "she spent her time digging people—digging her friends. She really looked and responded deeply to everybody and everything around her." Alex's daughter, May, adds, "I have never met anyone who relished life the way Diane did." Often she would wander through museums and *not* look at the art; instead, she would scrutinize the spectators. Or if she did look at a painting or a photograph, she would sometimes think (as she said later), "That's not the way it is . . . this is fantastic, but there's something wrong. I guess it's my own sense of what a fact is. Something will come up in me very

strongly of No, a terrific No. It's a totally private feeling I get of how different it really is."

But in those days she had little confidence in herself and she would rarely voice her own thoughts; instead, she might parrot Allan's opinions and he would order her to "Speak up, girl!"

Still, to her goddaughter, May Eliot, "Diane was like a new breath." Her parents' fights were "growing oppressive, so whenever Diane and Allan came over for dinner, I was joyful." She might share a meal with the four adults and then, before she fell asleep, "Diane would sit on my bed and talk in a husky whisper as she carefully and gently ran her forefinger along each eyebrow, from the center of my forehead out, and then down my nose and along my lips, from one end to the other. Then she would quietly leave the room. I can still remember the feeling of her hand some thirty years later."

The Eliots and the Arbuses were inseparable. They saw each other constantly, spending most weekends together, occasionally having dinner in Greenwich Village with Robert Lowell and Jean Stafford. Or they might drive up to Garrison, and picnic at Dick's Folly, a strange shell of a medieval castle which Anne Eliot's grandfather had started building for his wife in the 1920s but left unfinished. The crumbling edifice hung over a bluff overlooking the Hudson River and the Palisades. "We spent many lovely afternoons there," Alex recalls, "advising each other, teasing each other, criticizing life and art." They were positive that they said things in a way they had never been said before. And their marriages seemed tied together—bound up in their friendship, which they kept likening to a table with four legs. "And if one leg is removed, the friendship is destroyed." May Eliot remembers tiptoeing into the Arbus living room in the evenings and "there was this large double bed—a mattress, actually —on the floor, and my parents and Diane and Allan would be sprawled on it, talking happily and peacefully."

To Alex their "four-way friendship was extremely complex, rough-edged, but on the whole profoundly satisfying . . . in spite of the subsequent pain." And for a while the friendship must have had the radiant quality he attributed to it—he almost singlehandedly held them together with his booming energy and charm; he served as a catalyst, drawing them out—applauding Diane's ideas, Allan's need "to know everything about everything." He saw only the best in them and only the best in his wife, "the golden Anne," although she was increasingly driven and angry over her frustrated writing ambitions. She would drink and fall into despair and he could do little to comfort her. Often she would take their daughter, May, and escape to her grandmother's farm in Massachusetts

until the depression passed. But her pain was such she had little interest in Alex's career. In 1947, when he replaced Walker Evans as art editor of *Time*, it was Diane rather than Anne whom he first showed around the office, introducing her to his new friends James Agee and Bob Lax. And Allan would drive him out of town on some of his first assignments. Gradually Anne began complaining to Diane that she felt neglected; that Alex was getting so caught up in his job—interviewing the likes of Salvador Dali—that he wasn't paying enough attention to her. She felt "left out" and she wasn't at ease with most of the journalists he knew. So she clung to the Arbuses and depended on them, and they kept her entertained and occupied and were always very gentle with her. And Alex was so grateful he told everybody about the wonderful friendship they shared—he couldn't get over it. He would usually add that he and Diane were like "brother and sister"; when they were together in a room, they would always go off by themselves and have an intense conversation. Every so often she would absentmindedly stroke his wrist.

In all the years they'd known each other, they'd never totally consummated their fierce attraction—even while Allan was away in the Army during 1944 and Diane posed nude for Alex as he completed a great many sketches and paintings because "God, she was beautiful! Beautiful breasts, shoulders so beautifully shaped . . . but we were too inhibited. And besides, we were both married to people we cared about."

Over the Christmas holidays in 1947 the Eliots and the Arbuses traveled through the snowy New England countryside, stopping at an inn somewhere in Massachusetts. Before they retired for the night, Diane, clad in long red underwear, performed a little dance for her husband and friends. "Which part of my body do you like best?" she demanded. "Allan likes my legs best."

"I was still madly in love with her," Alex says.

10

Around 1947, Cheech McKensie* met Diane. "I was a John Robert Powers model, but not a very good one. I was walking down West 70th Street one day on a photographer's go-see, and there on the other side of the street was this young woman with the most extraordinary presence about her—she seemed haunted. She had wild, startling eyes and she was carrying a paper bag instead of a purse and she filled the space around herself with an almost palpable mood. Anyhow, we both stopped and looked long and hard at each other and then we walked on. And I thought, 'I've got to meet her!' And then I came to this beat-up brownstone—I climbed the stairs and rang the bell and a man answered. He was wearing a freshly pressed, very white shirt and slacks—turned out to be Allan Arbus, the photographer. I gave him my portfolio . . . he barely looked at it, he said, 'You have a funny expression on your face.' And I started telling him about this extraordinary woman I'd passed on the street—didn't know who she was, but she had this *look*—and then suddenly the door opens and Diane appears and I think excitedly, 'That's her!' and Allan says rather irritatedly, 'I thought you were going out,' and Diane stares at me and says, 'I just decided to come back.' We became friends instantly. It was as if we had always known one another. We saw each other almost every day for the next eleven years. Our friendship was metaphysical, rapturous. We were all things to each other. We were mothers to each other, we were daughters—sometimes we were little girls giggling in the attic, other times we were wise old women talking about our men, our kids. 'You're my best friend,' she'd say solemnly. We addressed each other as 'Grace.' 'How you doin', Grace?' we'd say, and then we'd laugh uncontrollably. Diane drew the story of my life out of me and we exchanged secrets, ideas, memories. She was never judgmental about me or anybody or anything."

A native from the farmlands of Ohio, Cheech was twenty-eight, a brilliant, perverse, slender woman with a dazzling smile and a fiercely deter-

*"Cheech McKensie" is a pseudonym.

mined manner. Cheech painted, designed costumes, composed operas; she didn't shave her legs or under her arms (neither did Diane) and wore cast-off clothes (quilted jackets, long, patched skirts). Often she and Diane would spend hours discussing what they'd read—everything from *The Little Prince* to *The Brothers Karamazov*.

Cheech lived a hand-to-mouth existence in an abandoned house on West 10th Street in Greenwich Village; she painted the staircase banisters every color of the rainbow. Nobody knew how she supported herself, but even when she was in desperate financial straits she refused to write home for money. When she couldn't support herself modeling, she found odd jobs. "It was nobody's business how I paid the rent, I just did," she says. "And the *I Ching*, the Taoist Book of Changes, helped me."

Cheech wanted to be an artist. She wanted to live fully and freely and rapturously, slowly savoring each moment. But if she missed something, okay, she'd get around to it in the "next life." She always did what she wanted to, not what was expected of her. She knew almost at once that the people close to Diane, like Allan and Alex, might think she was immature or selfish or even a little crazy, but that didn't matter. It never occurred to her to change her behavior, her way of dress, her life style in order to win approval. And Diane loved these qualities.

Among the other regulars at the Arbus apartment in the mid-forties was Robert Meservey, his then-wife, Pati Hill, a fragile but outspoken blonde from Kentucky who was briefly a model. When Pati and Diane weren't together, they'd chatter on the phone for hours; they were both keeping voluminous journals for "self-exploration." Diane envied Pati, who was exactly her age (twenty-six), because she seemed so free; she had no responsibilities and did exactly as she wished. She and Meservey soon divorced (amicably) and Pati went on to write a highly praised novel, *The Ninth Circle*, about her Southern gothic childhood.

Cheech did not get along with Pati even though she had known her long before Diane; she thought Pati was "affected in her cut-off blue jeans." Cheech even disapproved sometimes of Allan, "so trim and logical and niggly-piggly about everything including Karen Horney, and he never stopped playing his damn clarinet!"

As for Alex Eliot, Cheech found him "fat, sloppy, pompous—a buffoon." He was full of ideas about the latest American artists—he bragged he'd written about Willem de Kooning and Jackson Pollock before any other art critic. "He tried to upstage Allan at every turn to attract Diane's attention." Cheech didn't like the way "he'd mention to me that Diane didn't wear any underpants—you could *see* that if she stood in a certain light. What difference did that make to anything?"

Nobody measured up to Diane, as far as Cheech was concerned. "She

never asked for anything for herself or expected anything from anybody. Diane was exemplary—a saint. She was the most intensely curious person I've ever met—only interested in the essential nature of reality. Her curiosity drove her into unknown areas. And the more developed her curiosity became, the more acute, the more complicated and suggestive the world became to her.

"She had a funny attitude about herself—she was very much the loner. I related to that. One of the few times she cried was when she told me how in summer camp all her friends had been bitten by leeches and she wasn't. 'Not even leeches bite me,' she cried. She still felt immune to life—overly protected and insulated from it by Allan. Ultimately, of course, she was bitten by many leeches . . ."

Cheech eventually became something of an irritant in the Arbus household: "Maybe, because I could see that everything was not always sweetness and light." She grew so possessive in her friendship with Diane and so argumentative with everyone that Allan periodically banished her from the apartment and forbade Diane to see her. But the two women would speak surreptitiously over the phone and then meet secretly in Central Park. "We would take her daughter roller-skating." Eventually Allan would ask Cheech back to the apartment for supper and tell her he really liked her and that from then on things were going to be okay, "and they would be for a while, and then we'd get into some violent disagreement and the whole thing would begin all over again."

One time in the park Diane told Cheech she was thinking of going to bed with Alex Eliot and asked for her opinion. "I told her not to. Later she would complain about Alex. 'What does he want from me?' she would ask. As if she didn't know."

Sometimes Cheech and Diane sneaked off to swim at Coney Island. "We were fearless—we'd swim far out, breast-stroking toward the horizon," Cheech says. "The ocean embraced us—never menaced us. We could feel the electricity in the water coursing around our bodies." Afterward they'd sit on the beach and they'd watch the crowds. "I don't know whether I introduced Diane to the idea that Coney Island was like some huge living room. Everybody in stages of undress. Gypsies, Chinese eating pizza, Jewish matrons playing cards. Couples forgot their masks—you could really *see* their faces as they greased themselves under the glare of the sun. Tattered umbrellas draped with bedspreads—bathing suits held together with safety pins . . . And the wind would whip the bedspreads and the towels and orange rinds and dogs ran and barked in the waves and radios played noisily . . .

"There was this woman Diane and I always noticed—a big black lady who wandered around the beach calling herself God. She wore a tattered

Army uniform—one of her breasts was exposed. And she would rant and orate and talk to the sky."

Diane never got tired of watching her. She always had her camera with her and sometimes she'd focus it on the God woman . . . but mostly she stared at the water. According to Cheech, for all Diane's shyness and gentleness, she had a deep sense of personal ambition; a feeling that there was something very special inside her that had to get out.

In the summer of 1948 when the Arbuses went up to Martha's Vineyard, the Eliots joined them at the Victorian cottage they'd rented on the lagoon in Vineyard Haven. The two couples swam naked in the cove and collected seashells to decorate the house, and Allan would obsessively practice flying his kite across the dunes. He taught Diane to drive, and she "loved the feel of the steering wheel and the gearshift. It's like getting to know universal gestures I've always been aware of."

On weekends Doon and May would dance in the living room while Alex sang South African songs and Diane would lean back and smile. The vitality and the energy that burned in him like a furnace excited her, and his big, shaggy presence was comforting. He reminded her, she once said, of "a pillow against disaster."

By now most of Alex's colleagues at *Time* magazine knew of his obsession with Diane. "He seemed increasingly bewitched by her," Bob Wernick says. Whenever he returned from a weekend at the Vineyard, he'd talk about what an incredible thing it was to be in love with two women —Diane and his wife, Anne—and also share a close friendship with Diane's husband. It was perfect, he said. Of course nobody at *Time* believed it could be that perfect; there had to be some flaw, some sour note.

But for most of that summer it was fairly perfect, May Eliot recalls. Her mother and Diane were genuinely close on their own—"They really enjoyed each other's company." And Allan took photographs of everybody on the beach and they would all play a game in the cottage driveway— "We would tie each other up with ropes in all kinds of knots and then you had to work yourself free. Allan was reading about Houdini."

Diane was photographing that summer, too, but photographing simply because she loved to photograph, not for any other reason. (Years later she explained to *Newsweek* why she didn't start photographing seriously until she was thirty-eight years old: "Because a woman spends the first block of her life looking for a husband and learning to be a wife and mother, just

trying to get these roles down pat; you don't have time to play another role.")

That summer on Martha's Vineyard, Diane concentrated on homemaking: sweeping out the cottage with a huge broom; cooking leg of lamb, roast duck, stuffed cabbage—delicious recipes, because Allan loved "gourmet food." And she spent hours teaching Doon to swim. "My parenthood is such a joy," she wrote Tina Fredericks. "It's the one thing that makes me feel big."

Everyone else was busy trying to achieve "an artistic breakthrough." Alex finished first, completing two paintings nobody liked very much. Undaunted, he decided to show part of a novel he was writing about a brother and sister's incestuous desires in which the sister is roughly pat- terned after Diane. "I kept telling myself if I could paint a single good painting or write one decent book, I could leave *Time* magazine," he says. He read a chapter to the assembled trio one evening after dinner and when he finished there was a deathly silence followed by Anne Eliot's cry of "Disgusting! Terrible! Why did I ever marry you? You are totally untalented and I am the writer and I should be writing!" (Unbeknownst to anyone, she'd had a short story accepted by *Harper's Bazaar*. But, afraid it was too revealing to be published, she'd asked for the manuscript back.) In a moment she stormed out of the room, and later that night she left the island.

Alex says he was devastated by his wife's outburst. The following morning he dove into the ocean and "swam and swam." He wasn't considering suicide, he was just "extremely depressed and down about myself." He didn't realize he'd swum too far out until the tide began tugging at him and in a panic he realized he was so exhausted he might not be able to swim back. In the distance he could see Diane and Allan seated on the beach and he waved frantically at them, shouting "Help! Help!" and they waved back; they obviously hadn't heard him. He managed to rest by floating on his back "for what seemed like hours" and then finally he "clawed through the heavy surf" until he reached land and crawled on his hands, knees, and elbows up the steep beach, collapsing on the dunes.

Diane and Allan rushed to see what had happened. As soon as he caught his breath, he told them—how he'd been in such despair over their negative reactions to his work that he'd jumped into the sea and swum too far out. He'd been sure he was going to drown, a failure.

The three of them talked all afternoon. Just before the sun set, Diane sent Allan back to the house and suddenly, Alex says, "I found myself alone with her and she became even more tender and maternal and we fell, slow motion, into each other's arms—it was almost like a continuation of our

conversation. That evening Diane told Allan that she and I had made love on the beach. She was always honest with him, as she was with everyone." The following day Alex drove back to New York and *Time* magazine.

A week or so later Anne Eliot returned to the Vineyard, followed by her cousin Frank Parker and his wife. The Parkers had never met the Arbuses before. They thought Allan acted "polite and subdued" and Diane seemed "so timid you wanted to take care of her—assure her that everything was going to be all right," until they went swimming nude in the cove, and as soon as she "hit the water she became a mermaid—a creature from another world—undulating—gliding—exactly like a fish . . . and her face turned dangerously alive and very, very seductive."

On the weekend Alex came up from New York and "tension crackled through the house," Parker continues. "We didn't know what was going on. There was very little conversation between anyone—much fussing over the two little girls, May and Doon, who were demanding attention. I remember how tender Allan was with the children. And Diane puttered in the kitchen with Anne and my wife."

Finally—quite late—after much wine had been drunk, the adults sat down to eat. Suddenly Alex declared that he and Diane had been in love since they were teen-agers and had finally admitted it to each other a few days before on the beach and it had been beautiful. He didn't elaborate further, but it was obvious that he now possessed her. "He sounded positively triumphant," Parker says. With that, Anne Eliot snapped that she didn't think it was beautiful at all; it was a betrayal of trust, of friendship, and what about those goddamn table legs? What would happen to their table now?

And everybody turned to Diane, waiting for her response. But she just sat there, inscrutable. And again Frank Parker was reminded of the mermaid image, "because everything was swirling around this creature and she seemed oblivious to the havoc she was causing, until Anne rushed from the table and out into the night." Later she confronted Diane and demanded an apology, an explanation of sorts. "Aren't you sorry about what happened?" she cried. And Diane answered, "No." She didn't think she'd done anything wrong. She believed in trying to practice freedom and unpossessiveness in their marriage. As far as Anne Eliot was concerned, such an attitude tore the heart out of intimacy.

Although the Eliots remained together for another year, "Anne never forgave Diane and Allan," says her sister Liberty Dick; as far as she knows, Anne never saw the Arbuses again.

When they returned to New York in the fall, Diane and Alex found opportunities to be by themselves, but there were no regular meetings or

trysts. "I never knew when we'd be together, so I would sometimes walk the streets half the night. I wanted to phone her, but I couldn't. I never felt like her lover. I felt like a guilty husband, which I was."

To make matters more complicated, Alex continued to see the Arbuses together. He would find himself talking to Allan about Anne, who was in a hospital, suffering from manic depression, and Allan, who "continued to be a wonderfully forbearing friend," would listen and try to comfort him. "And here I was in love with his wife," Alex says. "It was lunatic!" There were never any scenes between the two men. Allan, in fact, never discussed Alex's ongoing affair with Diane. "When the three of us were together, it was almost as if it didn't exist—as if it hadn't happened. We acted as if everything was the same." But of course it wasn't.

Sometimes the atmosphere would grow strained and Alex remembers Allan's glaring at them and muttering, "Oh, go away!" At one point Pati Hill urged them to run off together. She thought Diane could have a "bigger artistic breakthrough" with Alex than with Allan. But Diane ignored the suggestion. The affair, with its ingredients of sex, love, pain, and hate, was just one of hundreds of experiences she was determined to have in her life—she was ruthless in this regard. She felt no guilt—the issue was emotional, not moral ("She wanted to try everything, that woman!" Alex says). Years later she confided that she was sorry they'd slept together because she'd hurt Anne and Allan and hadn't intended to.

Alex, for his part, was sure that his sense of rationality, of fairness, had been momentarily consumed by this gigantic passion. He was overwhelmed with guilt and suffered terribly because he couldn't stop thinking about what he'd done to Anne and he didn't know how to right it. On top of everything else, he still felt like Diane's brother, which both titillated and bewildered him. "But I feel like her brother!" he'd say to friends. (Later other men would say the same thing—"Diane treats me like a brother, not a lover." There was a conspiratorial, incestuous quality in many of her close relationships with men.)

Once, when Alex was flying to Paris on assignment, he stared out the window at the clouds and the sea below and prayed that the plane would crash so that he could be put out of his misery. He said as much to Allan, who interrupted with "Oh, Alex, what you really want is an adventure. But it would be different if you were married to Diane." And Alex cried, "Oh, no, no, it wouldn't!" and then he adds, "In retrospect I suppose he was right."

Sometimes other couples would join Alex at the Arbus apartment and they would dance—fox-trot carefully around the big mattress bed lying on the living-room floor. It was terribly cramped in those two rooms, but jaunty music floated through the air. And then a glass might shatter and

Diane would silently sweep it up and everybody would start dancing again.

"Allan danced beautifully," Alex recalls. "Once he stopped dancing and came over to me and sang in a husky Louis Armstrong–type voice, 'Took you for mah friend—thought you were mah pal—then I found out you tried to jive mah gal . . .' "

12

At the end of each week Diane and Allan would try to finish photographing early in order to get to the Nemerovs' on time. Rain or shine, there was a family dinner at the Park Avenue apartment every Friday night and they were obliged to turn up. It was almost a relief for Diane to escape her complicated private life and return, if only for a little while, to "Mommy and Daddy." She always complained about the dinners, but she could be briefly comforted by the familiar sight of the smoky, opulent rooms—that is, until her father began criticizing her appearance (she wore the same shirtwaist dress over and over and no lipstick "because Allan says it makes my eyes bigger"). "Why don't you go to Russeks and get some decent clothes, for God's sake?" David Nemerov would plead, and then Gertrude would change the subject by joking in her husky voice, "Sometimes I think you children just come here for a free meal."

It was partially true. Although Diane and Allan always pretended everything was going well in their work, they were still not earning much from fashion photography—they often earned barely enough to pay for rent and groceries, and, given the cost of film and paper, the extra music classes for Doon . . .

The Nemerovs were undoubtedly aware that Diane and Allan were struggling, but they made no move to help. They would just beam proudly and say, "What wonderful kids" and fuss over them, insisting (much to Renée's annoyance) that they describe to the group for the umpteenth time their latest fashion assignments.

Mr. Nemerov bragged to all his friends on Seventh Avenue about "the kids' " assignments from *Glamour* and later from *Seventeen*. He was particularly proud when they got their first *Vogue* sitting (in 1949 they photographed a young woman seated in a limousine wearing a polka-dot dress). Nemerov never knew how much Diane and Allan hated the fashion business. Renée says, "They never told Daddy, because fashion was so much a part of his life." Also he was having problems. During the late 1940s, Russeks, like most big department stores (Saks, Altman, Lord and

Taylor), was battling the unions in their fight to organize the retail sales-people.

Over the years Diane would always bring her camera to the Nemerov apartment. She told Tina Fredericks she wanted to capture the solemn ritual of the Friday-night dinner. Her sister recalls how she would wander into the dining room with her camera around her neck and wear it throughout the meal. "She would take a couple of bites of potato and then focus on all of us. The camera was almost like a shield. She seemed to be hiding behind it. I think she imagined that if she was invisible, everybody would forget she was there."

Often there wasn't any film in the camera, but she would click away—click! click! After she read Cartier-Bresson's famous essay on photography, she began talking to Renée about "the decisive moment" when everything falls miraculously into place—she talked about training her *mind's eye* (which is why she kept her camera with her at all times); how the mind's eye cannot see everything—that nobody can see everything in an image until the negative has been printed and hung up to dry.

At the Nemerov dinner table she would focus her camera on the familiar figures of her childhood—on Grandma Rose bent over her lace work (she loved to watch the gnarled hands work the colors), and on Howard's mother-in-law, Hilda, flirting delicately with David Nemerov.

Sometimes other relatives dropped by—like Harold Russek, Gertrude's handsome brother, and Aunt Ruth, who collected erotic art and was Howard's favorite because she had a terrific sense of humor. And there were also David's two "black sheep" brothers who were always borrowing money, and a crazy cousin who talked too loud and smeared lipstick all over her face and used to make scenes when she came to Russeks to shop.

On occasion there was Uncle Joe, the lawyer, who had offices on Broadway and had been a pacifist during the war. Joe died in 1950 and supposedly on his deathbed told his brother David that since he had no children of his own, he'd decided to leave his considerable fortune ($4 million) to Diane, Howard, and Ren. Always competitive with his older brother, David told Joe, "Don't do that. I'm taking good care of them in *my* will." Whereupon Uncle Joe agreed and left all his money to other relatives. When Diane, Howard, and Ren heard about this, they were flabbergasted, but there was nothing they could do.

Diane's family obsessed her. In the 1960s she would plan an autobiography with pictures and text (which she never completed, but which she called "Family Album"). By that time she had abandoned the idea of "the decisive moment"—there was no decisive moment for self-revelation—and gave as much importance to her crazy cousin as to her art-collecting aunt. All her subjects became equivocal. She said she found most families

"creepy—because none of us can ever grasp the scene of our own conception . . . it is probably the most tempting of all secrets . . . ," and she added, "Once in the middle of love-making I thought I was forgiving them for conceiving me."

Diane could never properly document the images floating around the Nemerovs' candlelit table. "How does one photograph one's father making funny noises in his throat to signal the maid?" For a while, however, she attempted a series of pictures of Renée, her younger sister—dark, sensuous, willowy Renée, who had just married twenty-three-year-old Roy Sparkia, a tall, handsome man from Owosso, Michigan, who resembled a college fullback.

Roy's nickname was "Slim." He could walk on his hands and do acrobatics. In an effort to see America, he had hitchhiked through many states before training as an engineer in Bay City. During the war he worked as a bridge builder and camouflager with the Third Army in Luxembourg and France. After VJ Day he studied playwriting at Shrivenham University in England, then came back to New York, where he paid his way through the Art Students League by sketching caricatures at the Hotel St. Moritz.

He and Renée had met when Renée was studying sculpture at the New School. "My roommate was in her class," Roy says, "and he arranged to paint a portrait of her in exchange for a bust of his head. I first saw her when she knocked on our door holding a heavy bag of clay in her arms. It was love at first sight. I proposed a week later."

The Nemerovs disapproved of Roy "because I was Gentile and poor. David Nemerov tried to buy me off—offered me ten thousand dollars if I wouldn't marry Ren. They took her off with them to Hawaii to think it over—but our love prevailed." They eventually got married at the Nemerovs' Park Avenue apartment on October 19, 1947. Diane was matron of honor.

Now the couple were living in a basement apartment on West 16th Street and Roy was studying writing with Saul Bellow at NYU while Renée went on with her classes at the Art Students League. To bring in extra money, she worked part time as a sales clerk at Wannamaker's department store.

Diane visited them frequently, remarking later that she couldn't believe Renée rose at three a.m. to cook breakfast with her husband. "That's one of the reasons they fell in love—because they actually *like* to get up at three in the morning," she said. After breakfast they would sit together holding their coffee cups on their laps in their darkness . . .

Renée recalls, "It was always great seeing D. Part of me still heroworshipped her—lived in her shadow, dressed like her, talked like her, even prayed to look wistful and waifish. When I fell in love with Roy,

Diane was my confidante. I'm not sure I would have had the courage to get married if Diane hadn't rebelled first and married Allan against our parents' wishes."

When they were together, the sisters discussed money. Neither of them had any idea how to earn it, let alone handle it. "We'd grown up rich and spoiled and been given all the advantages, so we never learned thrift—we couldn't even balance a checkbook. We were often near broke, but, you see, ladies didn't talk about money. It wasn't done. Being privileged had influenced us to the extent that we never thought we'd have to go out into the world and earn our living, which we were both now trying to do. We felt woefully inadequate. We always expected somehow to have money. It came as a continual surprise to us when we didn't."

Both sisters swallowed their pride and asked their father for small sums, which he always gave them in cash. "He still had power over us. We still wanted to be protected by him—but he never volunteered help— he always had to be asked."

"We were taught that money was meant to be saved, to be put away in a bank," Diane said. "Like when my grandfather would give me a ten-dollar gold piece, I wasn't ever supposed to spend it."

The two young women envied their brother, Howard, who was managing to be completely independent financially. He'd spent the last two years writing while he and his wife, Peggy, lived on the $7000 he'd saved from his Air Force pay. Howard describes his first attempt at a novel (begun in London) as "Kafkaesque—a fable about a village under a rock. I was lucky nobody published it."

For a while he wrote poems and sold them to the *Nation* for $10 apiece. He also composed essays that were published in the *Sewanee Review*. Periodically he would show them to Diane, who in turn would show them to close friends like Phyllis Carton. Phyllis remembers one essay in which Howard elaborated on his view that "mankind is at once hopeless and indomitable." She and Diane discussed this essay at length. "And Diane was so proud of Howard's intelligence." She envied his discipline because she fantasized about becoming a writer herself, but thought she was too disorganized.

In 1946 Howard became associate editor of the literary magazine *Furioso*, working with Reed Whittemore and John Pauker. "It was mostly editing by long distance," Pauker says, "because I was living in Washington, Reed was in Connecticut, Howard in New York." The three men filled the magazine with their own poetry, and, Whittemore adds, it was their joint inclination at the time to "write about the futility of action."

Howard was also at work on his latest novel, but he was restless— pacing up and down, running out for fresh bottles of gin—so Peggy

chained him to a chair. "It was my idea," she says. "He was *forced* to remain at his desk." It seemed to work until late one afternoon the doorbell rang and Howard bolted to answer it, dragging chair and chain after him. He flung open the door "and the look on the visitor's face was stunned," Peggy says.

Every so often, to relax, Howard would break his isolation and he and Peggy would borrow the Nemerov limousine and, together with Diane and Allan, they would career around Manhattan in the big car. Once they were stopped by the police, who were sure they were riding in a stolen vehicle until Howard (who was driving) solemnly convinced them he was the chauffeur.

When Howard began writing poetry, it was "to write the war out of my system." He was still having nightmares about the bombing missions (he would have them off and on for years). Like many other modern poets (Jarrell, Ciardi, Dickey—all of whom became his friends), Howard had been romantically attracted to the Air Force, and then the romance had turned to horror at war's bloody atrocities. In his first book, *The Image and the Law* (published in 1947), poem after poem draws the same conclusion: that death in war is usually casual, accidental, and always horrific.

> You watch the night for images of death,
> Which sleep in camera prints upon the eye.
> Fires go out, and power fails, and breath
> Goes coldly out: dawn is a time to die.

Poetry criticized Howard's "lack of style" and "conceptual confusion," and he was angered and upset.

His friend Reed Whittemore thinks that "the legacy of modernism . . . was part of [our] writing consciousness and it gave us depressingly conflicted instructions about what we should do with our writing lives. It instructed us to cultivate and preserve our isolation (else we would turn into stockbrokers and the Word would not be saved); but it also instructed us with great ambiguity in all the lessons of the thirties . . . lessons about commitment *and* the dangers of commitment—lessons that tended to cancel each other out, but still lessons . . . We worked too hard. We were uptight. I remember a dreadful summer when Nemerov was in the living room trying to write a novel and I was in a bedroom trying to write a novel and on weekends there would be other writers, there would be wives and guests and partying, but also the typewriters sat there making their demands. They were vicious, those typewriters."

By this time Howard had used up all his savings. He didn't know how he was going to support himself—he would certainly never turn to his father for money. Then a friend suggested he apply for a position at Ham-

ilton College in Clinton, New York, which he did. He got a job at $3000 a year teaching literature, and he and Peggy packed up and left Manhattan.

"Howard really started to educate himself after he became a teacher," Peggy says. "In spite of his Harvard degree, he felt there were great gaps in his knowledge and he determined to fill them. I've never seen a man study so. He read Proust, Auden, Yeats, Shakespeare, Montaigne, he re-read Thomas Mann, Kierkegaard, Freud."

Privately he'd committed himself to writing, and he adopted impossibly high standards for himself, measuring both his prose and his poetry with stern self-criticism against what he read. From time to time he contributed essays to magazines such as the *Partisan Review*, but he was never part of the "Jewish Jesuits"—Delmore Schwartz's description of the critics Lionel Abel, Harold Rosenberg, and Philip Rahv.

Diane grew irritated by her brother's dazzling ability to criticize and analyze and boast. He once cornered someone in the Arbus apartment, declaring, "I'm going to be the greatest novelist in the world!" and then he kidded Alex Eliot: "I'll criticize your writing only if you criticize my painting." (Howard couldn't paint.) He was prodigiously ambitious.

He stayed only two years at Hamilton, telling his old teacher Elbert Lenrow, "The place is like a country club." In 1948 he and Peggy moved to Bennington, where they remained for more than two decades.

Most of his colleagues remember him as a "solitary man," immersed in his work and so fearfully shy his hands shook; in public he'd start perspiring. Nobody got to know him well; it only came out years later that his family owned Russeks—then people speculated that he must be rich. (He dressed quite elegantly. "I thought he was White Russian royalty," a fellow teacher says.) However, he and Peggy lived simply; their house in the college's orchard was, said someone, "almost shabby." Howard was the first faculty member to own a TV set, which was both envied and looked down upon. Howard explained it away by saying that his parents had given it to him and he couldn't decline it.

He was considered by some to be a difficult teacher—"baroque, secretive, self-deprecating, although his erudition was intimidating," a student said. When nervous ("I'm *always* nervous," Howard says) he would start whistling during a student conference or in the middle of a faculty meeting, and it could be disconcerting. "I always got the feeling he was whistling away evil spirits," says Bernard Malamud, who also taught at Bennington.

"He seemed driven to excel," his friend and colleague, the distinguished poet Ben Belit, says. At one point he recalls Howard publishing his own magazine at Bennington "with nothing but Nemerov in it— poems, essays, short stories . . ."

"Howard knew it was going to be a long, hard road," Bill Ober says. "He refused to follow trends; he was never a joiner and he wouldn't logroll or go along with current cant—his work as it evolved was all about the excellence of art."

In 1949 Random House published Howard's novel *The Melodramatists*, a satiric family saga rife with sex and black magic. The major theme: the disaster that occurs when romantics (melodramatists) start facing reality. The heroines are two sisters, one of whom tries to find her identity in a totally unsatisfying exploration of her own sensuality. The father in the story is a dogmatic tyrant who goes mad and spends the last part of his life sitting in a bathtub.

At a noisy, drunken book party given by Alex and Anne Eliot in New York, which Diane and Allan attended, several of their friends murmured among themselves that the book was "too personal." Although Howard maintained that the characters he'd written were Boston aristocrats, "one of them sounded like a merchant prince to me," Arthur Weinstein says. The *New York Times* called *The Melodramatists* "gifted—perfectly written." Diane admired it and gave several copies to friends.

The good reviews didn't help Howard's relationship with his parents; he still felt uneasy whenever he visited them in their Park Avenue apartment. "I don't think they read my stuff—if they did, they didn't comment." He remained preoccupied with his guilt over being "a bad son." He remembers dropping by Russeks and being embarrassed by a photograph of himself on his father's desk. "One's photographed face appears singularly vulnerable and without defense." He was sure David Nemerov wished he would change his mind and help him run the store (now that Max Weinstein had died, Nemerov was the new president of Russeks)—he was sure his father was very disappointed in him.

Howard remembers only one conversation with his father sometime during the 1950s, when Nemerov asked him to accompany him to temple on Yom Kippur and Howard said he'd rather not. To which his father replied vehemently, "I don't blame you," adding suddenly, "I always hated my father and his religion." For a few moments they were close— then the feeling passed. "We had very few exchanges," Howard says. "We were both such uptight guys."

With Diane it was different; she and her brother spoke on the phone, and they corresponded. The year after his first son was born, Peggy and Howard went up to Cape Cod and stayed with Diane and Allan, and "Diane took a wonderful picture of little David wrapped in a towel which Howard had tacked up on his bulletin board for years."

Howard and Peggy also came down to New York for Frank Russek's funeral, which took place at Temple Emanu-El in December 1948. Earlier,

everybody had to sit shiva at the funeral home and "Diane became convulsed with laughter and made all of us laugh," her sister, Renée, says. Diane said, "My relatives looked so serious; it struck me as excruciatingly funny—I mean, there was this living corpse out there and everyone was so serious."

Howard also joined Diane and Allan for the opening of the latest branch of Russeks in downtown Philadelphia. The opening came at a time when most store owners were planning branches in the suburbs. "So I'm either going to be the biggest genius or the biggest fool," David Nemerov warned at one of the Friday-night dinners. He confided that the new store was costing a million dollars in Renaissance décor alone. There would be gorgeous replicas of Cellini mirrors—there would be a refrigerated, fireproof vault big enough to store fifteen thousand fur coats.

Roy Sparkia, who accompanied Renée to the debut of this newest edition of Russeks, recalls from his journal: "Feb. 1949—the latest Russeks is a disaster. Crimson carpeting, pink walls, chandeliers and fluorescent lighting so everyone who walks into the place looks sick and drained . . . there was piped music and champagne and models showing off the latest fashions . . ." Diors with big, rustling skirts containing up to fifty yards of fabric—dark crêpe dresses, white tulle, lots of gray jersey, taffeta scarves, navy-blue coats with gold buttons.

Buyers and friends of the family were everywhere. Nemerov cousins, Russek uncles and aunts and children, and finally, Roy writes, "We wander up to the executive offices and sit around pretending we own the place . . . Diane is prowling around . . . I remember Allan reciting Shakespeare into the intercom—he sounded like John Barrymore—God, he had a beautiful voice."

They returned to the main floor of the new Russeks just in time to see poor shoe tycoon Meurice Miller fall on his face over a fashion mannequin's pointed slipper while the Nemerovs stood by in shock. "Nobody knew what the hell to say," Roy says. "We all knew it was a fiasco. The store stayed open until 1956, but the Russek family lost millions."

Driving back to New York, "Allan suddenly began talking about the negative and positive aspects of sexual freedom between married couples," Roy goes on. "Renée and I were very possessive about each other and Allan kidded us about that. I got indignant because he said something like 'You two behave like newlyweds—you'd have to get permission from each other before you were unfaithful.' It all stemmed from the fact that Renée had wanted to have a drink with an old boyfriend and I'd told Allan I wouldn't let her."

Then the two couples started talking about what happens to a marriage after ten years, when some of the emotional adventure is gone. What

do you do? Play around? And if so, do you hide your affair or reveal it? "You've got to remember this was 1949—" Ray goes on. "Everybody was very uptight about sex—nobody talked openly about adultery, let alone illicit sexual pleasure. Diane had always been influenced by Allan in everything. His interest in sex got *her* interested in sex. We talked about sex—marital and otherwise—all the way home."

Months afterward Diane reminded her sister of their conversation in the car and confessed that she'd slept with Alex Eliot a couple of times and Allan had known about it. It wasn't meant to be serious, she said; it was for pleasure and to try and transcend possessiveness, and while she was deeply fond of Alex as a friend, she never felt so much as a twinge of the yearning anguish she associated with love.

She and Allan *really* loved each other, she said—would never stop loving each other. Theirs was romantic love. She believed implicitly in romantic love—in passion and a quickening of the blood. But she couldn't reconcile the perpetual conflict in herself between love and lust, between need and fear.

Sex was very important to her. She bragged that she and Allan "made love all the time." She had a growing curiosity about what other married people did in bed, and she had begun to ask friends intimate questions about their sex lives.

But the photographer Frederick Eberstadt, who used to run into the Arbuses in Central Park, thinks her interest was never prurient; rather, it was clinical. "Diane was just as fascinated by sexual duality and sexual conflict and ambiguity—sexual role-playing—as she was in sexual intercourse." And she was reading lots of books on the subject. She told Cheech that she believed "masculine" and "feminine" were transcendent realities; sex differences were mysterious, unfathomable to her.

On another level, however, Diane's sexual fantasies were dark and perverse. She once confided that she envied a girlfriend who'd been raped. She wanted to have that punishing, degrading experience, too. She could almost imagine it was like a murder—the murder of a woman's nature and body—though the woman lived to tell the tale.

By 1950, Alex says, "Diane was pulling away from me." She was committed to Allan, and the affair was incidental to her life, an experiment, and she didn't bother to examine the relationship except in those terms; such things didn't interest her. It was enough that when they were alone together her trancelike spirit might be suffused with a trembling vitality, an uncanny strength, and these occasions belonged to another plane—a friendly, enjoyable-enough plane that lay between their oh-so-different marriages.

Then they stopped being lovers. There was never any discussion, it was simply understood. Was she bored? Exhausted? Anxious in some way? Alex never knew, but he remembers their last time together and he insists he was not hallucinating. "It was late afternoon. We were on a high floor, so the blinds were drawn; the light was eerie. I was gazing down at her when suddenly her face became a death's head. The flesh decayed and fell away from her cheeks and I distinctly saw the shape of her skull. And the eye sockets—black hollows behind those glorious green eyes. I was terrified and lay there not moving. Diane didn't move either. I think she must have known what was happening. After a few moments the flesh swam back and covered her skull, forehead, and nose. My heart pounded very loudly on the pillow as I watched her hair—I used to call it smoky hair—burst out thickly and cover her bald head."

From then on Alex threw himself into his job at *Time*; he interviewed Picasso and Matisse in the south of France—he ground out cover stories, among them "Photography, the Number One Hobby in America." Subsequently he and his wife decided to separate and divorce, but "Diane had nothing to do with our break-up." Anne had been frail and ill for years; now her drinking and depressions had increased and she was spending more and more time in hospitals.*

*Anne Eliot died in 1981 after a long illness.

After her mother and father separated, nine-year-old May Eliot boarded with various family friends—among them the Arbuses, with whom she lived for six months during 1950. She remembers very little about the period except that she was "fat and clumsy" and Diane and Allan were exceedingly gentle with her. She noticed they no longer sprawled on the mattress in the living room with her parents; now the two couples no longer saw each other and separately they often wore frowns on their faces, and Diane in particular seemed eerily detached. But she took being May's godmother very seriously. "She was always *there* for me, a nurturing, magical force." May grew up maintaining a closeness to both her father and her mother, but she always loved Diane in a special way. "We never referred to her affair with my dad, but it was like an unspoken connection between us. And I couldn't hold it against her, because I knew she could never do anything intrinsically wrong. She was a wonderfully free spirit who had her own code of morality—she would never consciously hurt anybody. My mother stayed bitter, though, because she and Diane had been really good friends. She had liked Diane, so she was very hurt."

May was "unhappy" at the Arbuses'. She felt uprooted, lost, cut off from her family, her home. Every so often she tried to express some of the anger and confusion that bubbled inside her to Diane. "Afterwards she would always say something soothing. I invariably felt better after talking to her," May says.

Diane and Allan were listening to Alex a lot, too. After only a short hiatus he'd started dropping by their apartment again.

He could not stop seeing Diane and Allan—not completely. As far as he was concerned, the affair had been a "minor aspect" of their friendship, although "inevitable" from his point of view. But "we were creative souls in the making," he would write some thirty years later—"we merged together now and then . . . and loved each other truly, not just with an itch." Still, meetings proved uncomfortable for a while because "Allan seemed angry and he hadn't seemed angry while the affair was going on." Usually when he was with them Alex would lie on the couch talking about his latest *Time* assignments or the future of his daughter, May. Every so often he would start to laugh. "That was my way in those days—I tried not to let anything get to me—I laughed because I was so miserable and confused." For diversion Diane and Allan would take photographs of him looking very hung over. Alex used one rather sinister close-up, blurry with cigarette smoke, on his first book jacket. "That's the way Diane and Allen saw me then—as a boozer and a carouser, which I guess I was."

The following year he met Jane Winslow, and she convinced him to stop drinking and smoking. "Actually, she changed my life." Jane was a

striking, dark-haired, self-contained, twenty-one-year-old researcher at *Time* who'd lived all over Europe. "She came into my office to translate something from the Spanish and I fell—literally—head over heels in love with her. By that I mean I fell smack in front of her onto the floor, I was so hung over and smitten when we met."

However, Alex didn't ask Jane out until his separation from Anne was legal. Then he invited her to dinner and they talked all night. The following morning, after breakfast at Reuben's, Alex called Diane excitedly from a pay phone. "I've found another woman I can love!" he shouted. Diane's reaction sounded a bit subdued, but she urged him to bring Jane over immediately—she wanted to meet her. Nevertheless, Jane made Alex put the meeting off for a while. "All Alex had talked about that first night was Diane and Allan Arbus, Diane and Allan Arbus, and that he'd been in love with Diane, and that Allan was *still* in love with Diane, and that they shared this marvelous friendship. I knew I'd be coming into a very complicated situation and I wasn't sure I could handle it."

When they finally did meet, Jane's initial impression of Diane was "disorganized—ambiguous—undefined. She was twenty-seven then, but she spoke and dressed like a little girl. I don't think she was really close to anyone. But she was inordinately sexy."

After they became friends, Diane confided that she had been momentarily shaken when Alex said he'd found another woman he could love. "It was so nice having two men in love with me," she told Jane. She was rather sorry it had to stop.

(It isn't surprising that in the 1960s one of Diane's favorite movies turned out to be Truffaut's *Jules et Jim*, since Jules and Jim are in love with the same woman, Catherine—a mesmerizing creature played by Jeanne Moreau. Catherine is an untamed spirit, determined to live and love freely, but using every female wile to gain advantage, to increase her power position. Catherine suffers and feels ambivalent about being "free." Only the love relationships *she* establishes and dominates are correct. She can leave men she loves who love her, but if they leave her, she feels abandoned and destroyed.)

In the beginning, whenever Jane went with Alex to the Arbuses', they would take pictures of her, compliment her on her beauty, and urge her to become a fashion model, "which I had no interest in being." She knew they were trying to make her feel at ease, and she liked them—"they were so bright and attractive"—but she grew uncomfortable whenever they referred to their past with Alex, or repeated stories about "Diane and Alex" or "Diane and Allan and Alex and Anne." "That part of Alex's life was over," Jane says. "I wanted to forget it and get on with *our* life. We were madly in love. I kept telling Alex, 'Forget the past and live in the

now!' Eventually we did, but the Arbuses—at first—seemed more interested in reliving the *Sturm und Drang* of their shared experiences with Alex than in our new happiness. I think they resented me for a while because now I possessed Alex and they didn't."

Jane adds that, try as she would, she could never fit into the old friendship, "mainly because I refused to be slotted in as Anne had—as the fourth leg of that table. Diane and Allan and even Alex wanted to keep sharing in the friendship—have everything out in the open. They wanted to repeat the extended-family bit with me—well, I didn't. I didn't want to share everything."

Eventually Diane and Allan accepted Jane's position, but they never stopped asking personal questions. Diane in particular was exceedingly curious and nothing seemed to shock her—she was always interested in "How do you feel?" about everything. She and Allan appeared to share their thoughts, but they actually revealed very little about themselves as a couple. Only once Diane commented that during their quarrels Allan could become "cold, unshakable, tight-lipped, whereas I get hysterical and fierce like I'll try anything to get my way." But intimacy is mysterious and no one can prejudge a marriage, and the Arbus marriage was based on secrecy, as everybody's private life is. At that point they seemed anxious to preserve their privacy, and to some extent they did.

Occasionally the couples played a game: what kind of an animal are you? And Diane said she'd be a cat, and when it came to Jane, she declared she'd be all the animals—because we have all animals in us: we are greedy as pigs, passionate as lions; we're foxy, we're mousy; we can be swift as gazelles. That silenced everybody, and for a while they stopped playing the animal game.

With Jane in the picture, the intimacy between Diane and Allan and Alex shifted. Diane moved closer to Allan again, and Jane and Alex became very much a couple, and a new friendship was created which existed on a new level. It was warier. Since they didn't "share everything," the emotional investment was not so enormous.

In 1950 the two couples and Tina and Rick Fredericks spent the month of June together in the Adirondacks. Allan wanted to go to Lake George because his idol, Stieglitz, had summered there with Georgia O'Keeffe for years.

"There was a lot of traveling from island to island," Rick Fredericks says. "We paddled around in canoes—slept in sleeping bags on bunches of rocks. My back was killing me."

Alex remembers somebody losing their car keys and Jane diving into the lake over and over again in an unsuccessful effort to retrieve them. And Diane, fighting a depression, made a great effort to get close to Jane. She wore a strapless bathing suit identical to Jane's and they went swimming together and afterward they might lie on the sand next to Alex and try to talk. Much later she wrote about Jane's jealousy and her own and how well she understood it because in the past she'd always counted on Alex to cheer her up when she was low, but now that he was in love with Jane she couldn't count on him, and at times like that she wished she were Jane.

She was relieved when Cheech arrived so she could tell her that Alex was far more desirable now that he was unattainable—she had never thought she cared that much, but ever since he'd fallen in love with somebody else she suddenly cared terribly! Cheech told her, in effect, "This too shall pass . . ." She'd come up with a copy of Robert Graves' *The White Goddess*, which she urged everybody to read. She talked endlessly about the myth of the goddess, "the muse, the mother of all living, the female spider, whose embrace is death." "I thought Diane was a goddess," Cheech says.

Later that summer Bob Meservey visited with a new girl, followed by Richard Bellamy, a soft-cheeked, scruffy young man of twenty who was later called a "visionary" by his friends when he founded the Green Gallery and dedicated it to Pop Art. Bellamy's passion was art—he was then sweeping floors in museums just so he could be around painting and sculp-

ture. In the evenings he would go to the Cedar Bar and listen to de Kooning and Harold Rosenberg argue, and he haunted the Hansa then on East 12th Street so he could absorb the disparate styles of Jane Wilson, a watercolorist, and Richard Stankowitz, who created junk sculpture. Diane went to many of these shows with Bellamy, and to others at the Myers, which was showing Grace Hartigan and Larry Rivers, both of whom were doing figurative paintings in a loosely Abstract Expressionist manner. Painting had a residual effect on Diane's photography; she would ultimately experiment with painterly effects like Impressionism's soft focus, Cubism's linear composition, and corny symbolism (which she and Allan used in some of their fashion work).

She studied portrait painting—especially the canvases of Goya. She liked his looming giants, his hunchbacked dwarfs and demons. Everything she studied or thought about either fell away or sank into her austere, self-effacing style. She would always arrange her subjects like a painter and make them hold a pose for hours. Because of this, her contact prints showed relatively little variety.

In August, Alex gave Diane and Allan another chapter of his novel to read. "Yes, it was the novel I'd been working on since 1947 about a brother and sister's incestuous desires."

Allan read it, but said the book made him uncomfortable particularly in the chapter where the sister masturbates.

Diane murmured that she disagreed; she thought it was an extremely accurate description of masturbation and she didn't feel uncomfortable with it at all.

In the fall, life continued as usual. Diane and Allan photographed fashions in Madison Square Garden; they photographed college clothes in Central Park and bathing suits in the Caribbean. On Saturday nights she and Allan would join in two-room charade games at an actor friend's apartment in Greenwich Village. Diane would often bring along Stanley Kubrick, then twenty-one years old and a fledgling still-photographer for *Look* magazine. Broadway producer Mort Gottlieb, who participated in the charade game, says "the evenings were long and very lively—devoted to acting out the titles of hit shows like *Kiss Me, Kate—Edward, My Son—Death of a Salesman.*"

Occasionally Diane went on assignment by herself with *Glamour* features writer Marguerite Lamkin. Once they planned to do a feature on couples' bathrooms; they eventually abandoned the project, but while they were

on it, Diane "nosed around" people's johns, noting the details she might photograph—the flowering gardens that grew in some showers, the libraries of old magazines stacked by certain toilets, and the soaps, creams, nail polish, sleeping pills, vitamins, bubble bath, suppositories, diaphragms, rubbers, cologne, and witch hazel crowded onto cabinet shelves. "The contents of somebody's bathroom is like reading their biography," Diane said.

Once in a while she would do portraits for *Glamour*'s editorial page "if we really pressed her," Tina Fredericks says; "she was so shy." Frances Gill remembers attending a college-issue promotion luncheon and "Diane was darting around the tables taking pictures of the students and her finger was going 'click! click! click!' on the shutter of her camera—'click! click! click!' "

She did things like this in her spare time; usually she was too busy assisting Allan. But she liked "hanging around" the Condé Nast offices because by now she knew most of the editors there, as well as everybody else from secretaries to art directors.

"It was a protective, sheltered world at Condé Nast," Kate Lloyd recalls. Lloyd was features editor of *Glamour* then and she says, "We were insulated the way most monthly magazines were—a world within a world; everything ahead of time—Christmas-in-July kind of thing—and the perks that went with the media: free theater tickets, free bottles of scotch. None of us was aware of issues—controversial stuff like the electrocution of the Rosenbergs or the Alger Hiss trial were ignored. Most everything we dealt with was fluff."

At the office the women—whether they were art directors or fashion editors—called themselves "girls," and they were patronized by the men, and everybody did a lot of flirting. "That was the way to get the job done. When in doubt, we acted giggly instead of authoritative," Kate continues. "Most of us dressed in our mothers' cast-off Hattie Carnegie suits, and we always wore white gloves, and Diane fitted perfectly into the white-glove syndrome. I was astonished when she surfaced with all those freak pictures. She was as bland and colorless as we all were back then."

Still, there were undercurrents, because Diane and Kate and Tina Fredericks were all working wives in the era of the "housewife heroine." So they felt constantly torn. "It was the subtext of our lives," Tina says. "At the office we'd be making decisions, taking creative responsibility for things. At home we were susceptible and passive and dependent on our men. It was confusing."

But they never talked about this to each other. Life was more private then, less examined. Isolated by their loyalties to their marriages, these women never confided that they were secretly a little embarrassed about

having careers; secretly scared that they might lose their femininity. "So we worked doubly hard at home to compensate," Kate Lloyd says.

It didn't help that their independent, adventuresome movie heroines —Bette Davis, Rosalind Russell, Katharine Hepburn—were fast disappearing from the screen to be replaced by the kittenish Doris Day. It didn't help that magazines such as *McCall's* and *Ladies' Home Journal* were publishing articles and short stories showing women in the act of renouncing their careers because they'd discovered that all they really wanted to be was "Mrs. So-and-So." It was such a disquieting theory that in 1951 Tina Fredericks devised an article featuring working wives in *Glamour* entitled "I Love You Because . . . eight happy couples define the special quality that makes this one the one." Tina, Diane, Kate Lloyd, fashion editor Winnie Campbell and their husbands were interviewed. Paradoxically, all the couples—except for Kate—got divorced within the next decade.

When she photographed them, Frances Gill remembers, Diane and Allan seemed self-contained and quite happy. "I captured them at a moment when they were very close." Next to their portrait—an arresting one in which they resemble clones—are the following quotes:

> ALLAN: [I love you because] you have humility and dignity and are above competition.
>
> DIANE: [I love you because] your actions are more precise and simpler and happier than other people's.

And under the quotes this statement: "Diane was thirteen when she and Allan met and she was impressed with his sophistication. 'He talked over the phone with no hands.' Allan noticed she was the boss's daughter . . . they work together as photographers. . . . The Arbuses have been married nine years and have a seven-year-old daughter Doon."

Diane was determined that Doon would receive all the encouragement and nurturing she had never had as a child. She treated Doon like a sister, an equal; there were few rules in the Arbus household, and Doon was allowed to run free.

When she was small, Diane took her almost every afternoon to Central Park, where they often would play games. Doon later wrote: "She would say to me, 'I dare you to crawl between the legs of that man sitting on the bench, stand up and ask him where Central Park is.' And I would go off and do it . . . And then I would challenge her. 'I dare you to go up to that governess in the white uniform and ask her to lift you onto the swing.' And we would roar with laughter over what we had made them think of us."

For a while Doon decided she hated her name* and insisted on being

* According to a possibly apocryphal story, she was named Doon because she'd been conceived on the sand dunes of East Hampton.

called Billy. She would correct anyone who addressed her as Doon, and she would ask her mother over and over again, "Was I born a boy, Ma? Was I? Was I?" And Diane would be gentle and very loving with her.

At times she seemed almost intimidated by Doon's radiant beauty and funny, energetic turn of mind. She rarely denied her anything; she gave her a tiny chair, desk, and easel for her bedroom. Doon had music and dance lessons. When she demanded a horse, Diane seriously considered it, even approaching her father for the money, but Mr. Nemerov said no. In school Doon was showing a marked writing talent and Diane bragged about that—and Allan was proud of her ability to clown and mimic.

May Eliot recalls "being scared of Doon, although she was younger than I was." She remembers Doon saying in a threatening voice, "Stick 'em up!" "And I had no idea what she meant or why she was so angry at me."

Allan used Doon as often as possible in their fashion settings—Doon in her Hopalong Cassidy costume can be seen galloping over the pages of *Glamour* circa 1947–9; and Doon riding with Santa Claus in a horse-and-buggy through Central Park. And then there was the time Diane appeared with Doon in a "Pretty Mothers" feature. Diane in profile, utterly serious, wearing a navy-blue dress, is posed opposite Doon in flowered pajamas perched on a tiny chair. She seems to be nibbling on her mother's fingers.

In his off hours Allan took dozens of portraits of Diane and Doon together; mother and daughter possessed almost identical haunted moon-faces. A private subliminal knowledge seemed to flow between them in the photographs; each was the other's mirror image—the other's twin.

Abruptly, in the winter of 1951, Allan decided to leave New York and take Diane and Doon to Europe for a year. To anyone who asked why they were going so suddenly, he would reply that he and Diane were exhausted from the pressures of fashion photography and needed a break.

Meanwhile Alex Eliot remained ever present in their lives. He would drop by most evenings with Jane Winslow, whom he was planning to marry as soon as his divorce became final. The Arbuses seemed very pleased and the two couples joked and laughed about their futures; they appeared extremely compatible, even though occasionally Diane and Alex would still shut everybody else out while they carried on an intense conversation between themselves. Out of habit Diane had to get Alex's reaction to her ideas and impressions. She didn't see anything wrong in that and she never got a sense that anyone was uncomfortable when, say, she told Alex about her urge to photograph a tattooed lady in the Bronx and

Alex encouraged her as he always encouraged her and Allan mixed cocktails very efficiently in the background.

Sometimes when the couples had dinner together, Allan would go over his carefully prepared plans for their trip to Italy, Spain, and France. Suddenly Alex had a "brainstorm." They should photograph El Greco's Toledo from that same hill—from the spot where El Greco painted it, stormclouds and all. And they could do it for *Time* because he could get them the assignment. The idea thrilled Diane—even more so when Alex came up with another possible assignment, also for *Time*. They should photograph the Matisse chapel in Vence, France, and he would convince his boss to send him and Jane along so they could research the captions. Allen did not seem very enthusiastic. He had planned their European year very carefully and this was not part of the plan. Diane was devastated.

Rick and Tina Fredericks knew none of this little drama when they gave the Arbuses a going-away party along with Leslie and Frances Gill, who were taking a vacation in Europe, too. "It was jolly," Rick Fredericks says. "Lots of fashion editors milling around, like Geri Stutz, and my reporter friends from the *Times*."

Alex and Jane didn't appear, but nobody noticed because the crowd was too busy drinking and gossiping about the couples' travel plans. Allan kept repeating their itinerary, adding they'd got a *Vogue* assignment from Alex Liberman to do in Paris—this would help pay for the trip. Diane stood silently beside him. "She had dark circles under her eyes and I was sure she was very ill," Bob Meservey says. "She never said a word." When anyone tried to find out how she was, Allan would anwer all questions for her, explaining she was very, very tired. They were still arguing about whether or not to take the *Time* assignment, since Alex had gone ahead and suggested it to his bosses anyway.

The morning after the Fredericks' party, in spite of the unspoken tension between them, Alex saw the Arbuses off on the boat. "They seemed in good spirits," he says. Other friends who saw them off remember they seemed relieved to be getting away. It was Alex's birthday, and as he left the cabin Diane slipped him a tiny gift—a box with a string hanging from it. "I think she made it herself," he says. Clutching it to his breast, he ran down the gangplank and onto the dock so he could wave goodbye as the ship pulled up anchor. He started waving frantically to Diane and she kept gesturing from the railing to hold the box to his ear and pull the string. "Finally I did and a muppet-type voice piped, 'Happy Birthday, Alex!' I looked at Diane and I could tell she was giggling."

The year abroad was a revelation to Diane because she learned so much about looking. All her impressions were sensory—noises, colors, textures, shapes, expressions, whirled around in her head. In Venice and

Florence she took Doon with her while she wandered the streets, longing to explore every crumbling palace with her camera. The time spent in Spain was very rich for her, too, although she and Allan were unable to photograph Toledo—it just didn't work. Instead they watched an unending series of El Greco faces pass beneath their hotel window in Barcelona.

In New York, Alex was trying to arrange for the *Time* assignment in Vence. Allan remained adamant; he would not accept it. Letters flew back and forth between the two couples—lively affectionate letters because they cared for each other in spite of the confusion and pain. And Allan held firm and by the time they reached France in August Diane had come to the conclusion that Allan had been right: they shouldn't accept the *Time* assignment and it was better for them to be by themselves for a while. And they stopped arguing and grew close again.

And then Alex's letter came saying that *Time* had turned down his idea for a picture story on Vence and the whole thing seemed pretty anticlimactic. They were relieved and traveled to Vence anyway and tried to photograph the Matisse chapel for themselves. Diane referred to it as looking like "God's bathroom."

She stayed in the chapel for hours, watching the nuns move silently up and down the aisles. Their rosaries clinked. Light filtered through the enormous stained-glass windows and onto the floor. Diane was struck by the difficulties of photographing empty space.

Years afterward, still fascinated by empty, silent spaces, she remembered her experience in Vence when a friend from Fieldston, Stewart Stern, took her to Tyrone Power's grave and to the top of the Hollywood Hills. They ended up at a movie studio soundstage just before the sun went down. "Diane set her camera up and walked away from it," Stewart Stern writes, "explaining that 'a funny alchemy happens.' The camera in its goofy way would see what she couldn't. If she set it right and printed it right, it would make for her the picture of a mystery."

Returning to Paris in August, Diane and Allan stayed with Doon in an apartment on the Boulevard Victor Hugo. They completed their fashion assignment for *Vogue* and dined at the Ritz with the Nemerovs, who were in town for the collections. Allan's cousin Arthur Weinstein, who was living in Europe, joined them. He remembers David Nemerov being worried about the future of Russeks; the Philadelphia store was doing badly. He talked about it compulsively.

The Arbuses' last stop was Rome in December of 1951. They rented a huge old villa on the Appian Way, "full of halls and a vineyard and an

olive orchard and a housekeeper who has a voice so deep she sounds like the first creature blessed with human speech." Diane got sore feet from walking around Rome, so in the evenings she would soak for hours in a hot tub. "I feel on the brink of such marvelous things," she wrote.

When her feet healed, she went back into Rome proper and began photographing a lot—in the piazzas and along the Tiber—blurred pictures of child prostitutes and street urchins. Afterward she showed them to a few of her friends. "In them you can see Diane right there looking on very hard," Alex says, "trying to know and understand her subjects."

The Arbuses returned from Italy on the *Ile de France* in the late spring of 1952 and Bob Meservey met them at the boat because the Eliots were on their honeymoon in Mexico. "Diane still looked sick to me with dark circles under her eyes," Meservey says. "But she said nothing about the way she felt."

The following year she became pregnant, and carrying another baby seemed to please her. (She mentioned to Jane that she wanted "at least four children" but that Allan didn't.) She seemed more relaxed, complacent. Years afterward she confided how much she loved the physical changes in her body—she didn't even mind vomiting or headaches or getting bruised; physical sensations made her feel alive.

All the strange movements that take place in a woman's body—the fact that a woman gives birth—seemed the most incredible and mysterious miracle to Diane. She found singular physical pleasure in being a woman, in touch with earthy, natural things like the cycles of the moon. "Maybe that's why she loved the ocean so much," Tina Fredericks says. She particularly enjoyed menstruating—when her womb cramped up, when warm, wet blood coursed between her thighs. (Later when she became well known, if she was on assignment photographing a news event at that time of month, she might suddenly declare with great pride, "I've got my period!" to the other—mostly male—photographers who were near her, clicking away or changing film. After a while her colleagues got used to such announcements, but she was disconcerting at first.)

Big with child, Diane felt close and loving toward her mother, Gertrude, who approved of the pregnancy and wanted her to have a larger family—at last they had something to talk about. Diane felt closer as well to Cheech and Pati Hill and Tina and a new friend, Bunny Sellers.

At some point she announced she was going to have natural childbirth; she wanted the experience, she said, and when her time came on April 16, 1954, she went through it gladly, saying afterward that bearing her second daughter, Amy, without anesthetic—wide awake—was the most grotesque and transcendental experience of her life. Amy was a round-faced, steady little baby, very different from the more mercurial Doon. "Amy is

like Allan—not like me, thank God," Diane told Tina Fredericks. "I'll never have to worry about her."

With another baby, the Arbuses needed a bigger place to live. David Nemerov was friendly with almost every judge, congressman, and bookie in New York, as well as Mayor Impelliteri; he not only helped find a triplex at 319 East 72nd Street which had originally belonged to the sculptor Paul Manship, he arranged with someone at City Hall to have the zoning in the building changed, which enabled "the kids" to both live and work there.

"The studio was magnificent," May Eliot remembers. A living room two stories high with white walls, not much furniture—large cushions to sit on and a huge potted tree which gave one the feeling of being in an interior garden. At one end—the dining area—was a pink marble table and chairs. The other end of the room was always a jumble of photographic equipment—rolls of white paper for backdrops, lots of cameras. On the second floor was the darkroom and halfway between the second and third floors were bedrooms—Doon's and Amy's and Diane and Allan's bedroom with that same low mattress bed covered with a white spread on a pale purple floor. "The purple was startling and unfloorlike," May says. "It seemed to me the bed was floating—either on clouds or water."

Impulsively Diane and Allan urged Jane and Alex to share the studio with them. There was enough space, they argued—they could save on rent and it would be "fun." But Jane convinced Alex they should continue to develop a life of their own—no more groups. It was the start of a new period for both couples. The Arbuses became more successful as a photography team; Alex made great strides at *Time* as a cover-story writer. He and Jane had two children, and their days and evenings were full of activities and new friends. They continued to see Diane and Allan and even went on shared vacations, and a harmonious, relaxed feeling flowed between them. Allan got the Eliots one of their first apartments, a large, elegant room with a wraparound terrace on East 79th Street. He did this by accompanying Jane to a real-estate agency, where he behaved in such a disdainful manner the agent thought he was the Eliots' lawyer and agreed to a very low rent.

Not long before Amy's birth, Diane and Allan hired Tod Yamashiro, an eighteen-year-old Japanese photographer, to be their assistant.

Yamashiro, who is now a photography teacher, worked closely with them for the next six years, but he never spent time with them socially and so knew nothing of their private life. "They were extremely kind, cultivated people. And I learned a lot from Allan in the darkroom."

The only thing that ever "bugged" Yamashiro was Allan's clarinet-playing, which would go on between sessions. "Sometimes I'd yell at him, 'Stop the music and get another assignment!' "

By now Allan was taking virtually all the fashion photographs because Diane hated the big 8 x 10 camera; she preferred the Leica. "But her collaboration on every sitting was absolute," Yamashiro says. "She was in on every picture conference. We'd sit around the pink marble table and talk about the 'problem' and Diane would always have a solution." She had the stylist's eye. As a stylist, she created "the look" of the Diane and Allan Arbus fashion photographs. She knew how to put it all together—makeup, hair, clothes, accessories, backdrop; she could even chart the mood. (Winnie Campbell, a *Glamour* fashion editor who worked with them on many assignments, remembers a spread called "The Love Letter Dress" where all the accessories were pink—pink writing paper, pink quill pen, pink flowers, pink birdcage with pink doves cooing away.)

"I can still see Diane padding around the studio in her filthy bare feet," Yamashiro says. "She wore the same dress over and over. She'd choose the props, brush the model's hair, then once the sitting got started she'd stand on the sidelines and record the event with her Leica. She couldn't seem to stop taking photographs. It was like a compulsion with her."

Soon after Yamashiro began working for the Arbuses, the Nemerovs started dropping by the studio for Friday-night dinner, and then Diane and Allan, Renée and Roy, and occasionally Howard and Peggy might sit around the pink marble table and try to talk. But the subject on everyone's mind would never be mentioned—"the scandal," meaning the exposure of the Jelke call-girl ring. Stories about the $100-a-night prostitutes servicing wealthy executives and masterminded by Mickey Jelke, a twenty-three-year-old oleomargarine millionaire, had been all over the tabloids. There was a highly publicized trial and then another one in March of 1955, and during that trial it was revealed that David Nemerov's name was listed along with other well-known "johns" in Madame Pat Ward's scented red-leather telephone book.

There were actual references to Nemerov in Theo Wilson's account in the *Daily News* (March 17, 1955). Headlined "PAT NAMES 20 MEN IN HER $LOVE PARADE," the story went on to say: "Men's names popped in the Mickey Jelke vice trial yesterday like popcorn over a hot fire as Pat Ward went through a box score of 'customers' she met while she was peddling pleasure with a price tag."

Before her testimony ended, "she had totaled 20 who had 'relations'

with her and paid for it anywhere from $50 to $200 apiece and one other who dated her and gave her $500 but had never been intimate."

A double date with a Barbara Scott was described. Pat Ward went with Miss Scott to the Statler Hotel. Asked why, she said to receive money from somebody. For doing what? she was asked.

"For having relations with men."

There were lots of people at the Statler, Pat said, in what was the Governor's Suite. She went to a bedroom in the suite with a Mr. Nemerov, after having dinner there with men and women. Nemerov gave her $100 then and $50 before she left him. She explained, "They were playing dice at the party and this man [Nemerov] seemed to be winning."

Howard writes that at the time he wanted "to express sympathy and affection in my father's trouble, but I never did . . . I may have been scared . . . what if it had been a different man with the same name?" (Indeed, the *Herald Tribune* reported a "Dave Nemeroff" listed in Pat Ward's book.)

Howard never did mention it, nor did any members of his family. His friends showed their loyalty by saying that of course they assumed it was a different man.

Gertrude Nemerov appeared oblivious to the situation. "She was probably numbed by it," Anita Weinstein says. "Everyone felt so sorry for her —she had been going through this kind of humiliation for so long."

"The scandal turned out to be the start of the decline of David's career," a garment-district colleague states. "David had been caught with his pants down—literally and figuratively. Because of his connections, his name was kept out of the papers after a while, but the damage had been done both to the store and to him as a businessman." It was particularly embarrassing to Walter Weinstein, Max's son, who was vice president of Russeks and a scrupulously moral person. Weinstein confessed he found it difficult to walk down the street with Nemerov after his involvement with the call-girl ring was splashed across the front page of every newspaper in the country.

David Nemerov, meanwhile, behaved as if nothing had changed. His manner was as confident and charming as ever—but something *had* changed; his life was never quite so flamboyant or filled with as many women after the scandal.

He continued to work as hard as ever at Russeks, and Russeks remained "a flashy shop," according to one of Nemerov's friends. "David kept on believing Russeks should cater to the kept woman, the woman who loved wrapping herself in furs." But business sagged. Already the fur market had been squeezed out of Sixth Avenue and replaced by zipper, sportswear, and textile manufacturers.

I. J. Fox, Russeks' archcompetitor across the street, had closed up shop in 1953. The fur business was in drastic decline as housewives and their families moved to the suburbs. There they demanded casual dressing—no mink coats, at least not for a while. And the very nature of Fifth Avenue was changing, as were shopping patterns; as were customers. The quality specialty stores adjacent to Russeks—Bonwit, Mark Cross—had long since moved uptown, leaving Russeks to compete with Lord and Taylor, B. Altman, and Macy's.

"David longed to move to Fifth-seventh Street," Andrew Goodman says. "But he was losing his touch. He still thought customers wanted lavishness, elegance, beauty—but now they wanted useful, wearable clothes."

After the Philadelphia Russeks lost millions and closed, Nemerov couldn't afford to move Russeks Fifth Avenue anywhere. "The Philadelphia store had been a disaster," Walter Weinstein says. "It was the major factor; the Russeks empire started crumbling." That was one of the reasons he sold the controlling interest in Russeks stock to the Pritzcy brothers from Chicago. They were millionaire chocolate manufacturers who'd always wanted to get into fashion.

Sometime in 1955 the Nemerovs sold their big apartment on Park Avenue and moved into a much smaller one at 60 Sutton Place South. They got rid of a lot of their heavy antique furniture, replacing it with "classic modern." Their decorator, Jerry Manashaw, says, "They wanted the floors all white—the colors were beige and cream and yellow." They had designed built-in cabinets and bookshelves and Mr. Nemerov started painting at home. There was a view of the East River he liked—he would sit by the window sketching and watching the boats move by.

The apartment took about six months to decorate. It was Manashaw's first big job and he found the Nemerovs "really nice to work for," but he noticed that they kept to themselves mostly. He remembers meeting Diane. "She came in and out of the apartment a lot with her two little girls. Her mother said she was involved with photography."

The next few years were busy ones for the Arbuses, Yamashiro recalls. "They were starting to make money in photography. They were doing covers for *Glamour* and *Seventeen* and they did editorial work for *Vogue*; they had begun to get lucrative accounts from advertising agencies like Young and Rubicam and J. Walter Thompson. They did vodka ads and ads for the Greyhound Bus Company and Maxwell House Coffee which appeared full-page in *Life* magazine."

"Diane and Allen Arbus were real comers," remembers Fran Healy, who was an account executive for Young and Rubicam. "Diane shot the 'Modess Because' ads for me, and she did some terrific documentary stuff for a no-shrink shirt."

Yamashiro recalls a sitting where there must have been thirty people milling around the Arbus studio, including another stylist, a hairdresser, a copywriter, and a makeup man. At one point General Electric installed an entire kitchen in the studio for a big layout they were shooting, and afterward told Diane and Allan they could keep it.

Such generosity didn't impress the Arbuses; although they were increasingly active as photographers both in fashion and in advertising during the 1950s, it was impossible to know them and not hear complaints from them about "the business." They hated "the business"—meaning the fast-paced, trendy world of commercial photography—even though that world, in the middle fifties, was experiencing a veritable golden age. Television was in its infancy; there were no filmed TV commercials, so advertisers were pouring millions of dollars into magazine campaigns, for beer, cigarettes, cars, deodorants. *Life* and *Look* were swollen with ads. Every photographer wanted a piece of the action.

"But to get a piece of that action you had to be precise and clever and calculating twenty-four hours a day," says Art Kane, "and you had to hustle your ass off."

Diane and Allan tried to hustle by giving elaborate dinner parties in their new studio, to which they'd invite advertising executives, some fash-

ion editors, a copywriter or two. Whenever Howard came down from Bennington, he would be included at these dinners, and he always left the studio feeling that "Diane and Allan were leading an unreal but glittering life."

Unfortunately, the dinners didn't work in terms of getting more assignments, Alex Eliot says, "because Diane and Allan were incapable of operating. Diane always mixed lousy cocktails, couldn't make chit-chat; Allan would get nervous and very cold." They had no idea how to orchestrate the kind of relaxed, noisy gatherings that photographer Milton Greene threw at his penthouse studio on Lexington Avenue. There everybody operated like mad, but avoided discussion of topics like the hydrogen bomb, and models who lived on codeine and raw hamburger to keep their weight down got into vicious fights with their lovers. "The fashion/ad crowd was the meanest, smuggest, drunkest bunch of people you ever saw," the late designer Charles James said.

Eventually Allan told the Eliots, "No more parties in the studio. It's like entertaining at the bottom of a swimming pool." The ceilings were too high, he complained, and the place looked unfurnished, no matter how much stuff they put into it.

Instead he and Diane utilized the studio as a backdrop for their really theatrical assignments. They were probably most successful with big entertainment spreads for the Christmas issue of *Glamour*, which they shot in July. "They asked some of their friends and a few models to participate," Tina Fredericks says. "We milled around in heavy clothes, ate wonderful food, had a ball. Allan would shoot the spreads in color and they looked marvelous."

Nancy Berg, a beautiful brunette model, was booked regularly by the Arbuses then. "It was in the days when models were treated like shit," Berg recalls. "Other fashion photographers wanted to shave my eyebrows off, just to get an effect in the picture—they didn't care how *I* might feel. I was treated like an object at most studios. But the Arbs (as they were called) were terrific to work with. They treated me like a human being."

Nancy posed in a great many Judy Bond blouse ads for the Arbuses. "Diane and Allan would alternate with the shooting. Allan was more vocal —more dictatorial than Diane. When she photographed me, she never said much, but I got a sense of psychic strength from her. There was great nonverbal communication between us. And the studio was quiet, almost tranquil—not like the other studios I was booked into."

As one of the top models of her time, Nancy worked everywhere—at "factories" like the barn-sized Pagano on East 65th Street where Sears, Roebuck had its fashion catalogues done and Macfadden posed the *True*

Confessions pictorials. Then there were the photography studios massed in the 480 Lexington building which was connected by a ramp to 247 Park, where the John Robert Powers agency was located. The ramp made it convenient for the Powers models to traipse across to their bookings; the halls of both buildings smelled of developer and greasepaint.

During this transitional decade of the fifties (transitional because at the start stills and movie images dominated the public's eye; at the decade's end they'd both been replaced by television) New York was a mecca for a wild variety of photographers and not just in fashion. Rents were low, so photographers could live and work cheaply out of Murray Hill brownstones or lofts on the Bowery. "Everybody knew everybody else in the business and some of us did more than one thing," says Bob Cato, who, like Art Kane, alternated as art director and photographer. "It was a rich, exciting time," adds Walter Silver. He'd begun to document painters such as Grace Hartigan and Larry Rivers hanging around the Cedar Bar. Meanwhile dozens of other "street photographers" were wandering all over Manhattan snapping their cameras. Ruth Orkin and Jerry Liebling, veterans of the Photo League, immortalized views of Central Park or bleak new housing projects or just faces. Roy De Carava eloquently depicted Harlem.

Many of these photographers were supporting themselves in photojournalism since it was the heyday of the large-format mass-circulation magazine. Photojournalism of the 1950s was a visual medium of immense power and influence, often defining the way people saw the world. Pictures in *Life* magazine by Leonard McCombe, Margaret Bourke-White, Carl Mydans, and others stated attitudes, aroused curiosity, dramatized events, and occasionally even reflected the wacky smugness of the time—like Philippe Halsman's *Life* cover of thirty chorus girls immersed in a cloud of soap bubbles.

Often *Life* photographers complained that their editors manipulated the photojournalistic process, shaping images to conform to a specific idea or point of view. Eugene Smith, perhaps the quintessential photojournalist of the 1950s, rebelled. He eventually quit *Life* after his editors condensed what he planned to be a thirty-page essay on Albert Schweitzer into twelve pages.

In 1955 Smith agreed to be part of Edward Steichen's gigantic exhibit at the Museum of Modern Art called "The Family of Man."* Most photog-

* Smith's affirming picture of his two little children emerging from a dark wood into the sunlight capped the exhibit.

raphers of the period agreed as well—photographers like Elliott Erwitt, Ken Heyman, Henri Cartier-Bresson, Helen Levitt, Dorothea Lange, Alfred Eisenstaedt, Wayne Miller, to name only a few. It was "perhaps the last and greatest achievement of the group journalism concept of photography in which the personal intentions of the photographer were subservient to the overall concept of the show"—the concept being a benevolent, sentimentalized view of humanity. This was not shared by the younger, more rebellious photographers represented in the exhibit. Photographers such as Louis Faurer and Robert Frank were starting to document the Eisenhower years in their own idiosyncratic way. They were challenging the moral complacency of America with savage, grainy images—despairing couples, dingy Times Square bars. Frank called "The Family of Man" "the tits and tots show" because there were so many pictures of kids and bare-breasted mothers or just contented families (including Diane and Allan's bland portrait of a young father flopped on a couch reading the Sunday paper to his son).

Diane knew both Robert Frank and Louis Faurer casually (they'd all done fashion ads for Bonwit Teller). Once Diane had complimented Faurer on his portrait of a retarded man holding a flower. She responded to his emotional chaotic style—his images were often eccentrically cropped, faces were sometimes out of focus. This approach went totally against the Stieglitz philosophy, which valued perfect printing, classical composition, and tonal quality in a photograph. What Faurer did, and then Robert Frank, was to forget about elegance and experiment with exaggerated scale and light and shadow. This style ultimately became known as the "snapshot aesthetic," which hooked right onto the modernist sensibility.

Diane responded to that aesthetic. To her a photograph seemed more "real" when it was composed like a snapshot. On her own she would photograph Cheech—blurred—laughing—in motion. She photographed Jane Eliot and May ice-skating at dusk in Central Park. Alex still has that Brueghelesque portrait: inky-black images skimming across a scratched white pond.

But mostly Diane and Allan continued to work in fashion. They built their elaborate sets and cautioned their models to pose serenely and the pictures were invariably stiff and clean and neat. "Once just for the hell of it Allan got his models tipsy on champagne and then things got silly and disorganized," Alex Eliot says. "Allan hated that. He said never again."

He and Diane had many assignments from *Glamour* and *Vogue*, although Irving Penn was the "star" photographer at Condé Nast, producing luxurious, reasoned, structured fashion studies. As for "the *Bazaar*," as it

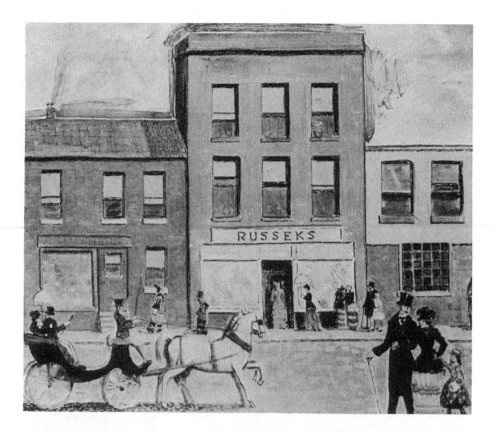

Russeks ca. 1897, when it was a fur
shop at 14th Street and University
Place, and in the 1930s (*right*), after
it had moved to this elegant Stan-
ford White building at 36th Street
and Fifth Avenue, and become the
grand Russeks Fifth Avenue.

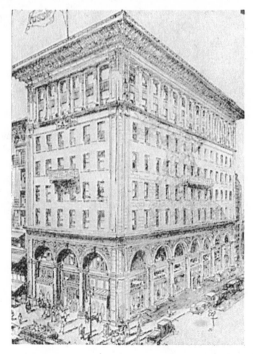

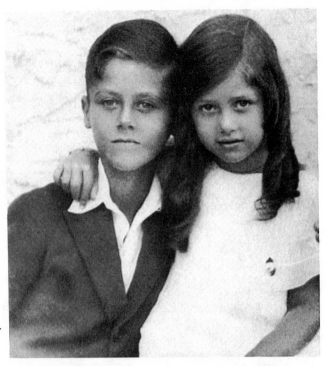

Diane, age five, with her brother Howard Nemerov, age eight.

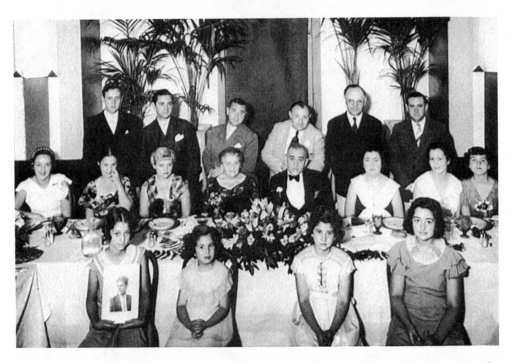

The fiftieth wedding anniversary of Diane's grandparents Meyer and Fanny Nemerov (*seated, center row middle*). Diane is holding a picture of Howard, who was ill with typhoid. Diane's father David is standing (*second from left*), her mother Gertrude is seated (*second from left*).

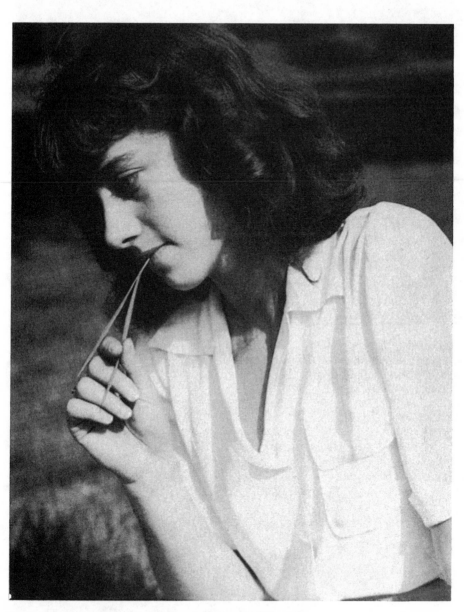

Diane at fifteen. She had just fallen in love with Allan Arbus.

Diane and her parents posing for the *Journal American*. They had just returned from Europe.

The beautiful Gertrude Russek Nemerov.

Gertrude made this collage of the Nemerovs and the Russeks. *Clockwise:* Grandfather Frank Russek, Howard with his arm around Frank, Diane in a hat, Renée dancing with David, Grandmother Rose Russek, Frank again, David after becoming president of Russeks Fifth Avenue, Gertrude, and Howard in Royal Canadian Air Force uniform.

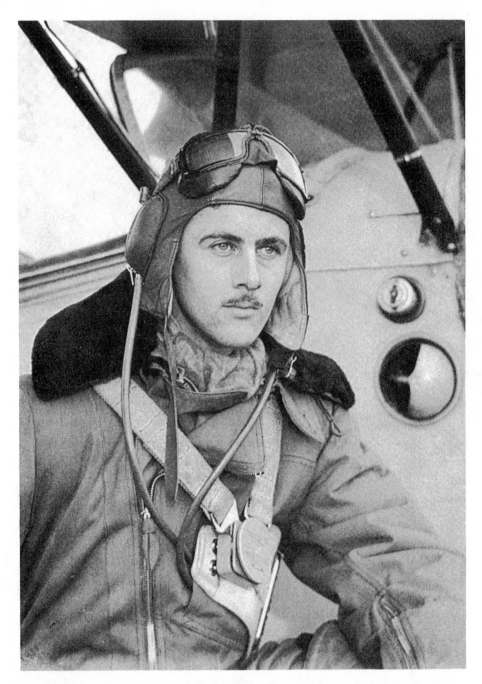

Howard during World War II. He was a pilot and flew fifty missions with the RAF
and later fifty-seven bombing missions over the North Sea with the Eighth U.S.
Army Airforce.

Roy and Renée Sparkia shortly after their marriage.

BECOMES ENGAGED

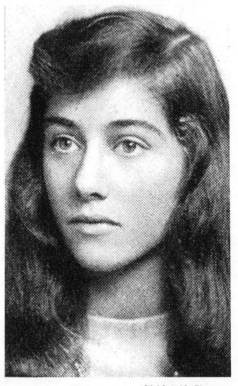

Chidnoff Photo.

Miss Diane Nemerov.

A. F. Arbus to Wed
Miss Diane Nemerov

Mr. and Mrs. David Nemerov of 888 Park avenue have announced the engagement of their daughter, Miss Diane Nemerov, to Allan Franklin Arbus, son of Mr. and Mrs. Harry Arbus of 1225 Park avenue.

Miss Nemerov is a graduate of Fieldston School. Her father is executive vice-president of Russeks Fifth Avenue.

Mr. Arbus attended the College of the City of New York and is now in the advertising business.

was snootily called, Diane and Allan had never been able to impress the wily, brilliant art director Alexey Brodovitch* with their portfolio.

Richard Avedon remained his favorite. Avedon dominated the magazine throughout the fifties and into the sixties with his wit and dazzling inventiveness. He covered the French collections on location in Paris, collaborating like a movie director with his models—Dovima, Sunny Harnett, Suzy Parker, and the exotic China Machado—and every image Avedon made was fraught with glamour and passion and a hectic gaiety.

Someone at Condé Nast said, "Diane and Allan were classy people whose pictures sold fashion, but you didn't get excited by them." In her history of fashion photography, Nancy Hall-Duncan writes, "The work of Diane and Allan Arbus was done in the studied mold of the time, having no real influence in the field."

Whether or not Allan cared about being influential as a photographer, nobody knew; he was a self-contained man who kept such thoughts to himself. He had tried to become a serious photographer in Italy, experimenting with blurred street images. Some of his pictures were "marvelous," according to Alex Eliot, "but Diane's crude portraits of Roman street urchins were even better," perhaps because she was already developing a distinctive point of view.

Friends wondered if Allan was upset about Diane being the better photographer. "It's rough on a guy when his wife is obviously more talented," Rick Fredericks says. "But Allan not only accepted it, he even talked about it. He was proud of her visual gift as a brother or father might be."

By himself he would struggle to perfect his photographic technique. "Allan was technically excellent," says an advertising executive. "The problem was, he was often unable to apply his technique to any specific idea—which is where Diane came in. She always had an idea."

Still, he would keep on studying light—the essential matter of photography—and the differences between the quality and quantity of light and the *nature* of light, and he would photograph a white screen over and over to test emulsions. He also used a special kind of lighting with a hanging reflector that he lowered or raised, and he would bounce strobe light off a corner of the reflector to achieve a soft and romantic effect. And he would stay for hours in the darkroom using up box after box of expensive Adox paper until he came up with the perfect print. And Diane would sit silently next to him as he printed an image over and over and over.

* The first art director to conceive that a magazine should have a distinctive design philosophy; that visuals could express a point of view as clearly as editorial content. At *Bazaar* he revolutionized the magazine with bold new layout concepts integrating photographs and text with white space which gave excitement, fluidity, and aesthetic unity to the magazine pages.

When he finished, he would go off to his room and practice the clarinet. He spent more and more time practicing the clarinet, and he never stopped dreaming of becoming an actor. But he knew Diane was as obsessed with the peculiar power of photography as he was with the art of make-believe, so he kept urging her to take pictures on her own: at least she could be doing what she wanted, even if he couldn't.

And she couldn't stop anyway—she always had a camera, usually a Leica, in her hand. Even when she was carrying on a long conversation with Pati Hill, she would have her eye pressed up against the viewfinder.

She snapped pictures all the time, although she had no particular focus or goal, just a vague, inarticulate feeling within her that somehow she wanted to photograph the private, secret experiences of people and of worlds hidden from public view. But she was too shy to ask strangers to pose, so instead she took pictures of friends.

She photographed a great many children*: enraptured Puerto Rican kids watching a puppet show in Spanish Harlem; a tiny, seemingly deformed boy and girl laughing into her camera (this picture became a 1962 *Evergreen* cover). Then there were endless candids of her daughters, Doon and Amy, and portraits of Frederick and Isabel Eberstadt's son, Nick, "but Nick disliked Diane so intensely the hostility radiated from the photograph." (In contrast, the Eberstadts' daughter, Nena, loved Diane—"went ape over her," Eberstadt says. "After Diane photographed her, she jumped up and down and tore off all her clothes and went racing around our apartment.")

Later Eberstadt arranged for Diane to go out to his father's estate on Long Island's North Shore to take a portrait of the distinguished financier presiding over a luncheon. Diane kept clicking away until the elder Eberstadt ordered her to stop. "You'll give me indigestion!" Afterward he told his son, "Anyone who insists on taking pictures of people having a meal should be put out in a barn!"

* John Szarkowski notes: "Her most frequent subject in fact was children—perhaps because their individuality is purer—less skillfully concealed—closer to the surface."

Meanwhile Diane's sister, Renée, was living with her husband, Roy Spar-kia, in an apartment at Park Avenue and 96th Street that they could barely afford. Roy was grinding out magazine articles and short stories while Renée struggled to achieve some recognition as a sculptor. She worked tirelessly with her clay, shaping forms of skinny ballet dancers. (Some of her work is now in collections at the Palm Beach Institute and Lord Beav-erbrook's museum in New Brunswick.)

David Nemerov was pleased by her efforts. "It was the start of me being close to Daddy," she says. "He ended up telling me I was his favor-ite."

At the time Diane showed no interest in what her sister was doing creatively. "We'd talk about my marriage but she always ignored my work," Renée says. "I was very hurt."

She remembers Diane as being "down in the dumps and awfully blue" during this period. Bill Ober, then a pathologist at Knickerbocker Hospi-tal, says that Allan would visit his office periodically to talk about Diane's recurrent depressions, which he was finding harder and harder to take. There seemed to be no solution.

These episodes, which took the form of extreme lassitude—she couldn't seem to respond to anything—came and went throughout their marriage, but never sprang from any particular incident. On the surface Diane appeared to be leading a rich, active life, sharing not only a success-ful career with her husband but two bright, healthy children as well. Even so, at the core something was false and empty for her and she remained restless and depressed much of the time.

Whether or not her depressions were genetic and caused by some defi-cient enzyme unrelated to anything that was happening to her day to day cannot be established, since there is no scientific proof as to whether depression is genetic or physiological. As a family the Nemerovs had shared in a mutual ongoing depression for years. "Mommy, Daddy, How-ard, and I were all periodically *very* depressed," Renée says. "But Diane's

depressions were somehow more dramatic—more extreme. And they seemed to last longer."

Often Diane barely had enough energy to attend the Friday-night dinners, but she would force herself to, and Renée and Roy continued coming to them "out of a sense of duty more than anything else," since there was increasing strain between the sisters. "I wanted D to acknowledge me as an artist—something she seemed unwilling to do. I was still the baby—I hadn't accomplished as much as my brother and sister. Well, I was working very hard and making progress and I wanted D to say something!"

Recently there had been a rather ugly outburst in the garden of the Nemerovs' Westchester summer home. The argument had started ostensibly over the "bad manners" of Roy's two Afghan dogs*—Gertrude Nemerov had a dislike of all animals.

Somehow the subject veered to Renée's sculpture, and, as Roy wrote in his journal: "I finally could stand it no longer and told Gertrude off—said the entire family had been treating Ren like a second-rate pet all her life—no wonder she felt so insecure. That Diane more than Howard was the pampered one—the one who could do no wrong." (He adds that Diane's remote, dazed manner intimidated her parents. They kept getting different signals from her. She could be totally unresponsive one day and gentle and loving the next. They never knew where they were with her, and this baffled them.)

"Anyhow [the journal goes on] I let Gertrude Nemerov have it. I was bold for once. I'd got so tired of Ren being the scapegoat, the butt of family jokes when she was just as talented as her brother and sister. Gertrude began to cry and allowed as to how maybe she had favored Diane over Howard and Ren but she loved Ren dearly she assured us. Diane meanwhile sat quiet as a mouse—not saying a word—not defending Ren or anything—the afternoon ended with Allan in a rage telling us he'd never feel the same towards us again. He was angry for months after—wouldn't allow us in the studio—when we dropped by once he was cold as ice. Diane acted as if nothing had happened."

In 1954 Renée and Roy left New York and moved to Roy's home state, Michigan. They settled in Frankfort on Lake Michigan and adopted a child. Roy began a successful career as "a paperback writer"—he has written thirty books, among them *Vanishing Vixen* and *Creole Surgeon*. Renée began experimenting with plastic sculptures, even inventing a synthetic bronze (mixing bronze powder with polyester). The resulting substances looked and felt like bronze and eliminated the process of casting. "But it was far too toxic for many artists to use," she admits.

* "When we were breeding our dogs, Diane took pictures of the animals copulating. I was embarrassed," Renée says. "Diane and Allan laughed at me."

Together, she and Roy collaborated on the design of plastic-topped tables embedded with shells, pebbles, and stones they collected from their daily walks on Michigan beaches. They briefly ran the RenRoy studios in Beulah, Michigan, and soon expanded to five decorative outlets across the country. Six of their tables exhibited at the International Housing Show in Chicago won an award from the American Institute of Decorators.

The more Renée did with her life, the more she realized that her rivalry with Diane was intrinsic to shaping her identity. "I would dream about Diane—dream about what she was doing—and then I'd wake up and realize I was doing a lot on my own."

Periodically Renée would phone Diane in New York and "we'd talk a long time and try to catch up—I'd always say, 'Please come out and visit' and D would always say she wanted to but just didn't have the time." She and Allan had more assignments from *Glamour* and *Seventeen* than they could handle. They were making money, but expenses were high, so Allan didn't hire a secretary; instead he himself kept the books and made the phone calls—and cajoled the clients—and Diane was by his side, giving advice and suggestions, shaping and styling the shots. She would still record the sessions with her Leica for her own amusement; it was the only way she could tolerate remaining inside the studio all day.

By 1956 Diane was telling Cheech she didn't know how much longer she could stand it. She hated the artifice of fashion—the fact that the clothes didn't belong to the models. "When clothes belong to a person, they take on a person's character," she said, "and they are wonderful and fit on the body a different way."

Mostly she hated the grinding monotony of the fashion sittings, the deadly "sameness" of the days—so much so that she would "grasp at straws" to create the slightest break in their routine.

This had begun recently when she and Allan had driven "a very tall ugly dumb but hypnotic model" Diane was especially fond of to La Guardia Airport to photograph her in spring clothes. As they approached the field, the model suddenly asked in a musing way, "Wouldn't it be terrific if a plane crashed?" Diane repeated that story to students over the years as an example of "spontaneous honesty." Everyone is secretly fascinated by disaster and death, but few people are willing to admit it.

When Grandma Rose died, Diane had taken photographs of her lying in her coffin. She was growing increasingly attracted to "off-limit experiences," she told Cheech; attracted and afraid. By this time Cheech had moved to a five-flight walk-up in Spanish Harlem. She had painted the walls blood red, the ceilings blue, and had filled the rooms with her potted violets, and glued photographs of her favorite artist (Jean Cocteau) and her favorite movie star (Katharine Hepburn) above her bed. Nearby, the

bathtub was filled alternately with green- or blue-tinted water in case she wanted to dye material very quickly (she was now designing costumes for Off-Broadway shows). There was also a junk room in the back, in darkness save for a big TV set always playing, but with the sound off. Diane took many pictures of the wavering images on that set.

She also took some lovely still-lifes of Cheech's rocking chair and dress-maker's mannequin. The light seemed to fall from nowhere, glancing off the rocking chair, before forming strange columns and then disappearing into the aqua-painted floor.

At Cheech's apartment on Orchard Street the space had been so dim and mysterious, Diane had had difficulty taking pictures. On Orchard Street, Cheech had hung out with a band of gypsies—had, in fact, seen many of them through illness, even death. She always hungered for knowl-edge of every culture in the world, and felt she could learn only through friendship or love. So far she'd married a black man and a Chinese, but "it was a beginning," she'd say. She seemed relaxed about the situation; she had plenty of time, since she was going to lead many lives after this one. She believed staunchly in reincarnation.

Recently she had convinced Diane that Elvis Presley had been a god in another life ("He was a Greek god—look at his curly mouth"). Together Cheech and Diane played Presley's current hits "Hound Dog" and "Blue Suede Shoes," singing along with the frenzied crooning and the thrum-ming electric guitar—bouncing up and down (much to Allan's annoy-ance), then collapsing into giggles on the floor.

It was this capacity for silly, childlike pleasure that drew the two women close. "We'd been best friends for ten years now," Cheech says. "We planned to live together in our old age. Two dotty old ladies tending our plants."

Once, when she was visiting Cheech in Spanish Harlem, Diane con-fided that she thought she might go crazy if she didn't stop styling soon. Every time she returned to their fashion studio to work, she felt dragged down, confined, and her depressions increased in intensity, although she tried to hide them from Allan because *he* was working so hard and she loved him dearly and depended on him completely. At the studio she would address him teasingly as "swami" or "boy" (he still called her "girl"). But living and working with him in the same space—practically twenty-four hours a day—was getting to be a strain; there was so little time to dream.

And, as with everything she did, Diane was intensely concentrated as a stylist/photographer; depressed or not, she worked strenuously, throw-ing herself into each new assignment with fervor. She would spend hours choosing the right accessory; she might scour New York for days searching

for the perfect prop, whether it was a hundred red balloons or a particular breed of kitten. As a result, her collaboration with Allan on every sitting made them more and more successful as a team (they were now *Seventeen* magazine's favorite cover photographers). But their work schedule was frenetic and suffocating; they started early and finished late, and neither of them was fulfilled by fashion photography. They viewed it simply as a way of making money.

How Diane longed to—just once—cut around or beneath a fashion image to get at the story behind that image, the fiction of it. As with the ravishingly beautiful model, married four times, whom she and Allan booked frequently even though the girl usually staggered into the studio black and blue from a lover's beating. Diane would minister with coffee and ice packs on her arms and thighs, especially if they were shooting a bathing-suit spread. Between shots the model—who later, briefly, became a movie star—would sit in the dressing room moaning and studying her exquisite reflection in the brightly lit mirror.

Sometime in 1957 Diane inexplicably burst into tears at a dinner party when a friend asked her to describe her routine as a stylist at the studio. She, who rarely cried, who hated crying, began to sob as she ticked off her duties: fix model's hair and makeup, accessorize her outfit with belt, necklace, earrings, hat, arrange the props just so. Since she hadn't had much practice crying, the sobs seemed to have trouble coming from her throat. They were ugly, constricted cries. She would never again "style" the shots for a Diane and Allan Arbus fashion layout.

Soon afterward Allan phoned Alex Eliot and insisted that he and Jane come over "right away. We have something very important to tell you." He sounded so urgent that the Eliots canceled their plans for the evening and rushed to the Arbus Studio. The minute Allan opened the door, he announced that Diane had made a dessert for everybody and that she had never made a dessert before; he seemed almost childishly pleased, since he had a sweet tooth that Diane had never catered to. "She had no real interest in food."

The couples ate whatever it was, and then Allan explained why he'd summoned the Eliots. He and Diane had decided to break up their business partnership, he said, and they were going to start doing things independently of each other. He would continue to run the Diane and Allan Arbus studio (and the name would remain, since it was so well established), but he would also take a mime class from Etienne Decroux, which he'd always dreamed of doing. And Diane would have nothing more to do with styling or fashion photography. Instead, she would now be free to

wander around photographing whatever she liked. Although he didn't say so, it was obvious he hoped this change would alleviate her recurring depressions.

The Eliots responded enthusiastically to the plan, particularly Alex, who had always maintained that Diane was potentially "a great artist— she can do anything she sets her mind to" and, although she kept denying it, the image of herself as an adventurer, a risk-taker, a "great sad artist" had been rolling around in her fantasies about herself since she was a kid. However, when Alex repeated, "You can do anything" that night, she looked a little frightened by the prospect of going out on her own and she said nothing because it was more than that—she had absolutely no idea how she was going to go about photographing anything and everything she wanted since she didn't know precisely *what* she wanted to photograph.

Weeks passed and Diane wasn't styling anymore—wasn't doing much of anything. Jane dropped by and urged her to take her camera and go out on the street. "You owe it to yourself," she said. Again Diane said nothing; she disliked talking personally—it wasn't part of her nature. She couldn't admit to Jane that she sometimes felt peculiar, not normal somehow, because her need to love and be cared for seemed to conflict directly with her need to photograph. What about her daughters? Would they get enough attention if she was out in the city with her camera? And Allan? What about her duties as his wife?

"Ma had always thought all her life was about helping Pa do his thing," Amy Arbus said years later in a radio interview. "It took her a long time to adjust."

For a while Diane went out every day and tried photographing strangers on the street. Her initial efforts were hampered by such extreme shyness that she enrolled in Alexey Brodovitch's workshop at the New School to see if he could help her overcome her timidity. She knew that as an art director Brodovitch had made a special place for documentary photographers such as Brassaï, Bill Brandt, and Lisette Model in the pages of *Harper's Bazaar*, photographers she felt a special kinship for although she wasn't quite sure why. Perhaps it was because they were all portraitists who explored people's roles. She knew as well that Brodovitch had encouraged fashion photographers like Penn and Avedon to be "serious." ("I learned from his impatience, his dissatisfaction, his revolutionary eye," Avedon has said.) However, once in the workshop, Diane discovered that Brodovitch—old, ailing, and suffering from extreme melancholia since all his possessions had been destroyed by a fire—had no interest in whether or not photographers were insecure. "He didn't care if we were broke or had stomachaches," Art Kane says. "His dictum was, 'If you see

something you've seen before, don't click the shutter.' " It was something Diane never forgot.

At the workshop the photographers would huddle around while Brodovitch went over different portfolios. He would hold up a picture and talk about its "shock impact," its "showmanship," its "surprise." He could be vicious in his criticism; he rarely praised. Occasionally he would suggest that they all cut out a rectangular section from a piece of cardboard and use the framed space to take mental pictures of things until their ordinary way of seeing turned into a photographic way of seeing. "It was a remarkable discipline aimed at ending the division between formal and informal vision—a way of turning camera-users into cameras," Owen Edwards wrote.

"Set yourself a problem—don't shoot haphazardly!" Brodovitch would cry before giving out assignments. "Shoot the United Nations, traffic jams, graffiti, Dixie Cups—give the subject your personal interpretation." For months the fledgling photographer Hiro photographed a shoe over and over again in a wild, imaginative variety of styles; finally Brodovitch told him he was ready to photograph for a magazine.

Eventually Diane stopped attending Brodovitch's workshop. She told Yamashiro, who'd accompanied her, that she simply didn't like the man, didn't like the forbidding atmosphere he created around himself, didn't like the abuse he heaped on his students, thought his approach was too monotonous, too narrow. He stressed visual coherence; she was interested in suggesting the mystery of existence, however unbearable, and in the deep, secret, interior lives of people. Brodovitch never mentioned secrets. But she left the workshop disturbed by one comment he made: "The life of a commercial photographer is like the life of a butterfly. Very seldom can a photographer be productive for more than eight years."

Now that she was freer, Diane began a study of photography back to the world's first photograph: by Joseph Niepce, a view from the window of his blurred French garden circa 1826. (She used to tell John Putnam that she liked Balzac's theory regarding the invention of the daguerreotype: that every human being in his natural state is made up of a series of superimposed images which the camera peels away.)

In time Diane would become familiar with the dreamy nineteenth-century portraiture of Julia Cameron, with Mathew Brady's documentation of Civil War battlefields. She would read about Paul Strand's switch from pictorialism to Cubist-inspired photographs in the 1920s; she would study Lewis Hine's powerful pictures of children working in coal mines. Hine's bleak images would impress her more than Stieglitz' gorgeous

cloud formations. Stieglitz believed that photographs could be metaphorical equivalents of deep feelings. He also believed that the fine print, the excellently made photograph, was the criterion of a good photograph. Diane did not believe that. Which is why she responded to the work of her contemporaries Louis Faurer and Robert Frank, who were experimenting with outrageous cropping and out-of-focus imagery. But Diane was even more impressed by Lisette Model's studies of grotesques, especially the grotesques of poverty and old age which she documented with almost clinical detachment.

Lisette Model was said to use the camera with her entire body; and her eyes—her eyes were "the most instinctive eyes in photography." Model's first pictures—massive portraits of French gamblers and the idle rich taken on the Promenade des Anglais in Nice—established her reputation when they were published in the New York newspaper *PM* in 1940 under the title "Why France Fell."

These portraits, and others taken on Coney Island, were later exhibited at the Museum of Modern Art, and at the time (1941) they were considered revolutionary in terms of both their size (massive 16 x 20 prints, they loomed out at you from the frame) and their subject matter (drunks, filthy beggars, ordinary people, blown up to such heroic proportions you could almost feel their existence). Model called her subjects "extremes," "exaggerations," and they were—either very fat or very thin, very rich or very poor. Model knew the ugliness of the flesh and she refused to shrink from it.

The child of wealthy and cultivated parents, Model was born in Vienna in 1906. Her father, Victor Seybert (half Italian, half Austrian), had millions in Venetian real-estate holdings. Her French mother, Felicie, was ravishingly beautiful and dabbled in poetry. Model, one of three children, was raised mainly by servants in a huge mansion now designated as a national landmark by the Austrian government. Her closest friend was Trude Schoenberg, the daughter of the composer Arnold Schoenberg. One day Trude was visiting Model and watched horrified as a maid slipped on her shoes for her. "Can't you tie your own shoes?" she asked Model, who answered airily, "I have a maid to do that for me." "Tie *my* shoes for me, then," Trude Schoenberg said. "Trude taught me to be more independent," Model said.

Throughout her teens she spent much of her time in the Schoenbergs' modest apartment. For the first time she saw a real artist struggling. "He'd been neglected by his peers, he couldn't understand why Richard Strauss was being played and he wasn't," Model said. She thought he was

a man of utmost integrity, one who would never compromise. She went to concerts with him and studied music and harmony with him. "He thought I was exceptionally talented."

In her twenties Model lived in Paris, where she studied singing and went into analysis. In 1936 she married Evsa Model, a Russian-Jewish painter living in Montparnasse. She became a photographer by chance. Sometime in 1938 she was painting—rather languidly—in Paris when a friend suggested that with the rise of Hitler she might be forced to earn her living; her family was part Jewish—and indeed their entire fortune was lost during the war. Although she had no experience with film, she decided to get a job as a darkroom technician. André Kertesz's wife, Elizabeth, showed her how to use a Rolleiflex. The resulting portraits, taken at Nice, were her first experiments with a camera.

She came to New York in 1941 and became celebrated when her pictures were shown at the Modern Museum, praised by photographers like Ansel Adams and Walker Evans and by authorities like Beaumont Newhall.

"I was praised on the basis of a few test rolls of film—it was as if I was being put on a pedestal. Only in America . . . The most dangerous thing that can happen to an artist, making every beginner into a star, putting me onto a pedestal for something I didn't even know what I was doing." (When Edward Weston asked how she got such a grainy quality in her prints, she retorted that she had her film developed at a drugstore. "I hate pretty prints," she said.)

Throughout the 1940s Model photographed regularly for *Harper's Bazaar*, working with Carmel Snow and Brodovitch on a wide variety of features—fashions on location, portraits of New York night life (Nick's jazz joint, Sammy's Bowery Follies). She learned to use a flash so she could photograph at night. On her own she did a series on feet—feet on Wall Street coming out of the subway, running down the sidewalk, standing in line at Radio City, shuffling, moving, stumbling feet; to her, moving feet symbolized the haste and energy and pace of New York—of America. "It's exciting and terrifying," she said.

She also made powerful studies of the immigrants living on the Lower East Side—and she photographed at Coney Island, producing perhaps her most famous image (it's currently on the cover of her Aperture book of photographs—a huge, laughing, fat lady squatting in the surf, an exuberant, unsentimental expression of female vitality).

Sometimes her pictures weren't used. She did a series on black delinquents in Harlem and *Look* refused to publish them: "They said they wanted white delinquents." She spent months with the Pearl Primus dance company, but Brodovitch said her film couldn't be used in *Bazaar*.

"Hearst won't allow photographs of Negroes in his magazine," Brodovitch said.

After Brodovitch left *Bazaar* in 1951, Model began lecturing on photography both in New York and in San Francisco, where she became friendly with Imogen Cunningham and Dorothea Lange. The three celebrated women photographers often met to talk shop, and while she was with them Lisette Model took candid portraits—Cunningham in her garden, a close-up of Lange in Berkeley.

In San Francisco, Model won the reputation of being a formidable talker. "You couldn't get a word in edgewise with Lisette," a friend says. She would ramble for hours in a somewhat convoluted fashion on subjects such as the art of the snapshot or the wisdom of Krishnamurti. (In her photography lectures at the New School, "Lisette combined good horse-sense with mysticism," a student says.)

By the mid-1950s Model had produced a small but impressive body of work—*Aperture* magazine, under Minor White, opened its first issue with a Model photograph. Her pictures were shown year after year at the Museum of Modern Art and it was as a regular lecturer there that she uttered her famous dictum: "Photography is the art of the split second." She still had photographs published in magazines like *Camera*, but she made barely enough money to pay the rent. In those days there was no market for art photography—you could buy a Lisette Model print for $15. Today the same print is worth $1000.

At one point, almost broke, Model went to see *Bazaar*'s editor, Carmel Snow, who had always admired her work ("Carmel used to say to her daughters, 'Listen to Lisette talk!' "). Model wanted to do a book on jazz musicians; she would take the pictures, Rudi Blesh and Langston Hughes would do the text—but they needed money to fund the project. Snow was enthusiastic; it sounded like a wonderful idea, she said, and she would ask Helena Rubinstein for $5000. Mrs. Snow then arranged for Model to meet with Rubinstein's son, Roy Titus. He was equally enthusiastic and told Model he was sure his mother would not only give Lisette $5000 for one year, but renew her support with another $5000 the following year. He promised to arrange a meeting, but it was canceled when Madame Rubinstein fell ill. Months went by and Model heard nothing. Eventually she phoned Titus and he invited her to the Rubinstein home to talk.

"I asked him what was cooking. Was his mother prejudiced about me or what! And there was a long silence and he produced a letter Carmel Snow had written Helena Rubinstein warning her not to help this Lisette Model, who was a troublemaker, a leftist, completely unreliable. I could not believe it," Model says. "I thought this woman was a friend of mine.

"Later at a Museum of Modern Art opening someone screamed 'Model!'

and threw her arms around me. It was Mrs. Snow. I shook her off me so hard it threw her against the wall. 'Don't you speak to me!' I said. But in what a voice I said it! Louise Dahl-Wolfe, who was standing there, asked, 'Why were you so cruel to Mrs. Snow?' I said, 'I'll tell you why in two minutes.' After I told her, she understood. But Brodovitch had a different response. 'Is that *all*?' he said. He was used to worse from morning till night—[the fashion business] was a world of intrigue and poison-pen letters, treacheries, prostitutions; these things were normal to Brodovitch, who was an extremely bored, extremely cynical man. But I was shocked."

After that Model took few pictures and refused to let her work be exhibited. When she gave interviews, she would later contradict herself and exclaim, "I didn't say that!" (She believed that once she said something, the thought disappeared and no longer existed.) Eventually she stopped giving interviews, subsequently gaining her reputation as "the Greta Garbo of photography." She trusted no one but her husband, Evsa Model, a gentle, handsome, almost saintly man who rarely spoke but who painted vivid scenes of street life in New York. "Evsa was as talented a colorist as Mondrian," Sidney Janis said, "but he wouldn't push himself." "Poor Evsa—he never made a penny," Model said. "I always had to support him."

The only time he showed initiative was at the age of thirteen when he left his native Siberia and "walked across Asia," a friend said. "Through Japan, China, India, stopping at various ports—Singapore, Bombay, Port Said—before settling in Paris to paint."

Now he and his wife lived an impoverished existence in Greenwich Village. "But they doted on each other," a neighbor says. "Evsa was Lisette's security blanket." Lisette would talk and talk and talk—wild, brilliant, angry monologues—and Evsa would listen or work over her prints ("He was the only one who really understood my work"). Finally, after hours of her non-stop talking, he would interrupt: "Lisette, you are a wonderful woman, but you talk too much."

In the evenings they might go to the Limelight,* a popular photographers' hangout on Sheridan Square in the Village, and join photographers like Robert Frank and Walker Evans over coffee. And they would argue

* The Limelight coffeehouse/gallery opened in 1954, the brainchild of Helen Gee, and it was the first gallery anywhere in America devoted exclusively to showing photographs. White walls and unaffected lighting were hallmarks of the Limelight, as were the excellent coffee and pastries served until one a.m. The record of exhibitions during its seven years was, according to Peter Bunnell, "a virtual international report on the state of the [photographer's] art ten years after the war." Shows included such names as Paul Strand, Ansel Adams, Robert Capa, the Westons, Bert Stern, Louis Faurer, Elliott Erwitt, Jerome Liebling, Robert Frank, Gordon Parks, Cartier-Bresson. A good sale was $25 a picture. The Limelight was forced to close in 1961.

about the importance of the "Family of Man" exhibit which Steichen had organized at the Museum of Modern Art. They all had photographs in the show, and although it was an enormous success, it proved to have little effect on the subsequent direction of American photography.

It was at this time that Diane Arbus began phoning Lisette Model to ask if she could buy her work—any print of her work—and if she couldn't buy a print, could she borrow one and just look at it? Model told her she had nothing for sale and nothing to look at either, but Diane persisted. Model suggested she join a class she was giving at the New School, and sometime in 1958 Diane enrolled.

According to Model, Diane was extremely nervous when she came to the New School, so nervous she kept bursting into tears. At thirty-five she still looked like a little girl in her shirtwaist dress and ballet slippers. Model, tiny, imperious, with prematurely white hair she had only recently stopped dying red, wouldn't allow her students to take notes; she was highly sensitive about being misquoted. However, once she got started in a lecture, she could be supremely eloquent, and she usually repeated her celebrated dictum: "The camera is an instrument of detection . . . we photograph what we know and what we don't know . . . when I point my camera at something I am asking a question and the photograph is sometimes an answer . . . In other words, I am not trying to prove anything. I am the one who is getting the lesson."

Her basic themes: that photography has extended our vision, but in ways we still cannot understand; that photography was first viewed as a superstition—it is now an addictive craving; and that there is a big difference between what the eye sees and what the camera sees—the transformation between the third dimension and second dimension can make or break a picture.

She spoke of the basic choices a photographer must make: picking a camera, choosing a lens or a filter, selecting a subject, discovering what one feels about the subject. She talked a lot about technique, but in the end, she told her students, they must forget it—photography is about creating a picture.

One of her first assignments was to have Diane and the others photograph something they had never photographed before. For another class Model had everybody photograph a face, but not in an ordinary way— "photograph a face like a Picasso." She urged her students to wander through the streets of New York carrying their cameras with no film in them: "Don't shoot until the subject hits you in the pit of the stomach," Berenice Abbott quotes her as saying.

She would spend hours talking about the importance of light in a photograph—light is everywhere, in all color; light has great psychological import. She often had a student walk around a model holding a light-bulb to show how it affects a face in terms of illuminating shadow—each face is different, so the light falls differently on each face.

She also talked about the relationship between the photographer and the subject—it can be a confrontation, a conversation, an occasion fraught with emotion, but some sort of visceral exchange is necessary and crucial to make the photograph valid. Larry Fink, one of Model's early students, has said that after Model pointed out to him that a sensual transition must take place between the artist and the subject, it took Fink seventeen years to understand totally when she meant.

The initial photographs Diane brought Model were "little balloons flying in the clouds—fragile—wispy." Diane told Model she had gone to the Ethical Culture School, where everything she'd done in art class was labeled "genius." "This was not a good thing for a person," Model said.

Their first extended conversation took place on a field trip to the Lower East Side (scene of one of Diane's earlier adventures with Phyllis Carton). Diane brought her two daughters along, and they trailed behind as she kept lifting her camera to her eye and putting it down.

According to Model, she was very pale. Finally she told her she couldn't photograph. Model asked her why and to please identify her subject matter. Diane said she'd have to think about it. The next time she came back with an answer. "I want to photograph what is evil."

"Evil or not, if you don't photograph what you are compelled to photograph, then you'll never photograph," Model answered and said later, "I had to push it out of Diane"—reach her where the deepest anxiety lay, the anxiety which fascinated and absorbed her and which she thought was evil. "And I pushed it out."

Years later Doon wrote that she thought what her mother really wanted to photograph was the forbidden not the evil.*

This was undoubtedly the case; Diane had always longed to scrutinize the perverse, the alienated, the extreme—ever since her mother forbade

*Diane Arbus was not the first photographer to photograph "the forbidden" or "evil subject matter."

In the 1880s American amateur photographers photographed their dead babies and Bellocq took portraits in a New Orleans whorehouse. During the 1920s Brassaï descended into the Paris after-hours cafés and brothels and photographed whores douching after sex.

Weegee's special target in the 1940s according to Weegee expert John Coplans was "people convulsed with pain or terror. . .people in extreme situations," which Weegee documented for the New York Daily News. He recorded "appalling bloody scenes," scenes full of gore and violence, and his work is "pitiless"; "there's a demonic edge" to it, an almost cruel humor. He "invaded people's lives" with his camera (later Diane was accused of that), and he could focus on a "lurid moment and get personal satisfaction from it."

her to stare at their nutty relative, the relative who smeared lipstick so violently over her mouth and made noises at Russeks. Diane had always dreamed of capturing the panic and loneliness in that woman's owlish eyes.

Now, with Model's encouragement, she began documenting people and places she'd been afraid to confront. "She liked being afraid because there was in it the possibility of something terrific," Doon wrote. She would take the D train to Coney Island. She noticed a tenement off Stillwell Avenue, marched inside and discovered it was actually a hotel full of disoriented old people and a barking dog. She spent hours photographing there. "If I ever went away for a weekend, this is where I'd go," she said. She returned to Coney Island again and again, sometimes bringing Doon and May Eliot along for company while she photographed the wax museum or Puerto Rican mothers or tattooed people. For a while tattooed people became one of her main subjects. She kept asking why do people get tattooed—for decoration? to hide scars? on a dare? The secret ritual of it intrigued her, since it was a combination of traditional art, physical pain, and sensuality. May Eliot remembers Diane photographing a tattooist and laughing and talking animatedly to the man; his stare froze every time she clicked her camera. May says she got a "nightmarish feeling" about the whole experience, although Diane seemed unchanged; she seemed "light and cozy" as she walked with Doon and May back to the subway; but she did seem relieved to be going home.

The hardest thing for Diane was trying to overcome her shyness, the nauseating feeling in the pit of her stomach whenever she had to ask someone to pose. She'd stop a man or woman who intrigued her by exclaiming, "Oh, you look terrific! I'd like to photograph you," and the person would hem and haw and ultimately consent because Diane seemed gentle and unthreatening. "I was terrified most of the time," she said. But terror aroused her and made her *feel*; shattered her listlessness, her depression. Conquering her fears helped her develop the courage she felt her mother had failed to teach her.

She believed that picture-taking is a profound experience because it involves the risk of seeing ourselves as others see us. She had been around cameras long enough to know that what people want is an image of themselves that is acceptable to themselves. "The very process of posing requires a person to step out of himself as if he were an object," she told

Diane revered Weegee, but she herself often vacillated between intimacy and distance, between identifying with and being alienated from her subjects. (Thus, her pictures of hookers and their clients taken in the 1960s and never published are said to be more restricted and harder to look at than Weegee—because they're just the subject and Arbus reflected in the image. When you look at her pictures, you see not only the relaxed self-image produced by the sitter but often the astonishment, terror, and fascination of Diane herself.)

Barbara Brown, another photographer. "He is no longer a self but he is still trying to look like the self he imagines himself to be . . . it's impossible to get out of your skin and into somebody else's, and that's what photography is all about."

After a while she realized that people paid attention to her when she had a camera in her hand; treated her with respect and kept their distance —gave her space. Eventually she wore a camera at all times. "I never take it off," she said.

As she struggled to articulate her sense of style and content and her vision of everybody's terrifying isolation and aloneness, she worked slowly and carefully, collaborating with her subjects. She began by photographing people at a distance, in the context of their environment; much later she shifted to close-up. "She learned from Model that in the isolation of the human figure one can mirror the essential aspects of society," critic Peter Bunnell writes.

Model taught her not to obscure the image. As time went on, Diane's subject matter became specific: "The androgynous, the crippled, the deformed, the dead, the dying, she never looked away, which took courage and independence," Model said.

In the late fifties Diane was working with a 35-mm. camera, so most of her early pictures were marked by an abrupt framing and graininess. "In the beginning," she said later, "I'd be fascinated by what the grain did because it would make a kind of tapestry of all those little dots and everything would be translated into this medium of dots. Skin would be the same as water would be the same as sky and you were dealing mostly in dark and light, not so much flesh and blood." She would come back from a day of shooting and dump off her rolls of film in the darkroom with the Arbuses' new assistant, Richard Marx. Marx developed and printed dozens of Diane's earliest contact sheets: shadowy portraits of little girls— Amy included—enraptured by magic tricks performed in Cheech's apartment. A deserted, eerie Central Park at dusk. Shadowy studies of a teenage retarded boy holding a candle and staring into its flame, hypnotized. Diane would show the contacts and later the enlargements to both Allan and Lisette Model. "There was a tremendous fantasy quality even to her early work," Model said. "There was an immediacy and directness which was positive and objective, but her fantasy feeling about people was subjective."

One day Diane asked if Model could direct her to prisoners who were condemned to die. Another day she asked her teacher, "Do you know any streetwalkers?" And Model replied, "Darling, those women work for a living, too; leave them alone."

Over the months a deep attachment developed between Diane and
Lisette Model. "I've found my teacher!" Diane told Cheech excitedly. And
Bob Meservey notes: "Diane stopped being such a little mouse after she
studied with Model—she got more confidence."

Alex Eliot believes that Model was more than a teacher. "She was a
mentor, a guru. She accepted Diane as she was, without judgment. All
great masters are like that. They look at you and know you are searching."

At that point Diane was photographing only when she could fit it into
her schedule. The Arbus maid had quit, so she was taking care of her
daughters and the apartment fulltime.

Occasionally on a free afternoon she would drop by Model's apartment
—the one on Grove Street, and later the tiny basement off Sheridan
Square. She loved the latter apartment because it was painted entirely
black; she was surrounded by black walls, very little furniture, and no
décor save for a few of Evsa's paintings. A faucet dripped in the back-
ground. And she and Model could be entirely alone in their own universe
without any visual interference, and they could talk and talk until night
fell.

The two women had a lot in common. Both had grown up alternately
spoiled and neglected, and surrounded by luxuries. Being born rich had
given them a subconscious edge, even though they were now struggling
artists, Model with her chipped red nail polish, Diane in her wrinkled
shirtwaist dress. They both behaved like aristocrats.

And they would gossip and argue the hours away, exchanging secrets,
theories, philosophy. Model believed herself to be psychic, clairvoyant—
so sensitive that she would lock her photographs up each night so their
souls wouldn't get at her.

"An extraordinary love" developed between them, "an enormous
friendship." Model was drawn to Diane's tenderness, her fragile quality.
"I think she found me powerful and real. And the respect she had for me!
Whatever happened to me, I knew Diane would be there. She had my love
as few people had."

Years later Diane told *Newsweek*: "Until I studied with Lisette I'd gone
on dreaming photography rather than doing it. Lisette told me to enjoy
myself when I was photographing and I began to, and then I learned from
the work. Lisette taught me that I'd felt guilty about being a woman.
Guilty because I didn't think I could ever understand the mechanics of the
camera. I'd always believed that since painters rendered every line on a
canvas, they experience the image more completely than a photographer.
That had bothered me. Lisette talked to me about how ancient the
camera was and how the light stains the silver coating of the film silver so

memory stains it too." She told Diane she could experience any scene she photographed as fully as a painter painting it. "And Lisette shook up my puritan hang-ups." Photographs that demand admiration have a power to disturb, she said. The best photographs are often subversive, unreasonable, delirious.

By 1958 Diane and Allan had moved again—this time to a triplex in Averell Harriman's townhouse on East 68th Street. Their studio had once been the grand ballroom and was replete with marble floor and ornate fireplaces. Downstairs were the living quarters, including a kitchen and a little garden where the family could eat during the summer. As with all their places, the new Arbus home was sparsely furnished.

Their daughters were growing. Amy was a plump little thing; Doon— quiet, withdrawn—was breathtakingly beautiful and, Jane Eliot says, wonderfully protective toward her little sister. Every morning Diane accompanied Doon to Fifth Avenue and 68th Street, where she caught the bus to the Rudolf Steiner school.

Doon's classmate Jill Isles recalls, "Diane always wore her camera around her neck, rain or shine. She looked bedraggled, but she was cheerful and every day she'd ask me politely, 'And how are you?' and she'd keep us both company until the bus came."

In the afternoon Diane often took Amy to the park, roaming with her across Sheep Meadow and Cherry Hill, around Belvedere Castle and the Glade. She loved the ruined beauty of Bethesda Fountain, the bird sanctuary, and Gapstow Bridge.

Renee Philips, an illustrator of children's books, used to bring her daughter to the park and she would often find Diane wrapped in a blanket, her nose in a book, while Amy played fearlessly on the swings. Renee had never seen such concentration. She was always so worried about her daughter hurting herself she could never concentrate on anything, but Diane just read and read, never looking up. Finally the two women got to talking and Renee asked, "Aren't you ever worried about your daughter? She may fall—skin her knee—something." And Diane said no, she wasn't worried, and besides Amy had to find out about life—she had to learn how to be courageous, how to survive. Diane couldn't teach her that.

With Renee, Diane talked mostly about what she wished for her daughters: "Independence and purity, if that combination is possible." She said

once about growing up: "It's a testing of the thousands of prohibitions that are put in front of you. I mean, can you go out without rubbers? And not catch pneumonia? I mean, I've *done* it! It's terrific to find out you can, and then you don't know what to say to your children about going out without rubbers. You know damn well it doesn't matter, because you know colds don't come from that."

During this period Diane was still going up to Condé Nast periodically, lugging the Arbus portfolio into the *Vogue* or *Glamour* art department, hoping to convince an editor that Allan should be booked for another editorial spread. Ever since they had stopped collaborating in fashion, it was no longer any "fun." It was more difficult to go after jobs alone, and without any of Diane's imaginative suggestions, let alone her companionship, it was now simply a way of paying the rent. He could hardly wait to leave the studio at the end of a sitting and rush off to mime class. He had bought a Vespa and would zoom around the city on it.

His friend Bob Brown kept encouraging him to audition for the theater. Off-Broadway was flourishing—Circle in the Square had given actors like George C. Scott, Jason Robards, and Geraldine Page their "big break." True, Off-Broadway didn't pay—Robards was being paid $25 a week to play Hickey in *The Iceman Cometh*—but Allan should try it before it was too late. He was almost forty—a fact that drove him into a deep depression whenever he thought about it. For a while, to divert himself, he took piano lessons from a young jazz musician, and on an impulse he cut off Doon's hair. "Oh, she is gorgeous," Diane wrote to the Meserveys, who were now in Boston. "Like an available angel." She added that she was terribly behind in photography. "It's almost as if I'll never know how to do it."

But when she did photograph, it intoxicated her. Then she floated in a "sort of weird rarefied air" and she felt "in danger of never coming home . . . it's like being in the ocean when the waves make you feel so strong [you believe you can] swim to Europe . . . there's an illusion involved which could prove its own trap."

Diane and Howard didn't see much of each other during this period. "I think it was hard for her to be so cut off from her brother," Peggy Nemerov says. "We'd keep on inviting Diane and Allan up to Bennington to see our garden, but they never came."

Howard, meanwhile, was resigned to academia. "A fairly agreeable way to make a dollar," he would say; "a perfect place to hide out." Between his classes he could write, dream, play the piano to his heart's

content. He and Stanley Edgar Hyman helped build a strong literature department, inviting novelists like Barnard Malamud to teach.

When his work wasn't going well, Howard still suffered from acute depressions which he could sometimes talk himself out of during long strolls with Malamud across the Vermont hills. Malamud would usually begin the conversation, often completing a veritable monologue before Howard would abruptly respond. Then he would describe his nightmares, his dreams. He would tell Malamud about his sister Diane ("They were obviously very close," Malamud says); he would describe her ghostly photographs, her sly way with words.

In his novel *Federigo, or the Power of Love* he had drawn from Diane and Allan's fashion world and had characterized some of the people he'd met through them—sex-obsessed couples who were having affairs without conviction. He imagined his sister and brother-in-law leading a fabled, bittersweet existence—"modern—chic—the kind I imagined Daddy lived, in a way. Diane and Allan made so much more money than I did, and I envied their money and what I thought was their glamorous life style."

Diane, for her part, envied her brother's literary versatility, his growing reputation. She still scribbled in a journal, still had fantasies of herself as a writer. In fact, some years later when she published her first photographs in *Bazaar* accompanied by her own text, she described herself as a "writer/photographer."

She was pleased when Howard won the Kenyon Review Fellowship in fiction, and when his third book of poetry, *The Salt Garden*, was published to uniformly excellent reviews. These poems, about man's divided nature and the workings of the human mind, are filled with images of reflecting mirrors, cameras, and the inside of dreams. The *New York Times* called *The Salt Garden* "important and beautiful."

Howard hoped he would capture some of the major prizes, but Wallace Stevens' *Complete Poems* won the Pulitzer. He tried not to be bitter, but he was. He yearned for applause, for more recognition. He felt he was being overlooked, ignored, because he wasn't writing in the present mold. He no longer measured himself against Auden or T. S. Eliot—Blake and Robert Frost were his guides, and while he still valued irony, he now regarded simplicity as the most vital element in a poem. He continued to work slowly and carefully and often drank far into the night. In Howard's world—the world of John Berryman, Delmore Schwartz, William Carlos Williams—the failure to obtain money, let alone recognition, was almost intolerable.

Occasionally Howard would read his poetry at seminars and colleges around the country, and this gave him some feedback. He enjoyed the fuss

that was made over him—admirers holding out his books for him to autograph. Elbert Lenrow remembers going to a reading at the 92nd Street "Y" in New York and afterward a line of people stretched down the aisle toward the stage, where Howard stood graciously greeting everyone. And Diane was there, too, watching silently nearby. Except for these readings, Howard did not travel much. He would always return as quickly as possible to Bennington after any public appearance—home to Peggy and his sons. He saw Diane and his parents infrequently. He assumes his father was aware of his published novels and poetry, but "he never made comments about anything I did, possibly because I'd made no money from my writing."

As usual, David Nemerov was busy with another new Russeks—this one opened at the Savoy-Plaza Hotel in 1955. Nemerov had always wanted to be in this area: "You get the out-of-town tourists and the rich New Yorkers," he said at one of the Friday-night dinners. He loved the elegance of 57th and Fifth—the presence and competition of Bonwit, Bergdorf, Bendel, and Jay Thorpe. The new Russeks was furnished with French antique furniture, dark blue walls; the outside was tinted concrete.

Russeks Fifth Avenue, the flagship store, was still operating, but at a $120 million deficit. The Russeks empire (stores in Chicago, Brooklyn, Cross Island Shopping Center) had been bought by a group of Chicago investors, among them the Pritzcy brothers, who maintained that they were going to modernize and expand. They owned controlling stock, but Nemerov remained chairman of the board.

Diane frequently dropped by the Fifth Avenue Russeks to visit her father. She often brought her daughters along and the three of them would remain in Nemerov's office until conversation lagged or he was called away. Then they might ride up and down the elevators, stopping at various floors to try on the latest sweaters or blouses or shoes, but Diane would quickly tire of shopping (it reminded her of the hours she'd spent shopping with her mother when every purchase became a drama), so she would hustle her daughters home and cook supper—usually chili. It was so often chili, in fact, that Allan would groan, "Oh, no! Not chili again!" every time the dish appeared on the table. Diane no longer wanted to spend time in the kitchen, so she usually served her family "poor food" (her term)—Spam, hot dogs, and spaghetti didn't take long to fix. However, when they had guests, she would broil a chicken or prepare a vegetable stew. "She could be a terrific cook when she felt like it," Tina Fredericks says. Tina would come to the Sunday-night suppers at the Arbuses' which had become almost a ritual for special friends in the mid-fifties—friends like the Eliots, like Cheech, like a new friend, the actor Robert Brown, "who was so handsome you'd gasp when you saw him,"

says actress Tammy Grimes, a friend of Brown's who would occasionally accompany him to the Arbuses' along with her then husband, Christopher Plummer.

Brown was then going out with an ethereal-looking nineteen-year-old actress named Sybille Pearson (who is now an award-winning playwright). Sybille has never forgotten those suppers. "They seemed glamorous and folksy at the same time." Beautiful glassware glittered on the pink marble table. A huge green tree stood in one corner of the high-ceilinged room, and photographic equipment—lights, camera—was propped in another. Amy and Doon would be padding around in their bathrobes trying to attract everybody's attention while Allan put another Benny Goodman record on the phonograph. He didn't say much, so Bob Brown talked—mainly to Diane—about the Off-Broadway shows he'd been appearing in. They seemed to have great rapport.

Sybille couldn't stop looking at Diane's tawny skin, at the thick blonde down on her upper lip. Her buttocks moved back and forth, undulating under the loose folds of her skirt as she walked barefoot across the room to fuss over her two daughters—tenderly smoothing their hair, buttoning their nightgowns.

"She was so sensuous! A mystery mother. I wanted her to be my mother and love *me*," Sybille says.

After the children went off to bed, Diane turned her attention to Sybille, directing gentle questions at her until she almost forgot her shyness. "She related to my sullenness—my insecurity. She accepted me as a person with an identity; she treated me like an adult."

Diane adored the story Bob Brown kept telling about how Sybille had auditioned for Arthur Miller and his play *A View from the Bridge*. She'd gotten the part, but she'd been so terrified, so sure she'd been awful, that she'd run out of the theater as soon as the audition was over without giving the stage manager her name or her phone number, so nobody could find her to tell her she had won the role. The producer, Kermit Bloomgarden, searched for weeks trying to track her down and finally had to cast another ingenue. Diane thought that was a marvelous story.

Sybille says, "I always felt wanted and loved and accepted by the Arbs." One Sunday she got the flu and phoned to say that she couldn't make supper. Within hours a present was hand-delivered to her apartment. It was a gift from Diane, beautifully wrapped, with a little note: "I hope you feel better." Inside a box was a paperback of *The Wanderer* by Alain-Fournier and a packet of mouches. "You know, those little stars and half-moons you stick on your cheek? The gift was so special—so Diane. I was very much moved. I still have those mouches."

Diane loved giving presents. She gave Cheech a warped green glass

bottle she'd found washed up from the sea (Cheech has it still on her fire escape); she gave Cheech a lovely copper lampshade, a string of fat brown wooden beads. Once she lugged a heart-shaped waffle iron out on the train to East Hampton for Tina Fredericks' birthday, and Yamashiro recalls receiving a globe of the world with a ticket to Haiti attached when he was about to go out on his own as a photographer. The film-maker Emile de Antonio remembers receiving a book from Diane called *Flatland*, "which was a geometric study of the universe told in the form of a fable. I tried to read the thing and I thought, 'What the hell does Diane mean by this?' Because everything Diane did seemed to have meaning."

Although they are invariably linked, Diane never admitted to being influenced by the photographer Robert Frank. Indeed, her very formal portraits of eccentrics and extremes, taken with the primitive frontality of an old-fashioned daguerreotype, bear no resemblance to Frank's abstract, powerful set pieces of Midwestern highways and bleak automobile graveyards. But in the beginning Diane did copy his abrupt framing process before going on to a more elaborate one. And she often referred to Frank's ironic pictures in his book *The Americans* as a major turning point in documentary photography.

Frank and his sculptor wife, Mary, were part of a loosely knit artistic community that by the late 1950s was flourishing throughout Greenwich Village and the Lower East Side. Diane had become acquainted with some of the group through her friendship with the art dealer Richard Bellamy. He knew everybody, it seemed: de Kooning, sculptor Bill Smith, poet Allen Ginsberg, painter Alice Neel, novelist William Burroughs, and the exceedingly handsome young couple Miles and Barbara Forst (both Abstract Expressionists), who gave wild parties where much pot was consumed. (This was still considered quite daring.)

Cheech thinks Diane and Robert Frank had their first extended conversation at a dinner party she gave in Spanish Harlem in the mid-fifties, at which the Forsts and Richard Bellamy were also present. "It was a rather uncomfortable evening because everyone there was shy and withdrawn. Robert had his usual stubble of beard and was his usual cagy, surly, Swiss-German self, and Diane grew even more tongue-tied in his presence as the evening wore on."

The Franks were often described as a "pagan couple," madly in love and so poor they frequently existed on a diet of bananas and Coca-Cola. Their children, Pablo and Andrea, ran wild. One of them had recently been hit by a car.

Mary was trying to sculpt massive wooden forms in her badly lit studio on the bottom floor of the Franks' 10th Street two-story loft. Walker Evans

told his wife he hated to pass through Mary's section of the loft because he could sense her frustration at being so poor, at being so hampered by her kids. "Mary wasn't allowed to be an artist in those days," a friend says. "*Everything* had to focus on Robert. And Robert had a Norman Mailer complex. *Powerful desires.*"

When they were first married (Mary had been just sixteen), they had lived in Paris, where Robert photographed in the streets, using a hand-held camera like his mentor, Henri Cartier-Bresson. Frank's early pictures were blurred, grainy, and so full of movement it seemed as if he were rushing to capture everything in his lens: a couple lounging by a jukebox, limousines gliding through the rain. The images scarcely seemed composed at all.

In 1947 the Franks came to New York and Frank began photographing for *Fortune, Life, Harper's Bazaar.* The pay was terrible ($50 a picture), so for a period he supported his family by creating a long series of award-winning *cinéma vérité* ads extolling the virtues of New York City for the *New York Times.* Louis Faurer, who shared Frank's darkroom from 1947 to 1951, writes: "Bob kept saying 'Whatta town! whatta town!'" (Faurer was then the quintessential street photographer, chronicling—almost feverishly—raw Manhattan faces and places with complete indifference to traditional composition. Frank was obviously influenced by Faurer's photojournalistic portraiture. Both men loved to salvage negatives made in hopelessly dim situations and produce eloquent, grainy prints.)

Louis Silverstein, who was Frank's art director at the *New York Times,* says, "Robert was one of the most innovative photographers I've ever worked with. Technically masterful, but everything he did seemed spontaneous. He'd 'direct' the ads as if they were little novels. Cast faces and locations like the Staten Island Ferry or the Fifth Avenue double-decker bus. His response to the world was so direct it was very pure. But there was always a suggested tension in his photographs between style and subject, because he never stopped exploring the photographic form. Which made his images more complex."

Looking at him, it seemed hard to believe that Frank had got his start as a fashion photographer for *Harper's Bazaar.* He and his family lived with nine cats in a grungy loft, and when he came to the *Times* he would be wearing the most tattered jacket imaginable—the lining would be hanging out and he would deliver his pictures in a filthy manila envelope.

"That's the way Robert was," Silverstein says. "It was no affectation. He seemed suspicious of any institution and certainly the Establishment of journalism—the Academe. But he was fascinated by America—by its energy and diversity. He was determined to explore America, and he did."

Accompanied by Jack Kerouac, Frank first went traveling across Amer-

ica on assignment for *Life*. But his pictures of the country were turned down "because they looked too much like Russia." Then in 1956 Frank won a Guggenheim and spent the following year driving around the country again with Mary and their kids in a rattletrap car. Using Walker Evans' Depression portraits as a guide, Frank photographed a series of eccentrically framed chiaroscuro images of desolate highways, cemeteries, parked cars, glaring TV sets, jukeboxes, sullen faces that eschewed Evans' classicism for something far more fugitive and ephemeral; his pictures reflected both the ironic complacency of the 1950s and their undercurrent of despair.

"I shot and developed rolls of film in about three different places and made contact sheets—fifty contact sheets in New York, fifty in the South, fifty in California," Robert Frank told Walker Evans during a photography seminar at Yale in 1971. "I looked at them when I printed them, but I didn't choose any photographs. I just looked at them and saw they were recurring images like the jukebox or the cars or the flag, and so it got bigger and I turned back again and took another trip to Detroit. Then I came back to New York and I enlarged all the pictures I liked, maybe two hundred of them, put them up on the wall and then eliminated the ones I didn't like. Then I put them together in three sections and I started each section with the American flag and each section with no people and then people."

Familiar now, Frank's wild freely framed iconography was so radical in 1956 that he couldn't get anyone interested in the work (which he called *The Americans*) until he got a friend to publish it in France in 1958. Grove published a U.S. edition in 1959; it slowly became a kind of underground classic. The introduction by Kerouac began: "To Robert Frank. You got eyes." Indeed Frank's personal documentary style along with a poetic vision full of narrative soon revolutionized photography.

A 35-mm. camera and wide-angle lens helped him create a complex new candid style that was "both situational and contextual . . ." one image played against another. Frank influenced scores of younger photographers including Diane, Garry Winogrand, Lee Friedlander, Bruce Davidson, Danny Lyon, and Arthur Freed, and they began in their own ways to explore the strange, threatening, hidden America Frank was discovering. Some of them made similar crosscountry pilgrimages to do so.

Frank always worked out of deep depression and he photographed *The Americans* in a depressive state. When it was done, friends say he was emotionally exhausted. He completed one more essay called "Bus Series" (pictures taken on a bus moving across West 42nd Street) and he would periodically take on assignments for *Bazaar* and later *Show* magazine. But he kept saying he was sick of "stalking, observing, then turning away with

my camera." He didn't want to repeat himself. In 1958 he began making documentary films.

When Diane and Allan got to know him, he was in the midst of shooting *Pull My Daisy* in collaboration with the Abstract Expressionist Alfred Leslie and Jack Kerouac. There were constant fights about whose film it was, but everybody agreed the focus would be on the sights and sounds of the Beat Generation. The setting was Frank's shabby loft on East 10th Street, and it begins with Kerouac and poet Allen Ginsberg wandering around and ad-libbing about bop, Groucho Marx, and Buddhism. Other characters join them—Larry Rivers and Alice Neel. Richard Bellamy plays a bishop who preaches to the bums on the Bowery; Delphine Seyrig floats through, flapping an American flag; composer David Amram plays himself. Allan Arbus and Mary Frank have bit parts. Nothing much happens. There is a lot of coughing and scatting—Anita Ellis sings "The Crazy Daisy"—and one gets a sense of a group of sweet, funny people who are innocently self-aggrandizing.

Walter Gutman put up $12,000 to finance the project, which is now considered a documentary classic. He also bought Mary Frank a fur coat. Gutman, a Wall Street broker, wrote an offbeat newsletter about the stock market with advice like "Buy a Rothko now."

(After *Pull My Daisy* was completed, Frank made eight more movies, including *OK* with Susan Graham before she married Charlie Mingus; *Me and My Brother* about Peter Orlovsky's catatonic sibling; and the infamous, raunchy *Cocksucker Blues* about a Rolling Stones tour across America, which tells much about the side effects of power, boredom, and isolation on rock-and-roll superstars.)

By 1958 Frank found himself positioned near the frantic intersection of the art world and the counter-culture. Around him his friends were discovering Hinduism, experimenting with mind-expanding drugs like LSD and mescaline; everybody suffered from violent hangovers. "It was an insane time," Frank said. New York painters had suddenly achieved a liberating self-awareness by moving away from the suffocating Paris-based aesthetics. Jackson Pollock, Helen Frankenthaler, Mark Rothko, Clyfford Still, Franz Kline, were becoming big names. Frank knew these artists, and others just starting out—like George Segal, who was painting Impressionistic abstractions, and Myron Stout, who composed hard-edged canvases in black and white—and Richard Bellamy gave them shows at the Hansa, now located in a walk-up gallery facing Central Park.

"It was insane," Frank repeated. "Insane." De Kooning spent an entire year on a single canvas, painting it over and over again because he didn't think it was working. Kline sketched drawings across the pages of tele-

phone books, and Elaine de Kooning tore sports photographs from newspapers in order to study their "abstract compositions."

"I learned a lot from these people," Frank said. "They had a lot to do with my development." (In *The Americans* he demonstrated how he could snap images in the energetic, responsive spirit of the Abstract Expressionists, but without any painterly effects.)

With Frank and his friends, the subject of money was avoided. (To pay the rent, everybody took odd jobs—at the post office, in restaurants, at department stores.) Publicity among artists was never an issue—in the 1950s the press was indifferent to the art world anyway; Jackson Pollock's spread in *Life* magazine had been a fluke. As yet, the galleries hadn't turned exploitative or commercial. "We were a scruffy, excitable lot," says painter Buffie Johnson, who "floated through the group" from 1950 on. "It was us against the world."

Even though the Franks never had any money, there was always food on their long artist's table—quiche, fresh raspberries, pickled watermelon with ginger. And sometimes Mary Frank and Barbara Forst would give joint parties at the loft, to which Diane and Allan might come, spectacular parties for which they would cover the walls with rolls of white photographic paper and then paint jungles of huge flowering trees and beasts and birds and exploding stars. An entire world would be created, and then the neighbors—like de Kooning and Milt Resnick—and other painters and photographers would crowd into the loft to dance and drink and smoke till dawn.

Theirs was a frantic, tortured community bursting with vitality and gossip and sexual experimentation. "Everybody was in everybody else's pocket," the dancer Sondra Lee says. "There was rivalry, yes—egos were gargantuan and there was a lot of competition—but the struggle was private and not corrupted by media."

In those days, the graphics designer Loring Eutemay says, "It didn't matter if you were a good Abstract Expressionist—what really mattered was, could you play the bongos well? Could you dance all night? We danced constantly in those days—incessantly. God, it was fun."

The painter Marvin Israel would hire a van and everybody would pile in and go up to the Hotel Diplomat in Harlem—"everybody" meaning Marvin and Margie Israel, Anita and Jordan Steckel, Diane and Allan Arbus, Robert and Mary Frank, Miriam and Tomi Ungerer, and lawyer Jay Gold. "Mary was the greatest dancer of all," Eutemay goes on. "She'd studied with Martha Graham, and she had a magnificent body, and she could dance and dance and dance, sometimes all by herself."

Often Robert Frank stood on the sidelines with Diane and they both observed the action on the dance floor. Diane yearned to dance, too, but believed she could not.

As she became more committed to photography, Diane moved deeper into downtown bohemia. But nobody ever thought of her as a particularly visible or articulate member. "She began appearing at places; eventually she was just *there*, a presence," says Rosalyn Drexler, who remembers her as a gentle, passive creature who could be open and friendly one minute and remotely mysterious the next.

Sometimes when Allan was at mime class in the evening, Bob Brown might take Diane to the Cedar Bar on University Place, where they might sit with the sculptor Sidney Simon or the watercolorist Paul Resika. "Diane never drank, but she had a way of listening which drew people to her like flies to honey," Resika says.

Diane also belonged to another group—of spectacularly talented women who were still for the most part "underground." Among them: Mary Frank, Anita Steckel, Rosalyn Drexler (who wrote hilarious, far-out plays and novels, who painted and was also a wrestler). Then there were film-maker Shirley Clarke and the novelist Pati Hill (who was usually in Paris, but remained very close to Diane). None of them had come into her own yet, but you assumed they would, they were so restless and ambitious.

In another league entirely was the chain-smoking Maya Deren. Deren —voluptuous, hyperenergetic, always broke—is today recognized as a major figure in American avant-garde film. Even in the fifties she was regarded as someone special. She taught, lectured, and wrote, directed, and produced a series of films, among them the classic surrealistic *Meshes in the Afternoon* and *Rituals in Transfigured Time*, which shows the passage of woman from bride to widow. In both Deren herself played the protagonist. Cheech had begun to work with Deren and worshipped her as she worshipped Diane.

In the summer of 1958 the Franks and the Arbuses rented houses near each other in Truro on Cape Cod, and Mary began drawing prodigiously: the curve of the beach, the line of the ocean. The light on the Cape was clear, shimmering, pierced with deep shadows. Diane photographed a lot that summer—most memorably her younger daughter, Amy, in a flannel nightie just before taking her afternoon nap. That eloquent photograph was later published in *Harper's Bazaar* and then in the Time-Life book on

Children in Photography, which commented: "Amy stands tiny, indomitable, against a background of storm-tossed clouds. She appears to have all the charged emotion of a 19th Century romantic."

Near the end of the summer Mary Frank sketched some of her dreams. (Later a critic likened her sculptures to "pieces of dreams—part memory, part desire.") She and Diane had become good friends; among other things they shared was a strong belief in dream images.

Back in New York that fall, the Forsts, the Arbuses, the Franks, and several other couples continued to see one another: in the Village, at screenings of underground movies, at Happenings—the rage of the late fifties. Between the couples, except for Diane and Allan, the unspoken competition was "ferocious," Barbara Forst says. "The men in our group sensed that the women were as talented as they were—in some cases maybe more so. Certainly we were different, and they were threatened by that and by our productivity, and they demeaned us and made us feel insecure. We were like handmaidens to our men—mothering, accommodating, putting off and in some cases putting down our own work—sometimes hiding or destroying it."

Whenever the women met for coffee, five or six of them, they would tell anecdotes about the men in their lives—their husbands, lovers, casual pick-ups, old boyfriends. None of the women was a feminist—certainly Diane wasn't; they never used that word. "We were just female, so basically we mistrusted each other," Barbara Forst continues, and they tried to woo and keep their men in the old ways, and tried to ignore their incompatible longings, their lacerating fights. Anger rather than tenderness seemed to be the chief means of communication between each couple —again with the exception of Diane and Allan, who didn't seem angry at each other so much as "cut off from each other and traveling on different wavelengths." "Everybody was screwing everybody else compulsively," Forst recalls. "We all thought, Diane included, that sex was very important; that our bodies were a source of power—maybe our *only* source of power." So the women talked of yearning to be "turned inside out—to feel naked, exposed, crushed, destroyed, and yet still remain alive." None of them believed that all this infidelity would break up their marriages (although indeed most of their marriages broke up).

Most of these marriages were in chaos because of drugs or drink or some terrible disappointment. Most of the women still believed that being wives and mothers would be their salvation, their ultimate destiny, "so we were not sustained by our work. We were shy about talking about our work to each other," Barbara Forst says. "We did not think our work was that important."

Diane certainly believed hers wasn't. She constantly vacillated about

her photography—how could she ever make a living as a street photographer? Who would want her pictures of a tattooed lady? How could she pitch a story about a female bum to one of her chic editor friends on Madison Avenue? Nevertheless, she was bursting with ideas. She once walked from Eighth Street to the Upper East Side with Paul Resika, telling him of her dream to photograph "the great losers of the world—Adlai Stevenson, Robert Oppenheimer, Khrushchev," and then she murmured, "If only Hitler were alive, I'd photograph him—he was the greatest loser of them all."

If Diane loved anyone unreservedly, it was her daughter Doon. She spoiled her, catered to her, marveled at her beauty, her quirky turn of mind, her disconcerting behavior. (Once while the apartment was being painted Doon wrote succinct directions across her bedroom walls, explaining to the painters the exact colors she wanted used.) So when at the age of twelve Doon got a crush on Tony Perkins, Diane did nothing to discourage her.

Subsequently Doon discovered where Tony Perkins lived in New York and every day after school she would go to his house on West 55th Street and stand outside, looking up into his windows, hoping to see him. She returned to West 55th Street day after day, month after month. Helen Merrill, a friend of Perkins' who lived in his house, began noticing "this exquisite golden-haired creature" staring up at her from the street. "Tony had a number of fans who camped outside his door—but never for this long, this doggedly, and this girl was so particular in her intensity and her beauty that I really wondered about her," Mrs. Merrill goes on. Finally, Perkins went out on the street himself to ask her name, but Doon wouldn't tell him. He persisted until she blurted out, "Both my parents are photographers."

Perkins gave her money for a cab and told her gently to go home, which she did. Meanwhile Mrs. Merrill, who had been a photographer herself, put two and two together and phoned Diane and Allan Arbus. "Do you know where your daughter goes every day after school?" she demanded, and Diane replied, "Oh, yes, of course we know, and we think it's fine— we trust her completely."

Diane remembered how as a girl she'd wandered the streets with her friend Phyllis Carton, but they'd never been as adventurous as Doon. "Doon is far braver than I was as a teen-ager," Diane said.

So Doon was allowed to continue standing outside Tony Perkins' building until finally Mrs. Merrill and Perkins came up with a solution: if Doon would stop standing outside every day, she would be invited for brunch

on Sunday morning. Doon agreed, and soon she began drifting by most Sundays for brunch, and on other days as well. "She was so bright and funny and lovely—she was impossible not to like. Tony and I adored her," Mrs. Merrill says.

Perkins was then starring in *Look Homeward, Angel* on Broadway, and it was an exciting and busy time for him. Doon got caught up in it. Through Perkins she met Michael Smith, an Off-Broadway playwright, and later she worked on two of Smith's productions at Café Cino. Throughout most of her adolescence Doon spent much of her free time at the Perkins house, and Diane and Allan allowed her to do so although they were undoubtedly aware that there was something unsettling in their own lives that she was wishing to avoid.

Allan had begun to get concerned before every fashion shooting, his assistant Richard Marx remembers. He was a perfectionist and he was sure his photographic perceptions were failing since he no longer had any interest in what he was doing. Shooting a *Seventeen* magazine cover, for instance, had become sheer hell for him. And there was no place to hide. A painter has a million ways of putting one color next to another; he can hide behind the richness of the painting process. But not the photographer. And in fashion photography there were so many elements to worry about: the lights might go; the film might not have been put in the camera correctly; the clothes might look lousy; the models could turn temperamental. Nor was Diane around anymore to smooth things out; to pull a sitting together. And when she did observe, she was often critical. As her own work grew more harshly realistic, she often found Allan's images too one-dimensional and idealized. Her criticism (although asked for) could be devastating. "By the end of a session he would be snapping at me," Marx recalls, and he would remain snappish through dinner, telling Diane and his daughters that he was in despair and could feel and express nothing. After dinner he would escape to his room, and the clarinet-playing grew so excessive that little Amy would shut the door to her room and refuse to come out. Scales and scales for hours, Diane told Cheech; she said she didn't know how much longer she could stand it.

Everything seemed to be going wrong. Their apartment, so beautiful and serene on the surface, wasn't working. They couldn't utilize the space —it didn't look lived in. Diane would murmur wistfully, "If only we had more furniture . . ." They still tried to entertain, but "the dinners fizzled —there was no spark," Alex Eliot says. They now knew a great many people, but they had few close friends. They still saw a great deal of the Eliots, but usually alone. "It didn't seem to work when we invited other people."

Alex had just completed a huge work for Time-Life Books, *Three*

Hundred Years of American Painting, which received an excellent review in the *Times* ("remarkable—contagiously enthusiastic about art and artists") and sold very well. Alex was pleased, but he was now considering leaving Time Inc. "I'd been there fifteen years; I was safe and secure and earning good money, and so what?" He took a leave of absence for a year in 1957, and he and Jane lived in Spain. Then he came back to *Time*, but only briefly. "By now our offices were in a new skyscraper on Sixth Avenue with sealed-shut windows. We began breathing stale air and feeling lousy. One editor got so bugged he kicked open his window, and within seconds someone from maintenance had sealed it up with a new pane of glass."

Finally, on assignment in Delphi, Alex had a dream "which clinched it for me." In his dream a voice cried out, "Alex, what will you do when there are no more museums?" And he woke up realizing that for years he'd been reporting on art, absorbed with art, but not living much of a life; he'd been waiting for significance, waiting for epiphanies. "I wanted to live life more deeply before I died." He applied for a Guggenheim to study the sacred places of the Mediterranean, the Middle East, and the Far East, and when he received the grant he and Jane and their two children set out to explore Greece and Italy and ultimately Japan.

One evening, just before the Eliots left for Greece, Alex arranged for Benny Goodman to come to the Arbus studio for a midnight drink. Allan was overjoyed, since Goodman was his idol; he'd been trying to emulate his musical style for over twenty years. Coffee and brandy were served; there was some conversation and then Goodman borrowed Allan's clarinet and began to play. He was only going to play a few numbers, but he ended up "blowing until the early hours—gorgeous, marvelous stuff," while Allan sat there very still.

Diane was starting to develop and print some of her most recent pictures in John Stewart's East Side darkroom. (Stewart, an English cosmopolite and memorable *Vogue* still-life photographer, lent Diane his studio whenever he traveled.) It was another small step toward independence, moving through a strange borrowed space—turning on lights, coming upon an unrecognizable chair, pillow, or dish. And then she would labor over her contacts in the darkroom, trying to decipher which were the most dramatic stances, the most peculiar evocative expressions, expressions that were at once familiar and strange.

Allan meanwhile had enrolled in Mira Rostova's acting class and he started doing scenes from Chekhov's *Uncle Vanya*. At first, he seemed constricted with emotion as he stood on the stage, and he would hide behind his rich, mellifluous voice. He was ten to fifteen years older than most of

the other students, so he was self-conscious and refused to go out with them afterward. But in time he did, and then everybody treated him with great deference because he was a well-known photographer. He kept insisting that he hated photography and wasn't much good at it; his wife, Diane, was much better, he said.

Gradually Allan got more caught up with acting; the classes with Rostova were stimulating, and he made friends with a few of the students and listened to them talk about auditions, rehearsals, the electric performances of the moment—Colleen Dewhurst and George C. Scott in *Children of Darkness*. Such talk only dramatized the fact that he loved show business, make-believe, the theater, more than anything else. He had to be an actor! he kept repeating.

He and Diane would go over and over again the pros and cons of his quitting fashion photography once and for all. But it was the same old problem: how could he support the family? Most of the actors he knew lived on unemployment insurance. He was afraid to take that chance— he couldn't bear to be without money—and Diane could do nothing to help since she was earning almost no money at all. Whenever she took her portfolio to a magazine, she would be dismissed. No art director warmed to her images of sideshows or "headless" men. Her close-ups of children—usually giggling hysterically, their bodies distorted by a kind of curious foreshortening—were like El Greco paintings. It upset her that she couldn't contribute to household expenses and she felt even more helpless when she confided to Lisette Model that on top of everything else she and Allan seemed to be growing apart. It was happening to several of her friends—working women like herself who had also been "child brides," had had babies in their teens, and now some twenty years later suddenly found they had very little in common with their husbands.

And yet in spite of this Diane was determined to stay married. Allan was decent, good, supportive, and he had helped to create a comfortable, well-run little nest for their family.

But nothing seemed right anymore. The days and evenings seemed bleak. They were starting to have little to say to each other, and Allan became, as time went on, increasingly unreachable.

He continued to seem miserable until he started rehearsing a scene for class with a young actress. They worked so well together he couldn't stop talking about the experience, and Diane grew uneasy, but she didn't show it; she behaved very politely even when the young actress visited their studio.

Weeks went by. Allan seemed happier. He had always worn his hair

slicked back, but now he began to wear it wild and curly around his head. The young actress had told him how terrific it looked.

This upset Diane. She confided to a friend she thought Allan might be falling in love. Days passed. Allan said or did nothing out of the ordinary —he just seemed happy now and Diane felt increasingly betrayed. Her identity seemed to evaporate. A possible sexual involvement didn't bother her—at issue were her emotions. She couldn't believe he would fall in love with someone else—that it was possible for him to fall in love with somebody new. Eventually she phoned Cheech terribly distraught and asked to see her right away.

Cheech says, "I told her to meet me at the Baths on Monroe Street. The walls were blistered from decades of steam, the place was dank—water dripping everywhere; the boards were rotting from so much water. I remember that the carpet was soaking wet and the flowered patterns had faded from so much extreme moisture. We sat fully clothed in the steam on the stairs and there were elderly Jewish women surrounding us—wrinkled old crones with hanging boobs and stringy hair wrapped in sheets, murmuring to each other while Diane poured her heart out to me, rocking back and forth."

She cried with great moans and sighs, tears streaming down her face. She had believed in their love, she cried, in their deep attachment—she believed that love between a man and a woman was the significant and all-encompassing experience and should be treasured. She had loved Allan since she was fourteen—loved him, revered him, trusted him, depended on him. Her own infidelities were unimportant—she had never loved these men or said she loved them! But she was sure Allan had fallen in love with another woman, head over heels, and she could not accept it. He was withdrawing his love from her, and that withdrawal was so powerful it was crushing the potential in her for feeling. "I am going to be numbed!" she cried. Finally she said, "I can't talk about it anymore!" And then, idiotically, "I'm going to take pictures!" With that, she took out her camera and began snapping away at the women lolling around in their sheets in the cloudy steam.

Cheech told her not to—it wasn't proper, it wasn't the time—but she kept on photographing—click! click! click!—as if her life depended on it. The women seated on the steps told her to stop, but she wouldn't. Instead, she crept around and squatted close as if she were trying to kill them with her camera. And suddenly en masse these old women rose up in their sheets screaming and began to attack her. They tore her camera away from her and tossed it into a bucket of water and "We were thrown out on the street by the management," Cheech says.

"Suddenly it was insanely funny. We came out into the day and collapsed into a cab, and although Diane's face was ugly and strained—her skin ashen—we laughed hysterically, uncontrollably, all the way back to East 68th Street. When we reached the studio, we were still laughing and Allan greeted us at the door and we kept laughing at him and he kept asking, 'What is going on between you two? What in God's name is so funny?' "

PART THREE

THE DARK WORLD

For a while Diane and Allan continued to live together; they didn't want to break up the family unit and they wanted to be civilized about everything. There would always be a residual affection and respect between them. "They were gently estranged," Robert Meservey commented.

In time they moved from the triplex down to Greenwich Village and opened a new photography studio in the mammoth parlor floor of a reconverted townhouse at 71 Washington Place. Ali MacGraw lived on the second floor; the *New Yorker* cartoonist Opi and his wife were on the third; and Off-Broadway director Jess Kummel, who committed suicide shortly after the Arbuses moved into the building, had the penthouse. (Kummel had been directing workshops at the Theatre de Lys when he found out he was going deaf and became unrelievedly despondent. Shortly before he killed himself, he pasted a *Variety* headline above his kitchen door: "LAST YEAR IT WAS GREAT.")

Diane never felt settled at Washington Place. Tina Fredericks came to lunch there once and the two women sat on the floor and ate from picnic baskets. "It wasn't very homy," Tina says. Allan had his Vespa parked in a corner.

Eventually Allan sublet the mezzanine of the studio to Arthur Unger, who ran his Young World Press from that space for the next eight years. "Allan said he didn't need so much room; I think he also needed the extra rent. He didn't seem to be doing much fashion business." Unger remembers a succession of very attractive women going in and out of the Arbus studio who seemed particularly at home there. Diane, on the contrary, did not.

Unger often ran into her early in the morning when he was coming back from the newsstand with the *Times*. Diane would be leaving the studio, usually dressed in her ratty fur coat. "She looked to me like an average college student. And she always seemed acutely embarrassed at being discovered coming out of the Arbus studio, even though as Allan's wife she presumably belonged there."

Subsequently, Diane and her daughters moved again, to a little converted stable at 121½ Charles Street, in back of the 6th Precinct police station. Diane gave the girls the upstairs bedrooms; she slept in the living room, putting up a screen next to her couch to give her some privacy, although it kept toppling over. (In time she covered the screen with some favorite images: her latest contact prints, postcards, a portrait of a woman with elephantiasis.) Allan helped with the move, even scraping and painting the floor, but he stayed more and more at Washington Place. In the evenings he let his acting teacher, Mira Rostova, use his studio for her classes—he was getting more involved with Off-Broadway theater and with mime, and began appearing in plays at the Café Cino. "He dreamed of being a movie star," Emile de Antonio says.

Ted Schwartz recalls seeing Diane backstage after one of Allan's performances—"I think she was wearing a tuxedo"—and she took photographs of Allan in a production of Chekhov's *The Cherry Orchard*. ("He was really good," says another member of the cast.)

Diane and Allan still entertained together sporadically, but there was a distance between them; their marriage was crumbling. Emile de Antonio remembers one party at which Diane was surrounded by Esta Leslie (now Mrs. Hilton Kramer), Tina Fredericks, Cheech, and Maya Deren. The women all treated her with fierce maternal tenderness as if they could sense what she was going through.

She appeared ambivalent about her situation with Allan. By now she knew they would have to separate eventually, but she couldn't face that inevitability. They agreed to remain partners in photography (the Diane and Allan Arbus studio didn't close until 1969). Throughout their difficulties they remained as close as brother and sister—as twins. And in some ways they still resembled twins—they had the same mournful, watchful expression in their round, dark eyes. They had lived like twins for so long; it had been their way of surviving.

Now their attitude toward each other and toward their lost love was one of nostalgia, of looking back into their teens when they'd met and been so passionate. And they still shared their collaboration, their perceptions, as they had for over twenty years of struggle to achieve something artistic and original. But only one twin was the real artist, as Allan was the first to admit. "Diane is the more talented," he would repeat over and over. Obviously he meant it; he was proud of her talent and encouraged and nurtured it. And Diane knew how necessary Allan's sympathetic, intelligent presence had been to her all those years. She wanted to go on sharing and discovering with him, and she went on trying to until she died.

. . .

Diane did not tell her parents, so her mother had no idea the marriage was in trouble. "I thought Diane and Allan would always be together," Gertrude Nemerov says. "They seemed to care about each other so much." Meanwhile the Nemerovs had made some major readjustments of their own. In 1957 David Nemerov retired as president of Russeks* and sold some of his stock. After auctioning off most of their antiques, he and Gertrude moved to Florida and the penthouse of the Palm Beach Towers, where David began painting fulltime—mostly vivid flower studies, but also paintings of Central Park, the Manhattan skyline, Radio City. In November 1958 he had his first major exhibit of fifty paintings at Gallery 72 in Manhattan and he sold forty-two of his canvases at prices ranging from $350 to $1250. "A lot of his Seventh Avenue cronies bought his stuff," Nate Cummings says. Cummings himself bought two Nemerovs for the lobby of his Sara Lee cheesecake factory in Chicago.

Alex Eliot flew in from Europe to review the exhibit for *Time* magazine. "Nemerov's paintings are crude and luminous and intensely colorful," Alex wrote. "He's obviously been inspired by the French impressionists." When he asked Nemerov to explain why his paintings sold so rapidly, Nemerov answered, "People who bought them were mainly people of means who prefer a colorful painting. But when a stranger walks in and pays for a painting of yours, life becomes wonderful. You see, I couldn't bear to be a failure. Not only in my eyes but in the eyes of the world."

Howard came to the exhibit and kidded his father about being reviewed in *Time* magazine before his son was. And Nemerov retorted, "You see? An artist can be successful at making money."

"It was a bitter pill to swallow," John Pauker says. "Howard had been struggling for years to write fine poetry and he had a wonderful reputation and received a great deal of praise, but he'd made very little money. Now in a matter of months his father was earning up to a thousand dollars for one lousy oil. It wasn't fair."

Not long after the Arbuses became estranged, Sudie Trazoff, a former student of Howard's from Bennington who lived across the street from Diane, offered to serve as baby-sitter and general factotum. She was the first of several young women who worked devotedly for Diane over the years and who became "like family." Amy Arbus remembered in a radio interview, "As we got poorer and poorer and after my sister, Doon, went away to college, we had boarders—people who would take care of me and

* In 1958 Russeks Fifth Avenue folded; one of the reasons given was "changing customer patterns." Other Russeks stores in Chicago and Brooklyn stayed open for the next few years. The chain, including the Savoy-Plaza shop, finally expired in the mid-sixties.

clean up the house a little even though it wasn't their job." This enabled Diane to go around peddling her photographs. She was desperate to make some money on her own.

Allan was, of course, supporting Diane and their two daughters, working as a fashion photographer—and acting whenever he could. It was an exhausting schedule, but he was determined to do both because he was suddenly happier than he'd been in years. And Diane was happy for him although she herself was miserable.

She had lunch with Tina Fredericks at the Museum of Modern Art and told her how Allan had left her for "this actress." She seemed in despair. She felt as if she had failed in some basic way. Was part of it that she had never been self-supporting? Never been financially independent? Maybe if she had contributed more money to the running of the household . . .

"She was upset about everything," Tina Fredericks says. "Nothing I said made her feel any better." They eventually began talking about her photographs. She told Tina she had to sell her photographs but didn't know how to market them. For the past couple of years she had been working in isolation, apart from Allan's encouragement and Lisette Model's teaching. She had been taking pictures haphazardly—village kids in the streets, Central Park. Lately she'd sneaked back into the Ukrainian Baths and managed to take some shots, hiding her camera under a towel, until she was thrown out again by the irate management.

Harper's Bazaar and *Vogue* were the only places where art photography was ever seriously considered editorially; otherwise as television became the all powerful medium, magazine outlets for photographers began shrinking. *Colliers* folded. *The Saturday Evening Post, The Ladies Home Journal, Look,* and *Life* kept asking for upbeat photo essays but that was something Diane had no interest in supplying.

Even so she tried to get an assignment from *Life*, since the single-page rate for a black-and-white photograph averaged between $500 and $800, but her portfolio was judged too idiosyncratic, as was Robert Frank's—he did get assignments, but his work was always rejected as being "too harsh."

Eventually Frank Zachary, the art director of *Holiday* magazine, gave her one job. "She photographed the gossip columnist Leonard Lyons on his nightclub rounds," Zachary says. "But she couldn't get Lyons to pay any attention to her, to relate to her, so finally she cornered him in Times Square, then she backed out into oncoming traffic and snapped the astonished expression on his face." She was paid $75 for the portrait.

Tina Fredericks was working in a building near *Holiday*; she had left *Glamour* and was now picture editor of the *Ladies' Home Journal.* Her

marriage had broken up and she was seeing a great deal of Emile de Antonio, or De, as his friends called him. "De knows everybody in the art world," Tina told Diane. "De can help you sell your work." A large, unkempt man with a rich, hearty laugh, De invariably wore different-colored socks and soiled sweatshirts. He was from Philadelphia and independently wealthy, but as an undergraduate he had organized rubber-plant workers and worked as a barge captain. He had been a classmate of John F. Kennedy's at Harvard. After Harvard he taught philosophy at the College of William and Mary in Virginia. Eventually he moved to a house in Pound Ridge, New York, near the avant-garde composer John Cage—and the two men became close friends. (In 1957 De organized Cage's twenty-fifth-anniversary concert at Town Hall, which turned out to be musically as wildly dissonant an event as Nijinsky's *Rite of Spring*.)

Through Cage, De got to know the painters Jasper Johns and Robert Rauschenberg, who were then penniless; once he got them a job designing window displays at Tiffany. "De connected artists with everything from neighborhood movie houses to huge corporations," wrote Andy Warhol, who maintained that De had defined his stark black-and-white painting of a Coca-Cola bottle as "remarkable art—a reflection of our society"; it was De who in 1960 convinced the Stable Gallery to hang the first major exhibit of Warhol's work. Recently De had been so inspired by the syncopated sound track and images in Robert Frank's *Pull My Daisy* that he became distributor of the film, and he himself was about to make a film on Senator Joseph McCarthy—"a collage-type film inspired by my friends Bob Rauschenberg and Jasper Johns" which he eventually called *Point of Order* when it was released.

Tina thought De could promote Diane and her photographs as he'd promoted Warhol's soup cans and later Frank Stella's black paintings. "But I was never anyone's manager—I never took a commission," De says. "I guess what you'd call me is a catalyst. I helped artists get galleries by putting dealers and artists together. For some reason Tina thought I was very 'together,' which was a crock. What does a displaced intellectual do who's never found an art? I'd originally wanted to be a writer. I used to drink myself into oblivion. I got married six times, but I gave the appearance of knowing what I was about."

Diane began visiting De in his grimy office in what he called "the Brute Force building" at Sixth Avenue and 53rd Street. "I called it that because the Mark Hellinger ad for his movie *Brute Force* was still plastered on one of the building's walls. Anyhow, Diane would drop by, always loaded down with cameras—and we'd talk." But not about her career or how she could sell her pictures. "And it wasn't that she wasn't ambitious—nobody

could work as hard as she did and not be ambitious—and it wasn't that she didn't care about money or fame; it was just that she made no effort to go after it; she refused to indulge in any ploys or subterfuges."

Instead she and De talked about monsters—mythic monsters like the Cretan minotaur and the dog-headed boy. Diane knew all about such literary *monstres* as Count Dracula, who turned into a vampire, and Poe's "Hop Frog," about a crippled dwarf who is also a Fool.

De took Diane to see Tod Browning's 1932 movie *Freaks*, which Dan Talbot was reviving at his New Yorker Theatre on the Upper West Side. She was enthralled because the freaks in the film were not imaginary monsters, but *real*—midgets, pinheads, dwarfs had always excited, challenged, and terrified her because they defied so many conventions. Sometimes she thought her terror was linked to something deep in her subconscious. Gazing at the human skeleton or the bearded lady, she was reminded of a dark, unnatural, hidden self. As a little girl she'd been forbidden to look at anything "abnormal": the albino with his flat pink eyes, the harelipped baby, the woman swollen with fat from some mysterious glandular disease. Forbidden to look, Diane had stared all the more and developed an intense sympathy for any human oddity. Those creatures had had normal mothers, but they'd popped out of the womb altered by some strange force she couldn't understand.

Diane returned to see *Freaks* again and again, sometimes with a woman friend, sometimes with De. Often they would go in the afternoon and sit in the dark, cavernous, almost empty theater smoking pot while in front of them beribboned, feeble-minded pinheads cavorted across the screen.

At this point Diane was photographing Miss Stormé De Larverie backstage at the Apollo Theatre on West 42nd Street; Stormé was the single and sole male impersonator in a female-impersonator show called *25 Men and a Girl*. She was black and she dressed as a man in impeccably cut suits she'd had made in London. Diane spent hours photographing and talking to Stormé as well as writing about "the delicate art of her transformation from woman to man. [Stormé] has consciously experimented [with] her appearance as a man without ever tampering with her nature as a woman," Diane wrote, "or trying to be what she is not." She quoted Stormé as saying, "If you have any respect for the human race, you know that nature's not a joke."

At some point, De says, Diane timidly showed him a few of her photographs of Stormé. "They were grainy and quite wrinkled. Apparently Diane was ironing her prints on her ironing board. But it didn't matter, she'd been able to capture a combination of anxiety and pleasure in her

subject's face. Stormé seemed pleased to have her picture taken, but worried that too much was being revealed in her collaboration with the photographer." De continues: "You know, I jotted down some notes about Diane. So many people have used these words I hate to use them again, but they meant so much to me when I read them as a teen-ager. It's what James Joyce suggested were prerequisites for an artist's survival in the modern world—[that the artist must practice] 'silence, cunning, and exile.' I always felt these were emblems of Diane's work. She was making herself an exile in New York, her home, the place she'd grown up in and lived her entire life. When I knew her, she was starting to move about the city unknown—quiet as a mouse. She seemed so small! I don't know whether she actually *was* that small, but she gave an impression of fragility, or smallness—she'd creep into a room or onto the street with her cameras and you almost couldn't see her. You forgot she was there. She blended into the scenery."

She had begun to prowl the city at all hours, striking up a conversation with any outcast she happened to encounter. It was hard at first, she was so shy with people, but she wasn't afraid of New York at two a.m. Her life was beginning to take on a night-blooming quality, De thought. She seemed to be more alive in the dark as she traveled by herself on the subway, laden down with her cameras. The trains pounded in and out of the dark tunnels, headlights shining like eyes. The stations were deep, empty, odoriferous—"like the pits of hell," she said. She saw hunchbacks, paraplegics, exhausted whores, boys with harelips, pimply teen-age girls. She was sure the ladies in ratty fur coats were cashiers.

She considered photographing the men who lived in the bowels of Grand Central Station—bums who wrapped their feet in old newspapers to keep warm. She befriended a bag lady—a woman who for a long time was a fixture in the long corridor connecting the Lexington Avenue subway to the Times Square shuttle. The bag lady would lie in a corner day and night, without moving. The rumble of the trains in the distance was like the sound of the sea in her ear; gradually it was going to rise up and envelop her completely.

Then there was the blind, bearded giant swathed in Army-surplus blankets who called himself Moondog. An imposing, hostile figure, he stood outside De's office on the corner of West 54th Street and Sixth Avenue for eight hours at a stretch; he tolerated the people who gave him pennies. Like a biblical prophet, Moondog carried a staff, and he wore a Viking's helmet decorated with tusks. "People keep asking me why do you dress the way you do?" he would say. "I tell them it's my way of saying no."

Diane got to know him. Sometimes she would sit with him while he ate his supper at a cafeteria near Carnegie Hall. Often she would take her daughter Amy along. Amy recalls, "He had an awful smile."

Diane discovered that Moondog considered himself a serious musician, had made several recordings, and had appeared on TV and in nightclubs. But he subsisted mainly by begging. "It's not degrading," he would say. "Homer begged and so did Jesus Christ. It was only the Calvinists who ordained that no man shall eat who does not work."

Moondog was the son of an Episcopal minister. He came to New York in 1942, immediately adopting his nickname out of devotion to a former pet who had bayed at the moon, and quickly established himself in Times Square, where he stood for several years on a traffic island playing the "oo" and the "uni," percussion instruments of his own design.

When around 1955 he decided to stop his street performances because of the crowds he drew, he moved to West 54th Street, where he remained still as a statue as the trucks and cars whizzed past. Sometimes he would sell copies of his verse written in rhymed heptameter—couplets such as "Christianity's uncompromising war on error or evil would appear to me to be an evil error."

Diane wanted to photograph him and he agreed on one condition— that she spend the night with him at his fleabag hotel on West 44th Street. "Presumably Diane did spend the night with Moondog," De says, "and presumably all they did was talk. I don't know what happened for certain —she said she took pictures of him, but she never showed them to me. Apparently Moondog had a wife and a small baby, but he and his wife didn't get along."

Diane talked about his tiny, cockroach-infested room, which he loved because there were pigeons flapping and cooing outside his window—"a little bit of nature." Although he couldn't see, he knew where all his possessions were in that room. Behind the door was his treasured trimba, two triangular drums with a cymbal attached. On the trimba Moondog would beat out what one newspaper critic called his "delicate Coplandesque modern rhythms."

It was weird photographing the blind, "because they can't fake their expressions," Diane said. "They don't know what their expressions are, so there is no mask."

Moondog had no idea what he was doing when she photographed him, she said, no idea that his huge, hairy face was so relaxed and goofy it seemed as if he were either drunk or floating through the great beyond.

Diane talked to De a lot about Moondog, and De would think, "Jesus!

these stories of hers—why can't she combine them with her pictures?" and then he realized that she was interested in freezing an image—not elaborating on it.

In past summers Diane and Allan had taken their daughters on vacation, but after they became estranged in the summer of 1959 Doon visited Howard and Peggy on Cape Cod and Amy was enrolled in a camp. Diane stayed by herself in the Charles Street house, concentrating on photographing "mud shows"—second-rate little circuses that played backwater towns throughout New Jersey and New England. At dawn she would hop a Greyhound bus to catch one—maybe outside Flemington, or in Pittsfield, Massachusetts. She would hang around all day, observing and photographing the fortune teller's tent, the contortionist shaving. One of her earliest circus pictures, taken in 1959, is of a midget clown convulsed with giggles.

Charlie Reynolds, a magician and circus buff ("I've been photographing circuses all over the country for thirty years"), used to bump into Diane at Hunt's Vaudeville, "the oldest traveling circus in America," when Hunt's was camped in the Pennsylvania hills. Through Reynolds (who lived near her in the Village) Diane met the Amazing Randi, the escape artist who is considered today's successor to Houdini. (One of Randi's recent tricks: writhing in a straitjacket while dangling upside down supported by a crane over Niagara Falls.) In the 1970s Randi gained celebrity for debunking the Israeli psychic Uri Geller.

Diane took hundreds of pictures of Randi, who in turn brought her together with Presto the Fire Eater. Presto, a great natural magician, did his act on Village streetcorners, draped in feathers, buckles, cameras, tape recorders, flashbulbs. Randi also brought her to Gangler's, a little truck circus which was playing in a loft on St. Mark's Place; he was performing there along with a pony and a llama, a bear and a dog. He introduced Diane to Yves, a French juggler with pale, waxen skin, "a really weird, far-out fellow who believed juggling was a mystic act, and he convinced Diane it was mystic, too." She took pictures of him and of another juggler named Adrian. Adrian was bugged that he couldn't juggle fulltime; to support himself, he simonized cars on York Avenue.

"Diane was fascinated by weirdos," Randi says. "Not just by their weirdness but by their *commitment* to weirdness. As far as she was concerned, I didn't count because I'd do my levitation act—very convincingly, I might add—and then I'd step offstage and drive to my house in New Jersey. I merely served as liaison for Diane into the worlds of magic and illusion. I introduced her to a lot of people I knew in the business—some

of whom she photographed, like Presto and Jack Dracula, the tattooed man. She could weave a spell around people like Presto and Jack so they'd reveal themselves the way they were and the way they presented themselves to the world. It was a magic double thing she caught."

Back in New York, Diane haunted the Coney Island sideshows and the sideshows in the basement of Madison Square Garden when Ringling Brothers' circus came to town. She often took her daughter Amy with her —once she was back from camp—and introduced her to "these very strange people."

Of sideshows Diane said later: "There's some thrill going to a sideshow —I felt a mixture of shame and awe. I mean, there's a sword box where they don't cut the girl in half, they stick a lot of swords in and none of them really go through her and besides they're not sharp and . . . it's fun because the girl is almost looney."

Diane's portraits of twin fetuses bobbling in a bottle of formaldehyde as well as of the "headless man" clad in a business suit were some of her earliest sideshow shots.

That same summer De was introducing Diane to the garish strip on 42nd Street between Seventh and Eighth avenues, where shabby peepshows and hot-dog stands never closed and third-run movie houses opened at seven a.m. "Even then robbings and stabbings were a common occurrence," De says. "Forty-second Street was dangerous. We'd pass a sea of empty beer cans, broken bottles, druggies, pimps, and then we'd go to Grant's for clams and french fries. Grant's was a tough place full of hard gays. There were lots of knife fights, but Diane didn't blink an eye. 'Places are the only things you can trust,' she would say."

After a meal at Grant's they would walk over to Hubert's Freak Museum, which had been operating for more than twenty-five years at Broadway and 42nd Street. They always visited with Professor Leroy Heckler, whose father had been a strongman; Heckler ran the flea-circus concession at Hubert's. Often Diane would sit with him while he fed his fleas. He'd roll up his sleeves and, using tweezers, pick up the fleas out of their mother-of-pearl boxes, drop them on his forearm, and let them eat their lunch while he read the *Daily News*.

There was seldom any talking, even when Alberto Alberta, the half-man, half-woman, dropped by, or Sealo the Seal Boy, who had hands growing out of his shoulders. Everyone did his or her act on the average of two shows an hour from eleven a.m. to eleven p.m., but they were never "on display" on their curtained platforms for more than five minutes at a time, speaking very briefly about their origins and their malformations in a bored, perfunctory manner to the handful of the curious who milled before them.

Diane was one of the most avid spectators, as attracted to the freaks as she was repelled by them, and some of them really frightened her. This was part of her motivation for coming to Hubert's—she *wanted* to get so scared that her heart would pound and sweat would pop out on her brow, and then she would conquer her fear and stay for hours, scrutinizing the fat lady's smelly waddle, the armless man's dexterity as he lit a cigarette from the match he held between his toes.

When she first approached the freaks offstage with her cameras, they stared at her blankly; they seemed haughty, taciturn; they didn't feel comfortable with a "normal" in their midst. She was gentle and patient with them, coming in every day, talking with them until they got used to her and "she became almost one of the gang," says Presto, who was performing his fire-eating act at Hubert's then. Once she felt the freaks trusted her, she asked them to pose.

Hubert's became one of Diane's principal hangouts in New York. Over and over again she photographed the midgets, the three-legged man, the lady with a serpent, attempting to penetrate their mystery and their fascination for her. Often she brought friends along—the photographer Joel Meyerowitz, the poet Marvin Cohen, and mostly her daughter Amy, who couldn't understand why her mother wanted to take pictures of freaks. "They were like foreign bodies to me." The pictures embarrassed her until her first year in high school, "when we were all taking photography class and [my classmates] were really impressed with Mom's work; they kept saying how amazing it was." Then Amy began to study Diane's work with a different eye and discovered the beauty and strangeness of it. (Today Amy is a photographer herself, documenting the Punk Rock scene for the *Village Voice*.)

Diane used to show the Amazing Randi her latest Hubert's Museum contact sheets. "I thought they were great. She photographed all the acts —the pinhead, the skeleton, the little people—and she seemed to capture the gothic fantasy—the supernatural qualities ... and the phoniness." Randi thinks Congo the Jungle Creep was Diane's particular favorite. "Because he was so extreme. She knew that his act was a hoax—essentially failed magic—but that was precisely his appeal to her. He believed so totally in his fakery, he was positively arrogant about it." She photographed Congo for years and never got tired of watching him stamping on saw blades, performing his sand act—he'd mix sand in a bucket of muddy water, shout "Ugga mugga," and then scoop up a wad of *dry* sand and flourish it at the audience. He'd also light a cigarette, swallow it, drink a glass of water, blow smoke out of his mouth and nostrils, grimace, scream, then cough up the cigarette. Congo was a natural magician, Randi says. "Everything he did came from his soul." In fright wig, T-shirt, loincloth

worn over his trousers, he'd thump on a drum, have dialogues with evil spirits, mix potions, cast spells, threaten the audience. "Diane would go ape shit over his act," says Randi. "And the way he used his hands—they were huge, oversized, with savagely long fingernails—they'd claw the air as he performed his mumbo-jumbo. Congo's real name was Hezekiah Trambles—he was from Haiti, and Diane used to describe him as a pseudo jungle voodoo-type character."

Congo made a lot of money from his act. During breaks from Hubert's, Diane and Randi would sometimes see him strolling down Times Square. "He'd be wearing a natty suit, no fright wig, and lots of diamonds on his huge hands. 'Hi, Congo,' we'd say. But he would studiously ignore us."

As the months went by, Diane wandered the Times Square area at all hours of the day and night. She talked with the habitués—the derelicts, the insomniacs lining up to get into the ten-cent movie houses. She found out that the deaf and dumb liked going to the Apollo Theatre; she discovered that a great many bag ladies used the Howard Johnson's ladies' room near the Automat.

Bag ladies seemed particularly solitary and tragic. They weren't crazy, she decided; they were wives and mothers like herself; some even had held jobs before tumbling out on the street, not by choice but because they had no money. She would watch silently as they clung to their bulging shopping bags—their only possessions. This was completely understandable to Diane, who until recently had usually carried a paper sack jammed with her favorite things.

She was still very shy and frightened as she approached each new situation, but the fear was thrilling. Photographing the blind Moondog had helped, and photographing the Amazing Randi and Presto the Fire Eater and Congo the Jungle Creep, and trying to calm the Russian midget Gregory Ratoucheff when she photographed him in his roominghouse at one a.m. He'd been so nervous he posed in his hat and coat; to get him relaxed, Diane talked to him a long time. (He'd been one of the stars of the movie *Freaks*. Married five times to normal-sized women, he did a terrific imitation of Marilyn Monroe singing "My Funny Valentine.")

It was getting easier to ask people to pose, and one of the reasons was that she had a new champion, a new mentor, who would be close to her for the rest of her life; someone who believed in her special talent, who goaded and pressured her to accept greater challenges, tougher assignments, more personal projects. "You can photograph everyone in the world," he said.

. . .

His name was Marvin Israel. Pale, bespectacled, a painter of grim visions (sinister rooms full of dangling electrical cords), Israel lived with his painter wife, Margie, in a basement studio on West 14th Street which visitors described as a "veritable menagerie of flapping birds and barking dogs." The Israels were a detached, remote couple who could go for weeks at a time without seeing anybody while they labored over various projects.

For a few years in the mid-fifties Israel had been art director of *Seventeen* and Diane had known him slightly then when she and Allan were doing fashion work for the magazine. Sometime in 1959 she ran into him at a party and he directed a fierce monologue at her that seemed to last half the night. Afterward Diane told Cheech she had never met such a riveting man. Depending on his mood, he could be expansive and charming or smug and downright insulting. (Many of his students at the Parsons School of Design, where he taught, recall breaking under his abusive comments about their work.)

His mind teemed with ideas and opinions on every subject from Proust to James Bond. He loved riddles, he loved magic, and he seemed to see the potential in photography, the parallels between experience and irrationality. Céline was said to be one of his idols, Céline the half-crazed Paris original who thought human beings should be categorized as either voyeurs or exhibitionists. His *Death on the Installment Plan* suggested that life's final reward was death, and his exaggeration of reality, his preoccupation with the grotesque and the dangerous appealed to Diane, too. Her rebellion against the conventional, the reassuring, had begun when she was a teen-ager.

"Marvin and I are similar," Diane confided to Tina Fredericks. "Rich, Jewish, protected," They'd both been raised on Central Park West and Israel's family had run a string of ladies' speciality shops around Manhattan called David's. But he did not talk about that much nor did he talk much about his brother or sister. "He was a very private fellow" says *Bazaar* editor Nancy White. However all of his friends knew he'd gone to the Yale art school, where he'd studied with Joseph Albers and then become one of Alexey Brodovitch's protégés.

He'd apparently been greatly influenced by these men—master teachers who acted as guides, counselors, protectors, to a generation of artists and photographers. Their methods were harsh, dictatorial, and as Israel's reputation grew in the 1960s as a painter/art director/teacher of graphics, he would behave rather like a Brodovitch with the small band of up-and-coming artists who gathered around him. "Marvin would always get turned on by a new talent," one of his students says, "but then he'd grab hold of it—try to mold it and control it. He had to believe he controlled you as a talent. If you let him, he would art-direct your life."

He saw Diane as an original talent who needed to be pushed. For the next eleven years he advised, cajoled, and promoted her. When she started telling Israel about the places she'd gone—the carnivals, Moondog's filthy room—when she showed him contact prints of the freaks and eccentrics, he praised her courage. He later described her in a magazine article as the "first great private eye," adding that she "loved being naughty . . . much of what she did came from that kind of delight. It made an explorer out of her."

"Marvin thinks an artist's obsessions are what make an artist interesting," the novelist Larry Shainberg says. During the 1960s there was an almost convulsive move against fixed traditions in art, and in New York, off-Broadway actors, painters, musicians, dancers were experimenting wildly. Drugs were a source of pleasure, sex a source of power, and there seemed to be an increasing interest in characters who were living on the edge. Israel encouraged Diane to go deeper into the dark seedy worlds with her camera. "He believed she could push her obsessions to the limit," Shainberg adds.

Some friends thought that Israel's surrealist leanings, his lack of sentiment as reflected in his own stark paintings, not only influenced Diane's photography but narrowed her vision as well. (Certainly modernist artists were deadly serious about their subject matter and their goals.) But the late photographer Chris von Wangenheim, who followed Diane's progress closely, believed that "Marvin was like a creative sounding board to Diane —he galvanized her into having faith in her own vision—but he had little to do with the ambiguities suggested in her pictures. And he had no control over what made the best of them so perplexing—so alienating."

According to Cheech, "Diane changed after she met Marvin. Her life got more fragmented—more secretive. She would never make plans. Everything was always last-minute. When I finally met Marvin, I told Diane I couldn't get along with him and it was the beginning of the end of our friendship. She would not tolerate criticism of Marvin—she absolutely worshipped him. She saw fewer of her old friends with Marvin, since nobody could get along with him." "He was very contemptuous of me whenever I visited Diane," Shirley Fingerhood says. "It soon became impossible to visit her."

The photographer Ben Fernandez remembers trying to speak to Diane on the street, only to have Marvin yank her away, exclaiming, " 'Come on! Come on!' He seemed to want her all to himself."

"Diane was always saying 'Marvin this' and 'Marvin that,' " Cheech goes on. "Marvin Israel began obsessing her. But she never saw him that often; sometimes he'd drive her someplace very fast in his car and then go on to another appointment. Marvin goosed her creatively," Cheech says.

"Allan got upset hearing Marvin's name mentioned so much. After all, Allan had nurtured and encouraged Diane all these years—he wanted some of the credit for developing her."

During the first year of their friendship Israel was art director of Atlantic Records and so wasn't in a position to place any of Diane's pictures, but he talked about her to everyone in magazines. Then in the late summer of 1959 she took her portfolio up to *Esquire*.

22

Throughout the thirties and forties *Esquire*, "the magazine for men," had been distinguished for publishing Hemingway and Faulkner and for its sexy drawings by Varga. Recently, perhaps out of a reaction to the banality of the fifties but more probably due to the increasing success of its fleshier rival *Playboy*, *Esquire* had been trying to change its image. In order to do that, publisher Arnold Gingrich had just hired a number of talented young men to revamp the magazine, among them an editor from *Life* named Clay Felker, and writers Robert Benton and David Newman.

Newman recalls, "We were developing off-the-wall takes editorially—Nabokov on nudists, Mailer writing about the political conventions. Later Gary Wills and Gore Vidal took on the assassinations of the Kennedys and John Sack covered Vietnam. A lot of it was smart-ass stuff—like the Dubious Achievement Awards. Some of it was shocking—remember the Lieutenant Calley cover with the little Vietnam kids? But the underlying message—defining the cultural climate of the sixties—was important."

Journalist Tom Morgan had suggested that Diane show her photographs to Harold Hayes, the articles editor who went on to be editor-in-chief. Hayes recalls being "bowled over by Diane's images—a dwarf in a clown's costume, TV sets, movie marquees, Dracula. Her vision, her subject matter, her snapshot style, were perfect for *Esquire*, perfect for the times; she stripped away everything to the thing itself. It seemed apocalyptic."

He took the portfolio to Robert Benton, who was then *Esquire*'s art director (long before he went on to win two Oscars for writing and directing *Kramer vs. Kramer*), and Benton agreed. "Diane knew the importance of subject matter. And she had a special ability to seek out peculiar subject matter, and then her way of *confronting* it with her camera, well, it was like something I'd never seen before. She seemed to be able to suggest how it felt to be a midget or a transvestite. She got close to these people—yet she remained detached."

But, despite their enthusiasm, neither Benton nor Hayes could think

172

up what to assign Diane, so she suggested Joan Crawford's closet—having heard that Crawford owned an enormous array of clothes, all labeled "pretty good," "fair," "sensational," and all wrapped in plastic. Hayes gave her the go-ahead, but she was unable to obtain an appointment with Crawford without submitting samples of her photographs, and she was afraid to do that. For a while she considered passing off one of Allan's celebrity portraits of Tony Perkins as her own, but Allan wouldn't hear of it, so she abandoned the idea.

Nevertheless she and Hayes met for lunch several times that fall to try to think of something else for her to do. Hayes remembers Diane at that time as "very sexual, very feminine—tentative—charming—fey. She wore marvelously cut linen suits—no other woman I knew wore linen suits." He remembers her loving references to her daughter Doon. "Diane was so pleased her daughter confided in her, trusted her."

By October of 1959 Hayes, Benton, and Clay Felker had come up with the idea of devoting an entire issue of *Esquire* exclusively to New York. Gay Talese, a young reporter from the *New York Times*, was going to write the lead essay; there would be contributions from John Cheever and Truman Capote, among others. Hayes told Diane he wanted her to do a photographic essay on the night life of the city, contrasting surprising events and people and places—events, people and places nobody knew about.

Diane was intrigued. "Let me waste some film!" she exclaimed to Benton, adding that she planned to photograph River House, drug addicts, Welfare Island, Roseland, and the *Bowery News* newsroom "for starters." She went on to tell him that she'd been "peering into Rolls-Royces, skulking around the Plaza Hotel." She'd also thumbed through the Yellow Pages under "CLUBS," since Harold Hayes wanted something "respectable" like the Colony Club and the Union League; she'd found ones called "The Rough Club" and "Ourselves Inc." She reminded Benton that Mathew Brady had once photographed the DAR and that the results had been "formidable." In a note scribbled to Benton, she asked for "permissions both posh and sordid . . . I can only get photographs by photographing. I will go anywhere."

Diane began the *Esquire* assignment by visiting the morgue at Bellevue, a cavernous building at 29th Street and the East River that was a place of dank tiles and refrigerated corpses. In the autopsy room the air was heavy with the smell of decomposing flesh, of viscera open for examination. Diane got to know some of the forensic doctors and she was allowed to photograph there. She began to collect information about death and dying.

Then there were the unclaimed bodies (one of which she photographed), bodies that landed in potter's field. Some fourteen thousand

adults and more than four thousand babies died anonymously in one year, she discovered. She read the yellowing police records: "William Harrington, sixty-five. Tailor. Had prison record. Found with fractured skull. Five feet six, slender gray moustache. Harmonica in pocket."

After photographing in the morgue Diane roamed in and out of Manhattan's flophouses, brothels, and seedy hotels, the little parks in Abingdon Square and Union Square, the parks near the Brooklyn Bridge and Chinatown. Soon her address books bulged with an unbelievable record of names with scribbled identifications next to them: "Detective Wanderer —West Side homicide . . . subway brakeman, Kass Pollack . . . Vincent Lopez, band leader . . . Flora Knapp Dickinson, DAR . . ." "I own New York!" she exulted to her sister, Renée. Ultimately Diane would say she was "collecting things"; she defined her special interest in photography as a sort of contemporary anthropology.

She placed a blackboard by her bed with a list of places and people she wanted to photograph: "pet crematorium, New York Doll Hospital, Horse Show, opening of the Met, Manhattan Hospital for the insane, condemned hotel, Anne Bancroft in *The Miracle Worker*."

K. T. Morgan, Tom's daughter, would visit the Arbus house in the evening and sit on Diane's bed while she pinned up her latest picture still damp and curly from the darkroom. "It would quickly mingle with the other objects and artifacts she kept around her bed—a wooden poster from an old bed, a California job case filled with tiny mementoes, a Bellocq photograph, a European postcard. There was always something new, whether it was something she made or something she collected. What I saw as a child were, as Susan Sontag says, 'the Halloween Crowd.' Diane's photographs showed me people who were unordinary, extraordinary or people I might never see otherwise." Like muscleman Kenneth Hall (who in his spare time played the bongos and married a dance-contest winner); like female impersonator Mickey Marlowe, age twenty-eight, who specialized in feather fan dances à la Sally Rand; and then there was Jack Dracula, "the Marked Man," whom she photographed in the tall grasses of Central Park, counting with care his 306 tattoos. "There are 28 stars on his face," she wrote later, "as well as 4 eagles in varying postures, 6 greenish symbols shaped like donuts, a Maori moustache and a pair of trompe l'oeil goggles . . ."

In contrast, she photographed Moss Hart's daughter, Cathy, getting out of a shiny limousine; she photographed a Boy Scout meeting, the Police Academy, elderly people on Welfare Island. She went down into the sewers and she visited a slaughterhouse: the scene reminded her of a drawing by Piranesi; she could hear the animals roaring before they came

out to be butchered—the smell and sight of so much blood, steaming rivers of it, almost made her vomit.

Out of anxiety, she shot hundreds of rolls of film on the *Esquire* assignment. Robert Benton and Harold Hayes were so excited by the raw images she kept bringing in—Roseland Dance Palace, the men's detention house, a pet funeral, a condemned Broadway hotel's tenants—that they considered illustrating the entire New York issue with Arbus pictures. "I foolishly decided against it," Hayes says now. "The pictures were such an indictment."

He and Benton finally chose six—among them, Flora Knapp Dickinson of the DAR; an unknown person in the morgue at Bellevue; beautiful blonde Mrs. Dagmar Patino at the Grand Ball benefiting Boys' Town of Italy; and Walter Gregory, whom Diane had developed a particular fondness for. Gregory was an almost legendary Bowery character known as the "Madman from Massachusetts." She was very upset when he was run over by a bus not long after she had photographed him.

For four months Diane had thrown herself into this assignment for *Esquire*, living in an almost constant state of euphoria—pedaling about on her bicycle, jumping in and out of cabs, cameras always weighing her down. She invariably wore a raincoat. "I feel like an explorer!" she would say.

Often Robert Benton and his girlfriend, Sally Rendigs, going home from a party, would see Diane coming up out of the subway. "It would be two a.m.," Benton says, "and she'd be running up from the station, eyes sparkling, not at all tired. I've never seen anyone work so hard."

"I was often frightened by her capacity to be enthralled," her daughter Doon has written, "by her power to give herself over to something or to someone, to submit. But it was the very thing that made her photographs possible."

23 _____

After completing the *Esquire* assignment, Diane finished reading Joseph Mitchell's epic profiles of outcasts, gypsies, freaks, and buffoons which appeared in the book *McSorley's Wonderful Saloon*. Possibly best known for his study of Joe Gould, a Greenwich Village eccentric, Mitchell had come to New York from Robinson, South Carolina, in 1929. He briefly wrote short stories before becoming a reporter, covering major news events like the Lindbergh kidnapping trial and Huey Long's assassination for the *World-Telegram* and *Herald Tribune*. He became a *New Yorker* staff writer in 1937 and, according to Stanley Edgar Hyman, "in a few years he reshaped the magazine's traditional reportorial forms 'the Profile' and 'Reporter at Large' into supple resourceful instruments for his own special purposes by blending the symbolic and poetic elements of his early fiction with the objectivity and detail of newspaper reporting."

Painfully shy and secretive, with a gray cast to his face and a low, hesitant voice, Mitchell spent much of his free time with his close friends A. J. Liebling and S. J. Perelman at Costello's Bar; otherwise he could be found hunched over his typewriter, struggling with profiles such as "Joe Gould, Greenwich Village Bohemian."

Few people were allowed access to his austere twentieth-floor *New Yorker* office, part of a warren of offices called "Sleepy Hollow." Surrounded only by desk, file cabinet, and, later, a poster of the ill-fated Broadway musical *Bajour* (based on his story of a slum gypsy king), Mitchell would labor for months, sometimes years, on projects like the eloquent "Bottom of the Harbor" series, studies of New York river life.

One afternoon, says Mitchell, he was "typing away in my cell when the phone rang and a tiny voice introduced herself as 'Diane Arbus—I'm a photographer.' For some reason—habit, I guess—I jotted her name down and the date of her call on my yellow pad, November 1960. We started talking and didn't stop for two hours—she had the kind of voice—light, friendly—that made you trust her immediately. I had no idea how old she was—she sounded like a little girl. But her thoughts—many of them were

extremely cultivated, erudite—if you'll excuse the expression, it was freakish.

"She told me she wanted to take pictures of some of the people I'd written about like Lady Olga, the bearded lady, and Mazie, who ran a movie house in the Bowery. She said she imagined they were a link to a strange, dark world—to an underworld. I said I supposed they were, but hadn't Brassaï done photographs like that of the Parisian underworld in the 1920s and wasn't Weegee doing it right now for the *Daily News*? Diane allowed as I was right but she was going to go about it in a different way —pursuing what couldn't be defined, pursuing what was missing in an image. I said Okay.

"Then she asked me *how* I found the kind of people I wrote about and I told her by being persistent—by hanging around. Around cafeterias, park benches, subway trains, public libraries, by interviewing ambulance drivers, scrubwomen, morgue workers. I told her about Professor Heckler at the flea circus, who was a good friend of mine. Did she know him? I asked. Indeed she did—she had been spending a lot of time at the flea circus for her essay in *Esquire*. We laughed when we found out we'd both spent hours watching him feed his damn fleas."

In another conversation Diane and Mitchell talked about freaks and Diane referred to Mitchell's definition of "class distinctions among freaks" which had appeared in his masterful portrait of Lady Olga, the bearded lady. "Born freaks are the aristocracy of the sideshow world," Mitchell wrote. "Bearded ladies, Siamese twins, pinheads, fat girls, dwarfs, midgets, giants, living skeletons, men with skulls on which rocks can be broken.

"Made freaks include tattooed people who obtain sideshow engagements, reformed criminals, old movie stars, retired athletes like Jack Johnson."

Again and again in their conversations Diane returned to Mitchell's distinctions among freaks, and one assumes that her own celebrated comments about freaks were inspired by him. She said: "Most people go through life dreading they'll have a traumatic experience. Freaks were born with their trauma. They've passed their test in life. They're aristocrats."

Mitchell says, "I urged Diane not to romanticize freaks. I told her that freaks can be boring and ordinary as so-called 'normal' people. I told her what I found interesting about Olga, the bearded lady, was that she yearned to be a stenographer and kept geraniums on her windowsill, and that the 450-pound wrestler I once interviewed cried piteously from homesickness for his native Ukraine."

Mitchell says Diane phoned him frequently in subsequent weeks. They would always talk for at least an hour, and Mitchell jotted down some of

the topics they covered: Kafka, James Joyce, Walker Evans, Grimms' Fairy Tales. She had been reading Edith Sitwell's *English Eccentrics* and told him of Sitwell's theory that contemplating eccentrics was a cure for melancholy—a way of distinguishing Man from Beast. She would giggle when Mitchell said something funny, and sometimes when he didn't she would giggle anyway. "She said she had looked for the people I'd written about, and Lady Olga was dead and Mazie down in the Bowery didn't want to be photographed. But she was making progress finding eccentrics, she said." And she talked about discovering "people who were anomalies, who were quixotic, who believed in the impossible, who make their mark on themselves." Mainly, she said, she was "nosing around."

Her idea of "nosing around" was to prowl the city from dawn to dusk, alighting at any number of her favorite haunts—Central Park, the 42nd Street Automat, Washington Square. When somebody caught her fancy, she would go over and strike up a conversation. Joel Meyerowitz, who sometimes accompanied her in her wanderings, says, "She could hypnotize people, I swear. She would start talking to them and they would be as fascinated with her as she was with them. She had a magnetic quality—a Peter Pan quality. I've never seen anything like it."

She didn't like being interrupted. Once when her former assistant, Richard Marx, saw her huddled outside the 56th Street Doubleday bookstore, camera poised, he spoke to her. "Shh," she hissed, "I'm working!" She was more polite with Dale McConathy, who ran into her during lunch hour on West 47th Street by the Gotham Book Mart. "I asked her to please take my picture, but she refused—with a smile. 'It would take five hundred exposures before I'd get you without your mask,' she told me."

She might wait for days or weeks until a face in the crowd intrigued her and then she would grab it with her camera. Her friend Marvin Israel wrote after her death that these contacts, which are different from her other work, are breathtaking. "There are hundreds of sheets where the same face never appears more than once, all very close-up." Thousands of exposures "like some strange catalogue,* and then there would be a contact sheet from several years later with one of those same faces in which you can trace Diane's progress from the street to their home to their living room to their bedroom. These are like a narrative, a slow process leading up to some strange intimacy."

She told Ann Ray of *Newsweek*, "I love to go to people's houses—exploring—doing daring things I've not done before—things I'd fantasized about as a child. I love going into people's houses—that's part of the thrill

* Diane left thousands of negatives. Over a decade after her death some of them are still being catalogued. However, Israel and Doon have chosen a select number of Arbus' published magazine work as part of a traveling exhibit and book.

of seduction for a woman—to see how he [the subject] lives—the pictures on the wall—the wife's slippers in the bathroom. But I'm not vicarious—I really am involved. And all the time I'm photographing I'm having a terrific time." (Sometimes such encounters could end disastrously, although Diane was never specific about the trouble she may have got into or the danger she may have faced in welfare hotels or carnivals. Jack Smith, the creator of the underground movie *Flaming Creatures*, said he kicked her out of his apartment when she persisted in taking his picture and pictures of his various costumes. And she was periodically ousted from transvestite bars. "She could be extremely aggressive as a photographer," Frederick Eberstadt says.)

"What came to really excite her was anything out of place," Israel wrote. He felt that Diane was quite proud that she was able to tell, just by seeing someone for a moment, that they had something secret or mysterious about them and that in their homes "they would be extraordinary." She'd approach these people and ask, "Can I come home with you?"

So it was with the various eccentrics she discovered in the next years. Some she went home with, some she didn't; some she photographed, others she just talked to, but everyone impressed her. Like the irate lady who appeared to Diane one night pulling a kiddy's red express wagon trimmed with bells and filled with cats in fancy hats and dresses. Like the man in Brooklyn called the Mystic Barber who teleported himself to Mars and said he was dead and wore a copper band around his forehead with antennae on it to receive instructions from the Martians. Or the lady in the Bronx who trained herself to eat and sleep underwater, or the black who carried a rose and a noose around with him at all times, or the person who invented a noiseless soup spoon, or the man from New Jersey who'd collected string for twenty years, winding it into a ball that was now five feet in diameter, sitting monstrous and splendid in his living room.

Sometimes friends suggested subjects. Abby Fink, who'd grown up with Diane, phoned to tell her about Polly Boshung, an attractive blonde who, because she was almost completely deaf and acutely embarrassed about it ("I'd wanted to be an actress, but realized I wouldn't hear my cues"), had created an entirely different identity for herself to hide behind whenever she appeared in public. At dinners, on cruises, the usually sedate Polly transformed herself into "Cora Pratt," an outrageous loudmouth who sported a wig, huge false buck teeth, and a shower cap. Once "Cora" pretended to be the maid at a party in Bucks County: sipped guests' drinks, blew ashes from ashtrays, and talked nonstop about the joys of Five Day Deodorant Pads before collapsing on the sofa dead asleep. She'd been so expert in her disguise that none of her friends recognized Polly as "Cora."

Diane took the Greyhound bus up to Peabody, Massachusetts, where Polly lived with her mother. Today Polly (now a saleslady in a Nantucket dress shop) remembers that "Diane Arbus was awful nice to me. Sweet. She spent all day photographing me in the garden and then she packed up her cameras and went down to catch the bus. But before she left she asked me a couple of times was I really sincere about having those two people inside myself? I kept telling her I was sincere, but I guess she didn't believe me because I didn't end up at her show in the Museum of Modern Art. Actually, I didn't mind, because I don't see how you could label me a freak."

Shortly before she and Allan finally separated, Diane went to see her school friend Shirley Fingerhood. Fingerhood, a lawyer and later to be a judge, had been divorced and was raising a baby son by herself. "How do you do it alone?" Diane asked. "What demands do you make?"

Fingerhood says, "I just told her it was going to be rough and that she had to be prepared for it."

Around them a generation of marriages seemed to be cracking at the seams. Couples like Rick and Tina Fredericks and the Forsts had already broken up, and couples like Robert and Mary Frank and Cheech and her husband were in high states of emotional agitation.

Sidney Simon, the sculptor, recalls that "last angry summer of 1960 when a few of us were trying to stick together and the effort was becoming almost unbearable." Simon knew Allan because the Arbus kids all went to the Little Red School House. During the summer Simon organized a car trip to Maine with Diane, "and Allan and Susan and her husband, the actor Michael Wager, were the other passengers driving up to see their children, who were attending Blueberry Cove Camp in Tenants Harbor. We were in the last stages—the last dying gasps—of our respective marriages, so the atmosphere was awfully tense. We'd booked rooms in the same motel for a night. The following morning Diane knocked on our door and announced, 'Allan and I have separated and he's gone back to New York.' She seemed totally composed, although she looked as if she hadn't slept a wink."

She didn't go into the whys, and nobody asked any questions. At breakfast the Wagers and the Simons tried to talk of other things. Diane insisted that everybody go to a traveling fair in Bar Harbor. It was at least sixty miles from where they were, but nobody was in the mood to argue, so after visiting their children they piled into the car and headed for the fair.

When they arrived, they wandered around aimlessly, eating too much sticky popcorn, trying to win at target practice. Meanwhile Diane disap-

peared. Hours went by. The sun was going down. Simon says, "We hunted high and low and couldn't find her and it was getting late and we were dying to get back to New York. Finally, at what seemed like the eleventh hour, we found her photographing a transvestite in a tent."

During the fall of 1960 Diane followed William Mack (also known as the Sage of the Wilderness). Mack, eighty-two, a retired seaman with flowing beard and bright black eyes, was a scavenger who lived in the Bowery, and Diane went with him on his daily ritual (which began at five a.m. in the freezing dawn), picking empty bottle caps out of the garbage and depositing them in his baby carriage, which he would eventually wheel over to a bottle-collector. She photographed Mack reclining in his tiny room stuffed with personal rubbish, his favorite items a squashed coffee pot and a pair of nurse's white shoes.

Also in 1960 she spent a great deal of time photographing Prince Robert de Rohan Courtney (whom Mitchell had written about). The prince was claimant to the throne of the Byzantine Roman Empire and lived in a "bejeweled 6 by 9 foot room on 48 Street called the Jade Tower," Diane wrote. "In his bureau drawer he keeps the ingredients for breakfast of 3 raw eggs and a pat of butter in hot coffee." Diane pored over his poems (nine thousand of them), scrawled in a kind of pig Latin, a fragment of which she unscrambled to read, "he who searches for trash so surely finds only trash." She eventually accompanied the prince (who'd been born in Oklahoma) when he went to the Bowery to distribute cigarettes and money to delighted derelicts, and several times she joined him for supper at the 57th Street Automat.

Diane was so excited by her photographs of eccentrics (the prince, the scavenger) that she wrote Harold Hayes asking for an assignment to photograph other eccentrics for a picture story, and she listed people she hoped to include, such as "a hermit and a very cheerful man with half a beard who collects woodpecker holes . . . these are characters in a fairy tale for grown-ups."

Hayes turned down the idea with the excuse that "you can't take a picture of someone with the express purpose of showing him or her as an eccentric." They spoke no more about it, but Diane continued to photograph regularly for *Esquire*, and she and Hayes sent each other brief missives about her work. She often kidded him about his brusque manner in rejecting one of her projects. Once she commented, "Your last letter was

a bit lacking in human warmth. It would have been an excellent one to send to the phone company."

By this time she was assured of another outlet for her work because in early 1961 Marvin Israel replaced Henry Wolf as art director of *Harper's Bazaar*. Immediately, Israel invited her to complete her essay on eccentrics. He also encouraged her to write about them (she had shown him the long captions she'd written for her *Esquire* pictures) and promised he would publish both text and pictures in *Bazaar*.

Diane went to Washington, D.C., by train to attend the Kennedy Inauguration with one of her favorite eccentrics, a tiny, gray-bearded, eighty-year-old man, Max Maxwell Landars, who called himself "Uncle Sam." Clad in a red, white, and blue Uncle Sam uniform (he'd originally worn the uniform when he was advertising an exterminator service), Uncle Sam talked compulsively about himself. "I am what I call a Personality," he told her. "I've got the greatest laugh in the country . . . I am writing my life story which will be similar to *Mission to Moscow* which Dwight D. Eisenhower wrote . . . I have the voice of a man, woman and child . . . I am a Phenomenon . . . M . . . E . . . Me!" During the train ride Diane photographed Uncle Sam as he trudged up the aisles proclaiming to the passengers how he planned to be THE FIRST MAN TO SHAKE THE HAND OF DWIGHT D. EISENHOWER WHEN HE WAS NO LONGER PRESIDENT.

She planned to photograph that moment too, but when they reached the capital, Uncle Sam panicked; they missed the Inauguration and Diane spent an entire night in Union Station calming him down. Periodically he would do Shirley Temple imitations and he repeated his name, "Uncle Sam," to anyone who would listen. Near dawn he was promising to "bring the Liberty Bell" back to New York. For a while they slept fitfully on benches in the waiting room, and sometime the following morning Diane photographed Uncle Sam climbing imperiously up the 898 steps of the Washington Monument during a raging blizzard.

Ultimately, she added Uncle Sam to her collection of eccentrics, along with the prince, the Marked Man, the junk collector, Polly/Cora, and Stormé, "the lady who appears to be a gentleman." She wrote a succinct little portrait to go with each picture after entitling the essay "The Full Circle—'who is it that can tell me who I am?' (Shakespeare)." Pictures and text were accompanied by an eloquent introduction also written by Diane: "These are five singular people who appear further out than we do; beckoned, not driven; invented by belief; each the author and hero of a real dream by which our own courage and cunning are tested and tried;

so that we may wonder all over again what is veritable and inevitable and possible and what it is to become whoever we may be."

Nancy White, *Bazaar*'s editor-in-chief, resisted publishing "The Full Circle." The pictures were not only marred by too much graininess and contrast, she said, but what *Bazaar* reader could possibly be interested in staring at the face of a recluse who believed himself to be the Emperor of Byzantium?—or a junk collector whose prize possessions were a squashed coffee pot and pair of battered nurse's shoes? Mrs. White resisted publishing certain things. She supposedly pulled Truman Capote's *Breakfast at Tiffany's* after it was already in galleys because she thought the character was too kooky and amoral. The real reason, however, was she was afraid it might offend Tiffany and Company, who advertised in the magazine. "Nancy did publish a lot of great stuff," says *Bazaar*'s former articles editor, Ilya Stanger, in her defense. "She published Flannery O'Connor and Natalie Sarraute . . . but she had a funny manner. She was never enthusiastic about anything that came across her desk. Dick Avedon often felt like tearing out his hair after an editorial meeting with Nancy."

So it was with the Diane Arbus pictures of eccentrics. Mrs. White says, "I didn't understand what all the fuss was about. I'd worked with Diane when I was at *Good Housekeeping*, when she'd done lovely things on children's fashions, and then these odd images came in and Marvin and his assistants, Bea and Ruth, treated them like the Holy Grail!"

It was not the first instance (nor would it be the last) when Diane's work polarized viewers into two camps. Mrs. White maintains she was turned off by Diane's preoccupation with grotesques and deviates. Marvin Israel presumably argued that the Arbus images were like no one else's in their force and originality, and hadn't *Bazaar* published Brassaï, Bill Brandt, and Lisette Model? After much discussion Mrs. White finally allowed Diane's pictures to be published in the November 1961 issue of *Bazaar*, but she pulled the portrait of "The Lady Who Appears to Be a Gentleman" as being too disconcerting for *Bazaar* readers.

Not long after that, Diane visited Emile de Antonio in his new Japanese-modern apartment on East 91st Street to complain. "We sat around and Diane smoked a little pot and I drank some whiskey and she was very angry about the Stormé portrait being pulled and she didn't like the look of the final layout, although she didn't tell Marvin at the time. She thought the pictures were too small."

(Diane held on to the rights, and the following year she resold both pictures and text to *Infinity* magazine—Stormé included—and retitled the essay "The Eccentric as Nature's Aristocrats—rare and precious people as seen from the inside as they would have themselves be seen."

(An *Infinity* art director comments, "We got a couple of cancellations after the Arbus pictures were published—some people couldn't take that kind of confrontation with life. At times the confrontation seemed so direct as to seem hostile.")

One of the first copies of *Bazaar's* November issue went to Joseph Mitchell at *The New Yorker* with a note from Diane written in tiny script on the cover: "Dear Mr. Mitchell, thanks for your kindness on the phone last fall when I was looking for people. Here are some I found (pp. 133–137) Diane Arbus."

She also sent copies to her sister, Renée, her brother, Howard, and her parents in Palm Beach. She received little response. Later her mother would comment that she didn't know why Diane took photographs of "such people."

A good deal of Diane's secret concern for respectability sprang from her family's attitudes. She knew her parents were embarrassed by her bare, unshaven legs, her smudged eye make-up. Since her separation from Allan, her habit of wandering the streets photographing night people and outcasts really upset them, particularly since Renée appeared to have created such a traditional life for herself with Roy, her adopted daughter, and their dogs in a house on a lake in Michigan. And Howard's marriage to Peggy seemed solid, too—they now had two sons, and Howard's academic career was festooned with awards and grants; he was currently Visiting Professor of Literature at the University of Minnesota.

"Howard was expected to be *the* somebody in the family. Diane was not expected to be anything other than a wife and mother," her cousin Dorothy Evslin says.

Howard's *New and Selected Poems* had just been published to superlative reviews. Thom Gunn had stated in the *Yale Review:* "Howard Nemerov is one of the best poets writing in English," and James Dickey had commented on his "poetic intelligence, his wit."

Howard was finally making money as well, having sold his novel *The Homecoming Game* to the movies. (Jane Fonda and Tony Perkins appeared in the film version, entitled *Tall Story.*) He told Diane kiddingly that his shoulder ached from carrying so many checks to the bank, and reminded his friend John Pauker that "Daddy never praised me until I made money in Hollywood," bitterly concluding, "It was the first time Daddy accepted me as a man." ("Oh, the pathology of the American obsession with success!" Pauker replied.)

By now the Nemerovs were living in a penthouse on top of the Palm

Beach Towers in Florida and Mr. Nemerov was continuing to turn out flower paintings which sold briskly. He was also wheeling and dealing with the money he'd made from his sale of Russeks stock, investing practically all of it in a real-estate venture that went "totally bust" near the end of 1961, Renée says. "Daddy was absolutely devastated—he'd thought he was going to make a huge killing and instead he lost almost everything. It broke his spirit."

She and Roy flew to Florida. They stayed on at the Palm Beach Towers for almost six weeks, keeping the Nemerovs company, trying to cheer them up. And they worked on their plastic sculptures and Roy's illuminated "stained glass" plastic. Both were eventually exhibited at the Palm Beach Art Institute.

As usual, Diane showed no interest whatsoever in her sister's latest artistic endeavor. When she came to Palm Beach she always chose to come when Renée wasn't there. At that point the polarization between the two sisters was acute. "I really did love Diane," Renée says. "And I wanted her to love me."

In retrospect it probably went back to their childhood when the Nemerovs began labeling Renée as "the normal one" and Howard and Diane as different. Renée was supposed to be her parents' salvation—she would vindicate them by growing up conventional. So Diane and Renée grew up in psychological opposition to each other, and although they both married men their parents disapproved of and both became artists, these similarities did not draw them close; instead they believed that deep within themselves something vital was missing. Diane spent most of her adult life revealing to no one that she had a sister. Renée, on the other hand, bragged constantly about Diane. When they were together, there was always unspoken tension between them.

There were other family tensions, too. By now the Nemerovs realized that Diane and Allan's trial separation was a permanent one—the marriage, for all intents and purposes, was over. This disappointed them deeply, so Diane had to cope with *that*, too. Even so, when her depressions over Allan became too extreme, she would fly to Palm Beach and Gertrude would try to minister to her; Diane always expected her mother to come to the rescue and relieve her of her terrible feelings of helplessness. But this rarely happened. They might talk haltingly—"at" each other; might talk as they wandered around Gertrude's beautifully appointed bedroom and out onto the sun-drenched balcony which overlooked the blue Atlantic Ocean. They might talk about money worries, family illnesses, Doon and Amy. (Motherhood was the only subject on which they could relate to each other easily.) But as often as not their conversations would grind to a halt

and there would be long, uncomfortable silences until Gertrude split open a fresh pack of cigarettes and then Diane might escape to the beach and plunge into the surf, swimming far out beyond the waves.

Most of the time Diane didn't mention her mother to friends; if she did, it was with some irony. Because, after all, Gertrude had shared an intense love with her mother, the wisecracking, chain-smoking Rose. And Diane and Doon were intensely, symbiotically connected. But with Diane and her mother, warmth and tenderness and love had always been repressed. There would probably never be a mutual confirmation between the two of them, although they obviously hungered for it.

Like most of her contemporaries, Diane had been using a Leica for years, but in 1962 she changed to a Rolleiflex. She once explained the shift by saying that the Leica's flattening perspective added to the air of unreality in her images; she'd grown impatient with the grainy quality of her prints and wanted to be able to decipher the texture of things. Her teacher Lisette Model stressed, "The most mysterious thing is a fact clearly stated."

The Rollei with its 2-1/4-inch-square, less grainy negative gave Diane the clarity she wanted and contributed to the refinement of a deceptively simple classical style that has since been recognized as one of the distinctive features of her work. At first, however, she was intimidated by the vividness provided by her new equipment and frustrated by what she called "the rigidity of the new square frame."

She wrote to the Meserveys in Boston: "I am very gloomy and scared. Maybe I have discovered that I have to use the 2-1/4 instead of the 35mm, but the only tangible result so far is that I can't photograph at all."

She was still getting used to her new life as a woman alone, trying to oversee her two daughters, rustle up magazine jobs, tend to her latest projects. She could often be seen peddling furiously around New York on her bicycle, in search of a different face, a new situation. However, unless she had a specific assignment, her days tended to be disorganized and chaotic and structured mainly by her daughters' schedules when they were both living with her and attending school in the city. "Diane always put her responsibility as a mother first," Tom Morgan says, "even when she was the most successful and in demand. Being a mother came first for her. She was a loving, thoughtful parent and concerned about her kids in the extreme."

When the Nemerovs visited from Palm Beach, Diane would dutifully invite them down to the Charles Street house to see their grandchildren. On these occasions she always hoped she'd get along better with her father, but they invariably disagreed about something trivial and Diane would try to stand up to him and then David Nemerov would do what

he'd always done—make up some crazy statistic to defend his point of view. "Like he'd say five million Chinese are doing such and such," Diane commented, "and he didn't know any more than I do whether that was true, but he would speak with such authority I'd be stopped in my tracks."

When her parents finally left, Diane would rush off to photograph someone, or she might drop in at Richard Avedon's studio on East 58th Street. She had been introduced to the great photographer in the early 1950s and was getting to know him better through Marvin Israel, who worked with him regularly at *Bazaar*.

Avedon was sharing his studio with Hiro then, so the place literally pulsated with activity; both photographers were doing a great deal of fashion work for *Bazaar*. The ambiance surrounding them was theatrical —blazing lights and music, ever-ringing phones, clouds of hairspray, preening half-nude models like the six-foot-two-inch Veruscha and later the ninety-pound nymphet Twiggy, who became the quintessential model of the period because she could fit so perfectly into fashion's baby styles— the tunics, the boxy little coats. It was the start of the sixties—"the wildest looniest time in New York since the 1920s," Tom Wolfe wrote. And Avedon (whom Cocteau called "that wonderful, terrible mirror") was tuned into everything from rock music to fashion to civil rights.

Diane admired Avedon's manic energy, his dazzling inventiveness—he could photograph eerie Roman catacombs or madhouses with equal intensity. He was currently doing fashion-in-motion studies where clothes, hairstyles, makeup blurred gorgeously. "Dick keeps setting photographic problems for himself and then solving them," Diane remarked. A major challenge for him had always been celebrity portraits because, he explained, "Celebrities have the faces of men and women familiar with extreme situations . . . they are defined by their accomplishments." As far back as 1948 (when he'd started serving as associate editor on *Theatre Arts* magazine because he couldn't stand being known simply as a "fashion photographer") he'd taken soft, almost worshipful pictures of stars like Mary Martin in *South Pacific*, Henry Fonda in *Mister Roberts*, a debonair Tennessee Williams posed next to his agent, Audrey Wood. By 1958 the portraits had shifted from show business to the arts in general, and Avedon grew bolder, capturing the hairy poet Ezra Pound as he shrieked into his lens, pouncing on wizened Isak Dinesen until her stare became transfixed. These were followed by a series of savage images, among them Dorothy Parker and Somerset Maugham looking so nasty and exhausted their expressions resembled police mug shots.

Diane was bothered by some of Avedon's methods. She didn't think they were always fair. The retouching—the softening or coarsening of prints—distorted and warped some of his celebrities on film. And while

she was painstakingly slow when taking a portrait, Avedon relied on his brand of rapid "unearned intimacy" with a subject. "Ten minutes" and it's a deep one-on-one situation with two strangers who share a moment. "Then, it's over, and thank you very much and how to get out the door." When asked what it felt like to photograph Ezra Pound or Marilyn Monroe, Avedon responded, "I forget. I'm so split the moment I photograph, I don't remember what they've said or what I've said." Diane couldn't believe he was unable to remember, since she remembered *everything*, but everyone was different. She had already formulated a belief (shared by Steichen) that photography was "born perfect." That an image at its truest should be both literal and transcendent. Diane didn't want the quality of her portraits to be sentimentalized or manipulated; what she hoped for was to dramatize a particular life.

Diane would occasionally voice her ambivalent feelings about some of Avedon's work to others—but never to him. Mostly she seemed to be his biggest fan, just as he seemed to be hers. He stood in awe of her curious talent and she remained impressed by his staying power in a business where there were so many burnouts; his ideas were limitless—and he could always solve the photographer's perennial problem, what to photograph next.

They became dear friends, perhaps because they possessed the same roots. Both were descended from immigrants; their fathers were driven, inarticulate men who had run Fifth Avenue stores at the same time. "Diane and I were so close we used to tell each other our dreams," Avedon once confided.

As a little boy, when he'd done poorly in school, he'd forged his parent's signature on report cards. He failed to graduate from DeWitt Clinton High, which disappointed his family greatly—they'd wanted him to get a good education because they believed education was essential for survival. "But I had a visual intelligence," Avedon would say. As a teen-ager he could not concentrate on math—instead he papered his bedroom walls with Munkacsi's exuberant fashion photographs from *Bazaar* and he collected autographs by writing letters to Toscanini, Einstein, Katharine Cornell. Once he found out that Salvador Dali was staying at the Hotel St. Moritz and went to his suite carrying his autograph book. The eccentric painter greeted him at the door wearing a snake wrapped around his waist. In the background his wife, Gala, stood nude, waiting to be sketched.

After he became a famous photographer, Avedon would try to convince various women friends to pose for him with snakes. In recent years one of his most publicized celebrity portraits was of the beautiful German movie star Nastassia Kinski, totally naked, her body entwined by a huge python.

Diane never saw that picture, but she did see Avedon's huge portrait of Eisenhower looking exceedingly absent-minded. She loved it "because Ike's expression is like he came out of the womb too soon." (It bore a slight resemblance to the ID shots Avedon took by the hundreds when he was in the Merchant Marine during World War II. That was part of his training as a photographer.)

Later Diane would say, "Dick does everything with grace." He had originally fantasized becoming a tap dancer (he was thrilled when Fred Astaire played him in the movie musical *Funny Face*). He effortlessly moved around his studio; his wiry body appearing even more slender because he often dressed in black suits. Terrified of gaining weight, he existed sometimes on a spoonful of peanut butter a day. Oh, he was gallant, Diane thought—she called him glamorous too, and mercurial and charming with everything—but he had a reserve, he held back. His family life with his wife, Evelyn, and his son, John, was scrupulously private and he had few close friendships apart from Diane—one was with Laura Kanelos, his devoted photo rep. When she died of cancer in the 1970s, he shut himself away from everybody for days. Ultimately he would move into his studio and live in one room, but during the sixties he kept an apartment on Park Avenue. Even so, he spent most of his time photographing in his studio, where everything seemed synchronized down to the last minute.

His studio with his many assistants was a miracle of organization and efficiency as far as she was concerned, she who was so inefficient! And the way he made so much money—$100,000 for one Revlon account, another $100,000 for CBS Records—he could complete shooting the accounts in a month or two and then be free to concentrate on personal work. Avedon showed "grace under pressure," Diane believed, including the time when one of his secretaries dropped dead in the studio and he'd got everybody involved. "It was a shocking occurrence," a friend said. "Happened right in the middle of a fashion shooting. Dick had never seen anyone dead close up before. He made everybody from *Bazaar* come to her funeral, and afterwards at the magazine's advertising conference, where he was supposed to talk about upcoming styles, he spoke instead very movingly of the girl's untimely death. Diane thought that was a terrific thing to do."

For his part Avedon thought Diane was a genius—a photographer with a rare and special gift. Marvin Israel called her an artist. "Avedon for all his phenomenal success was very insecure about his talent," Lee Witkin, the gallery owner, says. He wanted his pictures to be considered—noticed; more than anything, he wanted not to be thought of as "merely a fashion photographer."

In time he would be able to see that his fashion work was truly remarkable—unique. He would accept the fact, and he would also be influenced

by Diane—by her patience, her endurance, by her collaborative, confrontational portraiture organized around a single focus: the face.

But an Avedon would still be—distinctively—an Avedon, more isolated and energized than an Arbus and always immaculately, superbly printed on gleaming white semigloss or matte simulacrum to make the subjects stand out with a kind of hallucinatory sharpness.

Like Diane, Avedon used a Rollei, but eventually he switched to the old-fashioned 8 x 10 Deardorf camera "because I no longer wanted to hide behind the camera. I wanted to meet my subjects man to man. I wanted nothing to help the photograph except what I could draw out of the sitter."

He was now insisting on alternating his fashion pages in *Bazaar* with faces that interested him. He'd become obsessed with documenting the similarity between faces, matching up unlikely combinations: the baby doctor—the murderer (can you tell who's who?). He made Nancy White give him extra pages in which to publish his portraits of marriages in City Hall, or his portraits of the Student Non-Violent Coordinating Committee.

He was given total support by Marvin Israel, who was making the magazine's design concept as distinctive as its editorial content. He sent Robert Frank to Poland and Russia to photograph fashions against grim totalitarian backdrops; he hired Stan Vanderbeck to create imaginative collages; he applauded Avedon's idea of taking pictures of Countess Christina Paolozzi baring her breasts, and of photographing the Paris collections with the beautiful model China Machado surrounded by mottled, wrinkled, aging members of the French press.

Israel would talk of his future plans for *Bazaar*: yes, it would reflect trendy clothes and images, but also life as seen by Fellini. Dale McConathy, its former features editor, says, "Marvin loved *La Dolce Vita*. He wanted to capture the feel of that movie with its suggestions of tabloid sensationalism—upper-class apathy and corrupted sensuality; he wanted to capture that in the pages of *Bazaar*, in between the ads for perfume and jewelry and the editorials on lingerie and furs . . . and Marvin and Avedon had 1950s cultural heroes they longed to immortalize—cultural heroes like Carson McCullers, Truman Capote, Oscar Levant, who were starting to be physical *wrecks*."

Needless to say, Diane's severe vision—her fascination with freaks and eccentrics—seemed to be an asset, a weapon if you will, to wield against Nancy White, *Bazaar*'s stylish but rather conventional editor-in-chief.

Diane was dropping in at Richard Avedon's studio with increasing regularity and he always encouraged her and gave her technical advice. Occasionally they would exchange stories about how they had achieved a particular photographic result, but that was rare—Avedon ordinarily didn't reveal his tricks. Nor did he praise other photographers except for

Diane, though he admired Irving Penn. "What's Irving up to these days?" he'd ask.

Once he did confide how he got the Duke and Duchess of Windsor to appear so surprised in his ravaged portrait of them for his book *Nothing Personal*. He reportedly arrived at their Waldorf Towers apartment and began setting up his cameras as the royal couple carefully arranged themselves. "I'm sorry I'm late," he murmured, "but the most terrible thing happened—my cab ran over a dog."

The Windsors (both dog-lovers) gasped. "Acch!"

Click! went the shutter.

Diane liked that story and another he used to tell about the time Charlie Chaplin hid out for a day in his studio, hoping to avoid the immigration authorities. During that day Avedon snapped dozens of increasingly frenzied portraits of the great clown making faces at him through the lens.

Diane thought her own anecdotes about getting pictures weren't as "classy." Her stories were about how she'd finally been able to track down a hermit only to find he was "uh—a man more than a hermit." Then there had been the weird meal she'd shared with two transvestites in a diner . . . after she'd photographed them at a drag-queen ball.

At first she didn't have much to say when she visited Avedon to show him her latest prints. He and Israel were the only ones she trusted enough to let them see her rough, private work in progress. Usually the three of them would huddle over her latest set of contacts with magnifying glass and grease pencil. In these sessions Israel would demonstrate what museum people like T. Hartwell called "genius" because he would invariably help Diane choose from her contacts the shots which best revealed her personal style. He knew what made visual sense. He would often tell her to go back and shoot some more, or he might suggest cropping a photograph in a particular way that would result in a more powerful result. Neither he nor Avedon would ever tamper with her unique approach; all they could really do was encourage her, nurture her. The three of them developed a more or less free-floating system of equals. "They respected each other so much," the photographer Neil Selkirk says. What bound them together in that studio more than anything was a kind of shared energy. "And nosiness," he adds. As a trio they were insatiably curious, wandering the city together, until Diane went off to photograph in her "forbidden places" alone, returning with pictures and stories that often left the men howling. "These shreds of life stories are what she found from the people she photographed," Doon Arbus writes, "and when she told of these encounters, . . . she would become like someone possessed—possessed by phrases, accents, and peculiarities of speech, and bursts of laughter over her own performance."

"A photograph for Diane was an event," Marvin Israel said in a televi-
sion interview. "It could be argued that for Diane the most valuable thing
wasn't the photograph (the result), it was the experience—the event. She
was absolutely moved by every single event, and she would narrate them
in detail. She wouldn't just say, 'I took a photograph of so and so in their
home.' It was the going there—being there, the dialogue that came back
and forth, the moments of just waiting—no talk. It was an incredibly
personal thing and once [she] became an adventurer—because Diane
really was an adventurer—she went places no one else [no photographer]
had ever gone to. [Those] places were scary . . . But once [she] became an
adventurer [she was] geared to adventure and she sought out adventure
and [her] life [was] based on that . . . the photograph was like her trophy
—it was what she received as an award for her adventure."

After she had shown her latest photographs to Avedon and Israel and
told them her latest adventure, she might take off with Alen McWeeney,
the young Irish photographer who was then Avedon's assistant. They
would settle in at Grand Central Station and photograph the people hang-
ing around the waiting room late at night, and then they might go back to
the Charles Street house and talk about photography. "But she showed
me few of her photographs," McWeeney says, "even though I knew she
was working on a lot of new stuff."

She was starting to photograph more mythological types—dwarfs and
a giant. She never explained why she was so drawn to these fabled crea-
tures, but then Diane never gave specific reasons for anything she did
artistically. It was simply that the best pictures she took reflected her
attraction to the subject. Like Morales, the Mexican dwarf, whom she
photographed over and over again for years, getting to know his habits,
his thoughts. Eventually she posed him squatting bare-chested on his bed
with his hat on. By that time the rapport between them was palpable,
almost erotic, and you can feel it emanating from the image. "Taking a
portrait is like seducing someone," Diane told John Gossage.

The same thing happened when she began photographing the 495-
pound, eight-foot-tall "Jewish Giant," Eddie Carmel. Diane kept shooting
him for almost a decade, not printing the negatives until 1970 because
"the others were just—pictures." She first photographed him in the insur-
ance office on 42nd Street where he worked selling mutual funds. Next she
photographed him wandering around Times Square in the penny arcades,
looming above the traffic. In a good mood he would make up poetry for
her—"a kind of calypso," Diane said. "You would give Eddie a word or
two and then he'd compose a poem."

She felt in awe of his enormous height—particularly when she photo-
graphed him alone in a room. She said later to a class, "He's really very

moving, when he lies down, because he looks in a way like Alice. I mean there's something extraordinary about the way he fills a couch. I don't know—like a mountain range."

Throughout the years Diane and the giant developed a friendship of sorts. He confided in her that he still dreamed of being a great actor, but the only parts he could get on TV were monster roles. (He had played the son of Frankenstein's monster in a film called *The Head That Would Not Die*. In it he had chomped off a man's arm and tossed a half-nude girl across a table.) He bragged to Diane that he had auditioned for the lead in a Broadway show—that of a tall basketball player in *Tall Story*. He hadn't got it because he was *too* tall. Diane remarked that her brother had written the original version of *Tall Story*, the novel *The Homecoming Game*, but Carmel didn't seem impressed.

Eventually he invited Diane to photograph him at his home in the Bronx, where he lived with his normal-sized parents. Even though he was slowly dying of bone disease, he kept talking about joining a carnival. He had played the Tallest Cowboy in the World for Ringling Brothers' circus at Madison Square Garden.

From 1962 to 1970 Diane kept returning to the Carmels' cramped apartment until she finally captured the image she wanted—certainly one of her most memorable—in which giant and parents confront one another.

At one point she excitedly phoned Joseph Mitchell at the New Yorker. "You know how every mother has nightmares when she's pregnant that her baby will be born a monster? I think I got that in the mother's face as she glares up at Eddie, thinking, 'OH MY GOD, NO!' "

Gradually toward the end of 1962 Diane's freakish subject matter—the dwarf, the giant, the changing cast of characters at Hubert's Museum—was joined by another major project: nudists. She was to spend the next five years photographing nudists in camps around New Jersey and Pennsylvania. She hoped these portraits of dense, impenetrable "naked people," as she called them, would result in a book, with lengthy captions to be written by herself. Once she laid out all her pictures for John Gossage sequentially to show him how these images could tell a kind of story—the family of overweight nudists lying in the meadow; the leathery retired nudists who posed with nude pictures of themselves lolling in easy chairs; the slightly potbellied nudist lovers who reminded one of Adam and Eve; the nudist kids.

Many of them looked like statues to her—indeed, most of the nude figures she photographed fill the picture frame with weighty masses—you can almost feel the bulk and earthiness of their existence.

But Diane's book of "naked people" was never published because she couldn't get releases; nevertheless, photographing at the nudist camps was a singularly provocative experience for her because she collaborated so completely with her subjects; in order to get permission to photograph them, she had to agree to be naked too, which challenged her subjects as well as herself. "You feel silly for ten minutes and then it's okay," she said. "Nudist camps was a terrific subject for me." She polished her stories about photographing nudists by repeating them over and over again to Marvin Israel, her daughters, and friends. She would say that her first impression "was a bit like walking into a hallucination and not being sure whose it was. I was really flabbergasted at the time . . . I had never seen that many men naked all at once. The first man I saw was mowing his lawn."

She developed many theories about nudist camps. "They run the whole social gamut," she would say, "from people in tents (a lot of people are nudists because it's cheap) to people in trailers and homes—mansions almost . . . and you have a whole microcosmic society where everybody is supposedly equal . . . New Jersey is riddled with nudist camps because they're not allowed in New York State."

She might talk about another phenomenon—urban nudists, called Jaybirds. These were people who never went to nudist camps—they lived in the city in apartments, and when they got home they took off all their clothes.

She would recount a time when she met a prison warden at a camp: a warden from Sing Sing who spent hours watching the nudists trail down to a beach. And he would try to guess what kind of jobs they had from the accessories they wore. They were all stark naked, but the men smoked pipes and wore shoes and socks and others stuck cigarette packs into their socks . . . the women sport hats, earrings, necklaces, and high-heeled slippers or moccasins. "It was really loathsome," Diane said.

She told of a nudist camp where there were two grounds for expulsion: a man could get expelled for having an erection, and either sex could get expelled for something called staring. "I mean you were allowed to look if you didn't make a big deal out of it."

She recalled playing volleyball nude. "You're always jumping, and it's most uncomfortable without clothes . . . you're sort of jiggling and you can't just quietly miss the ball and let someone else take the blame. It's like a big production."

After a while Diane said that she "began to wonder about nudist camps . . . there'd be an empty pop bottle or rusty bobby pin—the lake bottom oozes in a particularly nasty way and the outhouse smells, the woods look mangy—it gets to seem as if way back in the Garden of Eden after the fall

Adam and Eve begged the Lord to forgive them . . . and in his boundless exasperation he'd said all right then, stay in the Garden. Get civilized. Procreate. Muck it up. And they did."

This particular period—1962–4—was one of the most productive and energizing periods of Diane's life.

She had finally adjusted to the Rollei, and one of her first set of prints made with it and completed in 1962 was of kids playing grown-ups—kids posed like Rogers and Astaire for a dance contest; there was also the now famous shot of the grimacing boy with a toy hand grenade, taken in Central Park.

Now she was not only deeply involved with her own work, she had magazine assignments, including several from *Show*, although *Show*'s art director, Henry Wolf, wasn't entirely pleased by her crude, abrasive work. "I couldn't use the pictures she shot for Gloria Steinem's story on movie theaters in Ohio—they weren't that good—and I refused to publish her portrait of the human pincushion, even though she kept urging me to." Wolf, a cultivated gentleman who later headed a successful advertising agency with Jane Trahey before becoming a photographer, confesses, "Diane always made me feel guilty for enjoying myself. Once I ran into her on a beautiful Saturday morning all decked out in her cameras. 'What are you doing on such a gorgeous day?' I asked. 'Trying to find some unhappy people,' she answered. Well, I couldn't relate to *that!*"

Alan Levy, who worked with Diane on another story for *Show* in 1962, has a very different memory, and he wrote about it in *Art News*: "she introduced herself to me over the phone with a giggle as [Diane Arbus] your photographer . . . when I met her, small and trim in black sweater and brown leather skirt, she looked like a teenager." Together they documented the making of a TV commercial for National Shoes. "I have never had more fun being paid to work than I did with Deeyan, as everyone pronounced her name. Our trail led us to a host of talented people with fascinating names and titles. The ad agency chief was named Mogul, the account supervisor, Gutteplan . . . The National Shoes official in charge was the low heel buyer . . . Deeyan, her eyes widening like camera apertures, watched several of our subjects wining me and dining us (Deeyan didn't drink). She was, she said, a person to whom funny things happened. She also confessed to having a radar that verged on the embarrassing. 'I can walk into a room and tell who's sleeping with whom. Sometimes I can even tell this before it's happened. I mean, later they'll make contact and eventually end up in bed.' "

Levy found that she was a voracious reader—she quoted Kafka and

Rilke and urged him to read Borges. One weekend morning she took him on the subway to Coney Island and made him peer into the face of every horse on the merry-go-round. "Deeyan taught me to look closely at things we look through. She was right about every horse being different from all the others."

They had only one fight, Levy writes. When they finished the *Show* story, he was pleased with the result, but she wasn't. She didn't want her byline under the pictures (tiny ones laid out rather like a comic strip). "On the other hand, I wanted to share a byline with her as badly as I wanted anything in 1962," Levy finishes, "so I bullied her, writing at least one impassioned letter complaining that she was hurting me. At 3 o'clock on the last afternoon before the issue was to be locked up she phoned and said alright."

Not long after that she went to California for *Show* to photograph the aging camp symbol Mae West, who'd agreed to pose in the white-and-gold bedroom of her Hollywood apartment. (Whenever she had visitors, sleek, mute muscle men stood at attendance; nobody ever commented on the monkey turds imbedded in the pale fur rug.)

Diane arrived in the early afternoon. The shades were drawn, the lamps lit, and West appeared to wade through the shadows with her ludicrous walk and gutsy insolence. While the camera clicked, she spoke of her dependence on health foods, enemas, therapeutic sex, all in an effort to stay young. "Stay outa the sun!" she warned Diane gruffly. "The sun wrinkles!" She added she hadn't left her apartment during the day for years "because I HATE THE SUN." Diane answered that she didn't much like the sun either—the light was too bright, too jarring; it gave her the jitters—made her squint. The two women agreed that they much preferred darkness.

After the session West handed Diane a $100 bill and said, "Thanks, honey" before sashaying off into another room. Diane guessed this might have been a habit—during the 1930s she'd tipped still photographers who snapped her on the movie set. Diane returned the money with a note, saying how thrilled she'd been to meet her. When the harsh black-and-white layout appeared in *Show* magazine, however, West was furious and had her lawyers write a threatening letter to the publisher, Huntington Hartford, claiming that the pictures were "unflattering, cruel, not at all glamorous." Diane was upset. "She was genuinely surprised when subjects disliked what she found in them," Charlie Reynolds says. Yet there was something beyond Diane's surface images that invariably disturbed. In this case West—despite her flauntingly curvaceous body—did not come across as a creditable woman. And her bedroom setting mirrored an imitation of reality only Hollywood could devise.

. . .

After Diane returned from California, Hiro would occasionally stop at the Charles Street house for an early breakfast before going on to Avedon's studio. "Diane would cook me an egg and she'd show me her Hollywood contacts," he says. She had done stills when she was out there, too, of Disneyland's fake rocks on wheels and a house on a hill, which was shot from an angle to reveal the supporting scaffolding behind the false front. The illusion seemed very personal and possibly a metaphor of the emptiness and pretension she'd hated about her past.

"But it was her portraits that got to me," Hiro says. "That subject matter! I remember Irving Penn saying to me once, 'How does she do it? She puts a camera between her bare breasts and photographs those nudists.' He couldn't get over it and neither could I."

Although he would soon become a virtuoso with cameras (alternating between instant strobe and Polaroid and slow-speed large format), Hiro thought portrait-making was the most difficult process of all. "It's almost trancelike—and the photographer has to give up some control." Hiro, of course, made classic portraits of Maya Plisetskaya, the Rolling Stones, Mifune, but Diane especially loved the picture he took of his tiny sons wearing grotesque masks. He gave her a print and in exchange she gave him her family of fat nudists lolling in the tall grass. Throughout her career Hiro would always be there for Diane—cool, analytical, seemingly dispassionate, offering darkroom advice, lending her cameras.

He was one of the few photographers she knew who not only thrived on the diversity of his fashion and commercial work (he photographed everything from emeralds and paper shoes to the launch of the Apollo 11), but believed such variety essential since it vitalized his more personal projects. He also enjoyed making a great deal of money, and gave credit to Avedon for teaching him how to market his special talents.

Diane, on the other hand, felt ambivalent about being paid for what she was doing. She was always ashamed of making money. "When I make money from a photograph, I immediately assume it's not as good a photograph," she once said. But this attitude didn't keep her from accepting more assignments; she was getting a great many from Robert Benton at *Esquire* now, "practically one a month," Benton says. She photographed stripper Blaze Starr dancing with her little dog across a violently patterned rug; she photographed Jayne Mansfield and her daughter, and city planner Jane Jacobs and her son, and Ozzie and Harriet Nelson looking faintly disagreeable.

"Diane would come up to the art department with her latest contact sheets and she always managed to surprise me," Benton goes on. "Or

rather she would reverse my expectations." Blaze Starr with her sequined nipples, Ozzie and Harriet, the middle-class ideal, and dumpy, proud mother Jayne Mansfield were photographed with the same intensity as her New York freaks. After a while Benton came to see that "we" (meaning the viewer) looked no different from "them" (meaning the subjects). "It was Diane's idiosyncratic style—her deceptively simple, singular approach that leveled all her subjects, regardless of who they were, and made both freak and normal appear in some aspects the same. The term 'freak' or 'normal' in her context became meaningless. Because Diane had made no distinctions—no concessions either."

David Newman (Benton's sometime partner) adds, "Diane made no concessions when she photographed Benton's wedding to Sally. And they are absolutely sensational pictures which Benton has in his living room to this day. Diane documented every single detail of that supposedly conventional ritual—rituals were what Diane was obsessed with, right? She photographed everything in sequence and she became part of the celebration. I remember her clicking away as Sally struggled into her wedding dress with her mother trying to help her—I remember her right after the ceremony crouching on the floor of the limousine, clicking away like mad."

In May of 1962 Tom Morgan went off to write about a peace march for *Esquire* and Diane covered it with him. The two of them joined thirteen pacifists who were somewhere in Maryland protesting the arms race. (They had begun the seven-hundred-mile march in Hanover, New Hampshire, and planned to end it at the Washington Monument.)

Twenty-one-year-old Paul Salstrom, the tall, sober leader of the march, was a conscientious objector from Illinois. He remembers Diane as "strong—athletic, muscular legs. She walked along with us for two days straight without tiring at all and she photographed everybody"—everybody like Marcie Bush, the sixty-year-old blind man who sold vending machines in Philadelphia, and Joel Kerr, who raised trees in Vermont, and Penny Young, the most experienced protester, who had been in demonstrations against the Atomic Energy Commission and spent five days in jail.

Salstrom says, "Diane spent time talking with all of us." He thought she was "totally apolitical but a humanist." He was impressed by her "because she seemed serious without being heavy about it." Diane ended up taking an individual portrait of every member of the march, but when she gave her rolls of film to *Esquire*, Robert Benton blew up the long shot of the thirteen pacifists trudging along a highway, flags and posters flapping in the wind, and he bled it across a two-page spread. It is a very

striking image that reminds the viewer of a medieval children's crusade —a crusade that is doomed, without hope of progress or relief.

Benton says Diane was "producing like crazy for us all during 1962, '63, '64." He was very pleased with what she was doing; her haunted, eerie images seemed to complement the jazzy, edgy journalism Clay Felker and Harold Hayes were conjuring up. Sometimes, after going over a layout with Benton, Diane would go out to the corner Schrafft's with him and David Newman to "share bacon sandwiches and talk." Benton believes she was almost happy then, "because she was part of a family again."

The family in question was journalist Thomas B. Morgan's. Morgan hailed from Springfield, Ohio, and he regularly wrote profiles for *Look* and *Esquire*. He and his wife, Joan, and their children lived across from Diane's converted stable in a lovely Federal house they'd just bought; the two families shared a common court.

"Actually, it was just a compound," Morgan says. "Our two houses were surrounded by a wall which backed the Sixth Precinct. Years ago the police kept their horses in the reconverted stable Diane now lived in."

Diane got into the habit of visiting the Morgans at least once a day. "Sometimes she'd whip up a batch of chili and we'd all share it," Morgan says. "Diane and I had chili-making contests because I thought I was the best chili-maker in the world until I tasted hers." When she wasn't photographing, Diane would spend hours in the Morgan kitchen listening to Tom and Joan talk. Usually Pati Greenfield would be there too—Joan's "best pal." And Diane became close to them both. "They were all married to restless, ambitious men who were away from home a lot—myself included," Morgan admits. "They were into making nests, so their friendship was very much a female-bonding kind of thing. I'd come back from an assignment and they'd seem to be communicating together in the kitchen in a language I didn't understand." Pati was tall, big-breasted, hugely energetic, raising five kids in a house on West 22nd Street. Diane admired her because she seemed the perfect maternal figure—available, responsible, uncomplaining. She was able to juggle everything simultaneously—hold a child in one arm while stirring a stew with the other. The three women would take turns baby-sitting for each other; they'd shop together in the markets and cheese stores around Greenwich Village, and on Saturdays Amy Arbus might go out to Wading River, where the Morgans and the Greenfields had weekend homes.

(In 1967 Pati Greenfield was the victim of a strange accident. Deeply depressed and on too many tranquilizers, she either jumped or fell from the second-story window of her house, pitched onto the sidewalk, and cracked open her skull. In 1971 Diane committed suicide, and Joan Morgan found herself surrogate mother to the Arbus and Greenfield kids. She

would never discuss either of her dead friends. "The whole thing is too personal, too painful," she cried.)

During the 1960s the atmosphere between the Arbus and Morgan families was harmonious and loving. "There was only one unsettling incident," Tom Morgan says. "Unsettling because Diane and I so violently disagreed."

It started when a close friend of Morgan's, the artist Paul Von Ringleheim (known for his huge environmental sculptures that embellish shopping centers), stopped at the Arbus/Morgan compound one afternoon and on the spur of the moment proceeded to decorate an entire interior wall of the courtyard with a mural. "It was twenty yards long and fifteen feet high," Von Ringleheim says. "I wanted to show how you could control space with color. The Arbus and the Morgan kids got into the act, with me splashing paint around. While I was doing swirls and squares on one wall, they did a mural on the opposite wall which had a more primitive, less abstract cast—jungles, birds, that kind of thing."

Everybody seemed enthusiastic about murals, but a week later Diane strode into the Morgan kitchen and told Tom, "I hate Paul's mural. Really hate it. It gets on my nerves, and I'm forced to look at it every time I walk outside. I want it painted out." Morgan says, "This caused some consternation since Paul was—is—one of my best friends and, I think, a fine artist. I didn't know what to do. But Diane wouldn't rest until something was done. We finally had a two-family conclave and Diane gave an impassioned plea and I gave my opinion. It was voted that Paul's mural be painted out, and only then did Diane calm down. She could be very determined when she wanted to be, but her determination always surprised me because she was usually so reticent."

Every so often, without any explanation, Diane would break into tears at the Morgans' and stumble back across the courtyard to her own little house. Once her sister phoned her from Michigan—"I always phoned D, she never phoned me"—and suddenly Diane was sobbing into the receiver about not getting over the break-up of her marriage. She didn't blame Allan, she kept saying, because they'd grown away from each other, they'd found they weren't what they'd thought they were—that they wanted different things—but why couldn't they still be married? It had never occurred to her that their marriage might be anything but permanent. Why, you could be on the other side of the world—you could have lovers —and *still be married*. It was like having a sibling. Even if you had nothing in common with that sibling, you could never lose a brother or a sister or a husband except in death. But she had been wrong, and now she was

disillusioned because she'd once believed so completely in the loony fantasies she'd had as a teen-ager about love and marriage lasting forever. These fantasies were now being replaced by the sexual battling between herself and the various men she was going out with.

She tried to keep from most people the torment she continued to experience over the end of her marriage. Eventually she began telling friends she no longer believed in love, and when Pati Hill wrote a short novel entitled *One Thing I Know* about the death of an adolescent passion, she dedicated it "to Diane Arbus." Diane scribbled ironic comments in the margins of the galleys Pati sent her from Paris, and yet when her goddaughter, May Eliot, told her that she was determined to marry a man she was crazy about, "Diane was delighted. She thought it was wonderful when people married the first person they fell in love with." She told May that she and Allan were really good friends and that their separation was relaxed and civilized. They were too polite for it to be otherwise.

May Eliot remembers going to breakfast at Charles Street and Allan dropping in, as he often did, and Doon and Amy were crowded around the table along with Sudie, the baby-sitter, and "there were big wine goblets filled with orange juice and the coffee mugs were brightly colored enamel with white insides and everybody giggled and joked about all sorts of things personal and cosmic."

But there was strain. De Antonio remembers visiting Charles Street and "Diane was trying to play the mother who took care of everything, and she laughed and smiled a lot, but the obligation to her children was an overwhelming burden for her." She was obviously under great pressure and weighed down by the responsibilities of raising two daughters mostly by herself. But she never complained; she went from grocery-shopping to helping Amy with her homework to advising Doon about one of her writing assignments before dashing off to photograph someone for *Esquire*. "I always saw Diane hurrying somewhere," Robert Benton says. "Getting in and out of cabs, lugging those cameras—she was frequently late. Or the cab hadn't got to the right address. It was always a drama." And Allan was helping her print. She could spend hours working on a negative under his guidance. Once a fashion editor who'd worked with them for over a decade found them huddling over a tray of hypo. "Allan was whispering something in Diane's ear—she had a sly little smile on her face. It was just like the old days at *Glamour* magazine. They still seemed very close."

And they were. Allan would often introduce Diane to the women he was seeing—she would tell him about Marvin Israel's plans for her career. However, she told Tina Fredericks that she never could see Marvin as much as she wanted to. Oh, they might meet at a party or run into each other at an art gallery; but ideally she wished he could be available for

comfort and advice twenty-four hours a day. Allan was still like that, and —when he was in New York—Alex Eliot, and sometimes her brother, Howard.

Meanwhile, Marvin Israel remained devoted to his wife. A shy, prodigiously gifted woman who rarely left their 14th Street studio, Margie Israel, née Ponce (she'd been born in Cuba), was totally consumed by her art. A master craftsman—she could sculpt, paint, sketch, build, and she invented various mixed-media combinations: plaster, ceramic, and papier-mâché sculpture, blackboard drawings, fabric constructions involving feathers and stained glass. Israel frequently mentioned his wife's impressive achievements to Diane; he was proud of her and took loving care of her. She was often in delicate health, but he never allowed her to go to a hospital; instead he nursed her himself.

Now that he was busy with his job at *Harper's Bazaar*, he had less time for Diane, so she would periodically wander over to the *Bazaar* offices at 56th and Madison Avenue, ostensibly to rustle up another assignment but actually to be near him for a while. She might wait in the fiction editor's cubicle, giggling over Alice Morris' gossip about the latest books. At some point Israel would pass by—she could count on that. Listening for the soft pad-pad of his tennis shoes, she could always sense his approach. He would saunter into view. She wouldn't even look up at him. They wouldn't exchange a word, and he would walk on.

Marvin Israel had a slight, muscular build, very trim. He exercised ferociously. Geri Trotta, *Bazaar*'s features editor, remembers he wore expensive but frayed clothes and had his hair cut by his pretty English secretary. Trotta once observed this being done in the art department. "Marvin perched on a stool scowling as the scissors clip-clipped." Nearby his two assistant art directors, Bea Feitler and Ruth Ansel, pasted up the layouts.

Bea and Ruth had been Israel's most brilliant students at Parsons. They were both twenty-three and precocious, original designers. (Later Ruth became art director of the *New York Times Magazine* and Bea would design *Ms. Magazine, Rolling Stone*, and, just before her premature death in 1982, the new *Vanity Fair*.) Back in the 1960s they were already copying Israel's cold, abrupt manner with editors and photographers, but they were unusually tender and solicitous to Diane, gave her many assignments, and allowed her free run of the art department. She came and went, and long after Marvin Israel was gone, the *Bazaar* office was one of Diane's chief places for hanging out.

Eventually the three women became friends. Bea, in particular— husky-voiced, imperious Bea—would invite Diane up to the stylish little apartment she kept on West 56th Street. She gave many parties there,

mixing French fashion models with Italian movie stars and the trendiest American designers and painters. The parties lasted late and there was, a guest said, "a bacchanal feel to them." "Plenty of wine and drugs and thumping disco music," recalled the late Chris von Wangenheim. "A lot of the guests were what you'd call polymorphous-perverse."

Bea came from a wealthy Brazilian family, and that, too, helped bring her and Diane together; they shared an understanding of the problems and pleasures of being born rich. Eventually Diane gave Bea some of her private unpublished photographs and she may have spoken to her about her increasing obsession with Marvin Israel. Bea was very close to Israel. She cared about him and she cared about Diane, too; as the years slipped by, she went on hoping that nobody would get hurt.

Sometimes, after leaving *Bazaar,* Diane would wander the streets before going home. And if Amy was being taken care of by Doon or a baby-sitter, she could stay out as late as she wanted—prowling about Grand Central Station, 42nd Street, and the bus terminal. She met the *Village Voice* drama critic, Arthur Sainer, in the Sheridan Square subway station on New Year's Eve, on her way to covering a big party. She dropped a lens from her camera bag and it rolled across the platform; Sainer ran to bring it back to her and they started talking. It was the only way to meet people, she thought. Spontaneously. No formal introductions, no planning.

She'd met the novelist John A. Williams (author of *The Man Who Cried I Am*) casually, at a party celebrating the publication of Tom Morgan's first book. Williams recalls: "Diane looked straight at me, then looked away, giggling, because Tom was trying to get her to go out with another one of his friends and she refused. Instead we went out to dinner—to some Spanish restaurant with Dave and Heije Garth. Diane told me she'd known we'd be together from the moment she laid eyes on me.

"Diane's friendship was nice," he continues. "No demands. We saw each other on and off for eight months and then I got married. Diane knew my plans." He would phone her in the evening and she'd usually stop off at his place, which wasn't far from hers in the Village. They would be together for a while and then he'd put her into a cab and she'd go home. She never asked him about his life. (At the time Williams' writing grant from the American Academy in Rome had just been withdrawn, with no reasons given. He believes it was because he was black and about to be married to a white woman.)

"Diane did ask a lot of questions about my family," he says. He told her that his mother had been a domestic and his father a day laborer, and

that one of his mentors in Syracuse, where he grew up, was a redcap at the railway station who was also a numbers runner.

In turn, Diane described her childhood to Williams. "She connected her identity to Russeks department store and with money, but she seemed ambivalent—almost angry about it."

She never talked about her photography except to say that she was trying to photograph some Hell's Angels gang. Williams asked her if she was frightened. She said she was *always* frightened, no matter what she did—she lived with fear and overcoming fear every day of her life.

"Sometimes," Williams says, "I got the feeling that Diane wanted me to treat her badly. But I wasn't into chains and punching in the mouth. I thought she was probably bisexual. Why I suspected it I don't know, except that she was inordinately sexy. There is something challenging and triumphant for a man if he can please this kind of mysterious creature, and I think I did."

Diane, in fact, would say that she went to bed with women but "liked men better." Apparently she did have occasional intimacies with women, but these liaisons were always discreet; Diane didn't talk about them. Emile de Antonio used to accompany her and two of her women friends to the movies and he always felt acutely uncomfortable, even though no one said or did anything out of the ordinary. It was just that "Diane could create a very pervasive sexual atmosphere around her and she had an especially tender, insinuating way with the women she was attracted to." It was as if she could not only sense the person's deepest needs and most passionate demands, but seemed to suggest that she was willing to comply with any of them.

"Diane was many things to many people," Marvin Israel has noted.

A New York hostess tells of a Halloween party she and her husband gave in the early sixties, "where many people seemed wired—on speed. Most of the art world came—Warhol, Frank Stella, de Antonio, Jasper Johns. Diane was there, hopping around with her cameras. I was costumed as Theda Bara. Bea Feitler wore a mask. We were both very drunk and Diane photographed us falling all over each other. Then she asked us to pose nude. We both refused. There was a lot of tension between Diane and Bea because Bea loved Diane—and she wanted Diane all to herself. She'd act possessive, but Diane would have none of it—she'd turn remote and detached, which drove Bea crazy. Come to think of it, everyone who ever cared about Diane became very possessive about her."

If at this point in her life Diane needed to have men and women fighting for her attention, there must be a connection to the unhappy truth that since Allan's departure she had often experienced an aching sense of

worthlessness so profound that she couldn't leave the Charles Street house. She had begun having an increasing amount of casual sex, which blotted out—at least temporarily—her feeling of abandonment; in the dark she could touch a stranger and be momentarily comforted.

During this period if you were with her for any length of time and she was in a talkative mood, the conversation might shift to sex and she would question you avidly about your sex life, or suddenly confide a detail about *hers*—that one of her lovers was a distinguished musician old enough to be her father; that the greatest thing about a pick-up or a one-night stand was the terrific sex—because neither one of you wants something from the situation and it isn't exploitative yet, so all you have to do is respond, and sometimes it can be ecstatic.

"I've never heard anyone talk as frankly about sex as Diane Arbus did," Frederick Eberstadt says. "She told me she'd never turned down any man who asked her to bed. She'd say things like that as calmly as if she were reciting a recipe for biscuits."

According to the late John Putnam, "Diane told me she wanted to have sex with as many different kinds of people as possible because she was searching for an *authenticity* of experience—physical, emotional, psychological—and the quickest, purest way to break through a person's façade was through fucking. She referred to such experiences as 'adventures'—as 'events.' Actually, everything she did was an 'adventure.' To talk about her life that way seemed to heighten and justify existence for her."

Morality was not involved. As far as she was concerned, men and women should be free to have as many, and as varied, sexual relationships as they wanted. Whether or not she got emotional fulfillment from any of her regular lovers is another matter. She could discuss technicalities of sex—the fact that she used amyl nitrate (a drug said to prolong orgasm), or that one of her lovers made her feel as if she'd climbed to the top of Mount Everest when he brought her to climax. But whether she was able to sustain or wanted another lasting love relationship—a true commitment with someone—she would never say. Increasingly, Diane maintained that she no longer believed in love and certainly not in sentiment.

It pleased her that in many cases she was now the seducer. The more successful she became with her camera, the more aggressive she became sexually; the camera was her protector, her shield, and it gave her access to forbidden places and she took advantage of that.

Some of the women Diane talked to thought she was merely experiencing "cheap thrills." "It was a turn-off whenever she'd tell me about the men she'd had," one woman says, adding, "It depressed me to hear that her 'adventures' were so limited—it was such a literal submission." But others admired her for her daring; they believed she was "fucking for

liberation" (women affirming the need for sexual pleasure *is* political); they felt she was breaking a taboo by not only frankly acknowledging her sexual needs but acting on them. (Her attitude about breaking taboos was well known to her intimates. Among her friends she had been the first to speak openly about masturbating, about her pride in her menstrual flow. She spoke about her attraction for blacks; she revealed her obsession with a married man.) Kathy Aisen, a young artist who posed nude for her, says, "Women of my generation considered Diane Arbus a heroine. But I wished she'd done her screwing around *before* she became a mother. I wonder how her daughters felt."

Diane never thought of herself as a revolutionary, let alone a feminist. And with her male lovers she continued to play the role of helpless female while bragging to them of her sexual conquests. "She had a dual persona," says one man. "She was sexual victim/lusty lady rolled into one. She told me she would have been devastated if I hadn't wanted her."

During this period she went on seeing Marvin Israel (who, it is said, alternately scolded and applauded her for the way she was leading her life). She might accompany him to Robert Frank's new apartment on West 86th Street, where the two men would hold earnest conversations that would often erupt into arguments while Diane sat in silence on the couch. Sometimes Israel's outbursts were excused or ignored because he was a diabetic; sometimes his rages would break out if he went too long without his insulin shot. For whatever reasons, Diane seemed to enjoy his disturbing theatrics—his hostility in public. "Because underneath Diane was hostile, too," de Antonio says. "Marvin expressed hostility for her."

25 _____

Although there were a great many fine women photographers working during the sixties (Margaret Bourke-White, Louise Dahl-Wolfe, Eve Arnold, Toni Frissell, Ruth Orkin, Inge Morath, to name only a few), Diane did not associate herself with them. With the exception of Lisette Model, she never sought out women photographers for either advice or friendship. But she did bring her photographs for Tina Fredericks to comment on; she continued to do so even after Tina had left magazines and gone into real estate on Long Island.

Diane would also show her contacts to Walter Silver, a documentary photographer who lived near her in the West Village. Diane liked his work and he liked hers. "We'd compare prints," Silver says, and then sometimes Diane would have coffee with him at the Limelight, where many photographers still hung out—photographers like Weegee, Robert Frank, and Louis Faurer. "We'd all sit together at a big table and Diane would sit with us," Silver adds. "She'd never say a word—she'd just listen and then suddenly you'd look up and she'd be gone. She was the only woman who ever was in our little group."

Which was her choice, of course, but some people got the feeling that Diane thought of photography as a man's profession. "I remember, though, that once I mentioned that women might be better photographers than men because women can inspire greater confidence," John Putnam noted, "and Diane said, 'Look, I'm a *photographer*, not a woman photographer.'"

As for making a great photograph, Diane believed men and women were equal, but she also knew that for many of her magazine assignments she was being paid half what a man would be paid and this bothered her. Still, photographing for magazines was the only way to survive; all the photographers she respected did magazine work. Walker Evans, for example, had subsisted for years on the money he earned from *Fortune*. He was contracted to do one tycoon a month for the magazine.

Marvin Israel wanted Diane to meet Evans, who had encountered

Helen Levitt and Robert Frank at crucial times in their careers. Diane was at a turning point in hers, but she was afraid to meet Evans, so she kept putting it off. She was still struggling to find her themes and master a style. She was afraid he wouldn't like her work, wouldn't like *her*. She revered Evans—revered his clear, straightforward portraits of Hart Crane and Lincoln Kirstein, his secret candids of subway passengers, his photographs of empty rooms and clapboard auto shops and peeling billboards and, of course, the moving documents of impoverished sharecropper families he'd taken during the Depression for the Farm Security Administration in collaboration with James Agee's text for *Let Us Now Praise Famous Men.*

To Evans, the artist was an image-collector—"He collects things with his eye." He once said: "The secret of photography is that the camera takes on the character and the personality of the handler. The mind works on the machine."

When Diane finally met him, Evans was fifty-nine and living on the top floor of a brownstone on East 94th Street with his new wife, Isabelle, a shiny-cheeked young woman from Switzerland who was thirty years younger than he. He had just undergone a serious ulcer operation and was frail, spending most of the day reclining on a couch. He taught photography at Yale and was still under contract to *Fortune,* but since he'd turned down its art directorship, the Time Inc. management had put him in a closet-sized office, where he was called an editor but had little to do. His wife, Isabelle, says, "He'd juggle three sets of friends—because the Robert Penn Warrens and the Lincoln Kirsteins didn't associate with Robert Frank or Berenice Abbott—or the Cass Canfields, for that matter. Walker loved going to the dinner dances at the Canfields'. He'd put on a tux and we'd waltz the light fantastic; he was a very graceful man."

Much of the time he was in despair because he felt he had "dried up creatively." He was a legend in photography, but he no longer had any ideas as to what he wanted to photograph. When Diane knew him, he was fighting alcoholism and taking amphetamines and occasionally escaping to the little tenement apartment he still kept on York Avenue—he'd had it since the 1930s. It was filled with letters and old negatives, and sometimes he'd just hole up there for a while.

Isabelle Evans says, "Marvin would phone Walker constantly, asking him to do things for *Bazaar.* He knew Walker was in a down mood. He would bring him fine bottles of Châteauneuf du Pape because he knew Walker couldn't drink hard liquor, and we'd sit around a roaring fire and talk."

One afternoon Israel came bounding up the stairs carrying a sheaf of Arbus photographs, "some of the eccentric photographs. Walker couldn't

get over them. He'd taken a lot of unposed portraits, so he could tell that Diane's subjects had collaborated with her; they'd had dialogues. He was as impressed as he'd been when he first saw Bob Frank's work.

"Marvin told him, 'Diane Arbus is outside in a cab—can I bring her up?' Walker urged him to, and Marvin tried; he went downstairs, but came back a few minutes later, saying, 'Diane won't. She's too shy . . . she can't.' But she did come soon afterward. It was tough going at first." She quotes a note Walker Evans wrote her when she was off on a short trip: "March 3, 1963. Cooked dinner for Marvin Israel and little photo girl, Diane Arbus. Not good evening. She was so inarticulate. He was in a poor mood." Eventually, Isabelle Evans says, Diane and Walker became friends and then "Walker had a falling out with Marvin after he left *Harper's Bazaar*, so Diane began coming alone. We often had dinner together."

Isabelle always noticed what Diane wore. "Maybe it was because Walker was so dapper—he adored his beautifully cut English suits, his thirty pairs of highly polished Peel shoes. Diane looked positively elegant whenever she visited us—she might be in a Courrêges jacket and pants, her hair cut chicly like a boy's. She said David did it at Bendel's." (Diane's personal appearance fluctuated as wildly as her moods. Some people remember her as "fashionable and immaculate," others insist she was "usually disheveled and not always clean." How she looked depended on how she felt. If she was depressed or working very hard, she didn't care how she looked.)

Once she visited the Evanses having just been taken in a jeep to the opening of Mainbocher's collection at the Brooklyn Museum. Earlier she'd told them that she'd been camping out at some transvestite hotel, photographing its occupants. "She seemed turned on by the fact that she could coexist in both worlds," Isabelle says. "But maybe there's a connection— a similarity—between the fashion world and the underworld; entry into each is difficult; each has a code and language of its own, and Diane seemed to know both instinctively.*

"Walker called Diane a huntress. He admired her daring, but couldn't understand how she was able to go so fearlessly into the underworld of New York . . . He'd always been attracted to and repelled by lowlife, but he had 'Victorian barnacles' on him, he said; couldn't shake them off. How did she do it? Diane admitted to being exhilarated by danger. Her obsessive search for adventures, for strangeness, was a way of escaping both boredom and depression; she suffered a lot from depression, she said."

* Years later Susan Sontag commented that for many photographers "class is the deepest mystery—the exhaustible glamour of the rich and powerful, the opaque degradation of the poor and outcast—social misery has inspired the comfortably off with the urge to take pictures . . . in order to document a hidden reality that is a reality hidden from them."

She continued to fight periods of helplessness and hopelessness, and would succumb to crying spells. When she gave in to her despairing moods, there was no reaching her; she would withdraw behind a wall of dazed silence which could last for hours. These periods came and went; they were more severe than the depressions she'd suffered in the past. To alleviate them, a male colleague supplied her with an anti-depressant, an "upper," which he would first break open, then shake onto his palm; she would lick the powder off. She was extremely sensitive to any stimulant —she could drink neither coffee nor tea nor liquor—so she tried to be very careful about drugs, never relying on them, let alone experimenting with them.

She did smoke pot and she'd tried LSD once, but with disastrous results—she'd had a horrific hallucination that whirled her head around for days. She disliked watching what was happening to people around her on pills—photographers like Dick Hyman and Mark Shaw ultimately died from too many "Dr. Feel Good" shots. And she was a friend of Tiger Morse, the skinny designer who ran the Teeny Weeny boutique on 73rd Street. Tiger created psychedelic fashions: paper dresses, silver boots and motorcycle suits, vinyl skirts with "HATE" on one side, "LOVE" on the other. Tiger ate amphetamines like candy—"I'm living proof speed does not kill," she used to say.

Since Diane's relationship with Walker Evans was essentially a formal one, neither of them discussed their depressions or the drugs they took ("although Walker tried everything to combat his despair," his wife says). To forget, he would tell Diane how he admired Flaubert—how he often read passages from *Madame Bovary* before going off on an assignment. Literature influenced Diane, too, but in "an oblique way," she'd say. Some stories were actual photographs to her, like Kafka's story "Investigations of a Dog." She called it "a terrific story written by the dog—it's the real dog life of a dog."

One evening Walker Evans talked to Diane about being a voyeur—a fantasizer. He even had a special trunk to keep his pornography collection in. It wasn't much—"feelthy" photographs he'd bought in Paris; a film of a woman taking a shower which he thought was quite arousing. He liked 1920s pornography—he liked the Bellocq pictures of prostitutes Lee Friedlander had discovered in New Orleans. Modern porn was too clinical—modern porn wasn't naughty or perverse or playful enough—modern porn turned him off.

He had never been able to photograph anyone nude, he said. Diane told him about photographing an orgy in a New Jersey motel "where everybody sat around eating peanut butter on crackers before they fucked." She'd found out about the orgy from a swingers' newspaper. It was a

pretty boring experience, she said. But taking the voyeuristic masculine role was peculiarly satisfying to her, and the camera protected her, distanced her, and permitted her to go into forbidden territory and have access to all kinds of relationships—she could witness primal scenes with husbands and wives switching partners or straight and gay intermingling; couples up to six on a mattress writhing around. On one level it became mythic to her. But on another level it was uncomfortable and "tacky," and once it got near-violent when a woman in the room wanted another woman and the pride of the man involved got hurt.

Evans confided that he'd been approached to go to an orgy by "a black who was shining my shoes" outside the Plaza Hotel. He couldn't bring himself even to take down the address. He was afraid, afraid of so much. He was afraid to go to Robert Frank's because there was so much smoking, and he wouldn't attend any of Norman Mailer's parties after Mailer stabbed his wife in November of 1960. Diane told Evans she'd photographed Mailer shadow-boxing with his own reflection in a mirror, and Evans loved that. But he kept saying he was so afraid—afraid of most things, and particularly death. Was Diane afraid of death? She wouldn't answer that question.

Her own father was dying; she knew that, although the doctors and the family kept saying he was going to be all right. The Nemerovs had only recently come back from an around-the-world buying trip, fashion-consulting for Lord and Taylor. David Nemerov thought at first he'd caught bronchitis; he'd started to cough convulsively. Oh, he'd been a heavy smoker for over forty years—"butts all over the place," Renée says. But he couldn't stop smoking; he loved to smoke. So did Gertrude—so did most of the Russeks and Nemerovs. "Even Grandma Rose smoked while we were growing up—we just thought it was smelly, not unhealthy," says Helen Quat. But not long after he returned from Europe Nemerov was not only coughing but complaining of an excruciating backache. There were tests. Soon he was ensconced in a room at Mount Sinai Hospital—the diagnosis was lung cancer, but he hadn't been told. So Gertrude continued to smoke as she waited in the hospital lounge with Howard, who'd come up from Washington, D.C., where he'd just begun his year as consultant in poetry to the Library of Congress. Howard chain-smoked, too, and caught a heavy cold. He was terrified of not crying, because his relatives would ask him why he didn't cry. He had an answer all ready: "My father brought me up not to cry, he told me men don't cry."

Aunts, uncles, cousins, moved in and out of David Nemerov's hospital room, conferring with Gertrude in the hall afterward, trying to be cheerful. "David had been the big gun, the big cheese, in the family," Helen Quat says. "He'd given everybody jobs and advice, loaned them money,

and now he was dying and everybody was very upset." At one point Diane urged Doon to "go in and ask your grandfather for your college tuition." Which she did, and he arranged to pay for it, and Doon attended Reed College for a year before dropping out.

Diane visited her father often. To help him keep his mind off the pain, she talked to him about finally winning a Guggenheim. It was the third time she'd applied; the first time she'd sent in 150 pictures and been turned down; the second time 75 pictures and been turned down. This time she'd sent in 12. Walker Evans had been one of her sponsors. And now that she'd won, she would explore "American rites and customs, contests, festivals . . . These are our symptoms and our monuments," she wrote in the original application, which she read aloud to her father. "I want to gather them like somebody's grandmother putting up preserves because they will have been so beautiful. I want to save these things, for what is ceremonious and curious and commonplace will be legendary."

And her father was very proud and he cried.

Near the end Renée flew in from Michigan and stayed at Diane's Charles Street house. It was spring of 1963 and New York glittered in the sunlight. But Renée stayed inside with Diane, pacing trancelike about the dark living room, and the two sisters forgot their differences, their hostility, and talked throughout the afternoon and into the evening, "mostly about Daddy," Renée says.

"I didn't really adore him," Diane said later. But she had been baffled by him her entire life; haunted by his seeming indifference, his veiled eroticism. She looked for these qualities over and over again in men. She felt held in hostage.

Her father had been the first person to acknowledge her talent, the first person to suggest to her an outside, energizing world. Hating him, loving him, she knew she had not always pleased him; she wanted his approval, but she'd had to rebel. Once long ago she'd demanded a sewing machine so she could make her own clothes rather than accept what he could give her. She remembered his cold displeasure when she told him she was going to marry Allan Arbus.

As a woman she did not believe she was allowed to make mistakes, so when her marriage failed she did not tell her father right away.

At Mount Sinai the two sisters entered their father's hospital room together and David Nemerov, perhaps aware that his cancer was incurable, began weakly reviewing his life. Ill as he was, he managed to tell his daughters that he'd been so busy while they were growing up he hadn't given them much love or attention. He regretted that now and hoped he'd

made it up to them a little. They assured him he had. But he soon lapsed into a half-waking state. He would rage and whimper and sweat and seem to speak in tongues—as if he had been flung out of time and space. He'd hallucinate "businessman fantasies," Diane said. "He'd take imaginary papers out of imaginary pockets and briefcases . . . and then he'd think he was a painter again and wave an imaginary brush through the air." He wrote garbled poetry to Gertrude, addressing her as "my angel, my saint." And Gertrude sat by his side, never moving, beautifully dressed, smoking her endless cigarettes.

Every so often one of the relatives would spell her, all except Howard, who didn't want his father to catch his heavy cold. Nor would he kiss his father, as he always dutifully had in the past. Later he wrote: "The cold was my revenge on my father, whom I punished by not kissing him. For in childhood, whenever my father was seriously angry at me the first symptom of it would be his saying . . . when he came to breakfast, 'Don't kiss me, I have a cold.' On such occasions I would then have to wait the whole day, until he came home, under the threat of his powerful, unforgiving will."

And finally when Howard did visit him briefly in his last days and watched him dying, he wrote: "[My father] was a man of immense powers and many powers he may have had and kept to himself, a deep cynicism about life and about his life in particular and who may have asked himself many times perhaps in relation to his children if the results had been worth living for," and Howard experienced a "terrible personal anguish at never having known my father and at never having tried."

After David became unconscious, Diane sat with him. "He looks like Everyman," she told Howard later, moved by the gaunt, spiritual quality in her father's face. He was becoming transfigured, ennobled in his terrible suffering. She was with him when he fell into the last coma and feebly began to masturbate as she watched. She described this later to Harold Hayes. "She was very upset," he remembered, "and *I* was upset because she'd told me this intimate thing, and I wondered why she had told me."

Diane was the only one to know about Uncle Willy's vision—Uncle Willy, one of David Nemerov's "black sheep" brothers, who had lived in his shadow but adored him. "Suddenly he woke up at five a.m. and knew [Daddy] was about to die—he rushed to the hospital and was with him at the end."

Diane felt "really awful when my father died. I mean I stood in a corner of his room like a creep. I was absolutely fascinated . . . I was spellbound by the whole process of his gradual diminishment. He became shrunken and he'd got to look like nobody . . . and I photographed him then, which

was tremendously cold of me, I suppose, although I resent that implication."

Following his death, Diane noticed "how [Daddy's] energy seemed reapportioned to others [in the family] and the women got incredibly strong . . . I remember hating that and thinking they should have told him he was going to die; it was an insult to him that he didn't know." The photographer Ben Fernandez recalls Diane sneaking into Richard Avedon's studio during a seminar not long afterward and announcing "in a whispery little voice that she'd just come from taking a series of photographs of her father dead. It was such an extreme statement, fraught with emotion . . . nobody reacted at all." She did not show the pictures, but Fernandez surmises that this is what may have inspired Avedon to take the agonizing series of portraits of his own father after he'd been struck by cancer.

A month after David Nemerov's death, in June 1963, Roy Sparkia's plastic "stained-glass"* artworks depicting the Seven Wonders of the World were unveiled on the south wall of the lobby of the Empire State Building (where they remain to this day). The panels, five by seven feet in dimension, depict the Great Pyramids, the hanging gardens of Babylon, the statue of Zeus, the temple of Diana, the tomb of King Mausolus, the Colossus of Rhodes, and the lighthouse of Pharos. The eighth panel depicts the Empire State Building itself.

At the ceremony Paul Screvane, president of the City Council, threw a light switch illuminating the panels in all their brilliant translucent colors. In his speech he noted that thirty-five thousand people visit the Empire State Building every day—more visitors in a single year than the combined total of all who visited the original Seven Wonders of the World throughout recorded history.

Renée says, "Mommy came, but Diane and Howard didn't." As far as she knows, they never saw the Seven Wonders of the World—"although they always had a good excuse." But she was hurt.

* Plastic "stained glass" is a technique Sparkia invented which exploits optical methods using a combination of new plastics that have varying refractive indexes that are lighted from behind and achieve a true third-dimension impression.

26 _____

In the summer of 1963 Diane floated around New York, sometimes accompanied by Arthur Sainer, the *Village Voice* drama critic she'd met in the subway. Once they were kicked out of a dress rehearsal of the Living Theatre because the producers, Julian Beck and Judith Malina, didn't like the idea of a woman crouched in the aisle with a camera pressed against her eye.

Sainer considers himself a friend of Diane's, "not an intimate, although originally I hoped I'd be." But at the start of their relationship she'd told him gently that she cared about somebody else—she wouldn't say who. Sainer accepted this "because I wanted to see her on any terms. She fascinated me as she fascinated most people, I guess, with her compelling, irresistible quality." For a while he thought he could fall in love with her.

He had been going out with her for a couple of months when he discovered that Doon was "really pissed off at my dating her mother. Maybe it was because I'd known Doon first—Michael Smith had introduced us. Anyhow, she didn't approve of me with Diane and she made that very clear to Michael, although she was always unfailingly polite with me."

If Diane knew how Doon felt, she never mentioned it to Sainer. Photographer Bruce Davidson, who was seeing Diane at the time, says, "Diane would have to have known. I've never seen such a symbiotic mother/ daughter relationship. They were intensely close—fascinated by each other and bugged by each other." He goes on to say that he developed a powerful attraction to both women and believes they played up to that. At one point he even considered dating both of them, but decided against it. "That would have really caused trouble!" He went on seeing Diane for a while and still remembers the undercurrent of tension whenever the three of them were in a room.

Meanwhile Sainer continued inviting Diane to the theater. "I remember she asked me to take her to *Mother Courage*."

Sainer, the poet Marvin Cohen, and the late John Putnam seem to have

taken turns walking with Diane around New York. Putnam recalled in an interview before his death in 1980 that he and Diane used to walk all the way down to Chinatown and the Bowery, "counting all the people on all the benches, counting all the screamers on the street."

The gray, perpetually disheveled Putnam was art director of *Mad* magazine. He lived in the West Village and in his spare time he took photographs, sculpted, painted, and was in the midst of taping the memoirs of a high-class hooker he also happened to be in love with.

"Diane really dug that," he recalled. "There I was, a divorced man in my mid-forties, father of three children, who was trying to cut loose with this completely zonked-out girl who had eighteen abortions. I'd gotten her completely dependent on me. I'd lend her money, get her out of jams, but I was nuts about her and fascinated by her sordid life."

Putnam said, "I'd tell Diane how I'd once visited my hooker's parents. They lived in a falling-down house somewhere in Queens—the walls were covered with color snapshots of genitalia. The father was a pimp, the mother was a prostitute. They were either yelling at each other or falling into abject silences. Diane was dying to photograph them, but somehow we never got around to it."

July came and Doon and Amy went away for the summer and Diane was left alone in the Charles Street house. She rose early—at five a.m. Sometimes she might listen to the recording of Mozart's *Requiem* which Howard had given her after their father died. Sometimes she invited friends over for breakfast, serving globs of cheese mix on bread. Or she'd hang on the phone with friends like Isabel Eberstadt, who was trying to arrange a sitting for her with Mrs. Dodge in the Fifth Avenue mansion where she lived with her fifty cats.

Diane was now starting to photograph teen-age couples—on the street, in Central Park, on the piers by the Hudson River. She was also photographing triplets in New Jersey. One of her most famous portraits from that period shows three identical sisters sitting on their beds. The style of the photograph seems almost flat, but the subjects suggest something extraordinary and paradoxical, all the more so when you know what Diane thought of the image.

"Triplets remind me of myself when I was an adolescent," she said. "Lined up in three images: daughter, sister, bad girl, with secret lusting fantasies, each with a tiny difference."

Apart from triplets, she was continuing to photograph all kinds of people and places in New Jersey because New Jersey seemed to contain everything: hermits, burlesque houses, nudists, reclusive gypsy fortune-tellers,

magicians, Princeton, inbred mountain people who spoke in strange tongues, Kenneth Burke, black gangsters, and the Palisades, which to her resembled mythic prehistoric mountains. New Jersey was a treasure trove, and she went there as often as she could.

But New Jersey or the "mud shows," second-rate little circuses in Pennsylvania—that was about as far as Diane wanted to travel, and then only for a couple of days at the most. She hated being away from New York for long; she seemed to have no desire to see the rest of the world. And Howard was the same way. He would appear at a poetry reading in Boston or even as far away as the Iowa Writers Workshop, but he would always try to catch a plane back to Bennington the same night. Occasionally he'd spend a weekend in New York. On his last visit Diane had taken him with her to Hubert's and introduced him to the man who ate lightbulbs and the midget who did impressions of Marilyn Monroe. Howard remembers "that a snake charmer wrapped her snake around my neck and I just stood there, damned if I was going to let my little sister know I was scared shitless."

Uncharacteristically, in the late summer of 1963 Diane, encouraged by Marvin Israel, took a two-week trip across the United States on a Greyhound bus. She was elated by the prospect, because the trip would enable her to complete her Guggenheim project of photographing ceremonies: pageants, festivals, contests, family reunions, baseball games . . .

Once on the bus, she lost herself in the vast landscape of America, surrendering her gaze to millions of new images. She could compose a new world with every blink of her eye. There were glimpses of orchards heavy with fruit, there were endless rolling hills, rusting automobile graveyards, neon-bright motels. There were factories and slums and funeral parlors and schools and zoos and gas stations, and women in soiled housedresses wearing vivid Cleopatra makeup. In a bar the wavery image of President John F. Kennedy shouted, *"Ich bin ein Berliner!"*

Along the way Diane sent cryptic little postcards to childhood friends like Phyllis Carton, who'd accompanied her on her first adventures into the unknown, and to another friend she wrote: "Everything is superb and breathtaking. I am crawling forward on my belly like they do in the movies. This may sound nutty but I have discovered that life is really a melodrama."

Afterward Diane implied that terrifying things had happened to her on that cross-country trip—experiences she would never describe. Danger stimulated her and she always associated taking risks with pleasure. She disliked compromise. She might strike up a conversation with somebody quite dangerous in order to take the consequences. And why not? It was

only through some violent initiation that one could really learn to "see" and "feel." Diane believed very strongly that as long as she had her cameras to shield her, nothing bad could ever happen to her. Nothing real. She was, she told someone, only afraid for the inside of herself. Never the outside. Outside things could never touch her.

Later Doon wrote that all she knew about that trip was that at a rest stop in Arizona her mother missed the bus and "burst into tears" saying she needed to get back to New York to pick up her eight-year-old daughter, Amy, from summer camp. "Finally somebody took pity on her and drove her at breakneck speed to catch up with the bus." When she returned home Diane felt this trip "had been her proving ground, and having survived it, she knew she could go anywhere."

In the fall of 1963, Marvin Israel arranged with Bea Feitler and Ruth Ansel (who were now art directing *Bazaar* together) to run another portfolio of Diane's pictures in the December issue. This one was entitled "Auguries of Innocence" and it featured portraits of children (two were of Amy). The images are soft, misty, romantic, and captioned by various riddles (both Israel and Diane loved riddles). One of her favorites, from Lewis Carroll's *Alice*, ended the four-page spread.

> Then someone came to me and said
> The little fishes are in bed . . .
> I took a corkscrew from the shelf:
> I went to wake them up myself.
> And when I found the door was locked,
> I pulled and pushed and kicked and knocked
> And when I found the door was shut,
> I tried to turn the handle, but——

"Is that all?" Alice timidly asked. "That's all," said Humpty Dumpty. "Good-bye."

(Carroll's blend of humor, horror, and justice always appealed to Diane; indeed, her own "adventures" with hermits, nudists, carnival geeks, and midgets sometimes seemed almost inspired by Carroll.)

That same fall Joseph Mitchell began getting regular phone calls from Diane again. "She called one morning I had a hangover and asked me how I was, and I answered, 'Suicidal.' She asked, 'Have you ever felt like killing yourself?' and I said, 'Well, most people have,' and she said, 'I'm not

asking about most people, I'm asking about you.' So I answered, 'No, I don't think so except that when I'm in high places I have the inclination to jump.' "

Diane went on to say that she thought people should have a choice about killing themselves; it was their right, and someone needn't be thought of as unbalanced or psychotic to kill himself. "We talked a great deal about suicide that morning," Mitchell says, "but in the most clinical, academic sense. I'd done a story once on various types of suicides—I'd worked with the police on it—and they had special terms for different kinds of suicides: the gas route, the dry dive (jumping out a window). Diane liked those expressions, but the one that really fascinated her was 'the hesitation cut.' Apparently people who consider killing themselves often give themselves 'hesitation cuts' on the wrist with a razor.

"Diane told me she wished she could have photographed the suicides on the faces of Marilyn Monroe and Hemingway. 'It was *there*. Suicide was *there*,' she said. Then she got depressed and asked, 'What is the point of life?' I quoted something from Robinson Jeffers which ends, 'Discovery is the world to live in,' and I said to Diane, 'That's what you're doing, *discovering*—that's the point of your life.' She said she disliked Jeffers' poetry but appreciated the idea that perhaps she was discovering something.

"During another conversation she told me she was Howard Nemerov's sister. I was very surprised. I knew Howard through Shirley Jackson and Stanley Edgar Hyman, who had an office at the *New Yorker*, but I wondered why Howard hadn't ever mentioned that he had a photographer sister named Diane Arbus." During that same phone conversation Diane mentioned that Howard's latest project was an autobiography, a kind of self-investigation which he was calling *Journal of the Fictive Life*. He hoped it would serve to release him from the block he had about writing fiction because he desperately wanted to write more novels.

It was astonishing that she told Mitchell as much as she did. She rarely admitted even to *having* a brother (let alone a sister), although she was very proud of Howard. She read all his work, attended every reading he gave at the 92nd Street "Y"—even the seminar on modern poetry at which he debated Allen Ginsberg and James Dickey, and which the critic John Simon artfully moderated. She would refer to "my brother's and my long but infrequent conversations" as "absolutely terrific." Although she complained that her own thoughts were "so personal and limited and exclusive and feminine, whereas my brother has a body of knowledge that is totally unpersonal and [totally] intellectual." In the *Journal* Howard cries out, "I hate intelligence and have nothing else." In the *Journal* he tries to confront his greatest fears, his most shameful feelings. Always he sees

himself as "a stranger, a mystery, which brings me to search in a spirit of guilt and isolation."

Throughout one section he digs far back into his memory: "A dream of many years ago. Two women, fairly young in . . . special motoring costumes from the twenties. They stand on the steps of a grey stone house, under a porte-cochère, and a voice outside this picture said: They do not know that they were both killed in an accident the same afternoon."

He writes that this dream "connects itself with a vague memory that my mother used to drive a car when I was very young, but later gave it up . . . the image of the two women, and what the voice said of them, has long been to me an emblem of the mystery and terror of time. I don't know why I suddenly recollected it again while thinking of the portrait of [Diane] and myself, and of the two children [Diane and myself] in the poem ["An Old Picture"] (who are supposed . . . to be betrothed royalties) . . .

"Something I remember being told in childhood: My mother pretends, for a home movie, to make love to another man. I threaten to kill him.

"The connexion, again, is *picture*. We have the portrait, the poem about a portrait, the photograph of the two women in the dream, or daydream, and now this home movie. My vocation as a grownup has to do with making images, but I have never much cared for photographs. The same sister [Diane] is a professional photographer, whose pictures are spectacular, shocking, dramatic, and concentrate on subjects perverse and queer (freaks, professional transvestites, strong men, tattooed men, the children of the very rich). Thou shalt make no graven image. Unlike a great many people, I do not keep pictorial representations of my family on the walls, on the desk, in the wallet (but this does not seem to be a strong prohibition; just now a photograph of my son at about the age of seven done by [Diane] is tacked to my bulletin board next to a photograph of Willie Mays given me by my son.) . . . So the portrait has reached out to draw to itself a cluster of notions relating to visual imagery; representation, likeness . . .

"People, tourists, say, who habitually respond to a sight by photographing it, appear to me very defensive about life. As though they wished to kill reality in order to guarantee it, as though only the two-dimensional past were to have a real (a historical) existence." He adds that "the camera's initial lie" is the phrase "The camera cannot lie" or a similar phrase, "One picture is worth a thousand words." The camera, a product of a materialistic civilization, only reports the surface of things "in 'simple location in time and space' (Whitehead) . . . Language, on the contrary, constantly asserts reality to be secret, invisible, a product of relations rather than things. The camera, whether in the hands of reporter or sci-

entist or detective, pries into secrets, wants everything *exposed* and *developed* . . . The camera wants to *know*. But if my hypothesis is correct, this knowledge is dialectically determined to be unsatisfying, so that there can be no end to the taking of pictures . . . Everything known becomes an object, unsatisfactory . . . hence to be treated with contempt and forgotten in the illusory thrill of taking the next picture." Howard finished by saying that this "critique of photography (my sister's art) is quietly but quite specifically intended to be set against writing (my art) as guilt against innocence. The statement, for example, that 'language constantly asserts reality to be secret, invisible, a product of relations rather than things,' may be aesthetically very intelligent, but is noteworthy on less attractive grounds as well. That is, by identifying myself with language, as against photography, I covertly seek to exculpate myself from any charge of having spied on my parents; their doings are still 'secret, invisible.' "

When *Journal of the Fictive Life* was published, Diane ignored Howard's ruminations on photography, but she read the rest of it. What struck her was the sameness of their childhood memories. "We had the same lexicon," she said. Howard could not forget the sensation he'd had as a little boy of going into the "windowless elevator hall [of the San Remo apartment house] . . . very sinister, with its closed doors on two sides, its closed sliding door on the third. It represented a final loneliness (waiting for the elevator on the way to school?)."

Diane remembered the elevator man "who became a peculiar clue to [what went on in real life]. He used to stop between floors and be rather flirtatious with me and I would sort of look at him . . . he was sort of lascivious, I mean he never did anything wrong but he made me feel trapped, made me feel aware; [when you're growing up] you operate on little hints like that because that's all you have to go on and in a way you construct the world on these terribly minimal bits of evidence. Which may not be far from wrong."

Diane kept in touch with Emile de Antonio, who was completing his first film, *Point of Order*, about the McCarthy hearings. He had been able to make the documentary, he told Diane, because he'd found 185 hours of the Congressional hearings stashed away in a New Jersey warehouse and had managed to buy the footage for $50,000. He told her everything about it when she visited him at his apartment on East 95th Street, where, De says, she seemed quiet and more contained. "She always seemed sad, but she had this internal grace." At the Charles Street house she appeared to

him to be under more pressure, giggling and trying to be the perfect mother to her daughters. She told De she was worried about Doon, who was restless; and Amy was having a weight problem . . .

But by herself Diane relaxed. At this time she was experimenting with cameras, borrowing from Hiro or renting cameras, even taking the same picture with different cameras. She still missed the lightness of her Leica, but knew the Rollei was better for her. Sometime in 1964 she began alternating with a Mamiya C33 with flash, which was a crucial change. Her subjects took on a stranger, more powerful life. The illumination of the flash not only stripped away artifice and pretense, it revealed another, deeper level—a sense of psychological malaise.

She talked about her camera experiments, but, De recalls, "I probably ended up talking more. She was very private. I don't think anyone will ever be able to totally capture her—she seemed so evanescent." She reminded De of Dick Bellamy, who was also an extraordinarily private and self-contained person—"possibly that's why Diane and Dick had such an affinity." She would visit Bellamy occasionally at his Green Gallery, which he was making into a center for Pop Art—Jim Dine, Frank Stella, Roy Linquist, were all shown there. George Segal, too. His immobile plaster figures represented terror, hallucinations, nightmares to Diane. She related to them the way she related to the wax figures in the Coney Island museum.

She would visit Bellamy periodically, and she would visit Alice Glazer, the high-strung, overly conscientious *Esquire* editor, who eventually killed herself. Whenever Harold Hayes called an article meeting Alice would call Diane in a panic and Diane would come to Alice's office and give her ideas. On her way home she might stop at Lord and Taylor and go up and down the escalators, studying the customers' faces. "I know a lot about shoppers," she'd say. Then she'd hop the Fifth Avenue bus to the Village, taking pictures of the passengers and sometimes using the flash. It didn't seem to matter to her that many of the passengers complained or flinched, or were blinded by its glare. Everybody seemed raw and open to her.

27 _____

By the mid-sixties Diane had become a familiar figure to most working photographers in New York City. She was seen everywhere—at art openings, at happenings, at the Judson Memorial Church, at Pop Art collector Ethel Scull's party held at a Nathan's hot-dog stand, at Tiger Morse's fashion show, which took place at the Henry Hudson Health Club with stoned models showing off lingerie, then falling into the pool. "Diane was at every spectacle, every parade," Bob Adelman says, "right up to the Gay Rights Liberation March of 1970."

Adelman, who eloquently documented the civil-rights movement in the pages of *Look* magazine, recalls seeing Diane at "most of the protests against the Vietnam war. But she would never plunge into the crowd like the rest of us who were all going for a sense of *immediacy*, of grabbing on to the entire vista—we wanted to record the action. But Diane hung back on the fringes—and she'd pick out one face, like the pimply guy with the flag or the man with his hat over his heart."

On assignment, in competition with other (mostly male) photographers, Diane could turn colder or more aggressive. Sometimes at an art opening or press conference she would hop about almost manically, click-clicking away at people until they'd run through their repertoire of public faces and stood exposed and blinking under the glare of her flash. "She used to drive people crazy at parties," Frederick Eberstadt says. "She'd behave like the first paparazzi. She didn't talk much, but she'd swoop like a vulture at somebody and then blaze away. And she would wait outside a place for hours in any kind of weather to get the kind of picture she wanted."

Sometimes it seemed as if every event in the sixties had been organized for the benefit of TV and still photographers. The media were creating a turbulent new world, based not on wealth and achievement but on being promotable ("Everybody can be famous for fifteen minutes," Warhol predicted). So photographers were involved as never before in recording all this voracious hunger for publicity, for notoriety. Sometimes dozens of

them would compete for a single image: at Truman Capote's party for Katharine Graham, photographers went crazy as to whom to photograph first—Margaret Truman, John Kenneth Galbraith, Babe Paley, Lee Radziwill, Gloria Vanderbilt, Mia Farrow, Frank Sinatra, Lauren Bacall, Henry Ford . . . But once again Diane would avoid the obvious image—the costume, the behavior, the visible effect—and would zero in close-up on a mismatched couple. The main detail, the woman's pale, broad, freckled back.

She knew she had an advantage on the job in the company of men. In the beginning she was ignored, but even after she got better known she could still get away with a lot of things a man couldn't. She'd appear insecure about her equipment; she couldn't always load film into a camera; she'd flirt. "I'd stop at nothing to get the picture I wanted," she told one of her students, Mark Haven. "And being a woman helped."

She could usually sell most of the pictures she took, but she would refuse credit if the image didn't come up to her standards. She was out to make a personal statement, no matter what the circumstances or assignment—she wished to be compared with no one, but to be better than the best. If she had a need to exaggerate the physical and psychological horror in her subjects, it was because she saw that beyond these exaggerations might lie transcendental worlds of absolute value. She would always go on exploring the question of identity versus illusion in her photography.

You see both in her ghostly, voluptuously daydreaming portrait of the ravaged former debutante Brenda Frazier taken for *Esquire* ("Frazier and I talked about nail polish," Diane told John Putnam). When she photographed the Armando Orsinis, the Frederick Eberstadts, the John Gruens for a "Fashionable Couples" series in *Bazaar*, she insisted that they hold the same pose for up to six hours until, exhausted, they all revealed a terrifying sense of mutual dependency.

And she kept on scrutinizing the stoic self-sufficiency inherent in her subjects, as with the portrait she took of Lee Harvey Oswald's mother in *Esquire*'s editorial offices. She had only a half-hour. Mrs. Oswald was there to sell her son's letters to the magazine. "She was peddling all the artifacts she had," Diane said. "And not only that, she was incredibly proud—like she had done the most terrific thing in the world . . . she looked like a practical nurse . . . and she was smiling—it seemed unnatural. Why was she smiling? What did she have to be so pleased about? We talked a little. She was dying to talk, you know? In fact, this was her big moment. [Her son had assassinated President Kennedy] and it was as if he had done something remarkable and she looked as if she'd manipulated the whole thing for forty years since she conceived him. She had this incredible look of authority, of pride."

As Diane grew more confident, the subject matter in her own work grew more extreme. Her constant journeys into the world of transvestites, drag queens, hermaphrodites, and transsexuals may have helped define her view of what it means to experience sexual conflict. She once followed "two friends" from street to apartment, and the resulting portrait suggests an almost sinister sexual power between these mannish females. (The larger, more traditionally feminine figure stands with her arm possessively around the shoulder of her boyish partner. In another shot the couple is seen lying on their rumpled bed; one of them is in the middle of a sneeze—it is both intimate and creepy.)

Diane also photographed drag queens in their seedy little rooms at the Hotel Seventeen near Stuyvesant Park, and she spent a day with a transvestite at the World's Fair in Flushing; they had an attack of giggling when he/she didn't know whether to use the ladies' or the men's room.

Lately Diane had become friendly with "Vicki," a huge, six-foot man who was a hooker; Vicki called himself "Vicki Strasberg" (after Susan Strasberg). Vicki took hormones and gorged on food so "she" would be plumper and more sexually desirable; she always dressed as a woman and whored as a woman, and supposedly no customer ever complained. Wherever they went, everybody ogled Vicki. She had "the most unbelievable walk," Diane recalled. "I couldn't see the man in her."

Vicki was dangerous, mean. She knew how to use a knife and she tortured her cats and once she stabbed a customer and was sent to the Tombs. Vicki adored Diane and gave her presents (which she'd stolen from department stores) and invited her to her birthday party at her hotel at Broadway and 100th Street. "The lobby was like Hades," Diane recalled. "People lounging around; the whites of their eyes were purple." A stench, a congealment, a heaviness pervaded the place, and the carpet was littered with broken syringes and orange peels. The elevator didn't work, so Diane climbed the stairs, stepping over inert figures on each landing. She arrived at Vicki's shabby room carrying a birthday cake and Vicki was waiting for her; she'd attempted to decorate a little, but the balloons she'd bought were sticking to the wall and to the bureau instead of floating in the air as she'd planned. For a few moments Diane wondered where Vicki's other friends might be and then she realized she was the only guest at the party. After a while she took photographs of Vicki semi-toothless and laughing on her bed, exposing her huge thighs. Near her balloon remains stuck on the side of the bureau.

Nobody would buy Diane's portraits of drag queens at first. "In the early sixties drag queens were sociosexual phenomena," Andy Warhol writes. He thinks Arbus was ahead of her time in terms of photographing them, because "drag queens weren't even accepted in freak circles until

1967." In the meantime, the more she photographed transvestites, the more she connected their sexual identity with "nature," "personality," and "style." To a transvestite, sexual identity seemed to be more a predilection than a necessity of gender.

Finally, when Diane photographed the man in curlers and the woman smoking a cigar, she was able to capture the confusion of male and female identities trapped in a single personality.

Occasionally Diane would show some of her latest work prints of transvestites to Walker Evans. He also liked the portrait of Norman Mailer, which she'd taken for the *New York Times*. In this picture Mailer is clutching his crotch. "You actually get a sense of what it's like to *be* Norman," Evans told his wife later. (As for Mailer, he commented, "Giving a camera to Diane Arbus is like giving a hand grenade to a baby.")

Evans was extremely pleased by Diane's progress. He wrote: "This artist is daring, extremely gifted, and a born huntress. There may be something naive about her work if there is anything naive about the devil . . . Arbus' style is all in her subject matter. Her camera technique simply stops at a kind of automatic, seemingly effortless competence. That doesn't matter: we are satisfied to have her make her own photography speak clearly. Her distinction is in her eye, which is often an eye for the grotesque and gamey; an eye cultivated just for this to show you fear in a handful of dust." He urged her to keep showing her latest pictures to John Szarkowski, the new head of the photography department of the Museum of Modern Art.

Szarkowski had already seen Diane's early work done in 35 millimeter (the eccentrics, Puerto Rican kids), but he hadn't liked it very much because "they weren't pictures somehow." However, he'd been impressed by Diane's elegance, her high intelligence, and her ambition . . . "there was something untouchable about that ambition."

They became friends and she continued to bring stacks of work prints to his office at the museum, and as she began photographing more at contests and parties and in the street—almost always using her flash— her rough, uneasy style evolved and then her subjects began alternating between freaks and eccentrics and the frankly middle-class, all posed in the same grave, troubling manner. By 1964 she was really collaborating with the people she photographed—collaborating and confronting them as she hunted for their private faces. However, her central concern remained unwavering—it focused on the nature of being alone and our pitiful range of attempted defenses against it. Szarkowski realized that "Diane was a marvelous photographer—nobody else photographed the

way she did. Nobody had such an enlarged sense of reality." On top of that she was running totally counter to the 1930s–'40s documentary photographers, who had tended to be almost benevolent to their subject matter and serene in their technique. Like Robert Frank's, Diane's attitude toward her camera was raw and unsettling. Szarkowski began re-examining his own definitions of documentary photography.

But at the same time he didn't want to lose sight of the history or traditions of the medium—possibly a reason he suggested to Diane that she look more closely at Sander's portraits (although today Szarkowski insists "Diane had already developed her own distinctive way of working"). However, studying Sander was just another step to work more deeply into "the endlessly seductive puzzle of sight."

August Sander lived in Germany during the Weimar Republic, and from shortly after the First World War until Hitler put an end to his project in 1932 for being "anti-social," he tried to record and document every archetype in his country—peasants, thieves, lawyers, pastry chefs, artists, Nazis, girls in their confirmation dresses, Jews, doctors, bankers. All his portraits are direct and confrontational, but never threatening. He didn't want to make anyone look bad. "The portrait is your mirror," he would say. "It's you." So Sander's sitters would look at him without expression and give him back the sense of self-reflection he wanted. Diane was reminded by Sander that the camera has an infinite capacity to reveal.

She had been thinking about photographing archetypes—indeed, she already had (teen-agers, flower girls, weightlifters)—and often referred to herself as "an anthropologist of sorts." Lisette Model repeatedly told her that the more specific you are, the more general you'll be. "I thought if I photographed some generalized human being, everybody would recognize it," Diane said. "It would be like the Common Man or something."

Avedon was studying Sander, too—studying the frontal symmetrical compositions, the crucial confrontations with subject matter. Avedon wanted to pursue the prototypical, but he wanted to assemble prototypical celebrities—the instantly recognizable, like Eisenhower and Malcolm X; the bigger, the better. He resented being known as just a fashion photographer, so he was doing a book—his second*—and Marvin Israel was designing it and James Baldwin, his high-school classmate, was writing the text. It would deal with America after John Kennedy's assassination —deal with the loneliness and violence in the country, deal with the rise of civil rights. Avedon's photographs would range from horrific blurred

* His first: *Observations*, with text by Truman Capote.

candids taken inside a madhouse to marriages at City Hall. There were studies of a naked Allen Ginsberg, a doleful Marilyn Monroe, sinister, sneering pop singers, Arthur Miller with five-o'clock shadow, and harsh portraits of Adlai Stevenson, John L. Lewis, and Bertrand Russell.

Skin—that, oh, so permanent mask—was another focus: skin harshly lit against a bare studio background—aging, flabby, baggy skin, bleary eyes, dry, cracking mouths. Diane usually ignored age in a person's face, but Avedon in *Nothing Personal* emphasized it—to him, age was a defining condition.

Avedon often had insomnia, and when he couldn't sleep, he would call Diane and they would talk for hours. Occasionally they attended parties together, armed with their cameras. They photographed a reading that William Burroughs gave at which Larry Rivers, Jack Smith, and Andy Warhol were present; they dropped by a fund-raising for Abby Hoffman held on a tenement rooftop—at this gathering the Fugs played obscene songs. They also participated in symposiums at one time or another at the New School along with Cornell Capa and Irving Penn, and they would discuss styles of portraiture. In public, Diane behaved as if she were in awe of Avedon—she would repeat how she envied his technical prowess, how she could never do the things he did.

Once she and Avedon agreed to be part of a workshop Bruce Davidson was holding in his studio on West 12th Street. Davidson had been experiencing a terrible creative block. "Suddenly I could not take a picture—couldn't hold a camera in my hand," and he'd been Cartier-Bresson's protégé and with the prestigious Magnum photo agency for close to a decade. Famous for his pictures of Freedom Riders, the first moon launching at Cape Canaveral—"but suddenly I couldn't touch a light meter—a piece of film," he says. "Maybe it had something to do with the break-up of my first marriage or that I'd just had a lousy time trying to make it big as a fashion photographer." For whatever reasons, he was teaching, "trying to get my creative juices going again." He'd selected ten students from various walks of life—among them a suburban housewife, a retired businessman, and a high-school dropout named John Gossage, who'd spent most of his time memorizing the entire photography collection at the Museum of Modern Art. Gossage went on to become a fine photographer as well as a special friend of Diane's.

"And I asked Kertesz, Avedon, and Arbus to participate by showing their work for an evening," Davidson says. "Kertesz brought his photographs of a naked man sitting on a rock, a woman in repose on a sofa, a cloud next to a tall building. Avedon showed his pictures of tormented patients in a mental hospital, an unmasked look at Marilyn Monroe. Diane

brought in her portraits of an overweight family lying naked in a meadow, midgets posed in a bedroom, and a widow sitting in her ornate bedroom. Each photographer gave clues to their inner worlds."

After one class, Davidson says, "Diane and I went for a walk around the Village and she began discussing Erich Salomon's candid snapshots, and Jacques Henri Lartigue, who'd been photographing in France since he was a kid—before World War I." Lartigue was fascinated by movement and he'd been recording it for almost fifty years—with enormous exuberance and a sense of the ridiculous: cars racing, people and dogs leaping, jumping, falling, caught in mid-air. "Diane started making me aware of the history of photography," Davidson says, but still he couldn't photograph.

A few weeks passed and Diane invited him to Atlantic City, ostensibly to see a burlesque show with her, but he sensed she was trying to get him interested in looking at the world again. He agreed to go with her, but said he wouldn't take any pictures, although through force of habit he brought along his camera. As they drove across the George Washington Bridge and later through the tackiness of the old summer resort, he resisted looking out the window, though passing the Boardwalk he thought he could smell saltwater taffy. They attended the burlesque show, sitting through endless routines featuring flabby strippers and bad comics. Afterward Diane went backstage and showed Davidson where she'd photographed—in the dusty wings and filthy, airless dressing rooms.

For the rest of the afternoon they drove around a series of smog-covered little towns, very quiet in the heat, pausing for a while by the ocean, which was blood red in color. "I'll never forget it," Davidson says. A foul odor drifted through the thick, hot breeze. Air and water were obviously polluted, but nobody knew about pollution yet or that factories were dumping their wastes improperly. It was so hot that crowds were paddling about, despite the scarlet waters, and Diane took pictures of some of the bathers, who glared straight into her camera as she talked to them.

"You're better taking pictures of people looking in the opposite direction," she told Davidson, who had a sudden urge to photograph the bathers *his* way. But he didn't, and it was getting late, so they started to walk back to the car, past a gas station and a motel. Suddenly they came upon a squat pastel stucco house set back from the highway on an incline. Behind the house was a yard filled with ugly plaster statues. A truck roared by, and with that Davidson started click-clicking away at the landscape with his camera. Then a fat lady with crazy eyes waddled into view shouting angrily that this was private property and she chased him away. Diane began to laugh and they ran back to the car. Later they parked by a

lake "which did not have red water." Davidson took a picture of Diane in her bathing suit. "Diane loved to swim."

After that day Davidson slowly began photographing again. "I don't know what happened—can't describe it—except maybe Diane turned me on to the screwball aspect of the world." He started photographing the New Jersey meadows, topless waitresses, West Coast trailer camps. Periodically he would drop by Diane's house for coffee or he would join her when she had supper with Lisette Model. "God, those two women had a strong bond!" he says. "Reminded me of a mother and daughter." (Model always denied this, but there was a parent/child aspect to the relationship. Diane hung on her every word; Model in turn treated Diane with extreme tenderness, like the child she'd never had.)

Model was fifty-seven now, but she looked older; her sturdy little body was quite bent, her hair snow white. However, her attitude toward people remained wary and intensely curious. She still spent most evenings sitting in Village cafés gossiping with old friends like Berenice Abbott.

Model was currently the most famous photography teacher in America (her students ranged from Larry Fink to Eva Rubinstein), but she had not taken a picture in over a decade. No one dared ask why, but Bob Cato, who'd worked with her at *Bazaar*, says, "Lisette had been intimidated by Avedon and Penn—by their energy, their aggressiveness. Lisette was shy, 'Mittel-European'—she couldn't make small talk with editors, with advertising types. It was unbelievably tough in the marketplace. It's even rougher now, but back then—in the 1950s–'60s, when the photography community was smaller, more intimate, and everybody knew everybody —you still had to fight and struggle to get an assignment. Lisette couldn't push herself." (Model maintained that she never turned down work, but that her images were too strong for the magazines.)

So she invested most of her time and thought in her classes at the New School, and she taught Diane everything she knew. That is to say, she taught her that there are no pat answers or easy solutions to anything in art, and that every photographer *sees* differently ("some are instinctive, some are just strong"); seeing is a process of learning, and the main point is that you have to care passionately about your subject matter or forget it. Diane was the photographer Model envisioned herself becoming. Diane was fragile as a person but strong as an artist, and Model respected that because she, too, was a combination of delicacy and power. Model understood that many of Diane's photographs had to be taken in order to relieve her mind of the faces and night worlds that were haunting it. Through some mysterious, unconscious force Diane was starting to create in her pictures a kind of art that would be both a release and a vindication of her

life, and Model more than anyone understood this. So she encouraged Diane to brood for weeks about a subject—as she did with a young mother who resembled Elizabeth Taylor and had a retarded son. She'd noticed them on the subway and followed them home, and when she spoke to the woman about photographing her, the woman told her maybe but that she'd have to check with her mother first.

If a subject obsessed her enough, Diane would carefully go about gaining the cooperation and confidence of that person until—as in the case of the Elizabeth Taylor look-alike—she felt relaxed enough to pose. Diane treated almost everybody the same way—she was invariably cheerful and unjudgmental and had no pretensions about what she was doing, demanding self-revelation of herself as the price of the self-revelation of her subjects. This often left her exhausted after a session.

Until recently Diane had brought all her work to Model for criticism, but lately she'd told her, "Whenever I photograph, you're looking over my shoulder, Lisette." So for a while Model didn't go over her contact sheets or enlargements. However, their friendship grew more intense. Diane confided in her as she confided in no one else. ("Oh—what she told me! Things I will never repeat!") She talked about her daughters and their future, her continued dependence on Allan, her complicated feelings toward Marvin Israel, whom Model did not get to know until a decade later* when Aperture asked him to design Model's book of photographs.

Model worried about Diane's need to live in a constant state of euphoria. "She had to be flying—and sometimes she was, but sometimes she wasn't. She became so depressed she'd rub her hand back and forth across my table and her voice was like a five-year-old girl's."

Evsa Model worried about his wife's shifting moods; after being with Diane for several hours she would be drained. He didn't like her spending so much time with Diane—he felt she was being exploited. To which Model would argue that such a thing didn't exist. "Let me be exploited," she would cry.

For the past two years Diane had been scribbling encouraging notes to the young pacifist Paul Salstrom, who was serving time in prison for refusing to register for the draft. He would write back, he says, "telling her of my plans to live off the land—to buy a farm, which I eventually did. I wanted

* In 1979 they met in Model's black apartment to go over possible layouts. "I was frankly very apprehensive," Model says. For a while they just stared at each other in silence, and then Model remarked, "Until now I've always been afraid of you, Marvin." And he said nothing for a moment and then he answered, "This is ridiculous. I've always been afraid of *you*." And after that, Model said, "we got along all right."

to travel, too, and I used to encourage her to travel more—open up her life. Once I told her to go to Iceland to photograph the Eskimos. Maybe because *I* wanted to go to Iceland myself. I wanted her to photograph the communes some of my friends were starting in New England—the demonstrations against the war—the Diggers . . . the kids who were living in the desert with their gurus—but she wasn't interested in that. She seemed more interested in stuff that was close to home."

When he got out of prison in May of 1964, Salstrom came through New York and visited Diane's Charles Street house. "It was a sunny weekend," he recalls. "Diane's brother, Howard Nemerov, was sitting there in the courtyard with his wife, Peggy. He seemed to be a kindly, courtly man. He talked about what it means to be a pacifist and how Robert Lowell had been a pacifist in the Second World War . . . It was the anniversary of David Nemerov's death, so Howard and Diane spoke a little bit about their father to me." Before he left, Diane showed Salstrom a big looseleaf book filled with her scribblings. There were pictures, snapshots, newspaper clippings, drawings—like a collage. She envisioned it as a book she might someday publish—it would be called "Family Album."

Compiling births, deaths, marriages, accidents, crises of the Russek and Nemerov clans and also the Arbuses—to her this was a most basic form of history. Diane was captivated not only by the number and variation and rearrangement of her images, but by the *connections* between her old photographs, moldering letters, clips, postcards. It was not just a story, but a story to which *her life* belonged.

During the winter of 1964, Diane met Gay Talese at Esquire and told him she admired a book he'd written entitled *New York: A Serendipiters Journey*, a highly impressionistic work that told the story of odd people and uncommon places in the city; it was a view of urban life that Diane identified with and was fascinated by, and she suggested that perhaps Talese might do a sequel and that she might accompany his text with photographs.

They discussed the project further over lunch but nothing came of it; nevertheless they continued to see each other for the next four years. "It was a deep friendship based on much professional compatibility and a delight in doing things spontaneously." Talese says, "Diane, like myself, never planned things in advance. In fact I don't ever recall having a scheduled meeting with her—it was always a last minute phone call, her saying, 'What about meeting me at 59th and Lex for a movie in half an hour?' Or, 'Are you in the mood for dinner downtown after I get my daughter to bed?' "

Sometimes, Talese recalls, Diane would invite him to wander with her around 42nd Street or to take a bus trip to New England for which there was no particular destination. She liked to hang out at bus stations she would say—to study the transit scene. On occasion she would permit herself to be picked up by a stranger. "She was obviously courting danger," Talese says. "In that respect she was like a man. Otherwise she was completely feminine. Lovely. Although she always seemed to be in another time. Whenever we were together I saw her as in another time. She'd be talking—about photographing nudists in Sunshine Park, New Jersey— and her face would take on an ashen quality. She'd go remarkably gray— out of focus. Often there was a sense of dust about her—as if she was uncared for. You wanted to wipe her off, and her skin looked older than it should have; it was as if she hadn't put on cream for years. But God, she had a beautiful face! Gorgeous. Particularly in profile. And strange deep-set watchful eyes."

Every so often she would mention her brother when Talese visited the Charles Street house. He saw Howard's picture tacked up on the screen next to a contact sheet of the nudists she'd been photographing. She urged Talese to read Howard's poems such as "The Town Dump," which took its subtitle from *King Lear:* "The art of our necessities is strange that it can make vile things precious."

In 1965 three of Diane's earliest pictures were included in a show at the Museum of Modern Art called "Recent Acquisitions." Yuben Yee, then the photo department's librarian, recalls John Szarkowski choosing the Arbus photographs to exhibit from a pile of two thousand purchased from various photographers in the past fifty years. "We exhibited forty pictures altogether—a Winogrand and Friedlander, too," Yee adds. Diane's portraits were of two female impersonators backstage, a fat nudist family lolling in the grass, and a young nudist couple staring unblinkingly into the camera, against a background of grungy New Jersey woods. They seemed totally unaware of their absurd exposure.

Before the exhibit opened, Diane came to the museum several times to express her apprehension. She was worried about how the public would react. Indeed, during the course of the show Yee would have to come in especially early every morning to wipe the spit off the Arbus portraits. Public reaction to them was violent, Yee says. "People were uncomfortable—threatened—looking at Diane's stuff." When Diane heard about the spitting incidents, she left town for a few days.

"I thought there was something profoundly moving about the way Diane *saw* things," Yee goes on. "She combined naïveté and conviction,

and her images were direct and primitive. She stripped away all artiness, which the public wasn't used to." He would watch people in Szarkowski's department at the museum—sophisticated viewers who would flinch when they looked at some of her pictures, like the headless man or the human pincushion. These repelled and disturbed people. "Diane Arbus' pictures evoked powerful emotions," says Jim Hughes, editor of *Camera Arts*. "I can't think of a bigger compliment."

By 1965 Diane's focus had sharpened and her vision and her discomfort (actually, her inner projections of the world as she saw it) had become more pronounced. The electronic flash and the square format she was using gave her more control and outlined her subjects in nightmarish detail. Her portrait of the Puerto Rican woman with a beauty mark is sneeringly strange, as is the old couple taken on a park bench—their expressions, bleached by daylight and flash, reveal a desperate and harsh despair. "I sometimes thought Diane Arbus believed in the devil," John Putnam said. "She could psych out what a person was feeling. Her camera seemed to X-ray it and capture it as in a vise."

He and Diane had begun to wander around the lower east side together, past the synagogues pressed close to the Ukrainian community. The supermarket, the bodega, and the kosher deli were side by side, competing for the hippies' pennies. Hippies had replaced beatniks around Tompkins Square Park. Putnam says, "The whole area had come alive with a kind of ethnic combustion. Diane and I started thinking about photographing it." Gangs from the Bronx and suburban teeny-boppers, all in wild clothes, congregated outside the Fillmore East, where rock concerts were now being given. "It looked like some gigantic Halloween party," Michael Harrington wrote.

On Saturday nights Diane would wander around Bleecker and Mac-Dougal streets and watch a group of bikers roar to a stop in front of the San Remo. Cheap wine bottles were smashed on the sidewalk. There was so much violence the local residents complained and the police tried to close the bars at four a.m., but a crowd of a thousand thwarted them.

At one point Diane phoned critic John Gruen, who lived on Tompkins Square Park. Gruen had just written a book called *The New Bohemia* about the Lower East Side becoming an "exciting new mecca for the arts—for freedom." For a couple of days Gruen guided her around the East Village —Slug's Saloon, the Peace Eye Book Store, the Film Makers Cinema-theque, where Charlotte Moorman played the cello and stripped at the same time. Diane thought she might photograph the Keristas, the free-love group, which had rented a store on East 10th Street, called the City Living Center. But she found the kids there (both black and white) hostile and uninteresting, so she didn't.

Instead she took her cameras to Washington Square Park. Originally the park had been populated by NYU students and middle-class mothers wheeling their babies around old bohemians playing chess under the trees. Now teen-age runaways milled about the paths from dawn to dusk, and young black and Puerto Rican kids kept their radios blaring rock-and-roll music and defaced the great white arch with graffiti: "collective cave painting," Norman Mailer called it.

Diane soon discovered that the park was neatly divided into territories, with young hippies and junkies on one row of benches, hard-core lesbians on another. In the middle came the winos—"they were the first echelon, and the girls who came from the Bronx to become hippies would have to sleep with the winos to get to sit on the part of the bench that belonged to the hippie junkies." Diane found all of this "very scary." She had become a nudist, but she could never be one of these people. There were days when she couldn't photograph. She'd just sit and watch—watch the panhandling teen-agers, the kids so stoned their eyes wouldn't focus. A strange sense of territoriality and aggressiveness permeated the area; everybody who came into the park regularly tended to look at it as *his*.

Other times Diane would photograph with flat, documentary exactness for up to six hours at a stretch. She got to know some of the long-haired, barefoot girls and the homosexuals holding hands. She got to know some of the hippies and the winos and the surly gang members from the Bronx who often had uneasy, pregnant girlfriends with them. She wanted to get close to them, so she had to photograph them. Sometimes she would talk to them, sometimes not. She realized, "It's impossible to get out of your skin and into somebody else's . . . somebody else's tragedy is not the same as your own."

Occasionally John Gossage would sit with her while she photographed in the park. "She was gentle and funny and she had a disarming curiosity," he says. She also had "an incredible quality—of involving you in yourself." She would figure out that you had a problem and she would ask around it and you'd find yourself blurting out some private thing. Gossage had not uttered a word until he was twelve years old—simply because he hadn't felt the need to communicate with anybody. Diane got him to talk about it to her—"I don't know how or why."

Invariably she would have to break off from a project because she needed money. She'd won another Guggenheim "to learn about everything I don't know about: sex, secrets—for picture pictures . . ." but she always complained that she needed money. She kept looking for more free-lance work. Avedon helped her get assignments to do educational film strips, which she hated, but they paid some bills.

She attended a meeting for Guggenheim winners at Bruce Davidson's.

Bob Adelman says, "Dorothea Lange had the idea that documentary photographers should band together and get major funding from government, from institutions, so that as a group we could record and document the sixties the way the thirties had been. A lot of us were enthusiastic about the idea, but Diane was only interested if it brought her money."

She was making very little money, but she was developing a rather fearsome reputation with magazine art directors—as a photographer who laid bare in her portraits ghostly psychological truths. For *Bazaar* she did an essay on relationships—the Gish sisters, friends Rudi Nureyev and Erik Bruhn, poets W. H. Auden and Marianne Moore—and she seemed to catch the ambiguities within these couples—the acute discomfort they all had in posing for the camera. But Diane's photographs could also be conventionally beautiful, as with the dreamy, ethereal "Girl in the Watch Plaid Cap" which she took on Fifth Avenue sometime in 1965. It is as rhapsodic as a Julia Cameron portrait.

In the fall of 1965 Marvin Israel arranged for Diane to teach a class in photography at the Parsons School of Design. She agreed to teach darkroom technique as well, but backed out at the last minute,* so Ben Fernandez replaced her. Later he and Diane covered parades together and she advised him on his Guggenheim application.

One of Diane's students at Parsons, Paula Hutsinger (now a herbalist in Soho), recalls that "Diane was a terrific teacher. She didn't tell you to read the Jansen book of art history. Instead she took us to the Met and made us really look at objects—Greek statues, parade armor, Persian rugs, designs full of animals, Egyptian jewelry—everything and anything to make us really see and notice and collect images with our eyes."

"In another class," Paula continues, "she paired us off. We took portraits of each other. I took one of Michael Flannigan which she loved because I'd posed him on his spool bed; that made it 'more revealing and personal,' she said." She always took note of a person's personal possessions in her own photographs—the balloons in the transvestite's bedroom, the geegaws in the wealthy matron's home. She once planned to photograph John Putnam's one-room apartment on Jane Street because it was crammed with his "artistic hang-ups": drawing board, tape recorder, paints, hundreds of tiny tin soldiers, intricate sculptures, piles of rare books.

At Parsons, Diane brought books for the students to go over, such as Erich Salomon's enduring portraits of 1930s German politicos and tycoons. Salomon was called "the Houdini of photography"—his lively, in-

* She often professed ignorance about the technical side of photography. She once told a class she was never sure about loading a camera, confiding that she was always afraid she might insert a roll of fresh film incorrectly into the winding sprocket.

novative work with a Leica (that small portable camera with fast lens and larger film capacity) enabled him to move into hitherto forbidden places —courtrooms, palaces, high-level meetings. Salomon's spontaneous style was crucial to the development of photojournalism, Diane said. "He influenced Brassaï, Eisenstaedt, Bresson."

But she talked more about Weegee's pictures in the New York *Daily News*. She admired news photography because it was factual. And Weegee's images were factual in particular and they had a demonic edge to them, a pitiless quality she liked.

Weegee (born Arthur Fellig) got his nickname—an allusion to the Ouija board—because he always arrived early at newsmaking catastrophes. Recording violence was his specialty. His 1945 book, *Naked City* (which included his pictures of bloody corpses and firemen lugging body bags away from burning buildings), was later turned into both a TV series and a movie that made him famous.

Recently, Diane had gone with him on assignment in his battered Chevrolet, which was equipped with police radio and makeshift darkroom in the trunk. He was up until dawn, he told her. The infrared film and flash he used completely concealed his presence; he often prowled the beaches of Coney Island on hot summer nights and would take pictures of couples making love on the sand, or he would sneak into movie theaters and snap pictures of kids necking in the balcony.

Diane admired the extremes he went to when he zeroed in with his direct flash and wide-angle lens on every kind of disaster—suicide, murder, fire, flood, plane crash. And if an image failed to compose itself to his satisfaction, he would enlarge or crop it to bring it closer to the viewer. Often he would eliminate the background entirely by burning it a deep, flat black in his darkroom.

On assignment she was taking photographs of the black rock singer James Brown to illustrate a piece Doon was writing for *New York* magazine. She went first to Brown's home in New Jersey to photograph him lounging under his beauty-parlor-sized hair dryer, and choosing glittering costumes for his show. Next she photographed him in performance at the Apollo Theatre. She described the experience as "wild—it was like he was presiding over some mass freakout—the audience seemed crazed— *scared*." But she loved the music—a Latin sound mixed with rock-and-roll beat. At the climax Brown sang "Please! Please!" and his voice got frayed and hoarse and he sank to his knees and writhed about before collapsing in a heap and covering himself with a voluminous gold cape. The audience's screams were frenzied.

It reminded her of the Presley phenomenon back in the 1950s. Then

there had been shock and wild acclaim. Nobody had known what to make of him. Nobody knew what to make of Brown.

Going home on the subway from the Apollo, Diane ran into Susan Brownmiller, who had covered the Brown concert for the *Village Voice.* "Don't you love freaks?" Diane demanded suddenly. "I just love freaks."

She was not exaggerating. She had grown increasingly fond of her collection of freaks and odd things at Hubert's—the living skeleton, the embalmed whale, the ventriloquist with his two-headed cat. Diane still turned up at Hubert's almost every day. When the museum closed in 1965, she took a picture of the core group, including Presto the Fire Eater, Congo the Jungle Creep, the midget Andy, and Potato Chip Manzini, the escape artist wrapped in chains.

"Diane said the picture would be published in the *Herald Tribune,* along with a story about Hubert's demise," Presto says. "But then Charlie Lucas, who ran Hubert's, refused to sign a release—he'd been in the picture, too, so the picture wasn't published. But Diane gave us each a copy." Presto still has his copy of the picture—grainy, blurred—in his home in New Jersey; so does Harold Smith, formerly of Ringling Brothers, now of the 42nd Street Penny Arcade. Smith keeps his Arbus print in a manila folder in his hotel room.

Before the museum shut its doors, Diane asked for and got most of the eight-by-ten glossies of freaks that had been plastered across Hubert's walls since the 1920s. Presto says, "She walked off with stacks of freak pictures in her arms."

Sometime in 1966 Diane contracted hepatitis. She was treated by her therapist, who was also a medical doctor. (Earlier he'd prescribed antidepressants for her "blues" and she'd got some relief.) For a while he seems to have cured her hepatitis too, and she was very grateful since she was photographing day and night. Most of her latest pictures were up in John Szarkowski's office at the Museum of Modern Art. The museum's photography department was very casual and friendly then—the research library was still open to the public without an appointment, so that young photographers could browse through Edward Weston's portfolios. And Szarkowski had not yet become so powerful or remote; his office door was never shut and Diane would wander in and possibly Robert Frank would be there, or Walker Evans, or Grace Mayer—Steichen's trusted assistant —who had a tiny office down the hall.

Everybody in the department knew that Szarkowski was scheduling a major show for 1967 to mark the end of documentary photography's ro-

mantic, benevolent vision of the world as expressed in the "Family of Man" exhibit. Replacing it would be the highly stylized, personalized approach of Diane's freaks and eccentrics pictures. Garry Winogrand's disturbing confrontations with animals and people, and Lee Friedlander's images bouncing off plate-glass windows, storefronts, cars. "These are a new generation of photographers," Szarkowski would write, "totally different from 1930s and 1940s photographers (such as Margaret Bourke-White, Dorothea Lange, Eugene Smith, Cartier-Bresson), all of whom either wanted to honor humanity" or use their art for social reform. "Arbus, Winogrand and Friedlander make no such claims," Szarkowski continued. "What unites them is not a style or a sensibility . . . each has a distinctive and personal sense of what photography is as well as the meaning of it." Diane, however, was the most radical aesthetically, since she would pose her subjects like a portrait painter and then record them in a snapshot structure. This clashing of contradictory styles was having a startling effect on her imagery, as is evident in her portrait of identical twin sisters; the combination of styles seems to pinpoint the eerie visual quality twins project—that of being both symmetrical and ambivalent. To Diane, twins represented a paradox she longed to continue exploring and she did. She would photograph actress Estelle Parsons' twin daughters over and over again; she would photograph elderly twins and twins married to twins, and each picture seemed to ask what is it like to live in a body that is virtually indistinguishable from your twin's? Diane suspected that the ultimate challenge was to try creating a separate identity.

Naturally she brought the twins portrait to Szarkowski and he decided to use it—he planned to exhibit at least thirty Arbus pictures. Diane, however, was reluctant to have her work shown at all. She kept saying no even after Walker Evans told her she was a fool and Szarkowski had blown up some of her prints to mammoth proportions in an effort to convince her.

She was afraid she'd be misunderstood—afraid that her pictures would only be considered on the crudest level, with no self-reflection on the part of the viewer. Months went by. She told Szarkowski in a note she no longer liked some of the pictures he'd chosen—early pictures she'd taken in 1962–4 while she was struggling to find her themes, her style. Maybe she was still sick with hepatitis, she concluded, but she thought her latest pictures—like the twins—were better. So in the fall of 1966 Szarkowski would come down to the Charles Street house and go over Diane's latest contact sheets and then she would print up some of his selections. She thanked him for his "steadying hand."

Eventually she did agree to be part of "New Documents," although she assumed from the start that most people would see only what they wanted

to see in her misfits—the surface distortion. But once she agreed, she couldn't stop talking about the exhibit, Garry Winogrand says. "She imagined all sorts of things coming out of the show." She kept repeating how lucky she was, how terrifically lucky.

Winogrand, coming to the Museum of Modern Art's photography department while Szarkowski was editing the exhibit, got to know Diane "a little bit." He says, "Before that I'd been seeing her around for a couple of years taking pictures. A couple of us used to hang out at the same street-corner—57th Street and Fifth." "Us" meant Joel Meyerowitz and Tod Papageorge, who often accompanied Winogrand in his wanderings around New York. He was known as "the duke of street photographers" because his energy was so prodigious and he seemed more alive than anyone else to the endless visual possibilities in the frantic, brooding city.

Winogrand says he felt uneasy with Diane. "I thought her idea of being an artist was very different from mine. A shooting had to be hard to do; that's why she lugged so much equipment around, I thought. Taking a picture couldn't be easy—it couldn't be pleasurable—because then it wasn't art."

It was true that Diane always appeared weighed down with equipment. "It was like her security blanket," Chris von Wangenheim said. John Putnam recalls that earlier that year she carried "two Mamiya cameras, two flashes, sometimes a Rollei, a tripod, all sorts of lenses, light meters, film, when she was on assignment to photograph the American Art Scene for *Bazaar*."

It took her weeks to complete, but this portfolio (some thirteen studies in all) turned out to be possibly her liveliest and most accessible portraiture. Out of it came an exuberant shot of Frank Stella on a tilt and displaying a goofy, toothless grin; James Rosenquist caressing his armpit; a bare-chested, handsome Lucas Samaras (who later evolved from paintings to Polaroids and said recently, "Diane Arbus influenced me"); Ken Noland wearing suit and tie; Claes Oldenburg clowning around with his wife. Obviously, Diane enjoyed this assignment, since she knew many of the artists personally—enjoyment radiates from the photographs, especially in her affectionate portrait of Richard Lindner, a tiny, wry man of great intelligence whose gigantic, earthy paintings of ferocious women, often nude, against a backdrop of sinister Times Square, had been construed as Pop Art; as a result, he was hugely successful in the sixties—by mistake, he would say. This amused him greatly.

Also included in this portfolio was a small shot of Marvin Israel, the only surrealist in the bunch, standing impassively in front of what looked like a blank canvas.

Some of the contacts were eventually published in the *Village Voice*,

along with an article by Owen Edwards describing Israel as "Diane Arbus's closest friend." The piece itself was entitled "Marvin Israel, the Mentor Who Doesn't Want to Be Famous." In it Israel was quoted as saying, "Diane and I shared everything—opinions, ideas."

She was seeing him now three or four times a week. Whenever she visted her mother in Palm Beach, she "phoned this Marvin person every day. He was obviously very important to her." (When Mrs. Nemerov finally met Israel, he told her, "Diane doesn't love Allan anymore, she loves me.") Certainly she relied increasingly on his advice and counsel; she referred to him as "my Svengali" and spoke of being "under his spell," "in his thrall." Although it was understood that they both led independent lives, she tried to keep herself available for him and was known to drop everything just to be with him for a short time. She loved to come to his studio on lower Fifth Avenue when he was designing a new book. And there was a deep darkness inside Diane that responded to Israel's violent paintings (as later expressed in a series of studies of dogs alternately embracing and tearing at each other's guts). He was increasingly involved with his own projects, although he was still concerned with promoting and advising Diane as well as advising Richard Avedon (who calls him "my biggest influence"). But the two men often quarreled. If Diane and he fought, nobody knew about their arguments.

"In public, Diane always kept her distance with Marvin," Emile de Antonio says. Even when they were among their coterie of intimates (attorney Jay Gold, Bea Feitler, Larry Shainberg), they remained cool and impersonal with each other. Sometimes they played intellectual "head games"—they were both expert at that. "It was like a weird battle," said the late Chris von Wangenheim, "because Diane was so mystic and intuitive and Marvin could be so stubborn—calculating—cold." And then they would go to a restaurant and Diane would seem to disappear. "Often it was as if she didn't have any identity when she was around Marvin," says literary agent Diane Cleaver, who had dinner with them a couple of times.

Occasionally he would abruptly criticize her clothes, her friends, her hesitant way of speaking. "Speak up!" he'd command when she was trying to explain something at a party. When she ignored him or escaped into a daze, he'd repeat, "Speak up!" and when she wouldn't, he'd get wildly angry. (Diane used to remark how she was struck by female powerlessness in the face of male power, by the phenomenon of women who are strong with one another and in their work, but who break beneath the domination of male mentor or lover—they feel they must play the passive role.)

However, the next day Israel's outburst would be forgotten and he would be trying to get Diane a book contract for her transvestite pictures or phoning *Harper's Bazaar* about a possible assignment for her. According

to an assistant in the production department, "Marvin kept in touch with Bea Feitler and Ruth Ansel, who were art-directing *Bazaar* together. He'd keep at them with possible suggestions for Diane, so she worked a lot for the magazine." And he was promoting her elsewhere with people who didn't know her work as well. Bob Cato, then Vice President for Creative Affairs at CBS Records, recalls "Marvin making a lunch date with me at the Ground Floor, and when he arrived, Diane was with him—very shy, withdrawn. The entire meal was taken up with Marvin very eloquently and with great dignity seeing if there was some way Diane could be used. I'd just okayed the hiring of Eugene Smith to photograph some recording sessions. Marvin thought that possibly Diane might do that, too. He so obviously believed she was a singular talent—he spoke about her with such understanding and intensity and tenderness. I was very impressed."

28 _____

Over the 1966 Christmas holidays Diane flew to Jamaica to shoot
children's fashions for an entire special section of the Sunday *New York
Times*.

Times fashion editor Pat Peterson came along to coordinate the project
and brought her son, Juan, with her, as well as her husband, Gus Peterson,
also a fashion photographer. Diane arrived with Amy in tow. Her camera
case was lashed to her shoulders and she never let it out of her sight.
Pinned inside the case were Allan's elaborate instructions for color expo-
sures. Since Diane hadn't shot much color, she was very nervous about
getting something wrong. She was being paid $5000 for the shoot and she
wanted everything to go well.

In the hot bright mornings she would rise very early and go swimming
by herself. Then she would come back to the hotel. Pat might pass her
room on her way to breakfast. The door would be open, the shades pulled
down, and Diane would be scribbling away in her journal, surrounded by
darkness.

The first days Diane scouted locations with Pat in and around Kings-
ton selecting several settings; one that proved to be her favorite was a
grassy meadow overlooking Montego Bay. Then Diane met with the
models Pat had chosen—none of them professional. Some were white kids
on vacation with their parents. A great many were black boys and girls
from the Jamaican slums and they were alternately sullen and awkward
in front of Diane's camera when she shot them dressed in expensive sun-
suits, terrycloth robes, denims, and caps. Because she was so nervous
about the results, she airmailed the unprocessed film to Allan in New
York. But she needn't have worried. The pictures turned out to be among
the most evocative of her career—some editors believe these pictures were
a steppingstone in the changing styles of fashion photography, certainly
of children's fashion. The pictures vibrate—they are warmly sensual im-
ages, alive with the secret meanings of what it's like to be young. It's

startling to see how well she documented the kids' ironic, wary, role-playing stances.*

After work she and the Petersons did "touristy" things. They'd wander through the markets and shops in Kingston and at one of the shops Diane chose an album encrusted with shells. "I think I'll buy this for Marvin," she said. She wrote him a letter every day.

In the evenings they might go out to a nightclub. "Diane would put on an Yves Saint-Laurent dress and look smashing." Usually she wore her "uniform" of cut-off jeans and sandals. She'd got very tan and her hair was cropped short as a boy's.

At the end of their stay Diane and Pat went back to the market and came upon a little shop "where an artist had concocted these exquisite hand-painted crowns. He only had two left. We bought them, but we could tell he didn't want to part with them both—his face screwed up with emotion as he packed them very tenderly for us in tissue paper. The next morning, driving to the airport, I had my crown on my lap (I still have it at home, and every time I see it I think of Diane). Suddenly I looked across at Diane and asked, 'Where's your crown?' and she said, 'I gave it back to the artist.' Just the way she said it moved me to tears."

When the Petersons, Diane, and Amy got back to New York, Allan was at the air terminal with his girlfriend, Mariclare Costello, to meet them. A few days later Diane wrote to the Petersons, telling them "how much the trip to Jamaica had meant to her and how wonderful we'd been to her and Amy and how she considered us her 'family' now.

"She wanted us to choose one of her photographs from the upcoming show at the museum and I said, 'Sure,' but I forgot, and a couple of weeks later Diane phoned and said, 'You want one of my pictures, don't you?' She seemed hurt that I hadn't chosen one immediately. So I ran over to the Charles Street house that very afternoon and I chose one of the nudist family and Diane signed it in her childish scrawl, 'to Gus and Pat, love Diane Arbus.' "

"New Documents," the photography exhibit at the Museum of Modern Art, which opened March 6, 1967, was probably the high point of Diane's life.

* Pat Peterson says that when the special fashion issue was published in May 1967, it was "quite controversial. We got a lot of negative mail becuse Diane's images were so strong."

Diane credited this first issue to the Arbus studio. But her next two issues of children's fashion, done in 1969 and 1970, she credited to herself. (All three have since become collectors' items.)

Nothing indicates more clearly her excitement than the hundreds of announcements she sent out to friends and acquaintances on postcard-sized replicas of her portraits. She sent them to the Alex Eliots in Greece, to Pati Hill in France, to John Putnam, Phyllis Carton, Harold Hayes, Robert Benton, John A. Williams, Barbara Forst, Renee Philips, Joseph Mitchell, Larry Shainberg, Lucas Samaras, hairdresser and rock singer Monti Rockill, Mr. and Mrs. Gay Talese, and many others. All had individual handwritten messages. "I urge you to come," she scrawled to photographer Irene Fay, and to her old English teacher Elbert Lenrow she added, "Do you remember me? Diane Nemerov—Fieldston—'39–'40?"

She talked to Grace Mayer about inviting pianists Arthur Gold and Bobby Fizdale, Mr. & Mrs. Leonard Bernstein—"he recommended me for a Guggenheim . . . Eddie Carmel, he's a Jewish giant I'm pursuing . . . Algernon Black, Ethical Culture . . ."

She passed out postcards as well—dropping one off at Tiger Morse's Teeny Weeny boutique and leaving one for David, her hairdresser, and others for the Tom Morgans and Mary Frank. Geri Stutz, president of Bendel, recalls "Diane marching into my office and plunking the postcard down on my desk. She was grinning like a happy little kid."

Opening night of the show it seemed as if everybody she knew in the art and photography worlds was there, including Emile de Antonio, Henry Geldzahler, Andy Warhol, Robert Frank, Walker Evans, Tom Hess, Lisette Model, Richard Avedon, Marvin Israel, and the Pop Art collectors Robert and Ethel Scull. At Pat Peterson's suggestion, Diane wore a white silk dress. Actress/photographer Roz Kelly,* who was there, says "Diane looked like an angel in the midst of a huge crowd." She never stopped floating. Eventually she came drifting over to Kelly. "I'd like to photograph you," she murmured. After a few moments she melted away in another direction. And much later a museum photographer captured her materializing ghost like from around a wall. She can be seen observing her brother Howard talking with Allan and Mariclare Costello.

Shortly after the opening the Bob Meserveys got a postcard emblazoned with Diane's portrait of the identical twins. The message read: "Get to the Museum of Modern Art . . . Everything here is overwhelming . . . I go from laughter to tears."

"For a while, she thought it was the greatest thing that had ever hap-

* Kelly (who later played the Fonz's girl on TV) used to dress up in outrageous constumes and wigs and take kitschy self-portraits in an effort to "find" her true image. In 1968 Diane took a series of portraits of Kelly posing à la Marilyn Monroe. And Kelly took pictures of Diane staring out the window of the 42nd Street automat. She is holding onto her camera and flash. "(She looked as if she was on a cloud and about to take off," Kelly said. "She took off alright [after that] I never saw her again.")

pened," Garry Winogrand says. "The 'New Documents' show meant everything to her." He adds that he doesn't think the show itself was so important, although it did suggest some of the pure potential of photography. "But it was more important because it introduced Diane Arbus to the world." And, indeed, the lion's share of attention, praise, and criticism was reserved for her thirty portraits of midgets, transvestites, and nudists, which were set off in a room by themselves, whereas Winogrand's paradoxical groupings of people and animals shared a space with Lee Friedlander's reflections in windows.

Crowds poured into the Arbus room and jostled one another in an effort to get close to the portrait of the lolling family of nudists. Elderly couples averted their eyes and often left hurriedly, murmuring, "Disgusting!" The critic Peter Bunnell believes that "what disturbed and disoriented people most was the pictures' power to dominate." John Szarkowski thinks "Diane's images reminded us that we could fail."

"Diane Arbus is the wizard of odds!" one critic blared, and another stated, "She caters to the peeping Tom in all of us." Chauncey Howell in *Women's Wear* called her eye "Grotesque." Robert Hughes in *Time* said, "Arbus is highly gratifying," while the *New York Times* described the Arbus vision as "bizarre . . . and it must be added in some cases that the pictures are in bad taste."

Some of the most enthusiastic viewers turned out to be hippies from Haight-Ashbury and East Village dropouts in beads and long hair. Diane's images didn't threaten them; they had already begun responding to paradox and ambiguity and recognized in the grimacing Arbus faces—the languid expressions of the drag queen—elements of their own rebellion and extremism.

Response from the photographic community was strangely muted. "It was like what happened when Bob Frank's *The Americans* was published," Saul Leiter says. "There wasn't much overt excitement, but the residual effect was enormous." The "New Documents" show reshaped the documentary photographers' approach through the 1970s. And Diane's work had a profound effect; her way of photographing in square format with direct flash was copied by hundreds of photographers.

However, Emile de Antonio recalls that most of the art world "at least on opening night" was its usual judgmental, carping self. He believes that Diane was dismissed except by a few discerning souls who recognized her singularity. "Her subject matter was just too difficult for most people to confront." But her "Man in Hair Curlers" and "Woman with a Cigar" went on looking out at the crowds "unflinchingly," Max Kosloff writes, "as if not to countenance but to challenge the prurience of the photographic act."

The psychological complexity of experiencing the Arbus photographs was acutely analyzed by Marion Magid in *Arts* magazine: "One does not look with impunity as anyone knows who has ever looked at the sleeping face of a familiar person and discovered its strangeness. Once having looked [at Arbus' work] and not looked away we are implicated. When we have met the gaze of a midget or a female impersonator a transaction takes place between the photograph and the viewer. In a kind of healing process we are cured of our criminal urgency by having dared to look. The picture forgives us, as it were, for looking. In the end the great humanity of Diane Arbus's art is to sanctify that privacy which she seemed at first to have violated."

Immediately after the show opened, Diane gave an in-depth interview to Ann Ray, a *Newsweek* reporter. While they walked around the exhibit one afternoon, stopping to consider the portraits of midgets and angry kids, Diane confessed, "It impresses me terribly to have a show at the Museum of Modern Art; the show looks wonderful. It's beautifully hung . . . but I would never have done it except for John Szarkowski. He's wonderful." Then she added, "I've spent the last eight years—which is how long I've devoted full time to my photography—exploring—daring—doing things I'd never done before—things I'd fantasized about as a child —going to circuses . . . sideshows . . ." But when pressed, she seemed reluctant to discuss her subjects or their situations except in general terms.

Ray noted that "Diane Arbus prides herself on getting people to open up their secrets," and so felt an obligation to keep those secrets to herself. "I work from awkwardness," Diane said. "Whereas Dick Avedon works from grace. By that I mean if I stand in front of something instead of arranging it, I arrange myself . . . it's important to take bad pictures—it's the bad ones that have to do with what you've never done before . . . sometimes looking into a camera frame is like looking into a kaleidoscope and you shake it and sometimes it won't shake out . . . I'm not virtuous . . . I can't do anything I want. In fact, I can't seem to do *anything* that I want. Except be a spy. I've captured people who've since died and people who will never look that way again . . . I'm clever . . . I don't mean I can match wits with people 'cuz I can't. But I can figure myself into any situation. I choose photography projects that are somehow Mata Harish. I'll not risk my life but I'll risk my reputation or my virtue—but I don't have so much left," and she laughed. "Everyone suffers from the limitation of being only one person."

She paused in front of her portrait of identical twins from Roselle, New Jersey, which perhaps better than any other of her images expresses the crux of her vision—the freakishness in normalcy, the normalcy in

freakishness. "I thought how ordinary is a charming pair of twins," Diane murmured. "In some societies twins are taboo, an aberration."

She paused again in front of her portrait of a peroxided, buxom burlesque comedienne seated in front of her cluttered dressing table. "She looks as if she'd stopped changing when burlesque died," Diane said. "With her Betty Grable hairdo and her platform shoes."

Asked if she deliberately distorted, Diane answered, "The process of photography is itself a bit of a distortion . . . but I'm not interested in distortion . . . you have to fuss with what you want and what the camera wants . . . the camera is so cold. I try to be as good as I can to make things even . . . the poetry, the irony, the fantasy, it's all built in."

She seemed pleased when told that some people likened her photographs to Joseph Cornell's boxes, particularly her portrait of "The Widow" in an apartment crammed with gewgaws and *objets d'art*. "I love Cornell's secrets—all those little secrets in little boxes—and I adore Steinberg and Pinter's *Homecoming* because the play has such secrets in his use of language."

Almost every day Diane came to the museum and moved through her exhibit, eavesdropping on the public's reaction. She maintained, "I love what people say . . . one woman looked at the pictures and said, 'I'd sure like to see the photographer, Diane Arbus,' implying that anyone who takes such weird pictures has got to be weird herself. Like the man and wife who came in and the husband said, 'This is great. I feel as if I know all these people,' and the wife said, 'You do?' "

But eventually she got tired of listening—most of the comments were derogatory: "strange," "ugly," "hateful," "distorted," "repulsive . . ."

She was told by friends that she had to develop an inner toughness, an indifference to people's negative opinions of her work—a belief that the opinions of others were of concern to *them* and not to her. John Putnam quoted Gertrude Stein's admonishment to Picasso: "All original art is irritating at first before it becomes acceptable to the public."

She grew increasingly depressed. She didn't really enjoy all the recognition; she liked to think of herself as someone who worked in private. Now the public and the art world had declared a stake in her career, and in the future everything would be done on display.

While the "New Documents" show was at the museum, she let John Gossage photograph her in Central Park. In the picture Diane is bundled up in a black quilted coat and a white turtleneck sweater, her Miniaflex camera with flash hanging around her neck. She confronts the lens with a look of utter desolation. After the session Gossage asked her how she felt and she answered, "Photographing is not about being comfortable, either for the photographer or the subject."

One weekend she escaped to East Hampton to stay with Tina Fredericks. "Even though the water was freezing cold, she swam far out in the ocean," Tina says. Her depression would not go away. She complained of being "dry and flat." Nobody understood her pictures, she said. She'd been afraid of that—that she would be known simply as "the photographer of freaks." It upset her that her motives were being misread. She was no more voyeuristic than any other photographer, nor was she "sicker" or "weirder." It was just that she was more open, more honest, about her fascination with what society labeled "perverted" or "forbidden."

As far as she was concerned, she simply wanted to take pictures of people whose faces and stories interested her. By now she had a stack of looseleaf notebooks dating back to 1959 which were crammed with brief accounts of hundreds of lives—romances, crises, disasters, jotted down in her nearly indecipherable scrawl. Nobody was identified by complete name because these were the secrets her eccentrics and her ordinary people had entrusted her with while she photographed them. Their stories never failed to excite her. She was thrilled, not only by what they had to say, but also by what they drew out of her. Because once they began talking to each other and she started clicking her camera, the gulfs that divided them—gulfs of race, age, expectation, craziness even—momentarily disappeared.

Collecting and exchanging secrets was a private bond between herself and her subjects; it was actually at the core of her work. Making something a secret was a way of giving it value. Secrecy kindled mystery and a belief in the sacred and it encouraged the distinctions and the connections between the midget and the Jewish Giant's doomed yearnings.

Like most imaginative photographers, Diane found the medium limited—so that her images were meaningless unless she had stories and secrets attached to them.

Her friend, the painter Richard Lindner, would confirm this. Lindner would say that creative people must deal in secrets—if your secrets disappear, you are nothing.

Both he and Diane were intrigued by the sexual role-changes that were occurring in the sixties. He thought men were the victims as well as the victimizers of women, that women were more imaginative than men because "they have secrets we don't even know about," and richer, more complicated interior lives. Diane appreciated that, given her intense involvement with self, her ability to live so freely with her restless body and caressing hands.

She and Lindner often discussed pornography. She had, in fact, begun to collect porn (both novels and photographs), and was mesmerized by the boring repetitiveness of it—the literalness, the minimal style. Whenever

she went to the 42nd Street "live sex" shows, she was struck by how, although the expectation was for sensation, there was finally no sensation at all, no eroticism, no mystery up on the rickety stage. Strangely enough, erotic images seemed to hold little interest for Diane; their complicated, self-defining qualities were almost lost on her.

29 _____

April 15, 1967. Easter Sunday "Be-In" in Central Park. A pungent smell of incense rose from the grass on the Sheep Meadow, mingled with the smoke of burning draft cards. Thousands of hippie kids in beads and body paint were tripping, stumbling, playing guitars, throwing balloons into the air, yanking off their clothes and rolling into the lake by Bethesda Fountain. Diane came to photograph the spectacle with *Village Voice* photographer Fred McDarrah and Garry Winogrand, both of whom snapped shots of her looking guarded and chewing on a daffodil. "She hated having her picture taken," Winogrand says.

Later that day she ran into John Putnam and complained that she wasn't getting enough work. She'd expected "New Documents" to generate some really lucrative assignments, but not much had happened. A lot of phone calls, queries—a lot of talk from *Life*, but no definite offers—and when she went to *Look* to ask if they'd like her to photograph Death Row (something she'd always wanted to do), she was told it was too difficult to get permission. She hated peddling her pictures, her ideas, to magazines; it seemed degrading. She was now more afraid of going to Condé Nast than to a leather bar or a brothel.

She was still working regularly for *Esquire* and *Bazaar*, but the pay rate was terrible—$150 for a single black-and-white picture, $200 for a spread.

To dispel the growing myth that she only took pictures of freaks, she made up a list of elegant people she wanted to photograph. She told someone she wanted to photograph beautiful people because "beauty is itself an aberation—a burden, a mystery . . . like babies. They can take the most remorseless scrutiny . . ."

As if to prove her point, she took a remarkable portrait of Gloria Vanderbilt's sleeping baby son, Anderson Hays Cooper, for a *Harper's Bazaar* Valentine issue. In this truly astonishing picture the infant resembles a flat white death's head—eyes sealed shut, mouth pursed and moist with saliva. When Gloria Vanderbilt saw the photograph, she forbade

Bazaar to publish it, but eventually she changed her mind and this stunning image opened Diane's retrospective at the Museum of Modern Art in 1972.

She was still phoning Joseph Mitchell. One of the last times they spoke, he says, "I suggested she photograph the Basque shepherds who come to New York once a year for a few days before going on their way to Wyoming to herd sheep. Most of their time was spent at the Jai Lai, a marvelous Basque restaurant that used to be on Bank Street. Diane wanted to photograph men out of their culture—here was an opportunity. Don't know whether she did."

Mitchell says that after seven years of phone conversations "we still hadn't met. She once said, 'You know, we *should* meet.' And then I admitted I'd caught a glimpse of her recently in the East Village at the Dom—she'd been photographing and she'd been so involved I didn't want to interrupt her . . .

"And there was a pause and she confided she'd seen *me*. At Costello's Bar—I'd been sitting with Sid Perelman and she'd looked very hard at me but decided not to come over. So we never met. And if memory serves, May of 1967 was the last time I ever heard from her."

As the weather grew warmer, there were more marches for and against the Vietnam war. Martin Luther King and Stokely Carmichael spoke to crowds in Sheep Meadow, and Diane, along with dozens of other photographers, would move through the masses of humanity with her flash. Afterward she might wander over to 57th Street and Fifth Avenue near Doubleday's and position herself by the store until the sun set, photographing. And in the evenings she might go to Richard Avedon's seminars, where Debbie Turbeville was showing her first monochromatic shots of slouching women trapped in ominous settings and Garry Winogrand talked about how he was planning to use his Guggenheim. From there she might head for the Dom, the biggest disco on the Lower East Side, which was always filled with the sound of rock music and strobe lights and movies projected against the walls; she would stay there documenting the couples dancing, preening, clowning for her cameras. These people were an essential part of what came to be known as the sixties subculture—druggies, transvestites, groupies, socialites, rich kids, all gathered together, performing for Diane's cameras. Everybody at the Dom acted hungry for approval, for recognition, but it was all surface—immediate, noisy, tedious, scanned. The girls wore outrageous styles—like the "plural love/

peace dress" which three could squeeze into at once (moving about the dance floor, they resembled a freaky six-legged animal). Then there were the boys in tight jeans and Sergeant Pepper jackets, little caps and granny glasses covering drugged, droopy eyes. Diane would quickly tire of such trivial self-revelation and end up at Max's Kansas City to meet Marvin Israel and tell him about her day.

Often they might be joined by Mary and Robert Frank, Bea Feitler, and Larry Shainberg. The other poets and painters who frequented the bar seemed to hold the bleak, despairing Frank and the shadowy Diane in awe. By 1967 the art world had lost its idealism, its sense of outsideness, and was turning art into big business, but Diane and Robert Frank seemed exceptions—pursuing harsh, subversive work without any thought of financial gain or self-publicizing. At the moment Frank, unshaven and tattered as always, was completing a documentary called *Me and My Brother* about a catatonic man, and he was about to start another movie in Nova Scotia with novelist Rudi Wurlitzer (already a cult figure for his book *Nog*, which is dominated by a fantasy of self as a "dark wet hole"). As for Diane, she would usually be "electric with anxiety," but eager to describe whatever had been happening to her.

Her latest story concerned releases. Her show was still up at the Museum of Modern Art, but she still hadn't been able to get releases from most of her subjects and this was worrying since it touched on a photographer's moral responsibility, the legal issue of invasion of privacy, as well as permission to reproduce the image. (Diane maintained that she always asked permission to photograph a person, and if he said no, she respected that.) In any event, she had recently hopped a cab, laden down as usual with her cameras, and the driver had asked laconically, "You a photographer?" "Yes, yes," Diane answered, looking not at him but at her appointment book because she was late for an assignment. "Funny thing," the driver droned on as he steered through traffic, "I went to the Museum of Modern Art the other day to catch a show and there *I* am big as life hanging on the wall. Picture of me! What a thrill! Wish I knew who the photographer was. Like to thank him." Diane stared at his profile and burst out laughing. "*I'm* the photographer!" she exclaimed, recognizing the driver as the earnest young man in straw hat and a BOMB HANOI button in his lapel whom she'd photographed at a pro-Vietnam demonstration. "Listen," she said, "I need a release* from you, all right?" With that he

* According to Neil Selkirk, who has printed her work since her death: "Diane obtained few releases." Had she lived, it would have been much more difficult to exhibit her photographs so widely since many of her subjects objected strongly to the way she depicted them. But, as Selkirk says, "Since she's dead, they figure there's not much they can do about it."

stopped the cab and scrawled an okay on a matchbook cover, obviously delighted.

Other subjects weren't. When her portrait of identical twins appeared in the "New Documents" exhibit, the twins' parents protested that the image was a distortion and tried to stop the picture from being reproduced elsewhere because they thought their daughters would be exploited. (Eventually "The Twins" became Diane's most famous photograph—her trademark, reproduced on posters, on her book cover, inspiring Stanley Kubrick in his horror film *The Shining*.)

The twins' family's reaction upset Diane, but she was equally upset about being copied. ("Imitation was not for her the sincerest form of flattery but an absolute horror," her daughter Doon has written. One wonders how she'd feel today when so many photographers use her square format with flash.) Peter Hujar recalls that once when he joined her for dinner with Avedon and Marvin Israel, "She refused to speak to me. Later I found out she'd thought I'd ripped her off—copied her way of photographing transvestites—with a black border around the picture." (One of Hujar's most famous shots is of the dying transvestite Candy Darling.) "When I first saw Diane's black-bordered portrait of the Gish sisters in *Bazaar*, I thought she'd copied *me*."

She frequently talked to Garry Winogrand and John Szarkowski about being imitated, and as a result she kept changing cameras in order to change her imagery. She would go to Marty Forscher's camera shop on West 46th Street a couple of times a week to look at the latest models. "In 1967 she was trying out a Fujica," Winogrand says. "It resembled a pregnant Leica—clumsy, clunky—but Diane believed that the more difficult the camera, the better. She didn't believe a picture that was easy to get could be good."

In the early summer of 1967, Peter Crookston, deputy editor of the London *Sunday Times* magazine, arrived in New York from England. He was a polite, rosy-cheeked young man on the lookout for "the hottest American reporters and photographers," so he'd already arranged to meet Harold Hayes of *Esquire*, that quintessential magazine of the 1960s. Hayes put him in touch with New Journalists like Gay Talese and photographers like Carl Fischer, but Crookston phoned Diane directly because the *Sunday Times* art director, Michael Rand, had seen her eccentric portraits in *Infinity* and wanted to give her some assignments.

Crookston says he was "instantly attracted" to the tousle-haired woman in miniskirt and workshirt who invited him into her little Greenwich Village house. She was soft and shy and giggled with pleasure at

some of the comments he made about her pictures. They sat in her cool, dark living room, which was so dim he found it hard to see the blow-ups she kept handing him—strange, angry, despairing faces, many of them. She had prints hung everywhere, tacked up on mats. There was one he liked in particular—a strong man flexing his muscles. "He looked like some mythic Hercules. I told Diane it was very good and she promptly gave it to me. It's framed now in my apartment in London."

They were interrupted periodically by Doon, who kept running up and down the stairs, shouting things at her mother. Diane would call back in reply, sometimes making a face of mock exasperation. Crookston noted that they seemed to have a very close, very warm relationship and that Doon was astonishingly beautiful. "You have a lovely daughter," he murmured finally, and Diane answered, "Yes. We're rivals." She did not elaborate, and then the phone rang and she proceeded to hold a monosyllabic conversation. "Hmmm. Yeah. Yes? No . . . not tonight . . . well, maybe another time." And she hung up and came back to sit down beside Crookston. "Have you ever been to an orgy?" she asked, and he replied, "No, have you?" "Yes," she answered, she went to orgies and she photographed them. "Would you like to go to one tonight? We could go, but it would probably be very boring. They usually are. Although sometimes they're fun." And Crookston answered quickly, "I'd rather take you to supper." Eventually they left the Charles Street house and went to a chili place nearby to eat. During the meal they talked mostly about their backgrounds, telling each other about their families. Then, after supper, they walked back to her car—"a beat-up Renault"—and she drove him to his hotel and they spent the night together.

At dawn, Crookston says, "I was awakened by Diane sitting bolt upright on the pillows and crying out, 'What are you doing with me? I go to bed with old men, young boys . . .' and then her voice trailed off and she giggled. 'I couldn't possibly have known that, now could I?' I answered. With that she murmured that she'd gone wild after Allan left—wild—and had started having sex with as many people as possible, partially to 'test' herself, partially *to see what it was like.*"

She was always frightened, she said, but that meant conquering her fear each time; developing courage was extremely important to her, as important and "thrilling" as the "adventures" or "the events" (as she called them) themselves. Because the only way to understand something was to confront it, she said, and when you had sex, restraints were broken, inhibitions disappeared. Sex was the quickest, most primitive way to begin connecting with another human being, and the raunchier and grosser the person or environment, the more intense the experience, and this enlarged her life.

She then described in a peculiarly detached way how one night she'd had sex with a sailor in the back of a Greyhound bus. ("If you sit on the inside back seat of a Greyhound bus, it means you're sexually available.") No introductions were made, not a word was spoken, and after this swift, mute encounter in the dark, she got off at the next stop and waited on the highway for an hour or so until another bus came along which would bring her back to New York. When the bus arrived, she got on and collapsed on a seat ("not the back seat"). It was close to five a.m. and suddenly she was hurtling through space, through tunnels, whirling, drifting, rootless. Gas fumes and air-conditioning enveloped her, and across the aisle other passengers snored or gurgled in their sleep . . .

Suddenly she launched into another kind of story, complete with gestures and accents, about a recent photo assignment. The subject had been a celebrated Washington lawyer. She'd arrived at his office and found a British journalist already there, interviewing him—a very pretty, very ambitious journalist who, Diane sensed, wanted to seduce him "because this lawyer was rather sexy and powerful, too." Diane decided "for kicks' to seduce him first—and for the next hour she exerted her fey charm on the man while blinding him with her flash. He got sweatier and more excited and finally the British journalist left, and Diane said she'd felt sorry for her because "she didn't have the patience I had. I hung in there."

It was almost as if she was determined to explore with her body and her mind every nightmare, every fantasy, she might have repressed deep in her subconscious. Crookston listened as she told him of picking up a Puerto Rican boy on Third Avenue "because he was so beautiful." She described other encounters with strangers and after a while they began sounding almost mythical, since identities were blotted out, leaving only the throbbing sexual reality.

At this point Crookston interrupted to ask if she hadn't ever faced actual danger as a result of such recklessness. Yes, she answered, but she'd always been "thrilled" to take risks to "test" herself—and, besides, nothing bad had ever happened to her and for some strange reason she was positive it never would. And she didn't drink or take drugs, and when her camera was with her she always felt in control. Crookston got the sense that if she was ever disgusted by much of what she'd seen and done, she'd faced the disgust fiercely and with dignity, which is why she seemed neither coarsened nor debased by anything that had happened to her. And in manner she remained gentle, ironic, almost passive.

Around five a.m. Diane got up, dressed, and left the hotel. Then later Crookston flew to California. But when he returned a few days later, they spent two more evenings together. And she told him more adventures, more stories. "And, yes, I believed Diane. I believed her implicitly,"

Crookston says. However, Marvin Israel, who presumably heard many of these same anecdotes, has written that her stories always had a "curious improbability." He goes on to say they seemed "exaggerated and very funny . . . only the barest account of what must have occurred."

As soon as he got back to England, Crookston began phoning Diane regularly and he gave her many assignments to do for the London *Sunday Times* magazine, starting with the "diaper derby" in New Jersey (out of which came the controversial portrait of a crying, snotty baby). They also began an intense correspondence in which they poured out their thoughts and concerns. Diane's letters—often written in almost indecipherable scrawl—form a record of her work ("nearly everything delights me!" she wrote in late 1967). She would phone Crookston her ideas for possible photo essays: "runaways, criminals, sex clubs, wives of famous men, rich people, vigilantes."

In most letters Diane is full of questions and concern for Crookston, for whom she had developed some affection. Referring to their first time together in an early note: "You were so gentle and generous and so very game . . ." And in another letter: "You looked at me as hard as I looked at you, as if we were England and America at the signing of the treaty . . . it is so mysterious. I am suggestible even to myself."

To which Crookston comments: "There was a part of Diane that needed to be valued, listened to, comforted . . . I had the feeling she didn't always get enough of the latter . . ." He adds, "There was never any talk of being in love[between us]. Actually, she told me she no longer believed in it, although I'm not sure that was totally true. I was not infatuated with her, but I was fascinated. She was a marvelous woman—wise, poetic. I was proud to be her friend. And she was witty, too. We'd been instantly attracted to each other because we always gave each other a good laugh. But it needn't have been a relationship that got into bed, although that was, as Diane might have put it, A GOOD THING."

In almost every letter Diane mentions money; it had become a gnawing worry to her. Allan had always taken care of their income, depositing any sum they earned in a joint account, balancing their checkbook. Diane herself rarely entered a bank; many of the checks she received for jobs lay uncashed about her apartment. Her way of dealing with money was rather like her father's—she carried wads of it with her.

In July Diane flew out to San Francisco to photograph for her second Guggenheim project. She had arranged to stay with Paul Salstrom, who was running a house for AWOLs and deserters in the Haight-Ashbury. Salstrom took her, almost at once, to the Living Theatre's production of

Paradise Now and afterward they went backstage to visit the Becks, who ran the Living Theatre. They were pacifists—Salstrom had been in prison with them. They began to talk together, so Diane sneaked off by herself and started prowling through the dressing rooms, hoping to catch a glimpse of the babies who'd supposedly been conceived by members of the Living Theatre company while on LSD. The babies were said to resemble mutants, with huge, pale protruding eyes, silvery skin, and spaced-out expressions. Diane was unable to find any such babies.

She spent the next few days wandering all over the Haight trying to find faces to photograph, but all she saw were stoned "flower children" wearing thrift-shop clothes. Some were begging. Most were runaways or high-school dropouts having a hard time surviving on junk food and bad dope. Drugs were everywhere—mescaline, cocaine, heroin, and amphetamines. Many of the kids were physically ill; those who weren't acted extremely aggressive, "like most speed freaks did," Salstrom says. The media were there in full force—TV cameras, *Life* and *Look* photographers, all documenting the "Love Generation" as it flocked into the Avalon Ballroom to hear psychedelic rock. "Diane thought the whole scene was degrading—commercialized. She wanted nothing to do with it," Salstrom adds. She made only a few photographs. When *Newsweek* phoned to ask her to do a big spread on hippies, she refused and instead went out to North Beach and took pictures of a topless dancer.

By the end of the week she was ready to leave San Francisco. The city and its population were too hidden, she said—hidden behind the fog and the shuttered windows of the houses and the rolling hills. She and Salstrom drove down the coast to Los Angeles. "We had no plans," Salstrom says, "Diane *hated* making plans." He remembers that often when they stopped at a diner or a gas station she would see something she wanted to photograph and would turn mute and unapproachable as she focused on the person or object. She never seemed satisfied with anything she shot. By noon she would have taken a hundred shots—by sunset another hundred.

When they reached the outskirts of Los Angeles, they both called friends from a pay phone, but were unable to connect with anybody, so they drove on to visit Salstrom's aunt and uncle, who lived in a tiny town near the California desert. Salstrom says that his aunt was "a heavy-set woman—a compulsive eater—deeply neurotic—obsessed with movie stars. Her husband, my uncle, had been a gambler in his youth but an unsuccessful one, so now they were very poor and my aunt cleaned rooms in a motel and my uncle drove a pick-up truck back and forth across an apricot orchard. In the evenings they were together, but they hardly ever exchanged a word.

"Diane spent most of the time photographing my aunt draped against her refrigerator—her prize possession. I saw a blow-up later in New York. It was very severe, in that square format she always used along with the flash. The effect was overpowering—like an X-ray of my aunt's emotions. All you can see is that she's been immobilized by her fantasies. Like it's obvious from her expression that she's resorted to total self-absorption or otherwise she'd fall apart. We stayed with my relatives overnight, but Diane refused to take photographs of my uncle the next day because he was too defenseless, she said. She couldn't bear to look at the eczema that flamed across his face and neck and made him both embarrassed and miserable."

They drove through the desert into New Mexico. Salstrom thought they should stop at the Hog Farm Commune, but Diane wasn't interested, so they drove on to Texas. "One night we slept together out under the stars." By now Diane was so anxious to get home that when they reached Dallas she went directly to the airport, paid for the car, and took the next flight back to New York. Salstrom hitchhiked the rest of the way.

In the fall of 1967 Diane was invited to attend "idea meetings" at *New York* magazine, which was about to start publication. She joined contributing editors Gloria Steinem, Tom Wolfe, and Barbara Goldsmith in editor Clay Felker's noisy, cluttered little office.

Felker was setting out to revolutionize the city-weekly format with a mélange of stylish graphics and articles about sex, money, and power (his favorite subjects). "Classy trash," Richard Reeves called it all. Diane knew about Felker's single-minded editorial methods, having worked with him when *New York* was part of the Sunday *Herald Tribune* and also at *Esquire*. Felker was on the prowl night and day for "hot" stories. He hung on the phone, not only badgering his writers to come up with the latest "trends," the latest "winners," but often encouraging them to cannibalize or humiliate the subject in question simply because when the story got into print it would be more "talked about." Diane understood his tactics. "He has a photographer's mentality," she once commented. "He'll stop at nothing to get the image—he'll pay any price."

They had already had a little run-in—almost forgotten now, but not quite—when Diane photographed him and his then wife, movie star Pamela Tiffin, for *Bazaar*. Felker had agreed to pose, since he liked publicity, too—but when he found out that Diane Arbus was the photographer, he panicked. He recalls: "She kept gushing that she wanted to capture the moony looks on our faces because we were so 'in love.' She'd never seen such a perfect couple, she told us—so romantic. But I wasn't fooled. I

knew she wanted me to relax my guard—take off my mask, reveal my neuroses. I wasn't about to. I clenched my teeth and gave her back nothing." Diane photographed them for hours, but the results were so poor that no picture was ever published, much to Felker's relief. He and Diane remained on amicable terms and he wanted very much to use her on *New York*, particularly after the attention her museum show had received. She was a "star," he told people—someone both talented and talked about.

At one *New York* editorial meeting there was a great deal of discussion as to whether or not the magazine should run an article on Andy Warhol, who seemed to be setting the tone of the sixties with his avid pursuit of publicity, his perpetual voyeurism, his wild parties at his silver-walled studio loft called the Factory, where sex, liquor, and drugs were available in unlimited quantities, and fading movie stars like Judy Garland and socialites like Marian Javits crowded in to watch Warhol film drag queens, transvestites, would-be poets doing "outrageous things" on camera.

Recently Warhol had been promoting an exceptionally beautiful actress named Viva. In his latest movie, *Lonesome Cowboy*, she could be observed nude and talking nonstop while participating in an orgy and a masturbation scene. Felker decided that Diane should photograph Viva and Barbara Goldsmith write about her. The two women went down to the Factory sometime in December 1967.

The moment they arrived, they were almost blinded by a gigantic mirrored strobe light suspended from the ceiling. Silver engulfed them; silver foil covered the walls, the water pipes, and even the little back room where homosexual acts took place. And propped against the chairs and tables were chunks of broken mirror and great slabs of silvery cracked glass.

Silver turned speed freaks on ("Silver was spacy, silver was the past—silver was narcissism," Andy Warhol wrote). And since almost everyone at the Factory was on speed—amphetamine—they would "sing until they choked, dance until they dropped, brush their hair until they sprained their wrists," and all their convulsions would invariably be reflected in the glaring, silvery mirrors.

That first evening, Beatles music seemed amplified to ear-splitting loudness. Diane snapped portraits of Warhol, his chalky face impassive behind dark glasses. He had his tape recorder on to document the murmurings of his druggie entourage—pimply transvestites, young, sleek hustlers, emaciated A-heads. Some of them camped for Diane, strutting in their costumes.

She was more interested in studying Warhol's death-image paintings —Marilyn Monroe's still smile on dozens of silk screens. But Viva was the assignment, so Diane eventually began photographing her preening in a black velvet Edwardian coat and slacks, and talking a mile a minute. In

person, Viva had a physical presence almost as commanding as Garbo's. Tall and very slender with huge green eyes, pale hollow cheeks, curly blonde hair, she had lips as prim as an Irish Catholic nun's.

Diana Vreeland planned to have Viva model an entire issue of upcoming fashions for *Vogue;* Avedon was to photograph. But Viva seemed unimpressed by that; she was intent on describing her horrible Christ-religion-sex obsession. How as a little girl she'd been afraid to go to Mass . . . how she'd had her first nervous breakdown in France. Nudity in Warhol movies had given her a certain celebrity, she said, but when she went on the *Tonight Show* or Merv Griffin, she was treated like a freak "because I hadn't been ashamed to display my naked body on film." She spoke for what seemed like hours with an edge of hysteria in her voice, as if an interruption might release some fearful depression.

The following afternoon Diane and Goldsmith visited Viva in her East 83rd Street apartment. The place was filthy. Dirty clothes were everywhere, and the remains of some pancakes rotted on tinfoil plates. Goldsmith began interviewing and Diane snapped pictures at a frantic pace while Viva wandered aimlessly around the room, telling stories about herself.

Her real name wasn't Viva but Mary Hoffman, she said. She'd come from a family of nine kids—birthplace, the St. Lawrence Seaway area in upper New York State, "Thousand Islands country." Her father was a criminal lawyer who had a collection of seventy-four violins. Her mother was a "Joe McCarthy supporter" whose two expressions were "Shut up" and "Cross your legs." Enemas were a routine of her childhood, Viva said. She rambled on about that and other bodily functions as she perched naked on the toilet. Diane photographed her there and in her cluttered bedroom, trying to push the stuffing back into a chair pillow.

She went on talking. Her first lover, the photographer Louis Faurer, had painted elaborate makeup on her face every night, very tenderly. Masturbation was a better solution than going to bed with someone you don't like. She compared Andy Warhol to Satan. "He just gets you and you can't get away. Now I can't make the simplest decision or go anywhere without asking Andy," Viva said. "Andy has such a hold on us all."

She babbled on until Goldsmith ran out of tapes and Diane had no more film. If her talk seemed self-exploitative, it was also self-generating —in talking she could perpetuate herself, assert herself, create herself. "I'm not as mixed up as I sound."

On one freezing holiday evening Goldsmith and Diane accompanied Viva to Max's Kansas City, where they were joined by Warhol, Ingrid Superstar, and Brigid Polk, whose father was Richard Berlin, president of

the Hearst Corporation. Viva sniffed meth from a spoon because, she said, she was suffering from menstrual cramps. Another time Diane went with Viva to an off-Broadway actor's apartment on Perry Street. That night, according to Viva, "we all got stoned on hash, Diane too, and we were all very comfortable and friendly together." That same night Diane took more photographs of Viva—having sex with the actor and his wife (who was mysteriously murdered later that year by an intruder).

The following morning Diane went back to the apartment very early to take a last batch of photographs. Viva's memory is a bitter one: "Diane rang the doorbell. I'd been asleep on the couch. I was naked, so I wrapped a sheet around me and let Diane in and then I started putting mascara on. I was about to get into some clothes when Diane told me, 'Don't bother— you seem more relaxed that way—anyway, I'm just going to do a head shot.' Asshole that I was, I believed her. She had me lie on the couch naked and roll my eyes up to the ceiling, which I did. Those photographs were totally faked. I looked stoned, but I *wasn't* stoned, I was cold sober. There was nothing natural about those pictures, nothing spontaneous. They were planned and manipulated. Diane Arbus lied, cheated, and victimized me. She *said* she was just going to take head shots. I trusted her because she acted like a martyr, a little saint, about the whole thing. Jesus! Underneath she was just as ambitious as we all were to make it—to get ahead. I remember right afterwards I phoned Dick Avedon because he'd just done some gorgeous shots of me for *Vogue*. I told him, 'Diane Arbus has taken pictures of me for *New York* magazine,' and he groaned, 'Oh, my God, no! You shouldn't have let her.' And Andy told me the same thing. After the fact. I'd never seen her work. I didn't know an Arbus from a Philippe Halsman."

The photographs of Viva which illustrated Barbara Goldsmith's compelling interview in *New York*, April 1968, were absolutely merciless. Out of the hundreds of contacts Felker and Milton Glaser, the art director, chose two. In a jarring, grainy close-up Viva appears dazed and drugged, eyes rolled back in her sockets. There is no suggestion here that life is still paradoxical and complicated; it is merely brutal. The picture seems cropped in such a way as to emphasize Viva's hairy armpit, her small breasts. In the other portrait Viva can be seen naked and roaring with laughter on a sheet-draped couch. There is a raunchy casualness about the pose; she appears pleased with herself right down to the soles of her dirty feet. The qualities that are distressing and alienating in some of Diane's work—the severity, the seeming disregard for the subject—are very apparent here.

When Diana Vreeland saw the pictures, she reportedly screamed and

canceled the rest of Viva's bookings for *Vogue*; the Viva pictures created such a furor along Madison Avenue that *New York* magazine seemed about to lose all its advertisers.

Today Clay Felker winces when he recalls the Viva portraits. "I made a terrible mistake publishing them," he says. "They were too strong—they offended too many people."

Diane told Crookston over the phone, "It is a cause célèbre." Much mail. Canceled subscriptions, pro and con phone calls, and even a threatened lawsuit (from Viva, which was ultimately dropped).

Tom Morgan thinks the Viva portraits were "watershed pictures. They broke down barriers between public and private lives. They were painful photographs—that's what made them significant. You're repelled by Viva's campy self-image, but you're drawn to it, too." By 1983 a culture glutted by media would be tolerating brilliant color candids of the Jonestown massacre and art portraits of a woman baring her stitched-up torso after a mastectomy. And by 1983 there would be an even deeper examination of photographic paradoxes as seen in the stark minimalist work of Eve Sonnemann or in Jerry Ulesmann's transfixing dreamlike moments or Cindy Sherman's chameleon disguises as she explored in kitschy self-portraits—woman's image as defined by media.

While the Viva controversy was at its height, some of Diane's friends wondered why after her prestigious show at the Museum of Modern Art, she would take such tawdry, exploitative pictures. Her sister, Renée, spoke to her about it. "Diane told me she knew the Viva photographs were sensationalistic. She said she'd taken them that way deliberately. She was determined to make more money so Allan wouldn't have to give her so much—she thought notorious pictures were one way of getting more assignments."

But at the same time in her own projects she was moving very consciously away from freak pictures. She didn't want to fall into the trap of repeating herself; she would never just turn out a product. And so she began choosing less theatrical subjects, ones less capable of imitation.

She was spending weeks in Central Park. She was still hanging around East 57th Street and Fifth—near Tiffany and Bonwits and the big Doubleday—watching the shoppers and musicians and the old people moving up the avenue. It was her favorite corner, where she always ran into friends—classmates from Fieldston, models, editors, other photographers. She was photographing mostly "normal" people now—housewives, matrons, widowers, kids; usually she'd photograph them confrontationally with the flash, and often, without their knowing it, their gestures, their expressions (sometimes startled, sometimes blank) suggested strange yearnings, strange dramas.

It would be that way when she photographed the Westchester couple. She loved that disorienting image. Bathed in sunlight, a husband and his beautiful blonde wife can be observed dozing side by side in lounge chairs set out on a great lawn. Behind them a baby plays weirdly by himself against what looks like a forest of black trees."The parents seem to be dreaming the child and the child seems to be inventing them," Diane wrote Crookston as an explanation for the picture before sending it to him for an article he was editing on "The Family."

1968 was not the best of years. Martin Luther King was assassinated in April, and the American public saw devastating images of dying Vietnamese on the television news. Avedon began talking about going to Vietnam to document the atrocities, and Diane demonstrated against the war. She, who had never voiced a political opinion, wrapped a white band about her head and joined a huge crowd, also in white headbands, who were marching silently across Manhattan to protest the escalation of bombing. Basha Poindexter, a Polish art student, trudged next to Diane "for what seemed like hours. We ended up milling around Central Park—thousands of us. Nobody knew whether the march had done any good. Diane and I talked some about that, and we exchanged phone numbers. But we never saw each other again. She seemed very, very depressed."

On March 14 Diane celebrated her forty-fifth birthday. The thought of getting old terrified her. After years of looking like a young girl, she had started to age and was now wearing thick Pan-Cake makeup to mask her lines. Sam Antupit remembers how the wrinkles—deep ones—"would shoot up around her cheeks and chin when she spoke, but then as soon as she got involved with telling you a story, they would momentarily disappear and she looked like a teen-ager again."

For a while she took dance classes in order to tighten her thighs. Shirley Fingerhood joined her, and while they were changing in the dressing room Diane confided her fears about growing old. She had visited her mother recently in Palm Beach and Gertrude was still fine—still so beautiful and "with it," smoking, shopping, playing cards—but the other people she'd seen were not. Frail old couples moved slowly along the blazing streets—some on walkers, others using canes. Eyes stared vacantly into space, and there was frequent talk about heart transplants, and what was the best hearing aid, and So-and-so has suddenly got arteriosclerosis or cancer of the liver . . .

She was depressed by the sight of so many old people. She never

wanted to get old! she said. She hated the idea that as the body ages, the imagination doesn't; she felt hers was sharper, more acute, than ever. And then, studying her friend's finely etched reflection in the glass, she blurted out, "I'm jealous of you, Shirley," jealous because although there wasn't much difference between them in age, Shirley Fingerhood had taut, smooth, unlined skin. Later, as they walked out of the dance studio and onto the street, she spoke of her envy again.

In June 1968 Diane and her daughters, Doon and Amy, moved from their Charles Street stable house to a duplex at the top of a brownstone at 120 East 10th Street. There was a brick-walled living room with many windows and a skylight, a kitchen, and, below the living room, two bedrooms. The rent was $275 a month.

Diane thought the place would be wonderfully cozy. She put all her plants around, and her X-ray of a human hand (whose is not known), and then she painted the exposed brick wall white and had a Japanese artist friend construct plaster-of-paris banquettes so that the entire apartment looked sculpted—the furniture appeared free-floating or molded into the walls. The place resembled a cave—rather like one of the rooms she'd designed when she was a student at Fieldston.

Not long after she moved in, her landlady, Judith Mortenson, took her to Macy's. "I wanted to buy her a new fridge. I wanted her to be happy there. Diane chose the biggest one available, and white—I'd hoped she'd choose salmon or pale green. She didn't seem particularly pleased about it. I got the feeling she was depressed and anxious. I got that feeling every time I saw her."

Mortenson lived in the building, too, so would often run into Diane in the hall. "She was usually with her two daughters—they were all dressed like hippies. They seemed very private—very close."

And they were. Diane always encouraged the girls to be independent and free, and never intruded on their lives—she wanted them to "create themselves." So when Amy had a weight problem, Diane didn't even comment. And when Doon decided to work for Richard Avedon, Diane offered no opinion either, although she expressed her concern to Pat Peterson, worrying that "Doon might fall in love with Dick because he's so bright and mercurial and rich and successful and then Doon might get hurt." (This presumably never happened, since Doon still works for Avedon periodically. Not long ago she wrote the copy for the controversial Calvin

Klein ads—"There's nothing between me and my Calvins"—which Avedon photographed.)

In 1968 Diane was behaving more like an older sister or friend to both girls, and they in turn were exceedingly protective and maternal. Doon has written in *Ms.* magazine of the many wrestling matches on her bed with her mother and sometimes with her sister, too. Her mother always won. "And when I think of it now I have the feeling she tricked me into losing . . . I have wondered since whether her subjects ever felt the way I did in those moments, that she had perpetuated some gentle sort of deception that had made me want to lose."

Diane's goddaughter, May Eliot, saw her from time to time. May was diffident, frail, unsure of herself, and Diane responded to that. They had dinner in Chinatown when Alex and Jane Eliot flew over from Europe, concerned for May's well-being—she had just gotten divorced. "Diane interceded for me—she came to my defense." Later they shared a cab uptown and May didn't want the ride to end—they'd begun to talk so frankly to each other; when they met again, they exchanged confidences like two women alone in the world and Diane blurted out that she had to be "very gay around Marvin or he couldn't take it—he couldn't take her despair."

While living in the East Village, Diane continued fighting an unrelieved depression. The depression had never completely disappeared after she contracted hepatitis in 1966—it had subsided briefly, but now it was unrelenting. The therapist continued to prescribe anti-depressants, including Vivactil, but nothing seemed to help and by the summer of 1968 she had other symptoms: she began experiencing nausea and weight loss.

The photographer Saul Leiter, who also lived on East 10th Street, would help her carry her laundry when she felt too weak to do it herself. He noticed her lassitude, her melancholia. Once she asked him if he knew any "battered people for her to photograph." He said he didn't.

Diane subsequently went to another doctor (some friends said later he was a "quack"), who told her she was anemic and prescribed a high-protein diet. For a while she existed on hamburger and desiccated liver, and when she entertained, which was rarely, she fed people peculiarly.

To boost her spirits, Avedon and Israel had got her involved in Steve Laurence's new *Picture Newspaper*, an all-photograph large-format publication that lasted through twelve issues from 1968 to 1971. There were various meetings about it at Avedon's studio, followed by more meetings at Diane's duplex. She seemed enthusiastic about what Laurence was doing and eventually let him use a photograph of Dracula taken off a TV set. She also let him use a picture of a crying baby along with a torn print of the pimply pro-war demonstrator wearing the I'M PROUD button.

"Diane pulled the prints out from a big stack at the bottom of her closet, " Laurence writes. "Most of the photographs were next to shoes and junk. Afterwards she cooked up a huge mound of hamburger in a frying pan and offered me some—part of it very burned—as she talked. She advised me about diet and health. She seemed terrified of getting sick."

By July 1968 she was feeling no better, and she had lost eight pounds. She believed she still had all the symptoms of hepatitis, but the various doctors she went to could not diagnose her case. At one point she phoned Cheech, whom she rarely saw now, and asked, "Can you catch hepatitis from going to bed with a lot of people you don't know?" Cheech says she was so appalled by the question she couldn't answer.

On July 18, complaining of dizziness, nausea, and back pains, she was admitted to Doctors' Hospital for observation and remained there for almost two weeks, undergoing a series of tests, including the 9.5 series, gallbladder tests, and a liver series, and with some apprehension she agreed to a liver biopsy. She was sleeping a great deal and feeling unduly weak. When Peter Crookston passed through New York, he saw Diane. "She looked wasted," he recalls.

After more tests Diane's condition was diagnosed as "toxic hepatitis ostensibly secondary to the combination of drugs used for depression and birth control." She was immediately taken off all the drugs (including Vivactil) and given lots of vitamins. She began feeling better.

Released on August 5, she went home to recuperate, resting for long periods in bed and eating children's food—Jell-O, oatmeal, mush. She rarely went back to a conventional diet, relying on raw and unprocessed foods as well as jars of honey for nourishment. Allan came by regularly to cheer her up, and after he left, she would phone Irene Fay and report, "My husband is taking wonderful care of me."

She still felt very weak. Eventually Marvin Israel took her to a party at attorney Jay Gold's. Loring Eutemay remembers that "Diane looked really awful. Hollowed out. Gray-skinned. Like a concentration-camp victim."

She wrote to Crookston: "During convalescence a strange rage developed in me, appearing every night like a werewolf. It feels like a raw wild power. I don't know how you make it energy."

It was deep in the summer and very hot, and when she couldn't sleep and was restless in her depression, she would go up to the roof of her building and curl up there. Sometimes she would knock on Seymour Krim's door. Krim, an iconoclastic writer, a chronicler of the beats, was currently editing *Nugget* magazine. He had lived in the apartment below Diane's—one tiny room overflowing with books—for more than twenty

years, cooking on his hot plate, laboring over his unpublished novels, grinding out his energetic essays. He hoped to die there, he said.

Krim would invite Diane in and they would talk. "I always thought she had an animal quality," he says. "Quick movements—silence—withdrawal, and then a total giving and opening up. But you could never predict how she'd be. What we shared as opposed to where we differed was a concern with the troubles of living with oneself. We both came out of the psychoanalyzed generation and that concern—perhaps over-concern—with self. She was a kind friend to be with or talk to on the phone. I always felt she understood or would understand, no matter what the problem. I guess this stemmed from her own psychological duress, but it made her as intuitive as a good dancer to the moods of others."

A book of Krim's essays, called *Shake It for the World, Smartass,* was being published, and Diane offered to take his author photograph. "She snapped me sprawled across my bed, fast asleep. I liked the picture, and my publisher, Dial, used it as the cover of my book, but Diane didn't want her name used. She said it wasn't the kind of image she was usually identified with."

Krim says he hadn't told Dial to pay her because she hadn't wanted to be credited, but of course she wanted to be paid and she put up a fight until she got her $500. Krim says, "It seemed uncharacteristically hard-boiled of her."

In spite of poor health and continued bouts of depression, Diane began working again—doing fashion spreads for *Bazaar* (beautiful blurred shots of Mia Farrow in lingerie) and portraits of men like Eugene McCarthy for the London *Sunday Times.*

After an assignment Diane might spend hours in Allan's darkroom, printing her work. She would move back and forth in the warm, charged darkness, uncorking solutions, filling the sink with water, dipping the negatives in, watching them bloom. Allan had taught her to print slowly and carefully, but she still couldn't resist tearing the edge of a perfect print. Sometimes she would print an image over and over again and then hang various versions up to dry and come back to study them the next day.

Now each face she was photographing dominated the frame. "The Woman in the Veil on 5th Avenue," "The Woman in the Fur Collar"—these are heroic portraits so textured they seem almost alive on paper. The way she was now handling light intensified her images, heightened their psychological drama. "She'd obviously learned a lot from Weegee and news photographs, from Lisette Model and from Cubism, too," her

old art teacher Victor D'Amico notes. "A left eye in one of the great Arbus portraits doesn't necessarily bear any relation to the right eye—a left shoulder to a right shoulder . . . Some of her finest pictures remind me of the paintings she did at school, where parts of the body had an unresolved relationship to one another."

Diane never showed these particular photographs to her goddaughter, May, when they were together that year—and she was seeing her as often as she could since May was living alone in the Village and "feeling very insecure." Diane would draw her out about herself or talk in her rambling fashion about Doon and her free-lance magazine assignments—the complexities of mother-daughter relationships—the mysteries that exist between human beings—the many kinds of love. "She told me how close she and Allan were," May says. "Closer than ever, although they were about to be divorced and he was thinking of marrying somebody else."

Soon after that talk May sent Diane some poems. Her replying letter said it was important to realize one has to write a great many terrible poems before writing a good one, and that the same was true of photography. May found the letter encouraging "because she never told me what I'd written was too personal. She seemed to trust me to work through that to something else." In another talk Diane told her goddaughter that "in all lives there are times when we seem to lose everything and have to start at ground zero again." Recently she had reached ground zero and watched her "gorgeous mountain of life become a desert," but it no longer frightened her "because you have to pay the price for your existence . . . it's like trees lose their leaves in winter and new leaves flower in the spring —it's the only way you can grow . . ."

Late that summer *Bazaar* flew Diane down to Atlanta to photograph Mrs. Martin Luther King still in mourning. James Earl Ray, King's alleged assassin, had just been caught, but there was little talk of that as Diane snapped pictures of Mrs. King standing serenely outside her home, hands clasped against her stomach, eyes raised to the skies. Diane couldn't get over Mrs. King's composure. Her mask would never come off—it was glued on tight! This whole business of deifying these famous widows— Jackie Kennedy, Ethel Kennedy, and now Coretta King . . . She was sure each one possessed *some* hidden trauma, if only she could bare it with her camera!

Ever since the "New Documents" show Diane's phone had been ringing with requests for interviews. She was being asked to lecture around the

country and to judge photography contests; photo journals were begging her to contribute. Then after the Viva pictures were published, her reputation as "a photographer of freaks" seemed to become even more of an established fact. She felt this was both exaggerated and incorrect, and it caused her great dismay. She would get defensive when anyone asked her questions about her method or choice of subject matter. She couldn't answer specifically in any case, it wasn't part of her nature—and most questions about photography were "terrifically boring" to her.

Now that she was no longer on antidepressants, her emotions were closer to the surface; she became easily irritated and cried a great deal. When she suddenly spoke contemptuously of a journalist she'd worked with, friends were surprised at her force; always before, she'd practiced such concealment. Jill Freedman, who later became known for photographing firemen in action, recalls how uninterested Diane was when she showed her her portfolio. "She offered absolutely no encouragement. She seemed to want to get rid of me fast."

Another photography teacher and writer, Bill Jay, has an even more curious memory. He had come all the way from London to see Diane. He recalls going to her apartment on a very humid summer morning in 1968 —"so humid I felt like a wrung-out dishrag." When he rang the doorbell, a voice shouted, "Go away!" He kept ringing and the voice kept yelling, "Go away!" until he reminded her that they had an appointment. Eventually she let him in "after a lot of scuffling and unlocking and unbolting of the door." And they faced each other.

"She was small and slim," Jay remembers, "looking very energetic, and I guessed she could be extremely explosive—hot-tempered, even. She didn't smile or observe the usual pleasantries." Instead, as she mixed him a dish of some kind of cold jelly, she needled him with remarks such as "All photographers are boring—why should you want to see them? All magazines tell lies and yours is no exception." The jelly prepared, she placed it in front of him and then straddled a bench so that her skirt rode up her thighs, revealing her panties—she either didn't know or didn't care. She glared at Jay belligerently watching while he took a mouthful of the jelly. "I thought I would vomit," he says. "It was the most foul-tasting stuff I'd ever encountered, like a mixture of dishwashing liquid and gravy." By this time he'd had enough, and he spat out a mouthful and told her angrily, "If I have any more, I'll spew it all over your table!"

With that, Diane burst out laughing. "Now we can talk about photography," she said. Jay doesn't know whether he'd passed some bizarre test or what, but after that "she radically changed personality and was full of warmth and good humor." Later she paved the way for him at the Museum of Modern Art with John Szarkowski. She also met him there to

introduce him around; at one point she showed him a sheaf of strange photographs featuring genitalia. She said they were some of the best pictures she'd ever seen.

Sean Callahan had said that Diane often invited people to her apartment in order to "scrutinize them," serving them strange concoctions and then waiting for their reactions. Yet when Lee Witkin (whose New York gallery was devoted exclusively to photography) was invited for an early breakfast, he was served an excellent plate of bacon and eggs. "Diane ate nothing, just watched me eat—stared at me without saying anything, which was a bit disconcerting. Finally I asked, 'What's the matter?' and she answered, 'You're eating,' and I said, 'Well, sure I . . . What do you expect I'd be doing? You just served me breakfast,' and she answered, 'Most of them don't eat.'

"Afterward she showed me a portfolio of her work and I did a terrible thing. When I saw the twins, I said off the top of my head, 'I don't see what all the excitement's about.' She didn't explain or deny the statement, which was a stupid one. The twins is a great photograph, but you have to look at it for a while before it sinks in—it's so personal.

"In spite of my idiotic remark, she allowed me to exhibit some of her pictures in late '69, but she wouldn't let me overmat them, even though they'd ripple. I told her they should be matted so they'd look more like art objects, but she said she didn't want them to look like art objects. I wanted to give her a show, but she was very reluctant, evasive, whenever I brought up the subject. I'd say, 'Why not, Diane?' and she'd never answer.

Nobody bought her work while it was at the Witkin except for a young photographer named Bevan Davies, who saved his money and purchased two signed Arbuses [the Russian midgets and the pimply boy with the American flag]. They cost $150 apiece. These same photographs are now worth $4500 apiece."

Davies, who was then in his twenties, says that when he saw the Arbus portraits he knew they were very important. "I couldn't say why, I just knew they were, and that I had to own them. They were a big influence on me."

Davies subsequently met Diane in Central Park. "I'd never seen her before, but I knew it was she from the way she was photographing— intensely concentrated, very intimate with her subjects." He introduced himself, explaining how much he admired her, and she invited him to her apartment on East 10th Street. "Without her cameras she seemed introverted, self-conscious. She looked at my pictures, which were very derivative of her work . . . she told me that, while it wasn't good to copy her, it was something every artist goes through before he evolves a style of his own. She was right.

"On another evening Diane took photographs of me—which I never saw, by the way. I remember we were walking down the street and suddenly she started shooting me and there was instant psychic communication between us. It was almost palpable. And I realized why she was such a great photographer. She was so disarming—she had this uncanny ability to relate to her subjects. She was very girlish—open, and *interested in you*. She asked very sharp questions, questions you couldn't resist answering because they were questions you'd been secretly asking yourself."

After he showed her work, Witkin says, "We never had any more long discussions about anything. She always seemed to be floating somewhere. She acted giggly, for instance, when she participated in a slide show with Gene Smith at the American Society of Magazine Photographers."

Yet she spent hours at Witkin's gallery when he exhibited Lewis Hine, the great slum photographer of the early 1900s. She told Witkin that she thought Hine was one of the great photographers, along with Sander and Weegee.

Weegee died in 1968, but Diane discovered that Wilma Wilcox, Weegee's common-law wife, still lived in his dilapidated brownstone on West 57th Street. The house was crammed with junk. Diane began going through shopping bags full of negatives and prints, and she found all kinds of hitherto unpublished pictures. She told Witkin and he started coming to the brownstone, too. "Weegee was a consummate slob," Witkin says. "It was a wild place."

Weegee claimed to have covered five thousand murders, and though he turned squeamish at the sight of blood, he had been, to use his own words, "spellbound by the mystery of murder." Diane would pore over his photographs. Many were discreetly distanced from the corpses, but Weegee always captured the horrified expressions on the faces of the onlookers.

In August, *Mad* magazine's art director, John Putnam, ran into Diane near Bank Street, and they walked together for a while. "Diane and I often talked about France," Putnam said. "She couldn't get over the fact that I still spoke French like a native. Sometimes I'd translate Proust for her, or Charles Trenet lyrics. She told me she'd had a French nanny as a kid and had once believed she spoke French fluently, but no longer could remember a word of it."

That morning they strolled near the Hudson River docks, where they both photographed often, and they spoke of the Chicago riots. The newspapers and TV had been full of stories of the fires in Lincoln Park, the huge sleep-in, the confrontations between the hippies and police. This led to a free-wheeling and rather disjointed discussion about their own children

Mr. & Mrs. Inc.

*Case histories of seven married couples
who are collaborating on joint careers
in the arts, the sciences and business.*

Diane and Allan Arbus found their forte in photography. They've known each other since their early teens, married young, and arrived at their chosen work only after sampling other careers. While Allan was working in advertising, he came into contact with fashion photographers and became a zealot. His enthusiasm converted Diane and they were soon planning, taking and printing pictures almost on a 24 hour a day basis. They began to specialize in fashions, established their own studio, and landed a large New York store account. They study their files of pictures constantly, seeking new design ideas and improvements. Working very slowly and carefully, they compose in the camera instead of relying largely on cropping and other mechanical photographic tricks. Result, a distinctive Arbus quality which includes elements of portraiture and fantasy.

feature article that ran in *Glamour* agazine in 1947 shortly after ane and Allan became partners fashion photography.

ane posing with her daughter on, who occasionally modeled r her parents.

DIANE AND ALLAN ARBUS

Diane and Allan, from a 1951 article in *Glamour* entitled "I Love You Because..."
Photograph by Frances McLaughlin-Gill.

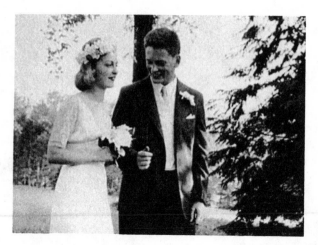

Anne Dick and Alex Eliot,
ca. 1940

Alex Eliot.

Jane Winslow Eliot.

Art director and painter Marvin Israel
(*right*) with photographer Peter Beard at
the International Center for Photography.
Photograph by Orn R. Langelle.

Diane's teacher, the photographer Lisette
Model. David Vestal took this portrait
in 1964.

Diane with an art student, Basha Poindexter. They had been
part of an anti–Vietnam War demonstration which
ended in Central Park.

Diane (*left*) teaching students at one of the small classes she sometimes organized.

Allan Arbus (*left*) and Mariclare Costello talking with Howard Nemerov at the opening of the "New Documents" show at the Museum of Modern Art in 1967. Diane is watching them. Photograph by George Cserna from the Collection of the Museum of Modern Art.

Diane in Central Park, April 1967. Photograph by John Gossage.

Diane in 1971, by Eva Rubinstein. She had given Eva an assignment "to take a picture of something or somebody you've never taken before or are afraid or in awe of..."

and the sixties generation in general—most of whom, they decided, were
into dope and rock and not believing anything. Putnam said he'd gotten
exasperated by how "media was turning Vietnam into an event, not an
aberation," and with that Diane murmured, "People think our depravity
is only temporary."

He asked her if she regretted not being in Chicago to photograph the
faces of the young—of the spaced-out, despairing radicals, the anarchists,
the yippies in their beads and paint. And she answered no, she wanted to
photograph blind people again. James Thurber. Helen Keller maybe.
Borges. And she wished she could photograph Homer, if only he were still
around. Poets were such a special breed, she said—so heroic. In the mean-
time she had lots of assignments; none of them particularly excited her,
but she tried solving the problems she was having in her own projects
with her magazine journalism. And as they were talking Putnam was
struck by an "aura of aloneness" about her. She was really a solitary figure
in photography, he thought, struggling intensely to turn grotesque and
shocking subject matter into poetry. And she was working in such a para-
doxical combination of styles (the snapshot, heroic portraiture) that the
public felt threatened by her images. And nobody except possibly Marvin
Israel and John Szarkowski understood or cared about what she was
trying to do. Not until the 1980s would her style and content be called
significant and a major influence in photography, and even then her work
would still be sometimes compared to "a horror show."

The last thing Putnam recalls Diane saying is that she was going on a
story with Gail Sheehy to Queens; Sheehy was writing a piece for *New
York* magazine on "The Important Order of Red Men," a branch of the
American Legion which consisted of former plumbers and druggists and
bank clerks, all of whom dressed up in Indian feathers and brandished
sequined tomahawks. The two women spent most of the day with the
group, and Diane took a forceful portrait of a grinning man in a huge
Indian headdress which was later part of her posthumous show at the
Museum of Modern Art.

Afterward Diane and Sheehy had coffee and discussed their daughters
and how emotionally insecure a mother alone could be. Sheehy had re-
cently separated from her husband; Diane wanted to know how she coped
with loneliness.

Diane's life had grown increasingly lonely. Both Doon and Amy were busy
and often away from the apartment, and since her most recent bout with
hepatitis she didn't always have the strength to see people, so she kept in
touch by phone. She could talk on the phone for hours with Pati Hill or

Richard Avedon or Mariclare Costello, Allan's girl. Sometimes she would see the Hollywood producer John Calley when he passed through New York. Calley was a brooding, handsome man nicknamed "the Dark Angel" by his colleagues. He had worked his way up from gas-station attendant to powerful studio executive (he ultimately headed Warners during the 1970s). Diane would visit him in the apartment in the East Seventies which he'd sublet and afterward they might have dinner with the screen-writer Buck Henry. Diane once brought along a portfolio of strange photographs of genitalia for the men to look at while they ate. It was the same batch of photographs she'd shown Bill Jay.

Occasionally she would photograph group sex parties. That was how she'd met poet/painter Stanley Fisher (now deceased), who'd participated in the "Doom, No!" and "Shit" shows at the Gertrude Stein gallery. (These garish art exhibits ridiculing a "plastic America" featured "the ultimate bowel movement" sculpture, as well as Fisher's shocking collages, photographs of concentration-camp victims superimposed on Betty Grable's nipples.)

Fisher's main preoccupation was sex. He was at the time "master" to three young female "slaves" in a shabby but immaculate apartment on King Street. Diane went there to take pictures of Fisher, a former Brooklyn schoolteacher, handsome, blue-eyed, perpetually angry, sitting regally in a shabby old armchair railing against sexual repression in America. He had been in Reichian therapy, and believed that sex was the driving force in life; he would lecture obsessively about the need for frequent orgasms in order to stay healthy, and his female "slaves" (or "tribe," as he called them) would hang on his every word—they never interrupted him except to go into the kitchen, where they would peel potatoes for dinner. If Fisher left the apartment (usually to make another "sexual conquest"), his "slaves" would follow him down the street, trotting behind him—out of deference, in homage.

Eventually Diane tried photographing Fisher orchestrating a group sex party and she was fascinated by his attempts to include everybody in such a mysterious act. She said later to a class, "The situation is both real and unreal and you have to deal with both . . . it's all different kinds of theater . . . I mean the spanking . . . there's a whole race of spanking people who are absolutely dotty about it."

However, Diane did not think enough of her group-sex photographs to develop many of the negatives. Neil Selkirk, who has printed virtually all her work since her death, maintains that there are "no erotic pictures in her files" except for a set of contacts which include one image that Harold Hayes describes as "remarkable." He saw it tacked on the wall in Diane's Charles Street house, and he says, "It was of a couple fucking, and I'll

never forget it because it was such a total expression of stasis, of detachment. The sexual act was all one saw, divorced from everything else." (This particular image is listed in the Arbus catalogue and may still be available from the Arbus estate's dealer, Harry Lunn, in Washington, D.C.)

Selkirk believes that this and one other picture (taken in a bondage house) are the only such Arbus pictures in existence. He believes that "a great many incorrect stories have circulated about Diane's so-called pornographic pictures because she did photograph at some orgies. But obviously she didn't think that the results were impressive enough to keep." Selkirk goes on, "Diane would never limit herself to just the aberrant or sexual; she was interested in photographing a wide range of people and events."

She would eventually tell fashion editor Carol Troy that she hoped to station herself inside Henri Bendel and "photograph a host of shoppers when things are 'on sale.' " She wrote to Peter Crookston of her plan to photograph fat ladies and capture the psychological panic brought on by overeating; and possibly women who'd had plastic surgery, "if they'll admit it." And she wanted to photograph the Kronhausens—sex therapists who at the time had an open marriage; they ran a museum in San Francisco that featured their collection of erotic art. (The Kronhausens had given Diane the pictures of genitalia which she continued to show to everyone.) In late 1968 she was about to undertake a search for a couple who shared a *"folie à deux."* She looked for this phenomenon in twins, husbands and wives, brothers and sisters, and a couple in a mental institution. For a while she considered the possibility of photographing schizophrenic patients under treatment by the controversial analyst R. D. Laing, whose existential theories were very popular during the sixties; he believed that no one can begin to think or feel or act except out of his alienation. Laing viewed schizophrenia as a valid experience—simply a negation of the negative experience of an alienated culture.

At Christmas, Diane flew to St. Croix with Pat Peterson to shoot another entire issue of children's fashions for *The New York Times Magazine*. Once more her pictures of kids are blunt and unsentimental, and in some of them she seems, astonishingly, to reveal the shape of their faces as adults.

When she got back from St. Croix, she ran into Studs Terkel at a party. Terkel recalls: "I knew her brother Howard already—had interviewed him for my radio show in Chicago. I was starting to do a book on the 1930s Depression—*Hard Times*, it was later called—and I guess I told Diane

about it, and then she mentioned that her father had been a colorful character during the Depression—running Russeks, staying afloat during and after the Crash. And how she and Howard had grown up as rich kids isolated on Central Park West, and at the time she hadn't been aware at all of the poverty, the bread lines. Which had bugged her in retrospect. So I decided I'd interview her for my book. She was called 'Daisy Singer' (most of the people I interviewed were given pseudonyms). But first we had lunch to get better acquainted.

"We went to a restaurant in the Village. Up close Diane looked like a little girl to me. Dressed in a leather miniskirt, I think. I remember indelibly—there was a sense of out of time about her, she wasn't quite *there*. Even though she was warm and friendly and terribly vulnerable, she was never quite *there*. And she had so little self-esteem—I remember that about her, too. So many self-doubts. And she talked about men using her. Some Hollywood type. And a writer or a critic . . ."

Afterward they went to the Arbus studio on Washington Place and Terkel taped her for a couple of hours. He kept trying to get her to talk about the Depression, "but she kept getting sidetracked, recalling anecdotes about her family—her father and mother—and she talked about art and money and courage, not necessarily in that order. I asked few questions; it just kept pouring out."

"My father was a kind of self-made man," Diane told Terkel. "After he died I found in his drawer—along with his condoms—a credo of ten things he wanted to achieve. One was to make a million dollars. My brother pointed out that for a man who had his heart set on being rich, what he achieved was totally inadequate. My brother pointed out also that while we were rich, my father was a gambler and something of a phony. That he could always appear richer than he was. His friends were richer than he was, but he was the most flamboyant of them and in a sense he made what he made go a long way. It was a front. My father was a frontal person. A front had to be maintained . . . in business if people smell failure, you've had it. I've learned to lie as a photographer, Studs. There are times when I come to work in certain guises, pretend to be poorer than I am—acting, looking poor."

She continued: "I always had governesses. I had one I really loved until I was seven and then I had a succession of ones I really loathed. I remember going with this governess that I loved—liked—to the park to the site of the reservoir which had been drained; it was just a cavity and there was this shanty town there. For years I couldn't get anyone to remember this, but finally someone at the Museum of the City of New York said yes, there was this shanty town. This image wasn't concrete, but for me it was a

potent memory. Seeing the other side of the tracks holding the hand of one's governess. For years I felt exempt. I grew up exempt and immune from circumstance. That idea that I couldn't wander down . . . and that there is such a gulf. I keep learning this over and over again . . . the difference between rich people and poor people. I'm fascinated with how people begin because it influences their attitudes about money and everything else . . .

"[My brother and I] never went far afield . . . the outside world was so far. Not evil, but the doors were simply shut. You were never expected to encounter it. For so long I lived as if there was contagion. I guess you would call it innocence, but I wouldn't call it pretty at all . . .

"I grew up thinking all my minimal conjecture was true. I thought I'd been born knowledgeable; that what I knew came from beyond the grave. I mean before birth. I didn't want to give up that wisdom for the ordinary knowledge of experience, which is the way I confirmed the way my parents brought me up, which is the less you experience, the better. You know what I mean? I'm accusative . . . what I mean is my mother never taught me courage and I don't mean to accuse her—parents only teach by default. What I learned was, if you were weak—if you didn't know something—all you had to do was confess it and then it would be all right—that's what femininity constituted in that time, and you found a man to take care of you in exchange for being taken care of. You see, I never suffered from adversity . . . I was confirmed in a sense of unreality.

"I've always been ashamed of making money, and when I do make money from a photograph, I immediately assume it's not as good a photograph.

"I can't believe that money is any proper reward for art. Art seems to me something you do because it makes you feel good to do it; it excites you or you learn something from it; it's like your play, your education . . . but I've never felt in a funny way . . . I don't even feel [what I do] is terribly useful. It might be historical. It's embarrassing. I can't defend this position, but I think I take photographs because there are things that nobody would see unless I photographed them. When I was gloomy I thought other people could take the photographs I wanted to take. You know, I could call up some good photographer and say, 'Why don't you photograph this and this?' I really think my photographs aren't very useful except to me. I think I have a slight corner on something about the quality of things . . .

"It's very subtle and I don't know that it's world-shaking, but I've always had this terrific conceit. I used to think I was the perfect thermometer for the times. If I liked a movie, it would be a popular movie . . . You

grow up split between these two things—thinking you're utterly average and inclusive or that every human emotion has its echo in you. Well, I do feel that in a certain way."

Finally, Terkel asked her, "How did the public experience of the Depression affect you?" and Diane answered, "I was aware of it partly because it *didn't* affect me. That sense of being immune—ludicrous as it sounds—was painful.

"[Now] I seek danger and excitement. It may be frivolous of me, [but] I've come to believe you can only really learn by being touched by something."

During the interview Diane kept referring to the horrific poverty she'd seen in South Carolina. A month earlier *Esquire* had sent her down to photograph Donald E. Gatch, a young white doctor who was trying to combat starvation and maggots in an impoverished black community called Beaufort. He had reported the shocking conditions to the local health authorities, but nobody would listen to him, so he was caring for the poor alone, with little federal funding.

Diane told Terkel: "I had never seen poverty like that." She had gone with Gatch to a home with sixteen children. "One child had only one eye, another was hydrocephalic." Another was scarred at birth; some showed symptoms of worms caused by filthy outhouses.

She and Gatch drove all over the countryside—to factories where women shucked oysters at $15 a season. He told her "incredible stories," she recalled to Terkel. About examining a dead woman whose body was infested with maggots. And another woman "with an illegitimate, mentally defective boy who couldn't get welfare, so she had to go to work and leave the boy chained to the bed."

And Diane had photographed Gatch standing outside a falling-down shack and inside stinking cabins fetid with the smell of old urine and up on the hills where some poor whites lived so inbred the children had one blue eye, one brown.

She took roll after roll of film which recorded the inbreeding, malnutrition, and pathological depression of deep Southern poverty ("as well as Walker Evans," Gene Thornton wrote in the *Times* when many of these pictures were finally exhibited at the Robert Miller Gallery in 1980. "What a picture of deformity and imbecility").

And Terkel said, "You saw what Walker Evans saw." And Diane replied, "Somewhat similar. Yeah. But now I'm seeing with double vision. With what I learned as a kid and what I've since learned. It seems to me the only pleasure about getting old is if you come through with more understanding than you had in the first place."

In 1969 Allan divorced Diane and married Mariclare Costello, a young actress who had been one of the original members of the Lincoln Center Repertory Company. Diane gave a small reception for them, writing to Peter Crookston later that she felt "sad happy" about the occasion. She said that Mariclare was a "good friend" of hers, and that the two of them hung out on the phone a lot.

Not long after the wedding party Allan closed the fashion studio on Washington Place and he and his new wife moved to Hollywood so that he could pursue his acting career in earnest. For more than twenty years he'd been dreaming of being an actor fulltime, and Diane outwardly applauded the move. But she was frightened.

Frightened because Allan would no longer be close by. They had been absorbed in each other's lives since she was fourteen; he was one of the few people who understood her. Now she would no longer be able to visit him, to get extra money when she needed it or to ask advice; she wouldn't be able to phone him daily—he would be three thousand miles away.

She ran into Garry Winogrand on the street. "She seemed to be in a tizzy," Winogrand recalls. "She said her husband had remarried and gone to California and she was going to be without a darkroom and what should she do? She also mentioned that she'd just recovered from hepatitis, that at first they'd misdiagnosed her case—but she hadn't *just* had hepatitis, she'd also been allergic to birth-control pills and tranquilizers, which made her feel rotten, and did I know that the combination could have an adverse effect on a woman?"

She told Shirley Fingerhood that she felt "funny" about Allan going away. She didn't resent it, she kept saying; she wasn't angry—she just felt that a part of her was going to California, too.

Although Allan continued to send as much money as he could from California, Diane needed to earn more now to make ends meet. But it was still

emotionally painful for her to see magazine art directors; despite her success, she had little self-confidence.

Avedon recommended her for a lucrative advertising job to photograph a new camera in her own particular way.

She was also discussing the possibility of becoming unit photographer on the film *Catch-22*, which Mike Nichols was about to direct in Mexico and Rome; John Calley was the producer and the pay would be astronomical, Diane told someone. But in the end she said no to Calley. She didn't think she could do it.

Instead, she flew to Boston for the London *Sunday Times* and photographed the lawyer F. Lee Bailey in his office and piloting his plane. Next she went to Chicago to make a portrait of Tokyo Rose and interview her for *Esquire*. This account, along with the picture, was published in the May 1969 issue of *Esquire*. Diane then flew to California and photographed novelist Jacqueline Susann with her husband, Irving Mansfield, for *Harper's* magazine.

Susann was currently promoting her novel *The Love Machine*, which was high on the best-seller list, and between interviews (some six a day) she was ensconced in a Beverly Hills hotel suite overlooking banks of geraniums and a smoggy sky. When Diane arrived, Susann began patting her jet-black Korean hair fall and adjusting her bubble glasses until Diane asked her to take them off.

"This Diane Arbus character was bossy," Irving Mansfield remembers. "She made us move all over the place. Then she wanted us to pose in our bathing suits next to the TV set. I didn't get it, so I said no to the idea, but Jackie, who was always cooperative with the press, said of course. And when we were in our suits and Arbus asked Jackie to plunk down in my lap, Jackie said yes to that, too. Particularly after Arbus assured us this shot would be for her portfolio—*not for publication*.* Her exact words. We held the pose for what seemed like hours—until my kneecaps went numb. The flashbulbs kept blinding us, she kept assuring us we looked terrific. Arbus looked tense. She told us as soon as she finished shooting she was taking the next plane back to New York; she'd flown out specifically to photograph us and she seemed a little angry about it."

Diane *was* angry. Privately, secretly, very angry. Because ever since Allan had left New York, Marvin Israel seemed to be paying less attention

* The resulting portrait of the Mansfields appeared in the October 1969 issue of *Harper's* and Diane sold the picture to other publications. "It was seen all over the world," Mansfield claims. "We thought it was undignified."

It was, however, consistent with many of Diane's finest portraits: a couple *in extremis*, if you will; middle-aged, paunchy, oily in bathing suits, presented in sweetly prosaic terms. Diane could not and did not accept all her subjects with grace. If she couldn't respond, her reaction was often severe.

to her. He simply couldn't always be there when she wanted him to be, and she couldn't understand that. With Allan gone, Marvin Israel had become the principal source of energy she could draw on; it wasn't that she didn't have plenty of ideas of her own, it was that she needed him to confirm them to her and to confirm herself. Often it seemed she resisted taking full responsibility for her life.

But she didn't express her anger, telling very few people how she felt; instead she brooded and sulked, and eventually her anger imploded and turned into depression. Shirley Fingerhood, who saw Diane often during this period, says, "Diane expected a great deal from her friends. She would actually refuse to do certain things for herself—like getting a new lock for her door, or reading a new lease (which I did for her). Diane was like a little girl in that respect. She expected others to do for her constantly, and when they didn't, her irritation was profound." She would get on the phone and make demands and then collapse and apologize saying she was terribly sorry she'd bothered anybody. Before the hepatitis she'd relished her independence, her solitude, but lately she'd felt an overwhelming need to be taken care of.

Often now—in fact, whenever possible—Diane would go flying with gallery owner Margo Feiden from a little airfield in Deerfield, Long Island. They flew at every conceivable time—at dawn, at dusk, in the afternoon —swooping over the island of Manhattan, past the Statue of Liberty and the Wall Street skyscrapers. "We always flew over Diane's place on East 10th Street," Feiden says. "Diane never spoke during these flights. She seemed mesmerized by the experience and relieved to be off the ground. I got the feeling she imagined *she* was piloting the plane. The cold wind was on our faces; we could see the clouds very close. She would have flown every day with me if I'd let her, but I usually wanted to go alone. I think she mentioned that her brother, Howard Nemerov, had been in the Air Force during the war; anyway, we flew steadily together for the next two years; Diane once told me she loved flying more than anything in the world. She loved flying so much Allan gave her a pair of wings—actually a pin shaped like wings. She was pleased about that and always spoke with admiration and affection for Allan. He had been her teacher of photography, she said. He had taught her how to develop and print her work. She seemed very grateful to him."

On the train trips back from the airfield Diane would invariably mention Marvin Israel. Suddenly, she said, she was starting to envy the attention Marvin Israel lavished on his wife. She had never really envied anyone before, she said, but now she not only envied Margie Israel, she hated Marvin for being so loyal, so responsible. Then she would add hastily that she admired him for it, too. She had also begun to wonder what it

would be like to *be* Margie Israel—Margie Israel, who was such a powerful font of unending creativity, who could tirelessly sculpt, paint, sketch, make collages, twenty-four hours a day. Who never needed to see people or go out into the world. During the 1950s many men had been drawn to the beautiful, black-browed Margie Ponce from Cuba—drawn to her Latin temperament, her vivid sense of fantasy. She had danced through the night at parties with many men and "then she chose Marvin," Diane would say in hushed tones, as if Margie had received a benediction. Sometimes she would fantasize about Marvin and Margie's life together—because certainly she had no clues. Her curiosity always got the better of her. (As it had years before when Allan had fallen in love with the young actress. After the initial hurt, Diane had made it her business to become acquainted with the actress—she had seen her act in several plays, even going backstage to visit. She had to know what this woman's appeal was, and she ended up liking her a lot—as she liked Allan's new wife, Mariclare.)

Although they shared mutual friends and sometimes attended the same parties, Diane did not really know Margie Israel, she could only imagine what she was like—she could only imagine how their studio looked. (She had heard it was a "fairyland" filled with dogs, the smell of cats and birds, and paintings, and a Christmas tree made of carrots hanging upside down from the ceiling.)

Sometimes the longing to observe the Israel's became so great she would sneak over to 14th Street and stand in the shadows of a building across from their studio, where she would wait for either of them to come out. She could wait for hours until Marvin finally emerged to pedal off on his bicycle, presumably to the other studio on lower Fifth Avenue, where he did most of his painting and book-designing. He never saw Diane. And finally—long after Diane had gone home—at around four a.m. Margie Israel might surface with her six dogs and walk the streets until the sun came up. If it was summer, Margie might go to the outdoor swimming pool on Carmine Street, scale the fence with her dogs, and then they would all plunge into the water. Diane never knew that Margie Israel liked to swim as much as she did. Lately when Diane stopped in at Marvin Israel's Fifth Avenue studio, which was crammed with his paintings, his plants, his dogs and cats, and even a black crow, she would complain that she could no longer swim at Coney Island because the water there was so polluted. Larry Shainberg was often at the Israel studio, and the sculptor Nancy Grossman, whose show of leather-sculpted zippered heads resembling knights, tribal fighters, motorcyclists had recently opened at the Cordier-and-Ekstrom gallery to controversy and acclaim. "Marvin Israel introduced us—arranged a meeting," Grossman says. "He loved bringing

different kinds of artists together. I remember Diane running into the studio the first afternoon I was there. She circled me like I was an object."

Grossman says that Diane's moods would shift wildly—"Some days, when she was up, she looked and acted like a very young girl. Other days, when she was depressed, her face would resemble an old, old woman."

Diane soon took to visiting Grossman in the loft near Chinatown that she shared with the painter Anita Seigal. Diane would wander past their walls of books, the gurgling fish tanks, and into a series of huge, dusty rooms crowded with paintings and sculptures. She would go over Grossman's collection of newspaper photographs that were stuffed into drawers and files—all sorts of elliptical, fragmentary images: Nixon holding hands with Governor Rockefeller, Churchill's birthday cake, plane crashes, fires, the face of a drunken driver, flood waters, terrified children after a misplaced napalm strike, an injured dock worker's expression after a boat explosion, women overcome by heat in a subway . . .

She marveled that so many photographs had been taken—so many millions of images. Would the ultimate be less easy to capture? Had the visible been over-exposed?

Obviously, Avedon didn't think so. Whenever Diane and Nancy Grossman visited him, he was busier than ever, photographing every pop hero of the 1960s from the Beatles to Cher to Andy Warhol's Factory groupies. (He'd already photographed Warhol after his near-murder—photographed his pale blond torso crisscrossed with ugly scars and bullet holes.) Rock music throbbed all day long in Avedon's studio while models like Penelope Tree and Donyale Luna traipsed through along with Revlon account executives and *Vogue* fashion editors. And Doon was taping everybody Avedon photographed (like Janis Joplin, frizzy-haired, clad in sleazo-freak clothes). Avedon planned to use taped voices as a backdrop for part of his mammoth upcoming show at the Minneapolis Institute of Art. The voices of the sixties would complement the strident-angry, laid-back, mammoth blow-ups of Tom Hayden and Abby Hoffman and Julie Christie . . .

Everybody who entered Avedon's studio was some kind of star. And there was a sense of excitement, of titillation in that huge, white, lighted space full of expensive cameras and equipment and gigantic rolls of pale backdrop paper—such an overwhelming sense of prosperity, of abundance. The people Avedon was photographing could afford to indulge themselves in any kind of rebellious, experimental behavior and it would be accepted, because the past had dissolved for most of them—the future only seemed conceivable as a continuation of the bizarre experimental present that was defined only by its novelty.

Visiting Avedon's studio excited Diane, disturbed her; the energy level

was always so high, the personality combinations were so fascinating, so unstable. Her spirits would rise momentarily, then sink again. She was being forced to lecture frequently for money, although she hated to. Irene Fay remembers hearing her speak at the Photography Club of America; suddenly in the middle of her talk she pulled her sweater up over her head and went on speaking through the material.

Friends who saw her during that period say she was depressed "almost all the time." She complained of being dragged down, of having no drive, no energy. She blamed this new depression on her two bouts with hepatitis. She'd never been ill in her life before then—she'd prided herself on being very strong, very healthy. This new dark feeling of weakness, of lassitude, reminded her of her mortality, and it terrified her. She needed to be strong to photograph—she had always been very strong.

In the past she'd been accustomed to depression; she'd lived with depression always—melancholia had pervaded the atmosphere of the Nemerov home. At times as a child she'd even enjoyed her depressions—the feeling of bleakness, of *angst*, protected her, isolated her. But this new depression was not like that—it was bone-crushing; it exhausted her.

The doctors she consulted prescribed tranquilizers—Librium, Placidyl. But she refused to take any anti-depressant pills after her bad reaction to Vivactil. She simply went on trying to live with her depression, although she told people it was choking her.

Toward the spring of 1969, with her depression no better, friends kept urging Diane to go into therapy again—it would surely bring some relief. She finally agreed after Marvin Israel insisted, although privately she didn't think it would do much good. She made appointments with several therapists who'd been recommended to her, settling on one a close friend insisted would be "perfect." Soon she began talking of how much she liked her new therapist—a young woman M.D., a Neo-Freudian who had incorporated the teachings of Karen Horney into her method of treatment.

As time passed Diane began referring to her therapist as "cute." But she remained depressed. At home she would stay on the phone for hours with friends (sometimes taping the conversations and playing them back to herself) and she would ramble on about Marvin Israel and Allan. Why couldn't she *depend* on them? she asked. Why weren't they there when she needed them? She seemed both angry and confused. It didn't bother her that these two most important men in her life were married to other women—she wasn't jealous, she *liked* both women; she just wanted Marvin and Allan to be available when she needed them. Was this too much to ask?

After a long, dreamy pause she would speak again—rapidly—her ideas twisting and turning, interrupted by further long pauses. (These pauses

had been characteristic of her speech since she was a teen-ager and Allan used to scold, "Finish your sentence, girl!")

She would go on to say—vehemently—to friends like John A. Williams or her former assistant Tod Yamashiro that she didn't enjoy earning money for money's sake. Richard Avedon could do both she said—earn a great deal of money and create art—but she said she couldn't, although in typical contradictory fashion she was doing both, perfecting her flat exacting style while completing a variety of magazine assignments. Her magazine assignments were one of the few constants in her life and she clung to them even as she complained.

For *Harper's Bazaar*, she photographed her idol, the great blind Argentine writer Jorge Luis Borges, in Central Park; she photographed the French novelist Natalie Sarraute, and afterward she and Dale McConathy took Mme. Sarraute to dinner at an Italian restaurant in Harlem, and in the midst of some magnificent pasta Sarraute expressed her fears that the Mafia would burst out of the men's room and start shooting.

McConathy recalls, "After Sarraute got so nervous, Diane tried to make her feel at ease. Eventually she discovered that all Natalie really wanted to do while she was in New York was to buy her daughter a fur coat, so the next day Diane took her to Kaplan's where she personally chose a coat for her. I went along, too. 'You don't want chinchilla—that's a dowager fur,' Diane told Natalie. 'You don't want Persian lamb or Russian sable.' Then she went into a long rap about furs and Russeks and her family, and she talked about every fur imaginable—why broadtail is so terrific (I think she chose broadtail for Sarraute) and how seal has long, dense fur and leopard sheds, so you don't want that, and how tipping is a way of dying long hairs with a brush to make inferior pelts look rare!"

Between assignments Diane was spending a great deal of time in Central Park. Although it was no longer safe or clean as it had been in her youth, it could still enfold her in greenery or snow, depending on the season. She knew every inch of the park by heart and never tired of returning to the bandstand or the skating rink or the bird sanctuary or the Children's Zoo. The carousel looked shabbier now, but the music sounded the same as it had in her childhood; the jaunty tunes reminded her of her French nanny.

Frequently she would arrive at the West 59th Street entrance of the park at around five a.m., and sometimes the photographer Barbara Brown, who describes herself as "a street pal of Diane's," would talk with her before they separated to begin shooting. "Diane almost always went off alone," Barbara says. "She rarely wanted company."

She might trudge along the two-mile walk up to Harlem Meers at 110th Street. The park was silent and brooding at that hour, its landscape

desolate. As dawn broke across Manhattan, mist would start rising from the reservoir and floating across the once rich green meadows.

By seven a.m. she might have come across some strange tableau which she might photograph or not—a fat lady in a Santa Claus outfit somersaulting heavily down a grassy hill; a solitary young man, totally nude, raising his arms to the sky.

It would still be very quiet, although some cars and taxis were beginning to traverse the park roads. As morning progressed, bums could be seen emerging from the bushes onto paths littered with newspapers and dog turds. And runaways and hippies would start to gather in Sheep Meadow. Diane would often disappear for a while into the Ramble, a small wood near the Shakespeare Festival Theatre. The Ramble was a homosexual trysting place—by noon on a Saturday dozens of men were moving furtively behind the trees Diane had played around as a child, some dressed in leather, others bare-chested, lounging against the boulders.

In April of 1969 Diane flew to London on assignment for *Nova* magazine. Peter Crookston (who'd just become *Nova*'s editor) met her at the airport and was shocked at the change in her face. "I hardly recognized her. She was gray and lined and her eyes seemed to burn in much deeper sockets." When he told her they couldn't spend the evening together because he had another commitment, she burst into tears. She cried frequently while she was in London, Crookston notes—in between wandering around Piccadilly Circus at night and shooting mod rockers in Brighton and photographing Lulu, the British pop star, backstage. Sometimes when she was alone with Crookston her eyes would suddenly brim over and tears would course down her cheeks, but she offered no explanation, although she did say she was homesick for New York. She assured Crookston later that "all my tears made it better . . . you sustained me." She kept repeating how much she loved the tacky hotel in Knightsbridge, where she was staying, loved the lumpy bed, the faded flowered wallpaper, the tattered but clean towel hanging next to the marble basin by the window.

She kept very busy photographing for *Nova*—photographing ordinary people who thought they looked like famous people—Elizabeth Taylor or Sophia Loren or the Queen of England. Diane got these women to pose like the celebrities they fantasized being, and she struggled to help them maintain their singularity or, rather, their *illusion* of singularity.

She also got some more London *Sunday Times* assignments, spending the day with the writer Francis Wyndham at a sanatorium "for terminally ill patients who were supposedly being cured by some kind of faith heal-

ing." It was depressing rather than macabre, Wyndham notes, and Diane was disappointed with the pictures she took—the feature they worked on together never ran.

Going back to London on the train, Diane kept pummeling Wyndham with questions about the Kray brothers—London gangsters who were about to go on trial. She told Wyndham she was spending her free time at Madame Tussaud's wax museum and was very upset because she couldn't get permission to photograph the figures. She confided gaily that her ambition was "to spend the night making love there."

As the trip neared its end, Diane's spirits seemed to rise.

A few days before she left London, she visited Alex and Jane Eliot, who were living outside the city in a place called Forest Row. Alex and May drove to the train station to pick Diane up. They were late—the sun had just set and they couldn't find her "until we saw what we thought was a boy in knickers, leaning against the platform," May says. "It turned out to be Diane. She was observing the passengers getting on and off the train and she seemed perfectly content and said she could have stayed there forever watching.

"The three of us drove back to our village," May goes on. "I remember being very happy that Diane was in the car." Later they talked for hours, trying to catch up on all the news. May told Diane about attending graduate school in London and writing more poetry, and the Eliots described their years in Greece and in Rome, where they'd made a documentary about Michelangelo's paintings in the Sistine Chapel, and about their last twelve months in Japan studying Zen, "which had been very rough." Diane listened, but made few comments. "If she was depressed, she didn't reveal it," May says. "But then she never acted depressed around me."

They didn't finish dinner until midnight and then they took a walk up a long green slope to the village cricket field. It was a beautiful night. The sky was moonlit, the air very fresh, and all the trees seemed soft and still, although a breeze flowed around them. May wondered about coming back to New York. Could she be happy and adjust to that noisy, dangerous, crowded city after experiencing so much beauty? Diane insisted she loved every encounter she'd ever had in Manhattan—loved every contradiction, every test, every risk.

The following morning a thick mist hung over the cricket field. The Eliots rose early because Diane had to catch a six-thirty a.m. train back to London. As they were drinking their coffee, Jane noticed that Diane had on an ornate gold ring, shaped like a bee. Ordinarily she never wore jewelry except for gold studs in her pierced ears. When Jane commented, "What a lovely ring," Diane took it off and gave it to her. "I want you to have it," she said gravely, and Jane recalls that "a chill went through me

because the bee is a symbol of death, of reincarnation. I wanted to cry out, 'Diane! Do you know what you're doing?' I felt it was a warning of some kind. After she'd left, I told Alex and he said, 'Don't be ridiculous.' " But Jane never saw Diane again, and she wore the bee ring only a few times before it broke apart.

The London trip had exhausted her. Once back in New York, Diane stayed in her apartment and fell into a depression. She tried to sleep, but she could not, except for brief spells. She would awake at dawn unrefreshed and start wandering around her living room, fussing with her plants, which appeared to be dying. She didn't want to look out the windows because when she did, all she saw were "bloodied people" in the streets. Her phone kept ringing with obscene calls until she took the receiver from the hook and bolted out into the day with her cameras festooned around her neck for protection.

One of the first people she ran into was John Putnam, and she rambled on about her trip, suddenly declaring, "There were no more freaks in England. Where are the freaks?" He tried to answer, to make some connection, but "she was on a different wave length. She wasn't listening." The same thing happened when she visited Lisette Model and over and over again she described her disappointment at being unable to photograph inside Madame Tussaud's. How she loved those waxy, ghostlike figures! Why hadn't THEY allowed her to photograph them? And she started rubbing Model's table in anxiety and her voice became the voice of a five-year-old girl. Model was used to these dramatic personality shifts. She believed Diane was schizophrenic—"as *all* artists are schizophrenic," she added firmly. Diane suffered from a kind of madness caused by "obsessive demands that cannot be satisfied," she said. "Diane could be inordinately demanding. Like all schizophrenics, she could take and take if you let her. I told Diane she must learn more about cooperation. That it was Nature's Law: the elephants make a circle to protect the small. If you see a piece of glass in the street, you pick it up, so that no one else will fall and hurt himself. She thanked me, she was grateful to me for saying these things. And Diane could learn—she was the greatest learner who ever lived."

After returning from London, Diane appeared to talk even more compulsively about her sexual adventures. Not just to friends but to casual acquaintances, even strangers she might meet at a party. She told how she had followed a dumpy middle-aged couple to their staid East Side apartment. She had sex with both of them, she said. There was never any

shame or embarrassment in her voice. She always reported this kind of experience as exactly as she could, going out of her way to state the facts clearly. It was as if she were bearing witness to her own life, observing, reporting on the explorations of other people's nightmares, other people's fantasies not her own. This was the public part of her, the adventuring somebody outside herself. Actually she was an exceptionally concealed person with an intense inner life nobody would ever know about. The perversities, the obsessions, the distinctiveness that were a part of Diane —her genius eye—where did they come from? "Nothing about her life, her photographs or her death was accidental or ordinary," Richard Avedon has said. "They were mysterious and decisive and unimaginable except to her. Which is the way it is with genius."

So that when she maintained she'd had sex with a dwarf or a couple of nudists her friends would listen—some in awe that she had the courage to go so totally with her obsessions. Others were shocked and disturbed as the stories grew more urgent. It seemed as if merging with her subjects, both "straights" and "freaks," was a way of giving herself to them after they revealed themselves to her camera. Such violent self-definition seemed part of her nature as an artist. To take extreme risks fed her art and energized her life. The purest experience for her was a body experience. The body's life was a matter of power to her. And if and when the sex act was perfect then the combination of intense physical pleasure and ecstasy along with the total psychic connection made the experience transcendental. But usually the quick impersonal sex Diane had was only "very very boring." The sex act could also be filled with dread and awe and death-awareness for her. (She once was talking to Gail Sheehy, "and without any prompting, Diane told me about the group sex she was into —photographing it and joining in it. It seemed to tempt and revolt her at the same time. 'All sensation and no emotion,' she said. The couples, most of them, were unattractive physically and there was no desire—no reconciliation of body and spirit. She described the experience as an attempt to lose herself, to give herself up to sex. Because no human emotion was involved. Not lust or fantasy and certainly no fulfillment. It was a denial of nature and our flesh. An out-of-body experience almost like death, she said." Sheehy said she thought Diane was unprepared for this kind of deadly exploration and it was damaging to her. But to others like John Putnam, to whom she told the same story, she seemed heroic for opening herself up to such extreme experiences.)

She seemed heroic to some of the students she lectured to at Cooper Union, Parsons and lastly at the Rhode Island School of Design. One student, Stephen Frank, recalls, "She blew everybody's mind. She was very

wound up talking about photography—nothing was sacred to her—there were no taboos and she was so sexy! She drew us out about ourselves. We all wanted to make love to her."

Another student, a girl, developed a huge crush on her. She was very young and highly keyed, malleable. She started dressing like Diane—in the same black leather outfit and short cropped hair that seemed to obscure gender and ethnicity. Eventually she tried to take pictures the way Diane did, in a harsh bleak way, and she would tell people Diane was a visionary because she saw the world as a frightening alienating place where everybody defined their own reality and she "saw" the world like that too—and identified with Diane's freaks and oddities—freaks were the metaphors of the sixties. There was a tension in this girl whenever she spoke about Diane and sometimes she trembled when she spoke.

For a while Diane allowed the girl to be her assistant and "go-fer." She babysat for Amy and in late afternoons or evenings she might listen to Diane talk about the extortionist she'd met and the pickpocket she'd tried to photograph after waiting for hours for him in a police station.

"It was Blow-Up time," said the late Chris von Wangenheim. "Photographers like Avedon—like Diane—were being lionized, romanticized. It was weird because photographers were starting to cannibalize—those of us who'd just come from Berlin or Paris were getting into images of cruelty and the forbidden. Fashion photography would soon turn pornographic. It was the time of the Manson killings too—Diane talked a lot about that and about witchcraft in Beverly Hills and strange rites practiced on a beach. She was dying to photograph Manson and his gang and this girl assistant wanted to go with her."

But instead Diane flew out to California alone. Since she couldn't get an assignment photographing Manson, she worked on one of her own projects, photographing a man who said he was Joan Crawford. He had made up a new identity, she would tell Francis Wyndym later, a new identity in order to survive in the world.

When she returned to New York, Diane was depressed. She went back into therapy but it didn't seem to give her much relief. "I think Diane saw her shrink just so she could talk," the late John Putnam said. "But Diane could seduce anybody with her talk. She could talk rings around you which is what I think she did with the analyst—you could never find out what was bothering her."

She did say over and over again that now that she was getting better known people *expected* things of her and she didn't want anyone to expect things from her since she didn't know what to expect from herself and never would. Photography consumed her. But her success and achieve-

ments held little interest for her. She continually denied her ability. It was almost like a reflex, something she'd been taught.

Howard was the same way. He'd often comment that he wasn't too bright. Diane referred to him in conversation as "my brother the poet." She never referred to him by name. But they seemed to have a very intense emotional relationship; it may have been the most sustaining relationship in her life, in spite of their protracted separations and silences. She would talk about Howard's visits to New York to see her.

By October Diane was telling people that therapy wasn't helping much, but she seemed less depressed when Garry Winogrand photographed her, flirty in black satin and decorated with her flash attachments, at the Metropolitan Museum of Art. They were both covering Henry Geldzahler's big party there celebrating the "New York Painting and Sculpture, 1940–1970" exhibit. A thousand people were invited and at least two thousand more crashed through what amounted to dazzling single-room retrospectives of Stella, Rauschenberg, de Kooning, Gorky, and Johns. "What no one realized at the time," Calvin Tompkins wrote later, "was the whole gaudy event—the paintings, the sculptures, the behavior, the baroque costumes, the din, the excitement arising from the brilliant work . . . would come to be regarded as the last exotic rites of an era that was ending."

Diane must have sensed this. She photographed "like a vulture" that evening, someone said—"hopping—swooping—blinding the mobs around the six bars and the orchestra blasting rock and the museum trustees, some of whom were grinding their hips against party-crashers dressed like Indians."

Late in 1969 Mary Frank and Diane discussed moving into Westbeth, the new artists' community that had just opened near the Hudson River docks. To outsiders the massive gray stone buildings might resemble "a Swedish prison," but Mary thought Diane would be less lonely there.

Mary herself later had a handsome studio in the huge thirteen-story reconverted Bell Telephone Lab, which overlooked both West and Bethune streets.

Apart from containing 383 moderately priced apartments and lofts (highest rent $209 a month), Westbeth had plans for a theater as well as galleries, a foundry, and a day-care center. The qualifications for admittance: you had to be judged a "serious artist" by a group of your peers, and your income could not exceed $12,700 a year. "Well, I certainly qual-

ify in that respect," Diane reportedly murmured. When she applied, she was accepted and was given a choice duplex on the ninth floor in the rear, so that she could have a view of the river.

She moved into Westbeth in January of 1970 along with the dancer Merce Cunningham, the poet Muriel Rukeyser, and the documentary photographer Cosmos, who hadn't shaved his beard since John F. Kennedy was assassinated. (Cosmos saved everything he'd ever received in the mail, calling it a "novel in progress." He loved "the rejected objects" of the world, and soon after moving to Westbeth he began carefully collecting Diane's destroyed prints and contact sheets, which he retrieved from the trash can outside her door.)

Once in Westbeth, Diane felt happy. She wrote to Peter Crookston how pleased she was with her apartment, and she'd been on a buying spree: "An ant farm so I can watch them working when I'm not . . . marvelous toys I've always wanted . . . fake worms, lady-shaped ice cubes, a transparent plastic lady with all her organs and bones."

For a time Diane seemed less lonely, less cut off. Living in Westbeth was like living in a big, turbulent stew. "Every artist was going through some kind of crisis—either with work or money or love," says one tenant. For a while the atmosphere was charged—energizing—and there was a real sense of community."

It was the end of the sixties. Westbeth residents left their doors ajar. There were endless parties, consciousness-raising sessions, group sex, and rock music floating through mile-long halls. "Everybody was into primal experience and learning about the subconscious," says David Gillison, a photographer.

Diane would have dinner at Westbeth with Alice Morris, the former literary editor of *Bazaar*, who now taught writing at the New School. (Renata Adler and Marvin Israel might be guests there, too.) And she visited other Westbeth apartments as well—like Tobias Schneebaum's, whose one room was leafy with plants, and where shrunken heads and primitive artifacts hung on the walls. An anthropologist and painter, Schneebaum spent part of every year in New Guinea studying the life styles of cannibals.

Thalia Seltz, a writer, lived across the hall from Diane and they became friends. "We'd discuss work and life." The two women also attended tenants' meetings—"something about noise abatement." Westbeth's block-long halls teemed with kids riding their bikes, roller-skating, fighting. Some of the artists complained they couldn't work, and a few resented Diane and said so. She had one of the best duplexes in Westbeth—it was

supposedly meant for a family of four and she was living in it alone (Amy was in boarding school; Doon had her own apartment). Diane was self-conscious about the special treatment she was getting, but Mary Frank got special treatment, too—she was allowed to move from apartment to apartment; she always needed more space, she was working so prodigiously. Her sculptures were fanciful, dreamlike: angels with leaf wings, faces turning into plants, deer into men; everything seemed in a process of metamorphosis, of transformation. Diane enjoyed being with her because Mary understood her need, her craving for the basic and mythic in her life, and Mary always had music playing in her studio. Mary loved to dance.

Not long after Diane moved to Westbeth, Al Squilaco, who ran as well as art-directed the Ridgeway Press, came to see her. He was extremely enthusiastic about her pictures and knew that no book* of her work existed, so they talked of the possibility of one. "Diane was gentle and kind," Squilaco recalls. "She showed me many photographs I'd never seen before. When I said, 'Would you like to do a book with me?' she answered, 'I'll have to ask my mentors—Richard Avedon and Marvin Israel. And of course Marvin would design any book I do.' And I said, 'But *I'm* the art director of Ridgeway, so that's out of the question.' She just smiled and shrugged."

In March 1970 the London *Sunday Times* asked Diane to photograph some of America's leading feminist theoreticians, among them Betty Friedan and Kate Millett. Diane knew little about the movement's troubled factions. All she knew was that at Westbeth consciousness-raising groups were popular with her artist friends—wives and mothers had invited her to join them in long evenings of intense talk and self-discovery. But Diane was skeptical. She wasn't sure that women uniting in a common cause (human rights) would behave any differently from men; she doubted they would be any less ambitious or competitive. Even so, she was intrigued by the feminist leaders she planned to photograph—especially Ti Grace Atkinson, considered by some to be the most extreme and charismatic.

Ti Grace Atkinson was tall and sardonic with an elegant feline face half hidden by blue-tinted glasses. The daughter of a wealthy Louisiana family, she was getting her Ph.D. in political philosophy at Columbia. Ti Grace

* Amy Arbus said later, "My mother was frightened by the idea of a book, she rejected it every time. She hated the finality of it. She thought once she [published a book], that would be it, kind of."

had resigned as president of the New York chapter of NOW to form the more radical Feminists, only to leave that group after being unable to create individual leaders among its members. Ti Grace believed in total separatism between the sexes. Lately she had been challenging not only marriage and children as the supreme fulfillment for women but love and sex as well.

Such theories were considered harmful to the movement's image by more moderate feminists like Friedan, who believed women should understand they had alternatives, while other feminists begrudged Ti Grace the publicity she was getting, and accused her of manipulating media for her own personal gain. She could be outrageous—as when she grappled with Eunice Shriver on the podium at Catholic University, disputing Shriver's belief that the Virgin Mary's conception of Jesus was immaculate.

Ti Grace was the only feminist who liked the photograph Diane took of her for the *Sunday Times*, declaring that it was "art." When *Newsweek* decided to run a major story on Women's Liberation with Ti Grace as one of its focal points ("I was going to be on the cover," she says), she insisted that Diane Arbus take the cover photograph and also insisted that Diane be paid whether the photograph was used or not.

Diane could not get over how outspoken and aggressive Ti Grace had been in her behalf. Ti Grace remembers that when they met, "Suddenly Diane asked me in a fresh, naive way if the reason I'd asked for her as my photographer was that I wanted her sexually; that was okay with her, she said. I was stunned. Here I was recognizing her for her work and she thought I was recognizing her sexually. It was cockeyed. I repeated that I'd suggested her because I admired her as an artist. The subject of sex never came up again."

In the middle of March, Ti Grace flew to Providence to speak on radical feminism and Diane went with her. After the lecture they went back to a motel, and some of the audience followed, "to pour out their torments." For the next few hours Ti Grace listened as wives and widows, mothers and divorcees, spoke of loneliness and depression and lack of identity; spoke of being victimized, of missing opportunities, of too many kids. "The stories were heartbreaking," Ti Grace says.

Diane took pictures, but mostly sat in a corner, listening, watching. After the women left, Ti Grace was eager for her opinion, but Diane was surprisingly unsympathetic, almost contemptuous. "She said she couldn't imagine laying out her hard times on anyone. I told her it's sometimes easier to tell your troubles to a stranger. 'Those women are weak,' Diane answered." What it boiled down to, she went on, for all their harangues about abolishing marriage and motherhood, was getting their men to take

on a share of the housework and child-rearing drudgery—and that she could understand.

"I felt Diane was defensive about what she'd heard—that she'd been threatened by what the women said. It hit too close to home. At one point she did admit, 'I was trying to hold my marriage together. I let ten years go by before I really started working at my own career. But it was my fault. I don't blame anybody but myself,' she said.

"I felt Diane was into absolutes," Ti Grace says. "And she wasn't particularly introspective. She kept a distance not just from me but from herself. And she didn't want to get into the conflict between being creative and free and traditional female role-playing. She couldn't understand my choice of living alone, without a man. To her, to be a woman living without a man was to be something of a failure."

For the rest of the weekend Diane shot rolls and rolls of color film on Ti Grace Atkinson for the prospective *Newsweek* cover. "It was absolutely exhausting. We'd photograph for hours, then go out for a snack, then come back and start photographing again. Every so often we'd take a break, lie on the twin beds, and talk—very intensely. Diane complained about constantly scrounging for jobs and having to do fashion stuff, interrupting her own projects, which she hated doing."

By the end of the weekend Diane was unsatisfied—she felt that none of the hundreds of pictures she'd taken was in any way revealing. "We both wanted a picture of me as Everywoman," Ti Grace says. "We kept trying to get the right light. I have very pale skin and Diane was afraid I'd look too washed out. I suggested going into the bathroom—the white tiles . . . water. I thought if I got into a tub, the water would reflect the light . . . nothing like being naked in a warm bath to get you relaxed. We both got very excited—because it was risky. Diane was click-clicking away. 'Nothing shows, does it?' I kept asking. 'Nothing shows. It's just a head shot,' Diane assured me. It was okay, she said. I thought she knew exactly what she was doing."

When they got back to New York, Diane delivered all her film to *Newsweek* to be processed. Weeks went by and she heard nothing. Ti Grace knew the Women's Liberation story was about ready for publication, so she phoned the art department and demanded to know why there had been no reaction to the pictures. Aren't they going to be used? she asked. There was a silence and then one of the art directors murmured that he wasn't quite sure what kind of political statement Diane Arbus was trying to make, and no, they weren't going to use the pictures; an illustration would be used for the cover instead.

Ti Grace asked *Newsweek* to send the color pictures to her, which was

done. Then she phoned Diane to hop a cab to her apartment on Park Avenue. For the next few hours they pored over the pictures—including dozens of beautiful frontal nudes of Ti Grace Atkinson smiling up from the clear, rippling water, and *"everything was showing,"* Ti Grace says. "And Diane acted flabbergasted—shocked. I guess it would have been pretty revolutionary to use one of those pictures for a cover of *Newsweek*. But they are absolutely gorgeous pictures."

Newsweek did pay Diane well for her work, and in the article itself they used her head shot of Ti Grace lecturing to a group of women.

Ti Grace did not see Diane after that; she became intrigued with Joe Columbo, the Mafia boss, and the two of them joined forces—she to support the Italian American Civil Rights League, he to help women (he took to wearing a FREE A FEMINIST button in his lapel). Periodically, though, Ti Grace would have long conversations with Diane on the phone. "She seemed to be drowning. She kept telling me, 'Here I am recognized as an artist, but I can't make a living as a photographer.' "

Although it was easier now to get work exhibited in galleries (which didn't pay until the prints were sold), it appeared to Diane that the better she became as a photographer, the more well known, the fewer magazine assignments she got. And there seemed to be no more grants available to her.

It was particularly frustrating because by 1970—liberated by the Pill, feminism, and federal funding—women artists in general were starting to be self-supporting. And, not so coincidentally, their creations—such as Eva Hesse's rope-and-cloth hangings, Nancy Grossman's powerful leather heads, and the androgynous sculptures of Mary Frank—were full of self-revelation.

But Diane had chosen a different route. In a era of self-revelation her work was detached and impenetrable; she refused to be lumped together with Frank and Grossman (much as she liked and respected them) as a "woman artist." "I'm a *photographer*," she insisted, although, paradoxically, she was the only woman to achieve status in what had been an all-male photography clique (its members included Walker Evans, Robert Frank, Garry Winogrand, Lee Friedlander, Bruce Davidson). This meant, of course, that she would have to go it alone. Her femaleness just complicated the issue, raised the stakes. She had less room in which to maneuver (and she didn't know how to play power games anyway) and fewer alternatives to fall back on. And no desire to make films like Frank, or teach like Winogrand, or get into industrial photography, which Bruce Davidson

was starting to do and which was the most lucrative of all, apart from advertising.

Eventually John Szarkowski paid Diane a fee to help edit a show of newspaper photographs he was planning to exhibit at the Museum of Modern Art called "Iconography of the *Daily News*." For the next six months—until July 1970—she went to the *Daily News* three days a week and worked with Eugene Ferrara, who headed the photo department there. "Diane began with the file of pictures starting with Beverly Aadland and she got through G . . . She rarely spoke to me—always wore the same outfit: denim skirt, shirt, and jacket. And she always ate at the Automat by herself."

This study of news photography was an extension of her interest in the snapshot as art—as a revelation, a recapitulation, a paradox. To Peter Crookston she wrote that editing the pictures was "funny to do. Some of the things are glorious. Yesterday I found a picture of a lady looking lathered as if for a shave sitting cloaked in white between a doctor and a nurse. All For Beauty's Sake, it is called . . . Harriet Heckman submits to plastic surgery by Dr. Nathan Smilie of Phila. as nurse assists. (5/21/35) Miss Heckman has asked for the perfect face and perfect figure and announces she is perfectly willing to face death to attain them. 'I want to do something about a body and face that have made me miserable,' she says."

By 1970, although she didn't often speak of it, Diane had decided to go beyond photographing ordinary people trying to project different images to the world (like her portrait of the middle-aged woman dressed like a teen-ager). Now she was concentrating on photographing retardates—middle-aged retardates at a home in Vineland, New Jersey. She was fascinated by their "extreme innocence," their total lack of self-consciousness. They paid no attention to her when she was photographing them. In front of her cameras they behaved like bizarre, overgrown kids, and their actions were unpredictable—they were either hyperactive or terribly slowed down. They would often make noises—eerie gurglings, yelps, squeals—while they frolicked clumsily on the grass. Their complete absorption in what they were doing—whether it was trying on funny hats or pulling at each other's hair—delighted and moved her. She went back to photograph them again and again.

She had gone on changing cameras—in order to change her images. As usual, she asked Avedon for advice. Hiro, who was still sharing Avedon's studio, said he'd started using a Pentax—he loved the way it worked. And he didn't use a flash. Diane borrowed it from him and used it for a couple

of weeks at Vineland. She was so pleased with the results that in gratitude she gave Hiro a rubber tree which he still has in his new studio on Central Park West. "A lot of people got cuttings from my rubber tree when they found out it was from Diane," Hiro says. "I bet maybe now there are a dozen Diane Arbus rubber trees around New York."

In July she went to Minneapolis to attend the opening of Avedon's exhibit at the Minneapolis Institute of Art. The show—spectacularly designed by Marvin Israel—displayed over 260 photographs, twenty-five years' worth of the finest examples of Avedon's exploration of portraiture. With this exhibit Avedon hoped at last to be critically "considered" as a photographer. Unfortunately, the *New York Times* photo critic, Gene Thornton, spent most of his review writing about the several nude portraits Avedon had taken of Allen Ginsberg and his lover, Peter Orlovsky. "I had to read this review about my life's work and it was all about one picture," Avedon told Connie Goldman of National Public Radio. "He had a hang-up about this one picture—it's as if all the others weren't even there. I was devastated . . . really thrown back. No artist is strong enough to stand that." (Avedon went on to be acclaimed—for the most part—for exhibits at the Museum of Modern Art, the Marlborough Gallery, and the Metropolitan Museum, and he would later say to hell with the critics— the artist works from the inside, not the outside, and reviews, no matter how praising, never really enrich his work.)

Diane, who had observed not only the hectic last-minute preparations for the Minneapolis show but had heard the enthusiastic response as well, was very proud of and impressed by Marvin Israel's creative involvement —his vision had fused with Avedon's. During the press preview she and T. Hartwell, the photograph curator, went off into a corner to discuss the visual impact of the exhibit and he brought up the possibility of the institute doing a companion show of her work. "I told her I thought Marvin could style and structure a show that could work just as dramatically for her pictures. And she agreed. She seemed very enthusiastic."

But when she wrote to Peter Crookston, she said nothing about a possible show at the Minneapolis Institute of Art. Instead, she told him about the hotel she had stayed at in Minneapolis, which had "a glass dome and a swimming pool next to her room." She sounded so pleased that Marvin had invited her—he'd been so nice. She phoned Tina Fredericks to tell her that, and Chris von Wangenheim, and a great many other people.

Diane still dreamed of getting a Pentax camera of her own. Hiro told her he could obtain one for her for the wholesale price of $1000, but she didn't

have $1000. Impulsively, she decided to teach a master class in photography at Westbeth and charge $50 a student; if she could collect twenty students, she could buy the camera. She asked Neil Selkirk, a young English photographer who was then Hiro's assistant, what he thought of the idea. He said he'd sign up in a second. So did one of Avedon's assistants. This gave her the impetus she needed, and after she put an ad in the *Times*, twenty-eight more students applied. She thought she should keep the class small, but she didn't have the heart to turn down any of the applicants, although the work of some didn't particularly interest her.

By this time Diane had become a legend among young photographers. She had just won the Robert Levitt Award from the American Society of Magazine Photographers "for outstanding achievement." In her acceptance speech she told the audience, "I am still collecting things—the ones I recognize and the ones I can't quite believe." "She was already a myth," her friend Susan Brockman said. "A lot of people related to her that way. She was a very literary character, very classical, which was unusual in this time." Everyone who attended her course (or "the last class," as it was later called) had seen her work at the Museum of Modern Art. "You couldn't forget those startling pictures," one of her students, Mark Haven, says. "There was such intense collaboration between photographer and subject." And the "freaks" and "normals" were both captured in such an unjudgmental, uniform style—their faces took on a rich strangeness. In almost every shot a ghostly emotion seems to rise from Diane's images. "Diane's pictures appealed to the mind, not the eye," Jerry Ulesmann says, "which is one of the reasons she broke new ground for photographers. Diane explored the psychological."

As soon as her class was set and scheduled to meet in a vacant Westbeth apartment, Diane grew terrified. What could anybody learn from her? What would she say? She never stopped doubting herself, asking, "What on earth can they get from me?" At the last minute she asked Marvin Israel to sit in on the class, as well as a fashion model she was fond of, and a filmmaker she liked, Susan Brockman. Suddenly she wanted to have friends hanging around—their joint presence would be comforting to her. But once the classes got under way, she seemed to forget her fears. At first there was some resentment because she had accepted too many students. "The room was overcrowded," Mary Ellen Andrews, a student, recalls. "We thought we wouldn't get enough individual attention." (Deborah Turbeville, in fact, demanded her money back, but Diane wouldn't give it to her.) However, the resentment quickly simmered down. At the first class Diane announced, "Nobody is going to love your pictures like yourself." "That was terrific for me," Susan Brockman said. "It was what she wanted you [to feel] in terms of your own work. It hit me like a ton of

bricks; really opened me up." And Anne Tucker says, "The class was not simply about photography. It was about people and relating to people and eliciting a genuine response."

Suzanne Mantell, another student, remembers how "Arbus asked us to bring in examples of our favorite things and explain *why* they were our favorites. Someone brought in Isak Dinesen's *Out of Africa*. I brought in a spatula—you know, the kind that flips over pancakes? And Diane brought in her collection of favorite cut-outs and rip-outs, images torn from every conceivable magazine and newspaper." "It was very significant," Neil Selkirk says. "It seemed to be saying you don't have to be an artist to produce something that moves people."

Another assignment was to describe an experience you couldn't photograph. "Diane wanted us to tell her our stories," Anne Tucker says. "She would get angry if we weren't specific. She kept insisting, 'Tell *exactly* what happened. Where were you when that happened?' "

Ikko Narahara, a young Japanese photographer who taped all of the Arbus classes, described the time he'd been in Holland trying to photograph a crane in flight. When he found a crane perched in a nest on a rooftop, he set up his cameras very carefully and then waited all day for the propitious moment. Finally the crane flapped her wings—and shit on the roof. Diane loved that story.

Anne Tucker described her father's funeral. "I was walking up the aisle of the church behind my father's coffin. And suddenly someone in a pew whispered, 'She doesn't have any gloves on,' and I looked down at my hands. It was a totally visual moment. Diane repeated that anecdote several times."

Another assignment was to photograph something or somebody you've never photographed before—or are in awe of, or afraid of. Eva Rubinstein asked Diane if she could photograph her. "Diane was a little taken aback, but she agreed. She insisted, however, that I do it at the ungodly hour of eight a.m. I said okay, although it would be hard for me; I tend to be a late riser. It was pouring rain that morning—the morning I arrived at Westbeth. Diane was ready for me, dressed in those funny, low-slung, black leather pants and black top she often wore. She seemed harried, but then she always seemed harried to me. She said she had an appointment at the dentist, so be quick about it. Her daughter Amy was there, too. She had just washed her hair and she was sitting on the bed with her head wrapped in a bright red towel. She watched us without speaking. Nearby, on the wall, there were strange pictures tacked up—of penises sticking out of belly buttons—kinky, strange stuff. I began setting up my tripod (I used a Rollei 66), and as I did, I noticed Diane sidle over to the mirror and begin to primp—fix her hair. I thought, 'What a reversal! Diane Arbus

trying to make herself look as good as possible before she's photographed.' And, of course, she knew how to pose after all those years of shooting fashion models—she struck exactly the right angle, and she was poised and cool. The session didn't take very long. Coincidentally, that afternoon I photographed Robert Frank—I'd been waiting months to do that. The following week I brought Diane's portrait in to class, but I could tell she didn't like it that much." (Rubinstein excels in austere, elegant still-lifes containing sumptuous light.) "The only other comment she made about my work was about another portrait—one of my best, a portrait of the dying Violet Trefusis [Vita Sackville-West's lover] which I'd taken in her bedroom in Florence. Diane remarked, 'The subject is better than the photograph!' I took that to mean that if she'd taken the picture, it would have been a better picture. Diane's childlikeness surprised me. She could giggle like a teen-ager one minute, then turn somber and exhausted the next. Once she commented to several of us in class, out of the blue, 'I was born way up the ladder of middle-class respectability and I've been clambering down as fast as I could ever since.' "

During class Diane would sit cross-legged on the floor, passing nuts and dried fruits for everybody to munch on. She kept saying, "You've got to learn not to be careful." She talked about how taking a portrait is like seducing someone. She talked about how she used everything she had to obtain a photograph—from "acting dumb" to dropping things, distracting her subjects so they'd feel less threatened. "Most people like having their picture taken," she said. "They like being paid attention to."

Somebody asked her, "Do you think your pictures are cruel?" And she answered, "No, these people wanted to have their pictures taken—agreed to have their pictures taken." She added that she would never take a picture of somebody who didn't want it, and she said that she had passed up possible photographs because she couldn't ask the subject to pose without hurting or embarrassing him. There was a man she saw one night, riding on the subway. She said his entire face was covered with warts and she wanted to take his picture, but she couldn't without making him feel even more self-conscious than he already was.

She always answered the students' questions very directly, although she hated being pinned down. (When Diana Edkins, Condé Nast photo-researcher, tried to interview her, Diane said, "Okay—let's do it right now, but I warn you, I may disagree with what I say now tomorrow.") But she loved to talk, and to these classes she talked and talked and talked. And Suzanne Mantell, Anne Tucker, Mary Ellen Andrews, and others took notes on some of the things she said.

She talked about photographing Bennett Cerf and "mucking it up." She had come back to his office a second time, even though she didn't think it would work a second time if it hadn't worked the first. "And Cerf presented his face to me from behind his newspaper and . . . it was like his ass because it was so round and blank." Famous people reminded Diane of "postage stamps. You know their faces but you don't know them . . . if you see a movie star on the street, you want to go up and pinch their cheek."

She said she once went to Paul Newman and Joanne Woodward's house in Westport and they looked "like they had lightbulbs inside them. Radiant with health—movie stars got this health thing faster than (the rest of us)."

She spoke of photography as "an adventure." And then in an aside she commented, "Someone once defined horror for me as the relationship between sex and death.

"Choosing a project can be ironic," she went on. "Everybody's got irony. You can't avoid it. It's in the structure, the detail, the significance . . . What I mean is, I would never choose a subject for what it means to me. I choose a subject and then what I feel about it, what it means, begins to unfold.

"[As a photographer] there are two feelings in you. One is you really want to get closer [to the image]. The other thing is that you've got some edge . . . you're carrying some slight magic which fixes [the subject] in some way."

She urged the class to "photograph something real . . . that's fantasy. Where fantasy comes from is the reality. The fantasy is [total], it really is. It is totally fantastic that we look [the way we do], and sometimes you see that very clearly in a picture. Because it's so real, it's fantastic—not that it's so fantastic that it's real. Reality is reality, and if you scrutinize reality close enough, you really, really get to it. It's fantastic. You have to use the term reality to represent what really is in front of the camera. What I'm saying is, let's call reality reality and let's call dreams dreams."

In class she kept stressing the factual, the literal, the specificity inherent in photography. She loved Bill Dane's postcard photographs of American landscapes. She encouraged Bruce Weber (who became celebrated in the 1980s with his beautiful, stately photographs of Calvin Klein underwear for men). At the same time Diane could not respond to Ralph Gibson's multiple images and she told him so when he asked her to recommend him for a Guggenheim.

She showed the class a few of her pictures—like the angry little boy

holding the hand grenade—but, according to one student, "Diane never actually explained *how* she got those images or how she convinced so many weird people to pose for her."

She referred to her most recent experiences photographing at a home for retardates, and she described attending a dance at the home and watching an incredibly heart-stopping handicapped couple dance—he was tall and skinny and his girl was tiny and radiant with "red hair like Maureen O'Hara." Diane herself had danced with a sixty-year-old handicapped man who was very shy and spoke like a six-year-old boy.

She took many photographs at the retardates' home, but she insisted, "I've never taken a picture I intended. They're always better or worse."

She went on to say, "A photograph has to be specific. I remember Lisette Model telling me, 'The more specific you are, the more general you'll be.' "

She ended one class with the thought: "When you get confused, look [away] from your pictures. Look out the window. Because somehow the reality is the act of making a picture yourself.

"I can tell you a picture. We're all verbal and visual; it's all open to us."

Between classes Diane spent a great deal of time at the Walker Evans exhibit at the Museum of Modern Art. She'd been so anxious to see it that she, Avedon, Marvin Israel, and Jim Dine had sneaked in while the show was being hung in early January of 1971, and they had wandered around "in great spirits," stopping to savor particular photographs that inspired them. As usual, Diane was also juggling a variety of assignments: photographing Cliff Gorman as Lenny Bruce for *Vogue*, photographing Hortense Calisher for her new book (but Calisher hated the portrait and asked that it be destroyed). She also flew to Detroit to photograph the controversial black separatist minister Albert Cleage for *Essence* magazine, and she caught him with just a touch of a smirk on his mouth. Cleage liked the portrait so much that it now hangs in the meeting hall of his new church in Houston. The rest of Diane's days were taken up completing a series for Time-Life Books. "It's about love," she said.

She photographed a bridal fashion show and girls trying on their gowns for their mothers and fiancés; she photographed a homosexual couple, but the culmination of the project came when she heard about a New Jersey housewife who was particularly devoted to her pet monkey, Sam. Sam was a baby macaque, and the housewife kept him dressed in bonnet and snowsuit so that he resembled a tiny, ancient-faced baby. Diane used

an electronic flash placed close to the camera to create harsh shadows, but there is a halo effect above the housewife's head. She called the resulting portrait "Madonna and Child."

By simulating amateur-snapshot techniques, she hoped to catch the "total ordinariness" of the backgrounds. Many of her pictures dissatisfied her because "the woman was cooing or eager or nervous," but the monkey picture she thought was right. It had the effect of looking like a father's snapshot of his wife and child, emphasized by the housewife, who, according to Diane, "was extremely serious and grave holding her monkey, the same way you'd be grave about the safety of a child."

Whenever she could find the time, Diane would go to her new darkroom located in a basement on Charles Street. It was totally quiet there and very well organized—all her pictures filed from one to a thousand, and she would print from six a.m. till noon if she could. She was making up a series of prints for a portfolio—a limited edition of fifty portfolios in which twelve of her best portraits (among them the nudist family and the twins) would be signed and annotated by her and displayed "in a nearly invisible glass box designed by Marvin Israel." She hoped to sell the portfolios to museums and private collectors for $1000 apiece.*

She was also developing and printing more retardate pictures from Vineland. She kept going back to the home and staying there as long as she could before returning with fresh rolls of film. The images excited and disturbed her every time they came swimming into the enlarger. By now she had enough pictures for a book, but she felt ambivalent about a book, just as she felt ambivalent about another show, although she didn't say that to T. Hartwell when he visited her at Westbeth; he sat on the floor of her apartment for an entire afternoon while she showed him a batch of the retardate pictures—like the old woman in the wheelchair wearing a plastic mask and holding a Halloween candy bag in her lap. "Diane was obviously very moved by these pictures. 'These people are so angelic,' she kept telling me." Hartwell says he was moved by the pictures, too, because even in her most anguished probing there was complete artistic control. "As always, Diane took you 'inside' and you got a distinct sense of what these characters were about." Once again Hartwell urged her to consider a one-woman show in Minneapolis—she was ready for it, he said. And she seemed almost to agree, although they set no date.

She could not tell him her true feelings: that if there was a book of her

* Only three portfolios were sold: to Richard Avedon, Jasper Johns, and Bea Feitler. Bea received an eleventh picture as a gift. Inscribed "especially for B.F.," it is from Diane's series on "love objects" for Time-Life Books—the portrait of the housewife with her pet monkey.

work, or another exhibit, her life would be "over." That would be it. Somehow, for her work to live—to flourish, to grow—it could not be contained between pages or hung on walls where it would be judged, scrutinized, interpreted by strangers. She preferred to give her work to friends —to Nancy Grossman, Harold Hayes, Robert Benton, Tina Fredericks, Peter Crookston, Bea Feitler, Richard Avedon.

Her friends accepted the powerful instability in her pictures—the disorienting light, the atmosphere of psychological crisis. One of her last portraits is also one of her greatest: an "albino sword-swallower" stands in front of a flapping carnival tent performing her act. Her arms are stretched out like Christ on the cross, but her head is thrown back so triumphantly you can almost feel the sharpness of the blade sliding down her throat. The image is grotesque and defiantly spiritual.

In her last class Diane spoke of the French photographer Brassaï and his shadowy images of whores and late-night cafés in Paris. "Brassaï taught me something about obscurity, because for years I've been hipped on clarity," she said. "Lately it's been striking me how I really love what I can't see in a photograph. In Brassaï, in Bill Brandt, there is the element of actual physical darkness and it's very thrilling to see darkness again."

After her final lecture Diane invited her students to her duplex for a party. Lisette Model was there, too, and Diane seemed particularly proud to have her teacher present. Everyone wandered around, intrigued by the apartment. The rooms were light, airy, sparsely furnished. Green, leafy plants flowered in one corner and voluminous cheesecloth curtains billowed out from the windows; a strong breeze blowing in from the Hudson River made the material flap and flutter. Someone noticed sharp prickles or mirrored chips embedded in the furs and animal skins draped across a huge bed set up on a platform. Someone else noticed black satin sheets covering the mattress; Avedon's portrait of Eisenhower stood on a table, and propped against a wall was a blow-up of what appeared to be people with their guts hanging out. Ruth Ansel assumed it might be something from the *Daily News* files. "What is it?" she demanded. Diane's only answer was, "I like it. It's terrific. Don't you think it's terrific?"

Toward the end of the party one of the students, Mark Haven, phoned to explain why he wasn't there—his wife had just had a baby. Diane asked all sorts of questions: Did she go through natural childbirth? Did he take pictures while she was in labor? Then she launched into a rambling monologue about the joys of natural childbirth until Haven interrupted to thank her for the photograph she'd sent him from the *National Enquirer*. It was of a girl holding a doll giving birth to another doll—a really weird

image—and although Diane hadn't enclosed a note, he'd known it was from her. She now admitted it was; she read the *National Enquirer* avidly —there were always things in it to laugh about: wild UFO stories, grisly murders, strange baby tales, "Gee Whiz" emotion stuff like the "neon cow" that had supposedly been zapped by an eerie substance from the sky. Diane told Haven that she occasionally got ideas from the *Enquirer* for pictures. Once, in fact, she described her own style of photography as "funk and news."

32

In the spring of 1971 there was a rape at Westbeth, followed by two sui-
cides. A woman came off the street, climbed up onto the roof, and jumped.
Her body lay uncovered and unclaimed for almost a day in the Westbeth
courtyard, and many residents and their children were forced to view the
corpse.

Then a photographer, Shelley Broday, jumped from the roof. He'd been
drinking a lot and taking pills. Not long after that suicide Thalia Seltz
told Diane that she was concerned because her kids were starting to com-
pose songs about people they knew who'd killed themselves—she thought
she ought to take them away from Westbeth, and ultimately she did move.
Diane replied that she had been surprised about Broday "because Shelley
didn't seem like the suicidal type." And then she added, "Frankly, hon-
estly, I've thought about suicide, too, but then I've thought about my
work, and my work is what matters—I couldn't stop my work." But Seltz
says Diane didn't sound convincing—she seemed very depressed.

Lately she had been going to the movies early in the day. A Fieldston
classmate recognized her at the 68th Street Playhouse. "It was two in the
afternoon—the lights had just come up because the film was over and
there was Diane slumped in her seat across from me. She looked spooked,
bedraggled. I had the impulse to go over to her and say, 'Are you okay?'
but I was very depressed myself, so instead I hurried up the aisle and out
onto the street. I don't think she ever saw me."

Usually Diane forced herself to keep on the move. She would drop by
the *Bazaar* art department to gossip with Bea and Ruth, or she would go
over to *Esquire* to sit in Harold Hayes' office, and Sam Antupit, who was
then art-directing the magazine, would give her "easy jobs because she
seemed very frail—very vulnerable. Like I sent her to Boston to photo-
graph Mel Lyman, the hippie leader who answered to the name of 'God.' "

She still took great glee in certain assignments, particularly in photo-
graphing Tricia Nixon's wedding at the White House on June 11, 1971, for
the London *Sunday Times*. She told Crookston, "The press tent . . . the size

of an airplane hanger . . . as for the ceremony itself, guests like movie extras, and a man with a trumpet and 50 of the photographers straining against the ropes and Secret Service and the Pres and the Mrs. and the Cox family incredibly hometown . . . illuminated sort of unearthly by the TV lights . . . it was like a midwestern celebration . . . endearing exaggerated. The President looks like he wears makeup.''

As soon as she got home from an assignment—from anything—she would shut herself in her apartment and pick up the phone. The phone was like an anchor—and she could keep in touch with an amazing range of people that way, from police chiefs and morgue assistants to John Szarkowski or her brother, Howard, now teaching at Washington University. She spent hours on the phone with Richard Avedon. And she kept in touch with Allan, who'd just got a lead in Robert Downey's *Greaser's Palace*, his biggest movie break. He would be playing a zoot-suiter Christ figure, first seen descending to earth in a striped helium balloon.

Diane also called Alex Eliot. He and Jane were planning to move back permanently to the States and would be living in Sam Eliot's old house in Northampton, Massachusetts, right next door to President Grover Cleveland's summer mansion. And Jane would be planting organic vegetables and baking flat bread and Alex would dress in flowing robes and sandals; his gray hair now touched his shoulders. He was thinking about writing a book which he would eventually call *Zen Edge*, in which his thoughts on Buddhism and meditation would be mixed up with memories of New York in the forties and Europe and Time Inc. His meeting with Diane during the spring of 1971 would ultimately be included in the manuscript—when they talked of their children: of May, who would soon become a teacher; of Doon, who was in Paris, and Amy in a New England boardingschool . . .

It was about four in the afternoon and gloom seemed to have descended into the duplex. Alex reminded Diane that once long ago, when they were teen-agers at the Cummington graveyard, she had written in the palm of his hand with a fountain pen. "What did I write?" she demanded, and before he could answer, she said, "Bone. I wrote 'bone' in your hand. You were talking so much that day it sounded like a crying of bones. I was sad. Our bodies must have been unquiet." Her face glowed silver and distant in the dusk, Alex writes. He remembered when he had called her "Moon." Now the face appeared to waver, full of hollows, dimly glittering. Alex adds that suddenly he found himself wondering what in God's name are we all looking for in life?

Diane murmured back as if he'd posed the question (but he hadn't), "Not childhood. There's something else we're looking for—something we're not conscious of as yet, although it may be here already." And then she spoke of her "monumental blues."

To her friends she was referring more specifically to her "blues," her depressions. After almost two years in therapy she seemed more communicative on a personal level, and she'd relaxed. She didn't converse in what some people called brittle cocktail chatter. She didn't perform—or refer to her adventures as if she was talking about another person. She'd begun alluding to a deep anxiety—a terror over her increasing responsibilities. Walker Evans had asked her to teach photography at Yale— wanted her to start in the fall of '71 (she turned him down). And Walter Hopps, the astute young curator of the Corcoran Gallery in Washington, had got her to agree to exhibit her work at the Venice Biennale in the summer of 1972. It was unprecedented—no photographer had ever been so honored—but Hopps believed that "Arbus was a central and crucial figure in the Renaissance of still photography—absolutely uncompromising in her vision . . . her importance stemmed from the fact that in style and approach she was radically purifying the photographic image."

Whenever she mentioned Yale or Venice, Diane would fall into wild crying. What did people expect of her? she would sob. She had nothing to give. Nothing! she kept repeating. Why were all these things happening to her? She didn't deserve them, didn't want them. On top of everything else, the May issue of *Art Forum*, usually devoted to abstract art, had published a portfolio of her pictures and they had created quite a stir in the art world. Suddenly painters and sculptors were noticing her—getting excited by her images—possibly because photographs like the Jewish Giant or the twins had such a metaphorical life apart from being very documentary.

Still, Diane maintained, she couldn't understand why anyone would be impressed with her work. She kept denying that it had value, except possibly to her. She sensed that the work was being noticed for the wrong reasons ("Her name was rapidly acquiring a semi-mythic status our culture confers on artists who specialize in extreme unfamiliar experiences," Hilton Kramer has written). She was certain she would always be known as "the photographer of freaks" and she resented that label because she felt that, at their best, her portraits suggested the secret experiences that are within all of us.

It distressed her that a great deal of the attention she was receiving came from "weirdos." A photographer in Massachusetts kept phoning her because he was sure she was into "morgue photography," the way he was. He kept calling her and calling her, demanding to see her. She kept putting him off. All she really wanted to do, she kept telling her friends, was to work in peace and solitude without any pressures or expectations.

On her own, she had begun to photograph bondage houses. She'd

shown Nancy Grossman a picture of a woman done up in high boots and not much else debasing a naked man down on all fours. The image was assaulting, Nancy says. It was like looking at a literal description of the act. Diane seemed a little scared and shocked when she handed it to Nancy, but she said nothing. She showed Peter Beard a photograph of "a Wall Street banker type, nude, getting hot wax poured on him." Beard says he and Diane were planning to "swap pictures—she wanted some of my big-game stuff from Africa—but then her stuff was big game, too. I always thought Diane had such guts. To go into places like bondage houses —really rough. I always wondered how did she do it?"

Later John Gossage recalled a statement Diane had made which might have explained her courage: "Once I dreamed I was on a gorgeous ocean liner. All pale, gilded, encrusted with rococo—like a wedding cake. There was smoke in the air and people were drinking and gambling. I knew the ship was on fire and we were sinking slowly; they knew it, too, but they were very gay and dancing and singing and a little delirious. There was no hope. I was terribly elated. I could photograph anything I wanted."

And yet finally even that wasn't enough. In order to perfect her art, she had cut herself off from so many people. She was lonely, she was alone— and she would fall into despair.

Deep in depression, she would seek out Lisette Model. She was closer than ever to her teacher, phoning her or going to her tiny black apartment on Abingdon Square. And Model was worried, because sometime in June Diane had phoned to tell her that she'd reversed her opinion about the retardate pictures—she hated them now, hated them because she couldn't control them! She had always controlled her pictures before—with the flash and her square format, she had imprisoned her subjects as if in a vise. But the Pentax was different, and of course the retardates were different from any other subjects: they did not collaborate with her in the making of the pictures—they didn't look her in the eye, they didn't acknowledge her presence or tell her their stories, nor were they charmed or seduced by her. Lined up in their Halloween costumes on the grass, they were in a trance. A strange illumination—almost an exaltation—rose up from their chunky bodies, their upturned, oversized heads. Their world, made up of noises and stampings and rolling about on the grass, was a world she could never know, could never enter, and this angered and frustrated her, depressed her. Not long after she phoned Model, she wrote her a note which read, "DEAREST LISETTE" in big block letters, and at the bottom of the page, in tiny, shaky letters, "diane."

And yet she could be charming and assured when the situation warranted. She lectured at the about-to-open International Center of Photography and compared taking pictures to "tiptoeing into the kitchen late at night and stealing Oreo cookies out of the fridge."

At Hampshire College in Amherst, Massachusetts, in June of 1971, she impressed Jerry Liebling and his students with her comments about photographing nudists. "There are two kinds of nudist camps—one is sanctimonious, almost prissy, the other is swinging—the Grossinger's of nudist camps." At Hampshire, Diane taught an advanced class on portraiture along with Lee Friedlander and Garry Winogrand. Liebling recalls, "Everything was confrontational because that's where things were in those days. Everybody did exercises to get in touch with their personal feelings. I have a photograph somewhere of a class where we're all covering our faces, trying to summon up deep emotion."

Many of the kids had already seen Diane's work and they related to her savage yet vulnerable images. Some of them were even more intrigued with her persona. She was aware that they liked her—she seemed open and unthreatening, not at all like a teacher. But there was something unsettling about her, too. One student recalls shaking her hand and finding it freezing cold to the touch, even though the day was exceedingly hot. Her deep-set eyes glared—severe, dead on. And then she'd grin suddenly and you'd see that part of a front tooth seemed to be missing—you couldn't really tell because she'd hold her hand to her mouth when she smiled. And she'd go right on talking. While she was there, Diane went swimming every day in a pond outside Amherst. A student took a photograph of her posing in the grass in her bathing suit. And Amy, who was staying in a nearby summer camp, came to visit.

When she returned to New York, Diane received a letter from "the little people's convention" (midgets who were gathering in Florida for an annual meeting), turning down her request to photograph them. "We have our own little person to photograph us," the letter said. Diane was extremely upset about this and mentioned it to most of her friends.

At about this time Marvin Israel was working on a miniature sculpture of a person of no specific sex lying on a bed. The person's wrists were obviously slashed. Diane helped him complete it.

By now, in late June, a humid heat had descended on New York. Diane hated and feared the summer. It reminded her of her childhood long

ago when her nanny—her beloved Mamselle—had abruptly left. From then on, every summer had brought back to her the pain of that loss. Her parents had always been away in the summer, too, traveling around Europe. After camp, Diane and Howard and Renée would return to the big apartment on Central Park West and be looked after by bored servants—they weren't often permitted to go out, and remained for hours in the airless rooms, Diane counting the silver and feeling that life was unlived and unlivable.

Now New York's million air-conditioners hummed and traffic snarled in the streets and many of Diane's friends escaped to the beach or the mountains, and the old hurtful feeling—the almost physical grip of anxiety at abandonment—returned to haunt her.

She still didn't have enough assignments, so would sometimes take pictures of media events and sell them later. That's why she attended a press conference for Germaine Greer held at Sardi's.

Greer—formidably intelligent and imposing, over six feet tall and clad in buckskin skirt and clogs—had just come back from England to continue promoting her best-seller *The Female Eunuch* around the United States. She had already created a sensation at Town Hall, debating Norman Mailer on female sexuality. She'd been on the cover of *Life* and she was in New York for the express purpose of emceeing the Dick Cavett show.

Today Greer says her first impression of Diane was of "a rosepetal-soft, delicate little girl. I couldn't guess how old she was, but she charmed me in her safari jacket and short-cropped hair. She was carrying such an enormous bag of camera equipment I almost offered to carry it for her—she could barely lug it around. She hopped around photographing me, and when she said she'd like to have a proper photographic session alone with me, I agreed. I recognized her name and thought, 'Why not?'

"It was a hot, muggy day," Greer goes on. "I was staying at the Chelsea Hotel in a seedy room. Diane arrived and immediately asked me to lie down on my bed. I was tired, God knows I was tired—I'd been flogging my book like mad—so I did what she told me. Then all of a sudden she knelt on the bed and hung over me with this wide-angle lens staring me in the face and began click-clicking away.

"It developed into sort of a duel between us, because I *resisted* being photographed like that—close-up with all my pores and lines showing! She kept asking me all sorts of personal questions, and I became aware that she would only shoot when my face was showing tension or concern or boredom or annoyance (and there was plenty of *that*, let me tell you), but because she was a woman I didn't tell her to fuck off. If she'd been a man, I'd have kicked her in the balls.

"It was tyranny. Really tyranny. Diane Arbus ended up straddling me

—this frail little person kneeling, keening over my face. I felt completely terrorized by the blasted lens. It was a helluva struggle. Finally I decided, 'Damn it, you're not going to do this to me, lady. I'm not going to be photographed like one of your grotesque freaks!' So I stiffened my face like a mask. Diane went right on merrily photographing—clickclickclick-click—cajoling me, teasing me, flattering me. This frail rosepetal creature kept at me like a laser beam, clickclickclick. She'd jump off the bed periodically to reload the camera. Just as I was breathing a sigh of relief, she'd be on top of me again! It was a battle between us. Who won? It was a draw. After that afternoon I never saw her again. I never saw the photographs either."

The first weekend in July, Diane went out to East Hampton to visit Tina Fredericks, who was getting to be one of the biggest real-estate agents on Long Island—she owned land and two houses and her phone never stopped ringing. But to Diane, Tina remained simply one of her oldest friends—an ebullient, auburn-haired woman who had been one of the first people to encourage her in photography. Diane loved coming to Tina's—it was like another home, and she would eat her delicious food and swim and walk on the beach for hours.

Tina says she knew Diane was very depressed and kept trying to cheer her up. "I said I would buy one of her portfolios—I'd buy two or three if she wanted me to. She didn't seem to hear me."

Instead, that weekend Diane took pictures of Tina's lovely twenty-one-year-old daughter, Devon. "She made me put on a leotard top and she took tons of photographs and when she sent us the contacts a week later, I thought, 'But I don't look like that at all.' I was unrecognizable. Now, ten years later, I've grown into the face Diane Arbus saw in me then."

Before she took the train back to New York, Larry Shainberg drove over from Amagansett to see her. She repeated what she'd told him over and over again in the last months—that she didn't know how much longer she could go on. Shainberg says, "I didn't believe her. I tried to kid her out of it. I don't think anybody believed she would actually . . ." Other friends also ignored her allusions to suicide. "We had our own lives to lead," says a poet from Westbeth. "And we didn't know how to deal with it—she was getting so tough to handle—really heavy. It was excruciatingly depressing to be with her. She would drag you down—she would bore you. But in retrospect a lot of us feel guilty about not being there when she needed us."

There were other friends who noticed that she was "tying things up."

She wrote to Pati Hill in Paris saying she had gathered up all her letters of twenty-five years and would Pati like them back? She phoned Tina Fredericks to say happily that Doon and Amy were both settled—Doon at work, Amy in school—and Allan was at last getting his big break in a movie. Years later Amy told friends that she thought her mother had done what she wanted to do in this life—there was simply nothing more she wanted to accomplish.

Cornell Capa had been trying to bring Diane together with Marge Neikrug, who had just opened a little photography gallery in her brownstone on East 68th Street. Marge wanted to learn how to print—"I'd fallen in love with the darkroom"—and Capa suggested that Diane Arbus might help her. The two women had a series of long conversations over a period of several weeks. "But I couldn't pin Diane down as to when we'd get together. Then about a week before she died she suddenly appeared at my gallery with her portfolio and we started talking . . . I'd played tennis with Harold Russek and that got her started on her family, whom she seemed obsessed with, and then we went from there to her portfolio and we made a list of the museums we hoped would buy them. I loved her work and told her I'd give her a show. She seemed agreeable. I asked if I could keep her portfolio overnight to study it, but she was possessive about it and wouldn't let me borrow it. She was very charming, but seemed tormented in some way—I couldn't figure out why. Something profound was bothering her. She talked about the future and photography and politics. She talked very fast, all in a rush, as if she was *thinking* too fast, and sometimes after she'd say something she'd contradict herself totally, but it was still a marvelous conversation that lasted five hours and then suddenly in the middle of a sentence Diane got up with her portfolio and bolted out of my gallery."

She began phoning compulsively. She phoned her mother in Florida, begging her to tell her how she'd coped with her depression back in the 1930s. She kept asking, "Mommy, Mommy, what happened? How did you get over it?" Gertrude Nemerov says she didn't have an answer. " 'I don't know, darling,' I said, and then I asked her if the therapist was helping and she told me, 'No, no,' and then she talked about her pictures not selling and how she wasn't getting enough assignments."

Later she phoned John Gossage, who was now living in Washington, D.C., to ask him, "Can't you find anyone to buy one of my portfolios?" She phoned her old art teacher from Fieldston, Victor D'Amico, and said she had to see him and talk about her work. D'Amico told her he was busy but

would try to see her soon. She phoned Lee Witkin. "The beautiful glass box Marvin Israel had designed for her portfolios was constantly breaking," Witkin says. "Diane was in tears about that."

Her brother, Howard, visited her at Westbeth. He had been moving around in the past few years—from Bennington to Brandeis and now he was settled at Washington University in St. Louis, where he held a prestigious chair in literature. He and Peggy lived in a spacious house with their three sons and he was part of a lively circle of writers that included Stanley Elkin and William Gass. He should have been content, but he remained edgy and easily bored. He was depressed by his continuing self-doubt in spite of genuine achievements.

All these years while he'd been sustained by his drive for perfection, for language in its purest, most concentrated, ordered, and expressive form, he'd made a supreme effort to conceal himself. He distanced his life, keeping it remote and formal except to a chosen few. Some of his closest friends, like Stanley Edgar Hyman and the painter Paul Feeley, had died, and although he wrote a great many letters, there were only a few people he felt close to; the constants after Diane were Kenneth Burke and his old English teacher Elbert Lenrow from Fieldston, who'd kept up with him regularly for forty years. To them he didn't have to reveal his private upsets, his disappointments. "In poetry the art itself has got to be its own reward," he once said dryly. He knew he would never get rich writing poetry, and only a few ever got famous, so there was little left to do except gossip, display, and jostle for position, and Howard (like Diane) enjoyed doing none of these things.

Still, he'd applied himself—he'd worked very hard and finally honors would pile up: membership in the exclusive Academy of Arts and Sciences, a Guggenheim. Eventually he would win both the Pulitzer Prize and the National Book Award in one year for his collected poetry. By 1971 he was a poets' poet—admired by his peers for his intricate use of language, his deep erudition; criticized by others because he had never cut loose or "gone confessional" as had Robert Lowell and Allen Ginsberg. Nor would he capture the imagination of the American public as Robert Frost had, or William Carlos Williams.

Only once could anyone remember him openly showing his frustration at being ignored. It happened at Bernard Malamud's house in Cambridge when Malamud was teaching at Harvard. The other dinner guests were John Updike, Philip Rahv, and Robert Lowell. It was at the height of the Vietnam war. Lowell had been very involved in the anti-war demonstra-

tions, and throughout dinner all attention focused on him as he spoke passionately and manically about his involvement. Although Howard and the others attempted to be heard, nobody else could so much as finish a sentence. Finally, as coffee was being served, Lowell pulled out a poem he'd written about Vietnam and read it aloud. When he finished, Howard got up abruptly and walked out the door. Later Lowell remarked, "Howard Nemerov is a minor poet, isn't he?" And Bernard Malamud replied very quietly, "Who isn't minor, Cal?" The subject was immediately dropped.

When Howard and Diane met that evening in July, they didn't discuss their careers; they never did. At the restaurant in the West Village where they had dinner, they reverted to the private language they'd always used as brother and sister—bantering, teasing, whispering conspiratorially, or just eating in silence as they had long ago on Central Park West with only their nannies for company.

That night they spoke of their children and of their mother, who'd briefly remarried. (Diane said of her stepfather, "Mommy told me his mouth doesn't water. My mouth waters at the thought.")

Howard says, "Diane seemed in a very good mood that evening. We had a marvelous time. Laughed quite a bit." Just before they left the restaurant, she suddenly announced, "You know, I'm going to be remembered for being Howard Nemerov's sister." ("How ironic and untrue," Howard says today.)

He brought her back to Westbeth feeling that, despite her cheerfulness and jokes, "she was terribly alone." The elevator they rode up in smelled of urine. The endless black hall which led to her apartment appeared shadowy and sinister. Howard was glad to leave.

During the weekend of July 10, Diane visited Nancy Grossman and Anita Siegel's loft. "She arrived Sunday afternoon, extremely distraught," Grossman says. "She said, 'We're on the street.' I thought she meant Marvin and she were on the street, but Marvin wasn't with her. She stayed with Anita and me until after it got dark.

"She had been close with Marvin twelve years, she said. He kept going off and she felt depressed and outside his life. The summers were always the worst for Diane and this summer was bad as usual; she felt general rage and depression about being kept out of his life.

"She spoke about Marvin in a torrent of words and tears and then about her work, which, she cried, was giving her *nothing back*. 'My work doesn't do it for me anymore,' she said. She had spent months photograph-

ing these mental retardates and she was exhausted, drained from the experience, and the pictures were no good—out of control. She could not confront these subjects as she had in the past—it was a new thing for her. She didn't know what it meant. She had just developed the contacts, but hadn't printed them. Suddenly it didn't matter. 'My work doesn't do it for me anymore,' she repeated. And, listening to her, I thought this must be the most devastating thing to happen to an artist—to lose one's need to discover. What does it mean when suddenly, inexplicably, we're no longer nourished by our work and it gives us nothing back? I tried to make her feel better by showing her the most recent pictures I'd been collecting from newspapers, but they didn't interest her. Instead she climbed into Anita's lap and Anita tried to comfort her, but Diane just went on crying. 'I love you two,' she said. 'I wish I could go to bed with both of you.' It was an extraordinary statement to make in that time—very controversial —and I was threatened by it. Anita and I were not lovers, had never been lovers; nor were we involved with Diane sexually—or with any woman for that matter. We had been Diane's friends for over three years. Had been together often, and we felt very, very close but there had never been anything sexual between us. In retrospect I guess what Diane wanted was comfort then. She wanted a nest. I was roasting a chicken, and when it was done we fed Diane. She ate ravenously, as if she hadn't eaten for days, and then again she told us how depressed she was and how during her last class at Hampshire College she'd tried explaining what being a photographer was like—about how a photographer can capture the soul of a person, which is why photography is so sinister and mysterious! And suddenly, remembering another experience at the New School, she said, in the midst of a class she'd been conducting there, she got her period and blood started flowing down her leg and she thought, 'How terrific.' She loved getting her period! She welcomed it, welcomed the cramps, welcomed the blood—she was feeling something, she was no longer numbed. She told us she had tried everything as an adolescent—Kotex, Modess, tampons—to staunch her flow. She said she'd even used some kind of gadget she'd bought at Rexall's Drug—something in the shape of a tiny cup that caught the blood and held it. As she told the story, she seemed to enjoy the memory of what it was like to have her period—what pleasure and pride she felt at being a woman, at being grown-up. Later when she was feeling more relaxed she made a hand rubbing on a piece of my drawing paper (I have it still). I helped her with it—she pressed her fingers down hard on the paper, hoping to see an imprint of flesh. Finally she left, looking wan and tired, but she assured us she was less depressed. We never saw her again."

. . .

On July 26 the Apollo 15 astronauts were launched to the moon. Shirley Clarke was setting up her cameras to film a documentary on the roof of Westbeth. She could hear the news of the blast-off on a thousand TVs and radios. "Suddenly, for no reason at all, an image of Diane flew into my mind. I thought I should call her—I must call—she's right here in this building."

That morning Diane had slipped a print of Kandinsky's death mask under Andra Samuelson's door. Andra had asked her for it, but Diane didn't wait to see if she was there.

Later she had lunch at the Russian Tea Room with Bea Feitler. She had accepted an assignment from Bud Owett to do some advertising photography for the *New York Times*, and Owett says he came over to her table to talk to her briefly about it.

Afterwards the photographer Walter Silver ran into her on the street. "She was carrying a flag. She said she was catching a cold. She also said she was thinking of moving out of New York. I told her, 'Don't be silly.' "

On July 27 the telephone kept ringing in Diane's apartment. Peter Schlesinger called and called, trying to confirm the fact that she would be conducting a symposium on photography that he had organized for later in the week. Marvin Israel called several times too and he got no answer. On July 28 he went over to Westbeth.

He found Diane dead, with her wrists slit, lying on her side in the empty bathtub. She was dressed in pants and shirt—her body was already "in a state of decomposition." On her desk her journal was open to July 26, and across it was scrawled "The last supper."

No other message was found, although Lisette Model claimed to have received a note but refused to divulge its contents. There is also a rumor that Diane had set up her camera and tripod and taken pictures of herself as she lay dying. However, when the police and coroner arrived, there was no evidence of camera or film.

At the morgue her uncle, Harold Russek, identified the body. He said his niece had always been subject to depressions. After the autopsy, her death was diagnosed by Dr. Michael Baden, the New York medical examiner, as "acute barbiturate poisoning."

In Palm Beach, Gertrude Nemerov was informed of Diane's suicide and made arrangements to come to New York at once. It was she who phoned Howard and Renée.

As soon as Richard Avedon heard the news, he dropped everything he was doing and took the next flight to Paris so that he himself could tell Doon about her mother's death.

Back at Westbeth the tenants started discussing Diane's suicide. Then

a squabble began between several artists as to who would get her apartment. "It was one of the biggest in the building," a playwright says. "It had such a great view."

Diane's funeral at Frank Campbell's at 80th Street and Madison Avenue was sparsely attended. Many of her friends were away for the summer; others weren't informed. There was only a death notice August 1 in the *Times*. Obits didn't appear in the newspapers or in *Time* or *Newsweek* or the *Village Voice* until August 5.

Allan Arbus flew in from California with his wife, Mariclare, and Bea Feitler and Ruth Ansel were there, as were Doon, Amy, Gertrude Nemerov, Renée and Howard, and Richard Avedon. (At one point during the service Avedon murmured, "Oh, I wish I could be an artist like Diane!" And Frederick Eberstadt says he whispered back, "Oh, no you don't.")

Howard gave the eulogy; it was short.

Later he wrote a poem for Diane which has since been reprinted many times.

To D—Dead by Her Own Hand

My dear, I wonder if before the end
You ever thought about a children's game—
I'm sure you must have played it too—in which
You ran along a narrow garden wall
Pretending it to be a mountain ledge
So steep a snowy darkness fell away
On either side to deeps invisible;
And when you felt your balance being lost
You jumped because you feared to fall, and thought
For only an instant: That was when I died.

That was a life ago. And now you've gone,
Who would no longer play the grown-ups' game
Where, balanced on the ledge above the dark,
You go on running and you don't look down,
Nor ever jump because you fear to fall.

Afterword

I am standing mesmerized in front of a huge black-and-white photograph by Diane Arbus labeled "Identical Twins, Roselle New Jersey." The picture was taken in 1967; Diane considered it her self-defining icon. The twins—Cathleen and Colleen—are posed against a neutral alley wall staring gravely into the camera; they're clearly responding to Diane as she clicks the shutter. At first glance this portrait seems to resemble nothing more than a snapshot since the little girls are placed together so simply in the frame. But the psychological reverberations run deep.

The seemingly casual treatment of the two little girls belies the fact that as identical twins they are quite extraordinary. This is characteristic of Diane's radical vision: portraying the extraordinary as ordinary and acceptable. And there is as well a mix of extreme concentration, eerie detachment, and belief in the photograph. Diane's spirit is mysteriously present too, looking steadily on.

"Identical Twins" was one of 200 prints of people and events in a remarkable exhibition entitled "Diane Arbus Revelations" at the Los Angeles County Museum of Art in the Spring of 2004. It was the first major retrospective of Diane since the landmark one at MOMA in 1972. The exhibition began in San Francisco, where the show caused a flurry of high praise and invective. But that wasn't surprising. Diane always polarizes. According to Michael Kimmelman of the *New York Times*, she's looked upon as either "a compassionate renegade" or "an exploitative narcissist of decadent elegance." After the show left Los Angeles it traveled to Houston and then in 2005 to the Metropolitan Museum of Art in New York before moving on to Essen, Germany; London; and Minneapolis.

Suffice it to say that, since my biography was published in 1984, Diane's reputation as a master has grown and flourished. Her portraits of drag queens, celebrities, nudists, suburban couples, and angry kids have

been acknowledged by scholars and critics as classics in the field; these images are fundamental to our understanding of twentieth-century photography—although in some quarters they are still thought to be controversial.

Diane's work remains a major force, along with Walker Evans's and Robert Frank's in the transition documentary photography made as it shifted its focus from the social concerns of the 1930s (rural poverty, the Depression in the big cities) to the personal and psychological obsessions that overtook society from the 1950s on. At the same time, Diane's suicide turned her into an instant legend like Sylvia Plath and Marilyn Monroe. She gained fame and was romanticized as "the tormented genius" more celebrated for living on the edge than for the artistry she brought to her emotional struggles. Novels were written based on apocryphal stories about her. There were poems and screenplays. A radio show on NPR documented the trials and tribulations of "the Jewish Giant" and his family, another one of Diane's most famous portraits. Stanley Kubrick (also a still photographer) was inspired by the "Identical Twins" when he directed an adaptation of Stephen King's *The Shining* with Jack Nicholson. The ghost twins in that movie were replicas of Diane's signature image.

Not surprisingly there were plays as well. One, *Silence, Cunning and Exile* by Stuart Greenman, was drawn in part from a chapter I'd written in my biography about a peculiarly intense summer Diane and Allan Arbus spent with another couple on the island of Nantucket in 1948. The drama was produced at Harvard University and then at the Public Theater in New York in 1995.

In 2003 another play, *Third Floor Second Door to the Right* by Doon Arbus, was produced by the Cherry Lane Theater as part of the New York International Fringe Festival. Allan Arbus, now white-haired and eighty-five, played the central role: an old man living alone who is interviewed by a young reporter about the old man's best friend, "a famous figure" who's just committed suicide. The reporter attempts to examine the impact of that bloody death on their complicated relationship. Arin Arbus (Doon Arbus's half sister), who directed the play, maintains that the drama "is not autobiographical."

Perhaps because of such notoriety and because her work is so singular, Diane's photographs remain in constant demand. The Arbus estate has brought new images out slowly and carefully so that the market has never been flooded. Each new work has been heralded as an event; the result: the value of an Arbus keeps going up. Consider that one of Diane's rare prints of "Identical Twins" recently sold at auction for $270,000 and a wistful self-portrait she took in 1945 looking into her parents' bathroom

mirror went for $101,000 in 2001. Even so, for the past thirty years there have been few exhibits of her work and relatively little written about her. That's because the Arbus estate has kept a tight rein on all Arbus papers and restricted reproductions. Scholars and critics who wanted to write about her work had to hand over their texts for estate approval in order to use illustrations. Some refused to do so.

Why such strict control?

Executrix Doon Arbus's reasoning is "to safeguard [the pictures] from the onslaught of theory and interpretation." Initially Doon Arbus thought the images should be as widely available as possible, but after the hugely publicized success of the MOMA retrospective in 1972 she decided that her mother was turning into "a phenomenon and that phenomenon . . . endangered the pictures." For the next three decades the pictures were guarded assiduously. However, in the past year the archive was opened up in order to contain the present retrospective as well as an accompanying book, also entitled *Diane Arbus Revelations*. Although Doon Arbus maintains that this new exhibit and the book "do not signal a change of heart but rather one of strategy," the fact remains that the public will at last be able to gaze into Diane's life and career on all sorts of new levels.

Beyond the 200 prints (many not seen before) there are work prints, contact sheets, notebooks, correspondence, Diane's collages, and her cameras under glass—as well as a fascinating and detailed chronology of her day-to-day life which ends with the coroner's terse report: "final cause of death (9/14/71) incised wounds of wrists with external hemorrhage. Acute barbiturate poisoning. Suicidal."

I think I must have stayed at the Los Angeles County Museum of Art for hours that day in February of 2004. I wanted to absorb all I could of Diane's process. I stopped for the longest time at some of her earliest pictures and some of her most mysterious, such as the crumbling movie palaces along 42nd Street and Times Square taken in the late 1950s. Diane went to the movies a lot, often in the afternoons, and she would photograph the theaters and their patrons. What's remarkable about these photographs is how they prefigure many of her later concerns. She would climb up into the balcony of the theater and juxtapose screen images with people—often to ironic effect. In one photograph I see the silhouette of a couple about to kiss; they're framed against a filmed shot on the screen of a menacing burning cross. A few essentially romantic images show a glowing angle of light spilling from the projector and through the smoky air over the audience spotted up and down the aisles.

I imagine I can make out a couple of street kids slouched together on a velvet seat; there's an old man asleep in his raincoat. I spy a bag lady. The overall tone is one reminiscent of her later work in which a fascination with grubbiness, loneliness, and sex is mingled with bleak irony and despair.

Diane loved photographing in the dark. Darkness interested her much more than light. As a matter of fact, the last time I ever saw her was on the dimly lit roof of a tenement building in the East Village. It was a very hot evening during the summer of 1970. My husband and I had gone to a fundraiser for "the Chicago Seven," the political radicals put on trial for their violent demonstrations during the Democratic National Convention of 1968, who were out on bail. The rooms were so crowded and noisy with antiwar activists that we climbed up on the roof to get some air.

Others from the party had fled there too. I could make out a few couples smoking. Someone had brought a guitar. Below in the distance a police siren wailed. An orange moon hung over the chimneys. That's when I recognized Diane rising out of the gloom. She was in a miniskirt and safari jacket, cameras slung about her neck, and she was taking pictures of Abby Hoffman, one of the most outrageous members of "the Chicago Seven."

Wild-haired, manic Abby Hoffman was a founder of the Yippies who'd once been a straight young man from upstate New York. In the mid-1960s he started working for peace before turning to drugs and street theater. He helped organize the explosive demonstrations against the war at the Democratic National Convention in Chicago in 1968. Hoffman was arrested for painting "fuck" on his forehead. In 1989 he too committed suicide.

But the night I saw him with Diane he was joking about his seven months on the stand as a "conspirator inciting the crowds to riot." He described how at one point he'd leaped over the velvet rope in the courtroom and how after he'd been sentenced and was being led off to jail in manacles he called out to his wife, "Water the plant." Meanwhile Diane was totally focused on capturing Hoffman's many animated expressions; she positively quivered every time another emotion flickered across his pockmarked face.

Eventually he stopped performing for her and his shoulders sagged. He was sweating under his flowered headband as he began to observe her. Their eyes locked. He listened to her soft questions, responding to her gap-toothed smile.

Diane was always connected to her subjects by some magnetic bond and that bond was the source of her formidable power. It's evident in all

her pictures and it's why no other photographer can imitate her no matter how hard they try.

By midnight she'd taken hundreds of shots, then she ran out of film.

I don't know whether Diane ever developed the Hoffman contact sheets. Maybe they're still lying somewhere in the vast Arbus archive. I do know that she must have seen all sorts of drama in Hoffman's gaze. She never photographed anything or anybody that was easy, but what she did see took consummate awareness.

As she once said, "I really believe there are things which nobody would see unless I photographed them."

<div style="text-align: right">

Patricia Bosworth
September 2004

</div>

Notes and Sources

Chapter 1

page
3 "I wanted to see . . .": Marvin Israel, "Diane Arbus," *Infinity*, Nov. 1972.

3 "a family of Jewish aristocrats": John Putnam to PB, interview, July 1, 1979.

3 Information on the history of Russeks department store gathered from interviews with Gertrude Russek Nemerov, Howard Nemerov, Renée Nemerov Sparkia, Walter Weinstein, Arthur Weinstein, and Ben Lichtenstein, and from the *Women's Wear Daily* archives.

7 "the snappiest of all of retail": Andrew Goodman to PB, interview, Sept. 8, 1978.

7 "Russeks survived . . .": Ben Lichtenstein to PB, interview, May 7, 1979.

7 "There was always . . .": Eleanor Lambert to PB, interview, January 25, 1979.

8 "We were the largest buyers . . .": Ben Lichtenstein to PB, interview, May 7, 1979.

8 "With money . . .": Ibid.

8 "He had Russeks' accountant . . .": Ibid.

8 "My father and David . . .": Walter Weinstein to PB, interview, Feb. 18, 1980.

Chapter 2

9 "they pronounced it that way . . .": Gertrude Nemerov to PB, interview, July 21, 1978.

9 "Even as a baby . . .": Ibid.

9 "cranky—always crying . . .": from DA, unfinished Fieldston autobiography.

9 "It was almost always dark . . .": Howard Nemerov to PB, interview, July 19, 1978.

10 "She had a hard sad quite lovely face . . .": from DA, unfinished Fieldston autobiography.

10 "this image wasn't concrete . . .": DA to Studs Terkel, interview, Dec. 1969.

10 "who had a terrific . . .": Howard Nemerov to PB, interview, July 19, 1978.

10 "a hard time figuring out . . .": Gertrude Nemerov to PB, interview, July 19, 1978.

10 "But she makes . . .": Renée Sparkia to PB, interview, March 12, 1979.

11 "You can look at De Pinna and Bonwit's . . .": Ibid.

11 "rubbing their hands together . . .": DA to Studs Terkel, interview, Dec. 1969.

11 "I was treated like a crummy princess": Frederick Eberstadt to PB, interview, Feb. 5, 1979.

12 "were both insulting and hurtful . . .": DA to Studs Terkel, interview, Dec. 1969.

12 "an overtly powerful . . .": Howard Nemerov to PB, interview, July 20, 1978.

12 "We were protected and privileged . . .": Ibid.

13 "In early life . . .": Howard Nemerov, *Journal of the Fictive Life* (Rutgers University Press, 1965), p. 84.

13 "And I for one . . .": Howard Nemerov to PB, interview, July 19, 1978.

13 "My motto was . . .": Ibid.
13 "We didn't 'explain' . . .": Ibid.
14 "My mother used to . . .": Ibid.
14 "[we sat] together . . .": Howard Nemerov, *Journal of the Fictive Life*, p. 77.
14 "A little, a very little . . .": Ibid, p. 79.
14 "An Old Picture": *The Collected Poems of Howard Nemerov* (University of Chicago Press, 1977), p. 129.
14 "The anecdote of the poem . . .": Howard Nemerov, *Journal of the Fictive Life*, p. 77.

Chapter 3

15 "Exasperated Boy with Toy Hand Grenade": *Life Library of Photography: Ten Personal Styles*, p. 222.
15 "[since] I was such a rich kid . . .": Ibid.
15 "Diane was my idol . . .": Renée Sparkia to PB, interview, March 12, 1979.
15 "No, no, it shouldn't . . .": Ibid.
16 "There was this dentist . . .": Ibid.
16 "It frequently crossed . . .": Howard Nemerov, *Journal of the Fictive Life* (Rutgers University Press, 1965), p. 125.
16 "The artistic development of each student . . .": Elbert Lenrow to PB, interview, September 5, 1978.
16 "Diane Nemerov demonstrates . . .": from Fieldston School file, *Diane Nemerov*.
17 "I refused to keep clean": DA to Studs Terkel, interview, Dec. 1969.
17 "The teachers always used to think . . .": DA, unfinished Fieldston autobiography.
17 "It was essentially dreary . . .": DA to Studs Terkel, interview, Dec. 1969.
17 "Please no more": Dorothy Evslin to PB, interview, May 8, 1979.
18 "I ohhed and ahhed . . .": Ibid.
18 " 'Most of them . . .' ": Ibid.
18 "I remember vaguely . . .": DA to Studs Terkel, interview, Dec. 1969.
18 "don't lower . . .": George Radkai to PB, interview, Jan. 15, 1979
18 "Once they displayed . . .": Ibid.
19 "we're predominantly . . .": Arthur Weinstein to PB, interview, July 19, 1983.
20 "I never knew I was Jewish . . .": DA to Studs Terkel, interview, Dec. 1969.
20 "It's irrational to be born . . .": DA to Ann Ray Martin, interview, March 20, 1967.
20 "Stubborn and stiff-necked man! . . .": "Debate with the Rabbi," *The Collected Poems of Howard Nemerov* (University of Chicago Press, 1977), p. 270.

Chapter 4

22 "to make some mind . . .": "Beginner's Guide," *The Collected Poems of Howard Nemerov* (University of Chicago Press, 1977), p. 444.
22 "even though a friend . . .": Howard Nemerov to PB, interview, July 20, 1978.
22 "*à la* Lillian Gish . . .": DA to Studs Terkel, interview, Dec. 1969.
22 "He got every Hungarian artist . . .": John Pauker to PB, interview, May 23, 1981.
22 "a basso . . .": Howard Nemerov to PB, interview, July 20, 1978.
23 "Mommy ridiculed me . . .": Ibid.
23 "nurse who taught me . . .": Howard Nemerov, *Journal of the Fictive Life* (Rutgers University Press, 1965), p. 74.
23 "Diane and I were as intimate . . .": Renée Sparkia to PB, interview, March 12, 1979.
23 "Obviously Diane possessed a gift . . .": Victor D'Amico to PB, interview, July 29, 1980.

23 "Once I gave her class . . .": Ibid.

24 "the first one to do it . . .": DA, unfinished Fieldston autobiography.

24 "based on exclusion . . .": Naomi Rosenbloom to PB, interview, Feb. 16, 1980.

24 "Diane would float away . . .": Hallie Baldwin to PB, phone interview, Oct. 20, 1982.

24 "They were married lovers": Naomi Rosenbloom to PB, interview, Feb. 16, 1980.

25 "Love involves a peculiar . . .": *Life Library of Photography: Responding to a Subject*, p. 110.

25 "But, darling, what is it . . .": Dorothy Evslin to PB, interview, May 8, 1979.

25 "secret, invisible . . .": Howard Nemerov, *Journal of the Fictive Life*, p. 84.

25 "That's my most vivid memory . . .": John Pauker to PB, interview, May 23, 1981.

25 "Gertrude was deep down . . .": Lillian Weinstein to PB, interview, Aug. 10, 1983.

25 "He was fantastic . . .": DA to Studs Terkel, Dec. 1969.

26 "a businessman must be ruthless . . .": Nate Cummings to PB, interview, Aug. 10, 1969.

26 "we'd play cards . . .": Nate Cummings to PB, interview, Aug. 10, 1979.

26 "lost the entire chain . . .": Renée Sparkia to PB, interview, March 11, 1979.

26 "Frank loved to gamble . . .": Walter Weinstein to PB, interview, Feb. 2, 1981.

26 "so I kept quiet . . .": Howard Nemerov to PB, interview, July 19, 1978.

27 "I was ashamed . . .": DA, unfinished Fieldston autobiography.

27 "We were a family of silences . . .": Renée Sparkia to PB, interview, March 12, 1979.

27 "Mr. Nemerov dropped in . . .": Judy Freed to PB, interview, April 2, 1980.

27 "Diane didn't seem to belong . . .": Phyllis Carton to PB, interview, April 16, 1980.

27 "Diane was definitely his favorite . . .": Helen Quat to PB, interview, June 1978.

28 "Dreamt and wished": DA, unfinished Fieldston autobiography.

28 "very much even though . . .": Ibid.

Chapter 5

30 "One of the things I suffered from . . .": DA to Studs Terkel, interview, Dec. 1969.

30 "impulsively—in the Bronx . . .": Phyllis Carton to PB, interview, April 15, 1980.

31 "Because *everything* in life . . .": Ibid.

31 "We'd crowd into the Eighth Avenue express . . .": Hilda Belle Rosenfield to PB interview, April 1979.

31 "I must have counted . . .": DA to Studs Terkel, interview, Dec. 1969.

32 "She had a talent . . .": Victor D'Amico to PB, interview, July 29, 1980.

32 "Maybe about Käthe Kollwitz . . .": Ibid.

32 "We felt like phonies . . .": Phyllis Carton to PB, interview, April 15, 1980.

32 "Not for long periods . . .": Victor D'Amico to PB, interview, July 29, 1980.

33 "They're *my* children, Buddy . . .": Renée Sparkia to PB, interview, March 12, 1979.

33 "Dorothy was probably . . .": Ben Lichtenstein to PB, interview, Jan. 1979.

33 "painfully shy . . .": Ibid.

33 "As a clan . . .": Lureen Arbus to PB, interview, March 6, 1980.

33 "Allan was bright . . .": Arthur Weinstein to PB, interview, July 19, 1983.

33 "Allan wanted to be an actor . . .": Ibid.

33 "the best actor . . .": Seymour Peck to PB, interview, Oct. 17, 1979.

34 "then fell madly in love . . .": Tina Fredericks to PB, interview, Oct. 23, 1979.

34 "take Diane out . . .": Arthur Weinstein to PB, interview, July 19, 1983.

34 "Allan became the most . . .": Renée Sparkia to PB, interview, March 12, 1979.

34 "And then the oddest . . .": Naomi Rosenbloom to PB, interview, Feb. 16, 1980.

35 "with a religious guilt . . .": Howard Nemerov, *Journal of the Fictive Life* (Rutgers University Press, 1965), p. 138.

35 "I thought it was a proud, odd household": Hilda Belle Rosenfield to PB, interview, April 1979.

35 "It was David's way . . .": Ben Lichtenstein to PB, interview, May 7, 1979.

35 "Diane and I learned . . .": Renée Sparkia to PB, interview, March 12, 1979.

36 "I could tell Diane . . .": Gertrude Nemerov to PB, interview, July 29, 1978.

36 "All I know is . . .": Ibid.

36 "but nobody could diagnose . . .": Ibid.

36 "He was oily . . .": Ibid.

37 "to treat me in our cabin . . .": Ibid.

Chapter 6

38 "It never occurred to Aunt Gertrude . . .": Dorothy Evslin to PB, interview, May 8, 1979.

38 "There were a lot of boys . . .": Eda LeShan to PB, interview, Dec. 11, 1979.

38 "I've never seen anyone . . .": Helen Quat to PB, interview, July 1978.

38 "I absolutely hated furs . . .": DA to Studs Terkel, interview, Dec. 1969.

38 "And I would cry": Howard Nemerov to PB, interview, July 21, 1978.

39 "David did everything . . .": George Radkai to PB, interview, Jan. 1981.

39 "A lot of yearning . . .": Renée Sparkia to PB, interview, March 12, 1979.

39 "Diane's thick brown hair . . .": Clara Park to PB, phone interview, Aug. 19, 1981.

40 "It was the most rapturous portrait . . .": Dorothy Evslin to PB, interview, May 8, 1979.

40 "Diane retaliated . . .": Renée Sparkia to PB, interview, March 12, 1979.

40 "Make Diane stop . . .": Victor D'Amico to PB, interview, July 29, 1980.

40 "in order to get close to nature . . .": Harvey Shapiro to PB, phone interview, Aug. 20, 1978.

41 "a beaming wunderkind . . .": Cranston Jones to PB, phone interview, Oct. 10, 1979.

41 "She thought everything I did . . .": Alex Eliot to PB, interview, April 21, 1979.

41 "Her physical presence . . .": Ibid.

41 "I told her, 'I noticed you . . .' ": Ibid.

42 "The minute I saw it . . .": Ibid.

42 "The emotion, the colors, the textures . . .": Ibid.

42 "It was a tiny, eerie place . . .": Louise Bernikow to PB, interview, June 5, 1980.

43 "It was a sweaty Sunday afternoon . . .": Alexander Eliot, *Zen Edge* (Seabury Press, 1979), p. 66.

43 "Diane had a funny breastbone": Alex Eliot to PB, interview, April 12, 1979.

43 "Diane was wondrously strange . . .": Ibid.

43 "Your father reminds me . . .": Ibid.

44 "She had told me . . .": Ibid.

44 "tender but dominating . . .": Ibid.

44 "Howard was a golden light . . .": Clara Park to PB, phone interview, Aug. 19, 1981.

44 "Howard wasn't going to be a poet . . .": Ibid.

44 "Writing was for me at the beginning . . .": Howard Nemerov, *Journal of the Fictive Life* (Rutgers University Press, 1965), p. 13.

45 "spiritual fathers": Howard Nemerov to PB, interview, July 21, 1978.

45 "Howard was absolutely crushed . . .": DA to Studs Terkel, interview, Dec. 1969.

45 "A crowded affair . . .": Alex Eliot to PB, interview, April 21, 1979.

46 "we became as close as brothers . . .": Ibid.

46 "Because, no matter how well we thought . . .": Ibid.

46 "Always surprising . . .": Ibid.

46 "I'm just going to hold her back . . .": Ibid.

47 "If you say that . . .": Frank Parker to PB, interview, Nov. 16, 1982.

47 "Getting married was essential . . .": Ibid.

Chapter 7

49 "trotting over to me during recess . . .": Naomi Rosenbloom to PB, interview, Feb. 16, 1980.

49 "For about four years . . .": DA, unfinished Fieldston autobiography.

49 "because she wouldn't accept . . .": Elbert Lenrow to PB, interview, July 1979.

49 "We talked . . .": Phyllis Carton to PB, interview, April 15, 1980.

49 "We were passionate . . .": Eda LeShan to PB, interview, Dec. 12, 1979.

49 "Falling in love . . .": Phyllis Carton to PB, interview, April 15, 1980.

50 "It was very strong . . .": Ibid.

50 "Her talent was very special": Victor D'Amico to PB, interview, July 29, 1980.

50 "to live under the wing . . .": DA to Studs Terkel, interview, Dec. 1969.

50 "Mommy and Daddy were going to . . .": Renée Sparkia to PB, interview, March 12, 1979.

51 "the deep selfish slowness of woman . . .": DA, Fieldston essay.

51 "Diane was simply scared stiff . . .": Phyllis Carton to PB, interview, April 15, 1980.

51 "She dragged herself around . . .": Elbert Lenrow to PB, interview, July 30, 1978.

52 "She seems very troubled . . .": Ibid.

52 "She told me . . .": Howard Nemerov to PB, interview, July 21, 1978.

52 "while the kids screamed . . .": Spencer Brown to PB, interview, August 1978.

52 "I've never seen . . .": Elbert Lenrow to PB, interview, Sept. 3, 1978.

53 "We were supposedly . . .": Dorothy Evslin to PB, interview, May 8, 1979.

53 "Is it evil . . .": Alex Eliot to PB, interview, April 21, 1979.

54 "First we walked . . .": Ibid.

54 "Everything is going to be all right": Phyllis Carton to PB, interview, April 15, 1980.

Chapter 8

55 "The building was next to . . .": Alex Eliot to PB, interview, April 21, 1979.

55 "but not much": Ibid.

55 "Nobody ever knew . . .": Liberty Dick to PB, interview, Nov. 16, 1982.

55 "If one leg collapses . . .": Alex Eliot to PB, interview, April 21, 1979.

56 "I frankly don't know . . .": Marian Wernick to PB, phone interview, Nov. 1982.

56 "make the marriage bed": Phyllis Carton to PB, interview, April 15, 1980.

56 "Diane would follow me around . . .": Liberty Dick to PB, phone interview, Nov. 16, 1982.

56 "We never benefited . . .": DA to Studs Terkel, interview, Dec. 1969.

56 "It was the era . . .": Ben Lichtenstein to PB, interview, Jan. 1979.

57 "wishing the war would be over soon . . .": Howard Nemerov, letter to John Pauker, 1943.

57 "I was finally on my own": Howard Nemerov to PB, interview, July 19, 1978.

57 "Allan was miserable": Hope Eisenman to PB, interview, September 28, 1983.

58 "Mommy keeps telling me . . .": Naomi Rosenbloom to PB, interview, Feb. 16, 1980.

58 "Diane Nemerov's little sister . . .": Renée Sparkia to PB, interview, March 12, 1979.

59 "She seemed more sure of herself": Ibid.

59 "She became a wonderful mother": Ibid.

59 "Now crawl . . .": Ben Lichtenstein to PB, interview, Jan. 1979.

60 "gauche, timid, and hideously dressed": Peggy Nemerov to PB, interview, July 19, 1978.

60 "Don't worry . . .": Howard Nemerov to PB, interview, July 19, 1978.

60 "they never ever accepted me": Peggy Nemerov to PB, interview, July 19, 1978.

60 "We never *felt* rich . . .": DA to Studs Terkel, interview, Dec. 1969.

60 "of everything—food, clothes, liquor": Peggy Nemerov to PB, interview, July 19, 1978.

60 "I wanted to be an actress . . .": Hilda Russell to PB, interview, July 19, 1978.

60 "get some hot tea . . .": Ibid.

61 "She was so dear, so sweet . . .": Ibid.

61 "Diane tried to be so nice . . .": Peggy Nemerov to PB, interview, July 19, 1978.

61 "I felt so sorry . . .": Ibid.

61 "I was not at my best": Howard Nemerov to PB, interview, July 19, 1978.

61 "If you didn't make a career . . .": Jerry Miller to PB, interview, March 6, 1979.

62 "What about 'man of letters,' Daddy?": Howard Nemerov to PB, interview, July 18, 1978.

62 "What made the whole thing . . .": Peggy Nemerov to PB, interview, July 19, 1978.

62 "The park was almost Edwardian . . .": Jill Kornblee to PB, interview, May 29, 1979.

62 "Diane's bony bare feet . . .": Ibid.

62 "Diane told me . . .": Hilda Belle Rosenfield to PB, interview, April 1979.

63 "so I didn't . . .": Ibid.

Chapter 9

67 "recalcitrant—it's determined to do one thing . . .": *Diane Arbus, Aperture* monograph (1972).

67 "We never saw them . . .": Peggy Nemerov to PB, interview, July 21, 1978.

67 "I thought it was the most revealing . . .": Alex Eliot to PB, interview, April 21, 1979.

68 "Our building was never well tended . . .": Dell Hughes to PB, interview, Aug. 19, 1982.

69 "They were very particular . . .": Ben Lichtenstein to PB, interview, Jan, 1979.

69 "As soon as I'd come out . . .": Carole McCarlson to PB, phone interview, March 21, 1980.

70 "She was building up her portfolio . . .": Dorian Leigh and Laura Hobe, *The Girl Who Had Everything* (Doubleday, 1980), p. 62.

70 "We weren't a very friendly bunch": Francesco Scavullo to PB, interview, March 19, 1980.

70 "Diane always wore beige . . .": Barbara Lamb to PB, interview, Feb. 10, 1979.

70 "Everybody in fashion drank": Betty Dorso to PB, interview, April 16, 1980.

71 "They reminded me of two little mice . . .": Art Kane to PB, interview, Feb. 1979.

71 "Actually, Allan would act out . . .": Robert Meservey to PB, interview, March 28, 1980.

71 "Diane and Allan came into my office . . .": Tina Fredericks to PB, interview, Oct. 23, 1979.

72 "a flair—a talent . . .": Alexander Liberman to PB, interview, Aug. 16, 1979.

72 "It was difficult . . .": Tina Fredericks to PB, interview, Oct. 23, 1979.

72 "They were so well liked . . .": Miki Denhoff to PB, interview, Sept. 20, 1979.

72 "But the results . . .": Tina Fredericks to PB, interview, Oct. 23, 1979.

73 "like kids . . .": Rick Fredericks to PB, interview, May 5, 1980.

73 "It seemed—in 1947–48—unshakable": Betty Dorso to PB, interview, April 16, 1980.

73 "He was my first teacher": Alex Eliot to PB, interview, July 21, 1980.

73 "Sometimes he seemed more at ease . . .": Rick Fredericks to PB, interview, May 5, 1980.

73 "Your eyes opened up . . .": May Eliot to PB, interview, Jan. 22, 1983.

74 "Allan would get very upset . . .": Renée Sparkia to PB, interview, March 12, 1979.
74 "He could be very, very funny": Rick Fredericks to PB, interview, Jan. 1980.
74 "she spent her time . . .": Alex Eliot to PB, interview, July 20, 1980.
74 "That's not the way it is . . .": Ikko Narahara, tapes of Diane Arbus class 1970–71.
75 "Diane was like a new breath": May Eliot to PB, interview, Jan. 22, 1983.
75 "We spent many lovely afternoons . . .": Alex Eliot to PB, interview, July 20, 1980.
75 "four-way friendship was extremely complex . . .": Alex Eliot, letter to PB, July 1980.
76 "God, she was beautiful! . . .": Ibid.
76 "I was still madly in love . . .": Ibid.

Chapter 10

77 "I was a John Robert Powers . . .": Cheech McKensie to PB, interview, March 6, 1979.
78 "It was nobody's business . . .": Ibid.
78 "so trim and logical . . .": Ibid.
78 "fat, sloppy, pompous . . .": Ibid.
78 "She never asked for anything . . .": Ibid.
79 "She had a funny attitude . . .": Ibid.
79 "Maybe because I could see . . .": Ibid.
79 "We would take her daughter roller-skating . . .": Ibid.
79 "I told her not to . . .": Ibid.
79 "We were fearless . . .": Ibid.
79 "I don't know . . .": Ibid.

Chapter 11

81 "loved the feel . . .": Tina Fredericks to PB, interview, Oct. 23, 1979.
81 "a pillow against disaster": Ibid.
81 "He seemed increasingly . . .": Frank Parker to PB, interview, Nov. 16, 1982.
81 "They really enjoyed . . .": May Eliot to PB, interview, Jan. 22, 1983.
81 "we would tie . . .": Ibid.
81 "Because a woman spends . . .": DA to *Newsweek*, March 20, 1967.
82 "My parenthood is . . .": Tina Fredericks to PB, interview, Oct. 23, 1979.
82 "I kept telling myself . . .": Alex Eliot to PB, interview, June 10, 1979.
82 "Disgusting! Terrible! . . .": Ibid.
82 "clawed through the heavy surf": Ibid.
82 "I found myself alone . . .": Ibid.
83 "so timid . . .": Frank Parker to PB, interview, Nov. 16, 1982.
83 "tension crackled . . .": Ibid.
83 "because everything was swirling . . .": Ibid.
83 "Anne never forgave . . .": Liberty Dick to PB, interview, Nov. 16, 1982.
84 "I never knew . . .": Alex Eliot to PB, interview, July 21, 1980.
84 "continued to be . . .": Ibid.
84 "She wanted to try everything . . .": Ibid.
84 "But I feel like her brother": Cranston Jones to PB, interview, Nov. 1979.
84 "Oh, Alex . . .": Alex Eliot to PB, interview, July 21, 1980.
85 "Allan danced beautifully": Ibid.

Chapter 12

86 "because Allan says . . .": Alex Eliot to PB, interview, July 21, 1980.
86 "Why don't you go . . .": Renée Sparkia to PB, interview, March 12, 1979.

86 "What wonderful kids": Ibid.

86 "then never told Daddy . . .": Ibid.

87 "She would take . . .": Ibid.

88 "creepy—because none of us . . .": DA, letter to Peter Crookston.

88 "How does one photograph . . .": Tina Fredericks to PB, interview, Oct. 23, 1979.

88 "My roommate was in her class . . .": Roy Sparkia to PB, interview, March 12, 1979.

88 "That's one of the reasons . . .": Tina Fredericks to PB, interview, Oct. 23, 1979.

88 "It was alwasy great seeing D . . .": Renée Sparkia to PB, interview, March 12, 1979.

89 "We'd grown up rich . . .": Ibid.

89 "He still had power . . .": Ibid.

89 "We were taught . . .": DA to Studs Terkel, interview, Dec. 1969.

89 "Kafkaesque—a fable . . .": Howard Nemerov to PB, interview, July 20, 1978.

89 "mankind is at once . . .": Phyllis Carton to PB, interview, April 16, 1980.

89 "It was mostly editing by long distance . . .": John Pauker to PB, interview, May 23, 1981.

90 "It was my idea . . .": Peggy Nemerov to PB, interview, July 20, 1978.

90 "to write the war . . .": Howard Nemerov to PB, interview, July 20, 1978.

90 "You watch the night . . .": "The Frozen City," *The Collected Poems of Howard Nemerov* (University of Chicago Press, 1977), p. 4.

90 "lack of style": F. C. Golffing *Poetry*, Nov. 1947.

90 "the legacy of modernism . . .": Reed Whittemore, "On Editing *Furioso*," *Triquarterly*, Fall 1978.

91 "Howard really started . . .": Peggy Nemerov to PB, interview, July 20, 1978.

91 "I'm going to be . . .": Alex Eliot to PB, interview, July 21, 1979.

91 "The place is like . . .": Elbert Lenrow to PB, interview, Sept. 5, 1978.

91 "I thought he was White Russian . . .": Kit Fowler to PB, interview, June 25, 1980.

91 "I always got the feeling . . .": Bernard Malamud to PB, interview, March 5, 1980.

91 "He seemed driven . . .": Ben Belit to PB, interview, June 25, 1980.

92 "Howard knew . . .": Bill Ober to PB, interview, Aug. 10, 1981.

92 "one of them . . .": Arthur Weinstein to PB, interview, July 19, 1981.

92 "gifted—perfectly written.": *New York Times Book Review*, April 3, 1949.

92 "One's photographed face . . .": Howard Nemerov, *Journal of the Fictive Life* (Rutgers University Press, 1965), p. 80.

92 "I don't blame you . . .": Howard Nemerov to PB, interview, July 20, 1978.

92 "Diane took a wonderful picture . . .": Peggy Nemerov to PB, interview, July 20, 1978.

93 "Diane became convulsed . . .": Renée Sparkia to PB, interview, March 12–14, 1979.

93 "So I'm either . . .": Roy Sparkia to PB, interview, March 12, 1979.

93 "Feb. 1949 . . .": Ibid.

93 "We wander . . .": Ibid.

93 "Nobody knew . . .": Ibid.

93 "Allan suddenly began talking . . .": Ibid.

94 "you've got to remember . . .": Ibid.

94 "made love all the time.": Tina Fredericks to PB, interview, Oct. 23, 1979.

94 "Diane was just as fascinated . . .": Frederick Eberstadt to PB, interview, Feb. 5, 1979.

Chapter 13

95 "Diane was pulling away . . .": Alex Eliot to PB, interview, July 20, 1979.

95 "It was late afternoon . . .": Ibid.

96 "fat and clumsy": May Eliot to PB, interview, Jan. 22, 1983.

96 "She was always *there* for me . . .": Ibid.

96 "Afterwards she would always say . . .": Ibid.
96 "minor aspect": Alex Eliot, letter to PB, July 21, 1981.
96 "we were creative . . .": Ibid.
96 "That was my way . . .": Alex Eliot to PB, interview, July 20, 1980.
96 "Actually, she changed my life": Ibid.
97 "I've found another woman . . .": Ibid.
97 "All Alex had talked about . . .": Jane Winslow Eliot to PB, interview, July 20, 1980.
97 "which I had no interest in being . . .": Ibid.
98 "mainly because I refused . . .": Ibid.
98 "How do you feel?": Ibid.

Chapter 14

99 "There was a lot . . .": Rick Fredericks to PB, interview, Feb. 1980.
99 "the muse, the mother . . .": Cheech McKensie to PB, interview, March 6, 1979.
100 "Yes, it was the novel . . .": Alex Eliot to PB, interview, July 20, 1980.
100 "the evenings were long . . .": Mort Gottlieb to PB, interview, Sept. 10, 1981.
101 "The contents of somebody's bathroom . . .": Peter Crookston to PB, interview, Dec. 14, 1982.
101 "if we really pressed her": Tina Fredericks to PB, interview, Oct. 23, 1979.
101 "Diane was darting . . .": Frances Gill to PB, interview, April 28, 1980.
101 "It was a protective, sheltered world . . .": Kate Lloyd to PB, interview, Nov. 1979.
101 "We were insulated . . .": Ibid.
101 "That was the way . . .": Ibid.
101 "It was the subtext . . .": Tina Fredericks to PB, interview, Oct. 10, 1979.
101 "So we worked doubly hard . . .": Kate Lloyd to PB, interview, Nov. 1979.
102 "I captured them . . .": Frances Gill to PB, interview, April 28, 1980.
102 "you have humility . . .": *Glamour*, April 1951.
102 "She would say to me . . .": Doon Arbus, "Diane Arbus, Photographer," *MS Magazine*, Oct. 1972.
103 "being scared of Doon . . .": May Eliot to PB, interview, Jan. 22, 1982.
104 "It was jolly": Rick Fredericks to PB, interview, May 5, 1980.
104 "She had dark circles . . .": Bob Meservey to PB, interview, March 28, 1980.
104 "They seemed in good spirits": Alex Eliot to PB, interview, July 20, 1980.
104 "I think she made it herself": Ibid.
104 "Finally I did . . .": Ibid.
105 "God's bathroom": DA to Alex Eliot, letter, c. 1950.
105 "Diane set her camera up . . .": Stewart Stern to PB, letter, March 14, 1983.
105 "full of halls": DA to Alex Eliot, letter, c. 1950.
106 "I feel on the brink . . .": Ibid.
106 "In them you see . . .": Alex Eliot to PB, interview, July 20, 1980.
106 "at least four children": Jane Winslow Eliot to PB, interview, July 20, 1980.
106 "Diane still looked sick . . .": Bob Meservey to PB, interview, May 19, 1979.
106 "Maybe that's why . . .": Tina Fredericks to PB, interview, Oct. 23, 1979.
106 "Amy is like Allan . . .": Ibid.
107 "The studio was magnificent": May Eliot to PB, interview, Jan. 22, 1983.
107 "The purple was startling . . .": Ibid.
107 "They were extremely kind . . .": Tod Yamashiro to PB, interview, Dec. 1979.
108 "Sometimes I'd yell . . .": Ibid.
108 "But her collaboration . . .": Ibid.
108 "I can still see Diane . . .": Ibid.
108 "PAT NAMES 20 MEN . . .": *New York Daily News*, March 15, 1955.
108 "she had totaled 20 . . .": Ibid.
109 "For having relations . . .": Ibid.

109 "They were playing . . .": Ibid.
109 "to express sympathy . . .": Howard Nemerov, *Journal of the Fictive Life* (Rutgers University Press, 1965), p. 98.
109 "She was probably numbed . . .": Anita Weinstein to PB, interview, Feb. 18, 1980.
109 "David kept on . . .": Andrew Goodman to PB, interview, Sept 8, 1978.
110 "David longed to move . . .": Ibid.
110 "The Philadelphia store had been . . .": Walter Weinstein to PB, interview, Feb. 18, 1980.
110 "They wanted the floors . . .": Jerry Manashaw to PB, interview, May 20, 1981.

Chapter 15

111 "They were starting . . .": Tod Yamashiro to PB, interview, Dec. 1979.
111 "Diane and Allan Arbus were . . .": Fran Healy to PB, interview, Oct. 29, 1979.
111 "But to get a piece . . .": Art Kane to PB, interview, Dec. 1979.
112 "Diane and Allan were leading . . .": Howard Nemerov to PB, interview, July 21, 1979.
112 "because Diane and Allan were incapable . . .": Alex Eliot to PB, interview, July 20, 1980.
112 "The fashion/ad crowd . . .": Charles James to PB, interview, date unavailable.
112 "No more parties . . .": Alex Eliot to PB, interview, July 20, 1980.
112 "They asked some . . .": Tina Fredericks to PB, interview, Oct. 23, 1979.
112 "It was in the days . . .": Nancy Berg to PB, interview, Nov. 20, 1979.
114 "perhaps the last and greatest achievement . . .": John Szarkowski, *Mirrors and Windows, American Photography Since 1960* (N.Y. Graphic Society, Boston), p. 17.
114 "Once just for the hell of it . . .": Alex Eliot to PB, interview, July 20, 1980.
115 "Diane and Allan were classy . . .": Miki Denhoff to PB, interview, Aug. 16, 1979.
115 "the work of Diane and Allan . . .": Nancy Hall Duncan, *The History of Fashion Photography* (Alpine Books, 1979), p. 224.
115 "but Diane's crude portraits . . .": Alex Eliot to PB, interview, July 20, 1980.
115 "It's rough on a guy . . .": Rick Fredericks to PB, interview, Feb. 1980.
115 "Allan was technically excellent": Fran Healy to PB, interview, Oct. 29, 1979.
116 "but Nick disliked Diane . . .": Frederick Eberstadt to PB, interview, Feb. 5, 1979.

Chapter 16

117 "It was the start . . .": Renée Sparkia to PB, interview, March 12, 1980.
117 "Mommy, Daddy, Howard . . .": Ibid.
118 "I wanted D to acknowledge . . .": Ibid.
118 "I finally could stand it . . .": Roy Sparkia to PB, interview, March 12, 1980.
118 "Anyhow I let Gertrude . . .": Ibid.
119 "I would dream about Diane . . .": Renée Sparkia to PB, interview, March 12, 1980.
119 "we'd talk a long time . . .": Ibid.
119 "When clothes belong to a person . . .": Cheech McKensie to PB, interview, March 6, 1979.
119 "grasp at straws": Ibid.
119 "a very tall ugly dumb . . .": Anne Tucker to PB, phone interview, Nov. 1981.
119 "off-limit experiences.": Cheech McKensie to PB, interview, March 6, 1979.
120 "He was a Greek god . . .": Ibid.
120 "We'd been best friends . . .": Ibid.
121 "right away . . .": Alex Eliot to PB, interview, July 20, 1980. Ibid.
121 "She had no real interest . . .": Ibid.
122 "a great artist . . .": Ibid.
122 "you can do anything . . .": Ibid.

122 "You owe it to yourself": Ibid.

122 "Ma had always thought . . .": Amy Arbus, interview on radio station WBAI, Jan. 3, 1973.

122 "I learned from his impatience . . .": Richard Avedon in Owen Edwards, "Zen and the Art of Alexey Brodovitch," *American Photographer*, June 1979.

122 "He didn't care . . .": Art Kane to PB, interview, Sept. 27, 1978.

123 "It was a remarkable discipline . . .": Owen Edwards, "Zen and the Art of Alexey Brodovitch."

123 "Set yourself a problem . . .": Frank Zachary to PB, interview, Nov. 2, 1978.

123 "The life of a commercial photographer . . .": Art Kane to PB, interview, Sept. 27, 1978.

Chapter 17

125 "the most instinctive eyes . . .": Ben Fernandez to PB, interview, Jan. 9, 1979.

125 "Can't you tie your own shoes?" from an unpublished essay on Lisette Model by Philip Lopate.

126 "He thought . . .": Ibid.

126 "I was praised . . .": Ibid.

126 "I hate pretty prints": Ibid. ·

126 "It's exciting . . .": Ibid.

126 "They said . . .": Ibid.

127 "You couldn't get a word in . . .": Irene Fay to PB, interview, June 21, 1981.

127 "photography is the art . . .": Ben Fernandez to PB, interview, Jan. 9, 1979.

127 "Carmel used to say . . .": from an unpublished essay on Lisette Model by Philip Lopate.

127 "I asked him what was cooking . . .": Ibid.

127 "Later at a Museum of Modern Art . . .": Ibid.

128 "Evsa was as talented . . .": Ibid.

128 "walked across Asia . . .": Ibid.

128 "But they doted on each other . . .": Irene Fay to PB, interview, June 21, 1981.

128 "a virtual international report . . .": Peter Bunnell; *Helen Gee and the Limelight* (catalog: Feb. 12–March 8, 1977, Carlton Galleries, 127 E. 69 St., N.Y. 10021).

129 "The camera is an instrument . . .": from an unpublished essay on Lisette Model by Philip Lopate.

129 "photograph a face like a Picasso": Ibid.

129 "Don't shoot . . .": designed by Marvin Israel, foreword by Bernice Abbott, *Lisette Model* (Aperture, 1979), p. 9.

130 "little balloons . . .": from an unpublished essay on Lisette Model by Philip Lopate.

130 "What I want to photograph . . .": Doon Arbus, "Diane Arbus, Photographer," *MS Magazine*, Oct. 1972.

131 "She liked being afraid . . .": Ibid.

131 "If I ever went away for a weekend . . .": Alan Levy, "Working with Diane Arbus: A Many Splendored Experience," *Art News*, Summer 1973.

131 "Oh, you look terrific! . . .": Barbara Brown to PB, phone interview, March 9, 1980.

131 "I was terrified most of the time . . .": David Nemerov to PB, interview, Jan. 31, 1980.

132 "The very process . . .": Barbara Brown to PB, phone interview, March 9, 1980.

132 "I never take it off": David Newman to PB, interview, Jan. 31, 1980.

132 "She learned from Model . . .": Peter Bunnell, "Diane Arbus," *Print Collectors Newsletter*, Jan./Feb. 1973.

132 "The androgenous, the crippled . . .": Lisette Model, interview on CBS-TV *Camera Three*, Nov. 12, 1972.

132 "I'd be fascinated by . . .": *Diane Arbus, Aperture* Monograph (1972).

132 "There was a tremendous fantasy quality . . .": Lisette Model to PB, interview, Feb. 6, 1979.

132 "Do you know any streetwalkers?": Ibid.

133 "Diane stopped . . .": Bob Meservey to PB, interview, May 19, 1979.

133 "She was a mentor . . .": Alex Eliot to PB, interview, July 20, 1980.

133 "An extraordinary love . . .": unpublished interview with Lisette Model by Philip Lopate.

133 "Until I studied with Lisette . . .": *Newsweek*, March 20, 1967.

Chapter 18

135 "Diane always wore . . .": Jill Isles to PB, interview, April 14, 1981.

135 "Aren't you ever worried . . .": Renee Phillips to PB, interview, Feb. 22, 1981.

135 "Independence and purity . . .": Ibid.

136 "It's a testing . . .": DA to Studs Terkel, interview, Dec. 1969.

136 "Oh she is gorgeous": DA, letter to Meserveys (undated).

136 "sort of weird rarefied air.": Ibid.

136 "I think it was hard for her . . .": Peggy Nemerov to PB, interview, July 20, 1979.

136 "A fairly agreeable . . .": Howard Nemerov to PB, interview, July 20, 1979.

137 "They were obviously very close": Bernard Malamud to PB, interview, March 5, 1980.

137 "modern—chic . . .": Howard Nemerov to PB, interview, July 20, 1979.

137 "important and beautiful.": *New York Times Book Review*, July 17, 1955.

138 "he never made comments . . .": Howard Nemerov to PB, interview, July 20, 1979.

138 "You get the out-of-town . . .": Renée Sparkia to PB, interview, March 12, 1980.

138 "She could be a terrific cook . . .": Tina Fredericks to PB, interview, Oct. 23, 1979.

138 "who was so handsome . . .": Tami Grimes to PB, interview, Sept. 1979.

139 "They seemed glamorous . . .": Sybille Pearson to PB, interview, Oct. 22, 1979.

139 "She was so sensuous . . .": Ibid.

139 "I always felt wanted . . .": Ibid.

140 "which was a geometric study . . .": Emile de Antonio to PB, interview, Oct. 1980.

Chapter 19

141 "It was a rather . . .": Cheech McKensie to PB, interview, May 1980.

142 "Mary wasn't allowed to be an artist . . .": Claire Kirby to PB, interview, Nov. 1979.

142 "Bob kept saying . . .": Louis Faurer photographs from Philadelphia and New York, 1937–1943. Compiled and Edited by Edith A. Tenolli and John Gossage. Art Gallery University of Maryland College Park, March 10–April 23, 1981.

142 "Robert was one . . .": Louis Silverstein to PB, interview, January 1980.

143 "I shot and developed . . .": Robert Frank to Walker Evans, Yale Photography Seminar, 1971.

143 "To Robert Frank . . .": Jack Kerouac, preface to Robert Frank, *The Americans*.

143 "both situational and contextual . . .": Garry Winogrand, *Public Relations* (Museum of Modern Art, 1977) p. 11.

143 "stalking, observing . . .": Robert Frank to Dennis Wheeler, *Criteria*, June 1977.

144 "It was an insane time": Ibid.

144 "It was insane": Ibid.

145 "I learned a lot . . .": Ibid.

145 "We were a scruffy, excitable . . .": Buffie Johnson to PB, interview, Dec. 17, 1979.

145 "Everybody was in everybody else's pocket": Sondra Lee to PB, interview, Nov. 10, 1980.

145 "It didn't matter . . .": Loring Eutemay to PB, interview, Feb. 1, 1979.

145 "Mary was the greatest dancer . . .": Ibid.

146 "She began appearing . . .": Rosalyn Drexler to PB, phone interview, April 20, 1979.

146 "Diane never drank . . .": Paul Resika to PB, interview, Oct. 3, 1978.

147 "Amy stands tiny . . .": *Life Library of Photography: Photographing Children*, p. 176.

147 "pieces of dreams": "Mary Frank Explores Women's Erotic Fantasies," by James R. Matthews, *New York Times*, Jan. 19, 1975.

147 "The men in our group . . .": Barbara Forst to PB, interview, February 1979.

147 "Everybody was screwing . . .": Ibid.

147 "so we were not sustained . . .": Ibid.

148 "If only Hitler were alive . . .": Paul Resika to PB, interview, Oct. 3, 1978.

Chapter 20

149 "this exquisite . . .": Helen Merrill to PB, interview, Oct. 10, 1978.

149 "Doon is far braver . . .": Tina Fredericks to PB, interview, Oct. 23, 1979.

150 "By the end of a session . . .": Richard Marx to PB, interview, March 3, 1979.

150 "If only we had . . .": Ibid.

150 "the dinners fizzled . . .": Alex Eliot to PB, interview, July 20, 1980.

151 "By now our offices . . .": Ibid.

151 "which clinched it . . .": Ibid.

151 "I wanted to live . . .": Ibid.

151 "blowing until . . .": Ibid.

153 "I told her . . .": Cheech McKensie to PB, interview, March 1979.

153 "I am going to be numbed . . .": Ibid.

153 "we were thrown out on the street . . .": Ibid.

Chapter 21

157 "They were gently estranged": Bob Meservey to PB, interview, June 1979.

157 "It wasn't very homey": Tina Fredericks to PB, interview, Oct. 23, 1979.

157 "Allan said . . .": Arthur Unger to PB, interview, June 7, 1982.

158 "He dreamed . . .": Emile de Antonio to PB, interview, Nov. 19, 1980.

158 "I think she was wearing . . .": Ted Schwartz to PB, interview, Dec. 1979.

159 "I thought Diane and Allan would always . . .": Gertrude Nemerov to PB, interview, July 21, 1978.

159 "A lot of his Seventh Avenue cronies . . .": Nate Cummings to PB, interview, Aug. 20, 1978.

159 "Nemerov's paintings are crude . . .": *Time*, Nov. 24, 1958.

159 "People who bought them . . .": Ibid.

159 "You see? An artist can be . . .": John Pauker to PB, interview, May 24, 1981.

159 "As we got poorer and poorer . . .": Amy Arbus, interview on radio station WBAI, Jan. 3, 1973.

160 "She was upset . . .": Tina Fredericks to PB, interview, Oct. 23, 1979.

160 "She photographed . . .": Frank Zachary to PB, interview, April 7, 1979.

161 "De knows everybody . . .": Tina Fredericks to PB, interview, Oct. 23, 1979.

161 "De connected artists with everything . . .": Andy Warhol and Pat Hackett, *POPism: the Warhol '60s* (Harcourt Brace Jovanovich, 1980), pp. 3–4.

161 "But I was never . . .": Emile de Antonio to PB, interview, Nov. 11, 1980.

161 "I called it that . . .": Ibid.

161 "And it wasn't . . .": Ibid.

161 "the delicate art . . .": Diane Arbus, "The Full Circle," *Infinity*, Feb. 1962.

162 "They were grainy . . .": Emile de Antonio to PB, interview, Nov. 16, 1980.

163 "like the pits . . .": John Putnam to PB, interview, July 19, 1979.

163 "People keep asking me . . .": William Borders, "Moondog," *New York Times*, May 15, 1965.

164 "He had an awful smile": Amy Arbus, interview on radio station WRVR, Fall 1972.

164 "It's not degrading . . .": William Borders, "Moondog."

164 "Presumably Diane did . . .": Emile de Antonio to PB, interview, Nov. 19, 1981.

164 "because they can't fake . . .": John Putnam to PB, interview, Aug. 20, 1978.

164 "Jesus! these stories . . .": Emile de Antonio to PB, interview, Nov. 16, 1980.

165 "I've been photographing . . .": Charlie Reynolds to PB, interview, Sept. 25, 1981.

165 "Diane was fascinated . . .": the Amazing Randi to PB, interview, Oct. 4, 1981.

166 "these very strange people": Amy Arbus, interview on radio station WBAI, Jan. 3, 1973.

166 "There's some thrill . . .": Ikko Narahara, tapes of Diane Arbus Class 1970–71.

166 "Even then robbings . . .": Emile de Antonio to PB, interview, Nov. 19, 1981.

167 "She became almost . . .": Presto to PB, interview, Oct. 5, 1981.

167 "They were like foreign bodies . . .": Amy Arbus interview on radio station WBAI, Jan. 3, 1973.

167 "I thought they were great . . .": the Amazing Randi to PB, interview, Oct. 4, 1981.

167 "Everything he did . . .": Ibid.

168 "He'd be wearing . . .": Ibid.

169 "Marvin and I are similar . . .": Tina Fredericks to PB, interview, Oct. 23, 1979.

169 "Marvin would always get turned on . . .": Nancy Grossman to PB, interview, March 24, 1979.

170 "first great female private eye . . .": Marvin Israel, "Diane Arbus," *Infinity*, Nov. 1972.

170 "Marvin thinks an artist's . . .": Larry Shainburg to PB, interview, Jan. 24, 1984.

170 "he believed . . .": Ibid.

170 "Marvin was like a creative sounding board . . .": Chris von Wangenheim to PB, interview, Dec. 8, 1980.

170 "Diane changed . . .": Cheech McKensie to PB, interview, March 6, 1980.

170 "He was very contemptuous . . .": Shirley Fingerhood to PB, interview, Feb. 24, 1981.

170 " 'Come on! Come on!' . . .": Ben Fernandez to PB, interview, Feb. 1, 1979.

Chapter 22

172 "We were developing . . .": David Newman to PB, interview, Jan. 31, 1979.

172 "bowled over . . .": Harold Hayes to PB, interview, Aug. 17, 1978.

172 "Diane knew the importance . . .": Robert Benton to PB, interview, Jan. 31, 1979.

173 "very sexual, very feminine . . .": Harold Hayes to PB, interview, Aug. 17, 1978.

173 "Diane was so pleased . . .": Ibid.

174 "William Harrington . . .": *New York Times*, 1935.

174 "Detective Wanderer . . .": Ibid.

174 "collecting things . . .": A. D. Coleman, *Light Readings* (Oxford University Press, 1979), p. 77.

174 "pet crematorium . . .": Ibid.

174 "It would quickly mingle . . .": K. T. Morgan, *Politiks & Other Human Interests*, March 14, 1978, p. 30.

174 "There are 28 stars . . .": Diane Arbus, "The Full Circle," *Infinity*, Feb. 1962.

175 "I foolishly decided . . .": Harold Hayes to PB, interview, Aug. 17, 1978.

175 "I feel like an explorer": Seymour Krim to PB, interview, May 14, 1981.

175 "It would be two a.m. . . .": Robert Benton to PB, interview, Jan. 31, 1979.

175 "I was frightened by her capacity . . .": Doon Arbus, "Diane Arbus, Photographer," *MS Magazine*, Oct. 1972.

Chapter 23

176 "in a few years . . .": Stanley Edgar Hyman, "The Art of Joseph Mitchell," *The Critic's Credentials* (Atheneum, 1978), p. 79.

176 "typing away in my cell . . .": Joseph Mitchell to PB, interview, Oct. 30, 1979.

177 "Born freaks are the aristocracy . . .": Joseph Mitchell, *McSorley's Wonderful Saloon* (Duell, Sloan and Pearce, 1943), p. 95.

177 "Most people go through life . . .": *Newsweek*, March 20, 1967.

177 "I urged Diane not to romanticize . . .": Joseph Mitchell to PB, interview, Oct. 30, 1979.

178 "She said she had looked . . .": Ibid.

178 "She could hypnotize people . . .": Joel Meyerowitz to PB, phone interview, Jan. 9, 1981.

178 "Ssh! I'm working": Richard Marx to PB, interview, March 3, 1980.

178 "I asked her to please take my picture . . .": Dale McConathy to PB, interview, Nov. 14, 1979.

178 "There are hundreds . . .": Marvin Israel, "Diane Arbus," *Infinity*, Nov. 1972.

178 "I love to go to people's houses . . .": *Newsweek*, March 20, 1967.

179 "She could be extremely . . .": Frederick Eberstadt to PB, interview, Feb. 5, 1979.

179 "What came to really excite her . . .": Marvin Israel, "Diane Arbus," *Infinity*, Nov. 1972.

179 "I'd wanted to be an actress . . .": Polly Boshung to PB, interview, Aug. 10, 1979.

180 "Diane Arbus was awful nice . . .": Ibid.

180 "I just told her . . .": Shirley Fingerhood to PB, interview, Feb. 24, 1981.

180 "last angry summer . . .": Sidney Simon to PB, interview (date unavailable).

180 "and Allan, Susan and her husband . . .": Ibid.

181 "We hunted high and low . . .": Ibid.

181 "bejeweled 6 by 9 foot room on 48 Street . . .": Diane Arbus, "The Full Circle," *Infinity*, Feb. 1962.

181 "On his left hand . . .": Ibid.

181 "He who searches for trash . . .": Ibid.

181 "a hermit and a very cheerful man . . .": Harold Hayes to PB, interview, Aug. 17, 1978.

182 "Your last letter . . .": Ibid.

182 "I am what I call . . .": Diane Arbus, "The Full Circle," *Infinity*, Feb. 1962."

183 "These are five singular people . . .": Ibid.

183 "Nancy did publish . . .": Ilya Stanger to PB, interview, Jan. 6, 1981.

183 "I didn't understand . . .": Nancy White to PB, interview, Oct. 13, 1980.

183 "We sat around . . .": Emile de Antonio to PB, interview, Nov. 19, 1981.

184 "We got a couple of cancellations . . .": Paul Aison to PB, interview, July 1981.

184 "Dear Mr. Mitchell . . .": Joseph Mitchell to PB, interview, Oct. 30, 1979.

184 "Howard was expected . . .": Dorothy Evslin to PB, interview, May 8, 1979.

184 "Howard Nemerov is one of the best . . .": *Yale Review*, June 1961.

185 "Daddy never praised . . .": John Pauker to PB, interview, May 23, 1981.

185 "Daddy was absolutely devastated . . .": Renée Sparkia to PB, interview, March 12, 1979.

185 "I really did love Diane . . .": Ibid.

Chapter 24

187 "The most mysterious thing . . .": Lisette Model to PB, interview, Feb. 6, 1979.

187 "I am very gloomy and scared . . .": DA, postcard to the Meserveys, c. 1962.

187 "Diane always put . . .": Tom Morgan to PB, interview, Sept. 6, 1979.

188 "Like he'd say five million Chinese . . .": DA to Studs Terkel, interview, Dec. 1969.

188 "the wildest looniest time . . .": Tom Wolfe, *The New Journalism* (Harper and Row, 1973), pp. 29–30.

188 "Dick keeps setting . . .": John Putnam to PB, interview, July 20, 1978.

188 "Celebrities have the faces . . .": *Newsweek*, Oct. 16, 1978.

189 "unearned intimacy": Richard Avedon to Connie Goldman, interview on National Public Radio, March 31, 1977.

189 "Diane and I were so close . . .": Jane Wilson to PB, interview, Dec. 18, 1978.

189 "'But I had a visual . . .": Richard Avedon to Connie Goldman, interview on National Public Radio, March 31, 1977.

190 "because Ike's expression . . .": John Putnam to PB, interview, July 3, 1979.

190 "Dick does everything with grace": *Newsweek*, March 20, 1967.

190 "Avedon for all his phenomenal success . . .": Lee Witkin to PB, interview, Nov. 19, 1981.

191 "because I no longer wanted to hide . . .": Richard Avedon to Connie Goldman, interview on National Public Radio, March 31, 1977.

191 "Marvin loved *La Dolce Vita* . . .": Dale McConathy to PB, interview, Nov. 14, 1979.

192 "They respected each other so much . . .": Neil Selkirk to PB, interview, Oct. 12, 1982.

192 "These shreds . . .": Doon Arbus, "Diane Arbus, Photographer," *MS Magazine*, Oct. 1972.

193 "A photograph for Diane . . .": Marvin Israel, interview on CBS-TV *Camera Three*, Nov. 12, 1972.

193 "But she showed me . . .": Alen McWeeney to PB, interview, Dec. 5, 1980.

193 "Taking a portrait . . .": John Gossage to PB, interview, May 23, 1981.

193 "a kind of calypso": Ikko Narahara, tapes of Diane Arbus Class 1970–71.

193 "He's really . . .": Ibid.

194 "You know how every mother . . .": Joseph Mitchell to PB, interview, May 9, 1980.

195 "You feel silly . . .": John Putnam to PB, interview, July 19, 1979.

195 "They run the whole social gamut": Ibid.

195 "I mean you were allowed . . .": Mary Ellen Andrews to PB, interview, Dec. 1, 1978.

195 "You're always jumping . . .": Suzanne Mantell to PB, interview, Dec. 5, 1978.

195 "began to wonder . . .": Ikko Narahara, tapes of Diane Arbus Class 1970–71.

196 "I couldn't . . .": Henry Wolf to PB, interview, Sept. 5, 1979.

196 "she introduced herself . . .": Alan Levy, "Working with Diane Arbus: A Many-Splendored Experience," *Art News*, Summer 1973.

197 "Deeyan taught me to look . . .": Ibid.

197 "On the other hand . . .": Ibid.

197 "Stay outa the sun . . .": Dan Talbot to PB, interview, Oct. 13, 1980.

197 "She was genuinely surprised . . .": Charlie Reynolds to PB, interview, Sept. 25, 1981.

198 "Diane would cook me an egg . . .": Hiro to PB, interview, May 6, 1982.

198 "But it was her portraits . . .": Ibid.

198 "It's almost trancelike . . .": Owen Edwards, "Hiro Who May Just Be the Great American Photographer," *American Photographer*, Jan. 1982.

198 "practically one a month": Robert Benton to PB, interview, Jan. 28, 1979.

198 "Diane would come up . . .": Ibid.

199 "Diane made no concessions . . .": David Newman to PB, interview, Jan. 28, 1979.

199 "strong—athletic . . .": Paul Salstrom to PB, interview, July 1, 1982.

199 "Diane spent time . . .": Ibid.

200 "producing like crazy . . .": Robert Benton to PB, interview, Jan. 28, 1979.

200 "Actually, it was just a compound": Tom Morgan to PB, interview, Sept. 6, 1979.

200 "Sometimes she'd whip up . . .": Ibid.

200 "They were all married . . .": Ibid.

201 "The whole thing is too personal . . .": Joan Morgan to PB, phone interview, Aug. 9, 1980.

201 "It was twenty yards long . . .": Paul Von Ringleheim to PB, interview, Jan. 22, 1980.

201 "I hate Paul's mural . . .": Tom Morgan to PB, interview, Sept. 6, 1979.

201 "This caused some consternation . . .": Ibid.

201 "I always phoned D . . .": Renée Sparkia to PB, interview, Aug. 2, 1978.

202 "Diane was delighted . . .": May Eliot to PB, interview, Jan. 22, 1983.

202 "there were big wine goblets . . .": Ibid.

202 "Diane was trying . . .": Emile de Antonio to PB, interview, Nov. 11, 1980.

202 "I always saw . . .": Robert Benton to PB, interview, Jan. 31, 1979.

202 "Allan was whispering something . . .": Barbara Lamb to PB, interview, Oct. 1979.

204 "Plenty of wine . . .": Chris von Wangenheim to PB, interview, Dec. 8, 1980.

204 "Diane looked straight at me . . .": John A. Williams to PB, interview, Nov. 1979.

204 "Diane's friendship . . .": Ibid.

204 "Diane did ask . . .": Ibid.

205 "She connected . . .": Ibid.

205 "Sometimes I got the feeling . . .": Ibid.

205 "liked men better . . .": Pat Peterson to PB, interview, Feb. 22, 1979.

205 "Diane was many things . . .": Marvin Israel, "Diane Arbus," *Infinity*, Nov. 1972.

206 "I've never heard . . .": Frederick Eberstadt to PB, interview, Feb. 5, 1979.

206 "Diane told me she wanted to have sex . . .": John Putnam to PB, interview, July 20, 1978.

207 "Women of my generation . . .": Kathy Aison to PB, interview, July 27, 1981.

207 "Because underneath Diane was . . .": Emile de Antonio to PB, interview, Nov. 16, 1980.

Chapter 25

208 "We'd compare prints . . .": Walter Silver to PB, interview, Oct. 23, 1981.

208 "I remember . . .": John Putnam to PB, interview, July 20, 1978.

209 "He collects things . . .": James Mellow, "Walker Evans Captures the Unvarnished Truth," *New York Times*, Dec. 1, 1974.

209 "He'd juggle . . .": Isabelle Story to PB, interview, Jan. 9, 1981.

209 "Marvin would . . .": Ibid.

209 "some of the eccentric photographs . . .": Ibid.

210 "March 3, 1963 . . .": from an unpublished letter of Walker Evans.

210 "Walker had a falling out . . .": Isabelle Story to PB, interview, Jan. 9, 1981.

210 "Maybe it was because . . .": Ibid.

210 "She seemed turned on . . .": Ibid.

210 "Class is the deepest mystery . . .": Susan Sontag, *On Photography* (Delta, 1977), pp. 54–55.

211 "I'm living proof . . .": Andy Warhol and Pat Hackett, *POPism: The Warhol '60s* (Harcourt Brace Jovanovich, 1980), p. 8.

211 "although Walker tried . . .": Isabelle Story to PB, interview, Jan. 9, 1981.

211 "a terrific story . . .": *Diane Arbus, Aperture* monograph (1972).

211 "where everybody sat around . . .": Isabelle Story to PB, interview, Jan. 9, 1981.

212 "butts all over the place": Renée Sparkia to PB, interview, March 12, 1979.

212 "Even Grandma Rose . . .": Ibid.

212 "My father taught me . . .": Howard Nemerov, *Journal of the Fictive Life* (Rutgers University Press, 1965), p. 70.

212 "David had been the big gun . . .": Helen Quat to PB, interview, 1978.

213 "go in and ask . . .": Renée Sparkia to PB, interview, March 11, 1979.

213 "American rites and customs . . .": DA, Guggenheim application, 1963.

213 "mostly about Daddy": Renée Sparkia to PB, interview, March 12, 1979.

213 "I didn't really adore him": DA to Studs Terkel, interview, Dec. 1969.

214 "businessman fantasies": Ibid.

214 "The cold was my revenge . . .": Howard Nemerov, *Journal of the Fictive Life*, p. 69.

214 [My father] was a man . . .": Ibid.

214 "He looks like Everyman": Howard Nemerov to PB, interview, July 20, 1979.

214 "She was very upset . . .": Harold Hayes to PB, interview, Aug. 17, 1978.

214 "Suddenly he woke up . . .": DA to Studs Terkel, interview, Dec. 1969.

214 "really awful when my father died . . .": Ibid.

215 "how [Daddy's] energy seemed reapportioned . . .": Ibid.

215 "in a whispery little voice . . .": Ben Fernandez to PB, interview, Feb. 1, 1979.

215 "Mommy came . . .": Renée Sparkia to PB, interview, March 12, 1979.

Chapter 26

216 "not an intimate . . .": Arthur Sainer to PB, interview, April 3, 1981.

216 "really pissed off . . .": Ibid.

216 "Diane would have . . .": Bruce Davidson to PB, interview, Feb. 5, 1980.

216 "I remember . . .": Arthur Sainer to PB, interview, April 3, 1981.

217 "counting all the people . . .": John Putnam to PB, interview, July 19, 1979.

217 "Diane really dug . . .": Ibid.

217 "I'd tell Diane . . .": Ibid.

217 "Triplets remind me . . .": Peter Crookston to PB, interview, Dec. 20, 1979.

218 "that a snake charmer . . .": Howard Nemerov to PB, interview, July 19, 1979.

218 "Everything is superb and breathtaking . . .": Doon Arbus, "Diane Arbus, Photographer," *MS Magazine*, Oct. 1972.

219 "burst into tears . . .": Ibid.

219 "She called one morning . . .": Joseph Mitchell to PB, interview, Oct. 30, 1979.

220 "We talked a great deal . . .": Ibid.

220 "my brother's and my . . .": DA to Studs Terkel, interview, Dec. 1969.

220 "I hate intelligence . . .": Howard Nemerov, *Journal of the Fictive Life* (Rutgers University Press, 1965), p. 92.

221 "A dream of . . .": Ibid., p. 78.

222 "We had the same lexicon": DA to Studs Terkel, interview, Dec. 1969.

222 "windowless elevator hall . . .": Howard Nemerov, *Journal of the Fictive Life*, p. 90.

222 "who became a peculiar clue . . .": DA to Studs Terkel, interview, Dec. 1969.

222 "She always seemed sad . . .": Emile de Antonio to PB, interview, Oct. 10, 1980.

223 "I probably ended up . . .": Ibid.

Chapter 27

224 "Diane was at every spectacle . . .": Bob Adelman to PB, interview, Aug. 5, 1981.

224 "most of the protests . . .": Ibid.

224 "She used to . . .": Frederick Eberstadt to PB, interview, Feb. 5, 1979.

224 "Everybody can be famous for fifteen minutes": Andy Warhol and Pat Hackett, *POPism: The Warhol '60s* (Harcourt Brace Jovanovich, 1980).

225 "I'd stop at nothing . . .": Mark Haven to PB, interview, July 17, 1981.

225 "Frazier and I talked . . .": John Putnam to PB, interview, Oct. 8, 1980.

225 "She was peddling . . .": Pat Rotter to PB, interview, Sept. 1979.

226 "the most unbelievable walk . . .": Ibid.

226 "The lobby was like Hades": Ibid.

226 "In the early sixties . . .": Andy Warhol and Pat Hackett, *POPism: The Warhol '60s*, p. 223

227 "You actually get a sense . . .": Isabelle Story to PB, interview, Jan. 9, 1981.
227 "This artist is daring . . .": Walker Evans in Louis Kronenberger, ed., *Quality: Its Image in the Arts* (Atheneum, 1969), p. 172.
227 "they weren't pictures . . .": John Szarkowski to PB, interview, Aug. 9, 1981.
228 "Diane had already . . .": Ibid.
229 "Suddenly I could not . . .": Bruce Davidson to PB, interview, Feb. 5, 1980.
229 "And I asked . . .": Ibid.
230 "Diane and I . . .": Ibid.
230 "I'll never forget it . . .": Ibid.
230 "You're better taking pictures . . .": Ibid.
231 "I don't know . . .": Ibid.
231 "God, those two women . . .": Ibid.
231 "Lisette had been intimidated . . .": Bob Cato to PB, interview, Aug. 5, 1982.
231 "some are instinctive . . .": Lisette Model to PB, interview, Feb. 6, 1979.
232 "Whenever I photograph . . .": Ibid.
232 "Oh—what she told me! . . .": Ibid.
232 "She had to be flying . . .": Ibid.
232 "Let me be exploited!" Lisette Model to Philip Lopate, interview.
232 "telling her of my plans . . .": Peter Salstrom to PB, letter, Sept. 16, 1978.
233 "It was a sunny . . .": Ibid.
233 "It was a deep friendship . . .": Gay Talese to PB, interview, Feb. 1, 1980.
234 "She was obviously . . .": Ibid.
234 "We exhibited . . .": Yuben Yee to PB, interview, May 25, 1981.
234 "People were uncomfortable . . .": Ibid.
235 "Diane Arbus' pictures . . .": Jim Hughes to PB, interview, July 1, 1982.
235 "I sometimes thought . . .": John Putnam to PB, interview, March 18, 1980.
235 "The whole area . . .": Ibid.
236 "collective cave painting . . .": documented by Mervyn Kurianski and Jon Naan, text by Norman Mailer, *The Faith of Graffiti* (An Alskog Book, 1974).
236 "It's impossible to get out . . .": John Putnam to PB, interview, March 18, 1980.
236 "She was gentle . . .": John Gossage to PB, interview, May 24, 1981.
237 "Dorothea Lange had the idea . . .": Bob Adelman to PB, interview, Aug. 5, 1981.
237 "Diane was a terrific teacher . . .": Paula Hutsinger to PB, interview, March 21, 1979.
237 "In another class . . .": Ibid.
238 "He influenced Brassaï . . .": Ibid.
239 "Don't you love freaks?": Susan Brownmiller to PB, interview, Jan. 3, 1980.
239 "Diane said . . .": Presto the Fire Eater to PB, interview, Oct. 5, 1981.
239 "She walked off . . .": Ibid.
240 "These are a new generation of photographers . . .": John Szarkowski, wall label for "New Documents" show, March 1967.
241 "steadying hand": DA, postcard to John Szarkowski, c. 1966.
241 "She imagined . . .": Garry Winogrand to PB, interview, Nov. 10, 1981.
241 "Before that I'd been seeing her . . .": Ibid.
241 "I thought her idea . . .": Ibid.
241 "It was like . . .": Chris von Wangenheim to PB, interview, Dec. 8, 1980.
241 "two Mamiya . . .": John Putnam to PB, interview, March 18, 1980.
242 "Diane Arbus' closest friend . . .": Owen Edwards, "Marvin Israel, the Mentor Who Doesn't Want to Be Famous," *Village Voice*, Oct. 23, 1975.
242 "Diane doesn't love . . .": Gertrude Nemerov to PB, interview, July 24, 1978.
242 "my biggest influence . . .": Owen Edwards, "Marvin Israel, the Mentor Who Doesn't Want to Be Famous."
242 "In public, Diane always kept her distance . . .": Emile de Antonio to PB, interview, Nov. 9, 1980.

242 "It was like a weird battle . . .": Chris von Wangenheim to PB, interview, Dec. 8, 1980.

242 "Often it was as if she didn't have any identity . . .": Diane Cleaver to PB, phone interview, March 15, 1980.

243 "Marvin kept in touch . . .": Carol Barilla to PB, interview, March 2, 1980.

243 "Marvin making a lunch date with me . . .": Bob Cato to PB, interview, Aug. 5, 1982.

Chapter 28

245 "I think I'll buy this for Marvin . . .": Pat Peterson to PB, interview, Feb. 22, 1979.

245 "quite controversial . . .": Ibid.

245 "where an artist . . .": Ibid.

245 "how much the trip . . .": Ibid.

246 "Diane marching into my office . . .": Geri Stutz to PB, interview, Dec. 9, 1981.

246 "Diane looked like an angel . . .": Dorothy Seiberling, "Pinky's Pictures," *New York*, Feb. 21, 1977.

246 "Get to the Museum . . .": DA, postcard to Robert Meserveys.

246 "For a while . . .": Garry Winogrand to PB, interview, Nov. 10, 1981.

247 "what disturbed and disoriented people . . .": Peter Bunnell, "Diane Arbus," *Print Collectors Newsletter*, Jan./Feb. 1977.

247 "Diane's images reminded us . . .": John Szarkowski to PB, interview, Aug. 9, 1981.

247 "It was like what happened . . .": Saul Leiter to PB, interview, May 18, 1981.

247 "Her subject matter was just too difficult . . .": Emile de Antonio to PB, interview, Nov. 19, 1981.

247 "unflinchingly . . .": Max Kosloff, "Some Contemporary American Photographers," *Nation*, May 6, 1967.

248 "One does not look . . .": Marion Magid, "Diane Arbus in New Documents," *Arts*, April 1, 1967.

248 "It impresses me terribly . . .": DA to Ann Ray Martin, interview, 1967.

248 "I work from awkwardness . . .": Ibid.

249 "I thought how ordinary . . .": Ibid.

249 "She looks as if she'd stopped . . .": Ibid.

249 "The process of photography . . .": Ibid.

249 "I love Cornell's secrets . . .": Ibid.

249 "I love what people say . . .": Ibid.

249 "Photographing is not about . . .": John Gossage to PB, interview, May 24, 1981.

250 "Even though the water . . .": Tina Fredericks to PB, interview, Oct. 23, 1979.

250 "they have secrets . . .": Richard Lindner, *Vogue*, Aug. 15, 1967.

Chapter 29

252 "She hated . . .": Garry Winogrand to PB, interview, Nov. 10, 1981.

253 "I suggested . . .": Joseph Mitchell to PB, interview, May 9, 1980.

253 "we still hadn't met . . .": Ibid.

254 "electric with anxiety": Larry Shainberg to PB, interview, Oct. 12, 1982.

255 "Imitation was not for her . . .": Doon Arbus, "Diane Arbus, Photographer," *MS Magazine*, Oct. 1972.

255 "She refused to speak to me . . .": Peter Hujar to PB, phone interview, March 4, 1980.

255 "In 1967 she was trying out . . .": Garry Winogrand to PB, interview, Nov. 10, 1981.

255 "instantly attracted": Peter Crookston to PB, interview, May 24, 1980.

256 "You have a lovely daughter . . .": Ibid.

256 "I was awakened . . .": Ibid.

257 "If you sit on the inside . . .": Peter Crookston to PB, interview, June 1982.

257 "because he was so beautiful": Peter Crookston to PB, interview, Dec. 14, 1982.

257 "And, yes, I believed Diane . . .": Ibid.

258 "There was a curious improbability . . .": Marvin Israel, "Diane Arbus," *Infinity*, Nov. 1972.

258 "You were so gentle . . .": DA to Peter Crookston, letter, c. 1967.

259 "like most speed freaks did": Paul Salstrom to PB, phone interview, July 1, 1981.

259 "We had no plans": Paul Salstrom to PB, phone interview, July 1, 1981.

259 "a heavy-set woman . . .": Ibid.

260 "She kept gushing . . .": Clay Felker to PB, interview, Jan. 10, 1979.

261 "Silver was spacy . . .": Andy Warhol and Pat Hackett, *POPism: The Warhol '60s* (Harcourt Brace Jovanovich, 1980), pp. 64–65.

262 "because I hadn't been ashamed . . .": Barbara Goldsmith to PB, interview, Dec. 1, 1979.

262 "He just gets you . . .": Ibid.

262 "I'm not as mixed up . . .": Ibid.

263 "we all got stoned on hash . . .": Viva to PB, phone interview, Aug. 21, 1979.

263 "Diane rang the doorbell . . .": Ibid.

264 "I made a terrible mistake . . .": Clay Felker to PB, interview, Jan. 10, 1979.

264 "It is a cause célèbre": DA to Peter Crookston, letter, c. 1968.

264 "watershed pictures . . .": Tom Morgan to PB, interview, Sept. 6, 1979.

264 "Diane told me . . .": Renée Sparkia to PB, phone interview, Aug. 2, 1978.

265 "The parents seem . . .": Peter Crookston to PB, interview, June 1982.

265 "for what seemed like . . .": Basha Poindexter to PB, interview, April 13, 1983.

265 "would shoot up . . .": Sam Antupit to PB, interview, Jan. 11, 1979.

266 "I'm jealous of you, Shirley": Shirley Fingerhood to PB, interview, Feb. 24, 1981.

Chapter 30

267 "I wanted to buy her a new fridge . . .": Judith Mortenson to PB, interview, May 1981.

267 "Doon might fall in love with Dick . . .": Pat Peterson to PB, interview, Feb. 22, 1979. .

268 "And when I think . . .": Doon Arbus, "Diane Arbus, Photographer," *MS Magazine*, Oct. 1972.

268 "And Diane interceded for me . . .": May Eliot to PB, interview, Jan. 22, 1983.

268 "battered people for her to photograph": Saul Leiter to PB, interview, May 18, 1981.

269 "Diane pulled the prints . . .": Elsa Bulgari, "Steve Laurence Remebering Diane Arbus," *Fire Island News Magazine*, June 1980.

269 "Can you catch hepatitis?": Cheech McKensie to PB, interview, May 2, 1982.

269 "She looked wasted": Peter Crookston to PB, interview, May 24, 1980.

269 "toxic hepatitis . . .": Doctors' Hospital Medical Records, July 18, 1968.

269 "My husband is taking . . .": Irene Fay to PB, interview, June 21, 1981.

269 "Diane looked really awful . . .": Loring Eutemay to PB, interview, Feb. 1979.

270 "I always thought she . . .": Seymour Krim to PB, interview, May 14, 1981.

270 "She snapped me . . .": Ibid.

270 "She'd obviously learned a lot from Weegee . . .": Victor D'Amico to PB, interview, July 29, 1980.

271 "She told me how close . . .": May Eliot to PB, interview, Jan. 22, 1983.

271 "because she never told me . . .": Ibid.

272 "She offered . . .": Jill Freedman to PB, interview, Jan. 1982.

272 "so humid I felt . . .": Bill Jay, *Photographers Photographed*, Monograph (Smith: Utah, 1983), p. 32.

272 "She was small and slim . . .": Ibid.
272 "Now we can talk about photography . . .": Ibid.
273 "Diane ate nothing . . .": Lee Witkin to PB, interview, Nov. 19, 1981.
273 "I couldn't say why . . .": Bevan Davies to PB, interview, Nov. 24, 1981.
273 "I'd never seen her before . . .": Ibid.
274 "We never had any long discussions . . .": Lee Witkin to PB, interview, Nov. 18, 1981.
274 "Diane and I often talked about France . . .": John Putnam to PB, interview, July 20, 1980.
275 "aura of aloneness": Ibid.
276 "The situation is both real . . .": Ikko Narahara tapes of Diane Arbus Class 1970–71.
276 "no erotic pictures . . .": Neil Selkirk to PB, interview, Oct. 12, 1982.
276 "It was of a couple . . .": Harold Hayes to PB, interview, Aug. 18, 1978.
277 "a great many incorrect stories . . .": Neil Selkirk to PB, interview, Oct. 12, 1982.
277 "photograph a host of shoppers . . .": Carol Troy to PB, interview, June 10, 1981.
277 "I knew her brother . . .": Studs Terkel to PB, interview, Nov. 13, 1980.
278 "but she kept . . .": Ibid.
278 "My father was a kind of self-made man . . .": DA to Studs Terkel, interview, Dec. 1969.
278 "I always had governesses . . .": Ibid.
280 "How did the public experience . . .": Ibid.
280 "I was aware . . .": Ibid.
280 "I had never seen poverty . . .": Ibid.
280 "incredible stories . . .": Ibid.
280 "as well as Walker Evans . . .": Gene Thornton, "Narrative Works—and Arbus," *New York Times*, Aug. 31, 1980.
280 "You saw . . .": DA to Studs Terkel, interview, Dec. 1969.

Chapter 31

281 "She seemed to be . . .": Garry Winogrand to PB, interview, Nov. 10, 1981.
281 "funny": Shirley Fingerhood to PB, interview, Feb. 24, 1981.
282 "This Diane Arbus . . .": Irving Mansfield to PB, phone interview, Dec. 20, 1978.
282 "It was seen all over the world . . .": Ibid.
283 "Diane expected . . .": Shirley Fingerhood to PB, interview, Feb. 24, 1981.
283 "We always flew . . .": Margo Feiden to PB, interview, Jan. 26, 1982.
284 "then she chose Marvin.": Lisette Model to PB, interview, Feb. 6, 1979.
284 "Marvin Israel introduced us . . .": Nancy Grossman to PB, interview, May 27, 1980.
287 "After Sarraute got so nervous . . .": Dale McConathy to PB, interview, Nov. 14, 1979.
287 "Diane almost always . . .": Barbara Brown to PB, phone interview, March 9, 1980.
288 "I hardly recognized her . . .": Peter Crookston to PB, interview, Jan. 4, 1982.
288 "all my tears made it better . . .": DA to Peter Crookston, letter.
288 "for terminally ill patients . . .": Francis Wyndham to PB, letter, June 15, 1982.
289 "to spend the night . . .": Ibid.
289 "until we saw . . .": May Eliot to PB, interview, Jan. 22, 1983.
289 "What a lovely ring . . .": Jane Eliot to PB, interview, April 21, 1979.
290 "There were no more freaks . . .": John Putnam to PB, interview, July 17, 1980.
290 "as *all* artists are schizophrenic": Lisette Model to PB, interview, Feb. 6, 1979.
291 "nothing about her life . . .": A. D. Coleman, "The Mirror Is Broken," *Village Voice*, Aug. 5, 1978.
291 "very very boring": Peter Crookston to PB, interview, May 20, 1980.
291 "and without any prompting . . .": Gail Sheehy to PB, interview, May 8, 1980.

291 "She blew everybody's mind . . .": Stephen Frank tp PB, phone interview, May 26, 1981.

292 "It was Blow-Up time": Chris von Wangenheim to PB, interview, Dec. 8, 1980.

292 "I think Diane saw her shrink": John Putnam to PB, July 20, 1980.

293 "What no one realized . . .": Calvin Tompkins, *Off the Wall: Robert Rauschenberg and the Art World of Our Time* (Penguin, 1980), p. 281.

294 "novel in progress," *New York* Magazine, March 13, 1978, "The Strange Universe of Cosmos" by Tom Bentkowski.

294 "An ant farm . . .": DA to Peter Crookston, letter.

294 "Every artist . . .": Thalia Seltz to PB, phone interview, Dec. 1979.

294 "Everybody was into primal experience . . .": David Gillison to PB, phone interview, Dec. 1979.

294 "We'd discuss work and life . . .": Thalia Seltz to PB, phone interview, Dec. 1979.

295 "Diane was gentle . . .": Al Squilaco to PB, interview, Aug. 1980.

296 "I was going to be on the cover": Ti Grace Atkinson to PB, interview, June 20, 1980.

296 "Suddenly Diane asked me . . .": Ibid.

296 "The stories were heartbreaking": Ibid.

297 "I felt Diane was defensive . . .": Ibid.

297 "It was absolutely exhausting . . .": Ibid.

297 "We both wanted a picture of me . . .": Ibid.

298 *"everything was showing . . .":* Ibid.

298 "She seemed to be drowning . . .": Ibid.

298 "I'm a *photographer*": John Putnam to PB, interview, July 20, 1980.

299 "Diane began with the file . . .": Eugene Ferrera to PB, interview, April 1979.

300 "A lot of people . . .": Hiro to PB, interview, May 6, 1982.

300 "I had to read this review . . .": Richard Avedon to Connie Goldman, interview on National Public Radio, March 31, 1977.

300 "I told her I thought Marvin could . . .": T. Hartwell to PB, phone interview, Sept. 17, 1982.

300 "a glass dome and a swimming pool . . .": DA to Peter Crookston, letter.

301 "I am still collecting things . . .": DA, speech at American Society of Magazine Photographers when she accepted the Robert Levitt Award "for oustanding achievement," Sept. 1970.

301 "She was already a myth . . .": Susan Brockman to Anne Tucker in *The Woman's Eye*, selections from the work of Gertrude Kasbier, Diane Arbus and others, edited and with an introduction by Anne Tucker (Knopf, 1973).

301 "You couldn't forget those startling pictures . . .": Mark Haven to PB, interview, July 22, 1982.

301 "Diane's pictures appealed to the mind . . .": Jerry Ulesmann to PB, phone interview, Sept. 1981.

301 "The room was overcrowded": Mary Ellen Andrews to PB, interview, Dec. 1, 1978.

301 "Nobody's going to love your pictures . . .": Susan Brockman, interview on radio station WRVR, Fall 1972.

302 "The class was not simply about photography . . .": Anne Tucker to PB, phone interview, Dec. 11, 1981.

302 "It was very significant . . .": Neil Selkirk, interview on radio station WRVR, Fall 1972.

302 "Diane wanted us to tell . . .": Anne Tucker to PB, phone interview, Dec 11, 1981

302 "I was walking up the aisle . . .": Ibid.

302 "Diane was a little taken aback . . .": Eva Rubinstein to PB, interview, Sept. 12, 1982.

303 "Okay—let's do it right now . . .": Diana Edkins to PB, interview, March 20, 1979.

304 "And Cerf presented his face . . .": Suzanne Mantell to PB, interview, Dec. 5, 1978.

304 "like they had lightbulbs . . .": Ikko Narahara, tapes of Diane Arbus Class 1970–71.

304 "an adventure": Eva Rubinstein to PB, interview, Sept. 12, 1982.

304 "Choosing a project . . .": Ibid.

304 "photograph something real . . .": Suzanne Mantell to PB, interview, Dec. 5, 1978.

305 "I've never taken a picture . . .": Mary Ellen Andrews to PB, interview, Dec. 1, 1978.

305 "a photographer has to be . . .": Mark Haven to PB, interview, July 22, 1982.

305 "whom you get confused . . .": Suzanne Mantell to PB, interview, Dec. 5, 1978.

305 "I can tell you a picture . . .": Ibid.

305 "in great spirits": Anne Tucker to PB, phone interview.

305 "It's about live": Peter Crookston to PB, interview, Dec. 1982.

306 "was extremely serious . . .": *Life Library of Photography: The Art of Photography—Responding to the Subject*, p. 110.

306 "Diane was obviously very moved . . .": T. Hartwell to PB, phone interview, Sept. 17, 1982.

307 "Brassaï taught me something . . .": Ikko Narahara tapes of Diane Arbus Class 1970–71.

307 "What is it? . . .": Ruth Ansel to PB, interview, Aug. 1978.

Chapter 32

309 "because Shelley didn't seem . . .": Thalia Seltz to PB, interview, c. 1979.

309 "easy jobs . . .": Sam Antupit to PB, interview, Jan. 11, 1979.

309 "The press tent . . .": DA to Peter Crookston letter.

310 "What did I write?": Alex Eliot to PB, interview, July 20, 1980.

310 "Not childhood . . .": Alex Eliot, *Zen Edge* (Seabury Press, 1979), p. 67.

311 "Arbus was a central and crucial figure . . .": Walter Hopps to PB, phone interview, July 8, 1981.

311 "Her name was rapidly acquiring . . .": Hilton Kramer, *New York Times*, Aug. 5, 1972.

312 "a Wall Street banker type . . .": Peter Beard to PB, interview, Nov. 22, 1982.

312 "Once I dreamed . . .": *Art News*, May 1971.

313 "There are two kinds of nudist camps": Jerry Leibling to PB, phone interview, Aug. 1981.

313 "Everything was confrontational . . .": Ibid.

314 "a rosepetal-soft . . .": Germaine Greer to PB, interview, Oct. 25, 1979.

315 "I said I would buy . . .": Tina Fredericks to PB, interview, June 1980.

315 "She made me put on . . .": Devon Fredericks to PB, interview, June 1980.

315 "I didn't believe her . . .": Larry Shainberg to PB, interview, Sept. 29, 1982.

316 "I'd fallen in love with the darkroom . . .": Marge Neikrug to PB, interview, Dec. 3, 1981.

316 "Mommy, Mommy . . .": Gertrude Nemerov to PB, interview, July 22, 1978.

316 "Can't you find anyone . . .": John Gossage to PB, interview, May 24, 1981.

317 "The beautiful glass box . . .": Lee Witkin to PB, interview, Nov. 17, 1981.

317 "In poetry the art itself . . .": Howard Nemerov to PB, interview, July 20, 1978.

318 "Howard Nemerov is a minor poet . . .": Bernard Malamud to PB, interview, March 5, 1980.

318 "Diane seemed in a very good mood . . .": Howard Nemerov to PB, interview, July 20, 1978.

318 "she was terribly alone . . .": Ibid.

318 "She arrived Sunday afternoon . . .": Nancy Grossman to PB, interview, March 27, 1980.

320 "Suddenly, for no reason . . .": Shirley Clarke to PB, phone interview, Sept. 1980.

320 "She was carrying a flag . . .": Walter Silver to PB, interview, Oct. 23, 1981.

320 "acute barbiturate poisoning": Dr. Michael Baden to PB, interview, May 14, 1979.

321 "Oh, I wish I could be an artist like Diane!": Frederick Eberstadt to PB, interview, Feb. 5, 1979.

322 "To D——Dead by Her Own Hand": *The Collected Poems of Howard Nemerov* (University of Chicago Press, 1977), p. 431.

Note: Information about Arbus' death was provided by A. D. Coleman, "The Mirror Is Broken," *Village Voice*, Aug. 5, 1971; *New York Times* death notice, Aug 1, 1971; *Notable American Women*, ed. Barbara Sicherman and Carol Green (Harvard University Press, 1980), p. 30. Assistance and information was also provided by Howard Nemerov, David Gilliam, Renée Sparkia, John Putnam, Linda Amster, Peter Cott, and Larry Shainberg.

Index

Abbott, Berenice, 67, 129, 209, 231
Abel, Lionel, 91
Abrahams, Billy, 44
Abstract Expressionism, 100, 144–5
Adams, Ansel, 126, 128 *n.*
Adelman, Bob, 224, 237
Adler, Felix, 16
Adler, Renata, 294
Agee, James, 76, 209
Aisen, Kathy, 207
Albers, Joseph, 169
Alberto Alberta, 166
Alice in Wonderland (Carroll), 15, 29–30, 219
Amazing Randi, 165, 167–8
American Legion, 275
Americans, The (Frank), 141, 143, 145, 247
American Society of Magazine Photographers, 274, 301
Amram, David, 144
Andrews, Mary Ellen, 301, 303
Angleton, James, 44
Ansel, Ruth, 203, 219, 243, 307, 309, 321
Antonio, Emile de, 140, 158, 161–3, 166, 183, 202, 205, 207, 222–3, 242, 246, 247
Antupit, Sam, 265, 309
Aperture, 127, 232
Apollo Theater, 162, 168, 238
Arbus, Allan, 33–4, 38, 39–40, 43–6; acting career of, 158, 281, 310; in acting class, 151–2; clarinet playing by, 34, 55, 68, 74, 78, 108, 116, 150; continues to support Diane after separation, 160, 264, 281; at Diane's funeral, 321; dreams of becoming an actor, 33–4, 68, 74, 116; as fashion photographer, *see* Arbus studio; marriage of Diane and, *see* Arbus, Diane; marriage of Mariclare Costello and, 245, 281, 284; meets Benny Goodman, 151; in mime class, 121, 136; moves to California, 281; painting of, by Diane, 40, 42; in photographers' unit, in World War II, 57, 58; photographic technique of, 115, 270; photographs of Diane by, 40, 67, 103; in *Pull My Daisy*, 144
Arbus, Amy: birth of, 106–7; childhood of, 135, 139, 150, 159–60, 164, 165, 167, 202, 217, 219, 223; in Jamaica, 244, 245; as photographer, 167; photographs of, 116, 132, 146–7, 219; teen-age years of, 267, 275, 295, 302, 310, 313, 316, 321
Arbus, Bertha, 8, 33, 71
Arbus, Diane
 CHILDHOOD AND ADOLESCENCE
 artistic talent, 16, 23, 31–3, 42, 50, 51, 130, 271; birth, 9; depressions, 48, 51–2; dress and appearance, 39; education, 13, 16–17, 23–4, 29–32, 40, 49–52, 130, 267; favorite books, 15, 29–30, 219; fearfulness, 17, 23, 24; feelings of separateness, 12, 23; French nanny, 9–10, 12, 17, 274, 287, 314; friendship with Phyllis Carton, *see* Carton, Phyllis; friendships and cliques, 24, 28, 31, 34, 49; homes and family life, 9–10, 17–19, 23, 50; as "Jewish princess," 19–20; in love with Allan Arbus, 34–5, 38–40, 43–6, 49–51; relationship with brother, 12–14, 15–16, 22, 24, 39, 45; relationship with Alex Eliot, 41–8, 51, 53, 54; relationship with father, 12, 16–17, 27, 32–3, 50–1, 278; relationship with mother, 9, 10–11, 15, 25, 35–8, 43, 54; relationship with sister, 15–16, 23;

Arbus, Diane

 CHILDHOOD AND ADOLESENCE (*cont.*)
Russeks, family involvement with, 11, 33, 38, 45–6; sense of unreality, 20, 30, 279; sexuality, 34–5, 50; summer experiences, 12–13, 27–8, 40–4, 314; teen-age autobiography, 9, 17, 24, 27, 28, 49; wedding, 53–4

 MARRIED LIFE
apartments and studios, 55, 68, 73, 107, 135, 157–8; daughter (Amy), birth of, 106–7; daughter (Doon), birth and infancy of, 59, 61, 62–3; daughters (Doon and Amy), relationship with, 82, 102–3, 135–6, 149; depressions, 74, 99, 117–18, 120, 122; dress and appearance, 62, 86, 139; family income, 56, 60, 71, 86, 89; friendship with Tina Fredericks, *see* Fredericks, Tina; friendship with Cheech McKensie, *see* McKensie, Cheech; goddaughter, *see* Eliot, May; homemaking, attitude toward, 56, 81–2, 101, 122, 133, 147–8; interest in art and literature, 74, 78, 100; interest in writing, 89, 137; lack of self-confidence, 75; living arrangements during World War II, 57–60; marital relationship, 73–4, 93–4, 98, 102, 147, 152–4; Nemerov family gatherings, 86–8, 92–3, 108, 118; parties and social activities, 84–5, 100, 111–12, 138–9, 145–6, 150, 158; relationship with brother, *see* Nemerov, Howard; relationship with Alex and Anne Eliot, 55–6, 59, 61, 68, 75–6, 81–5, 96; relationship with Alex and Jane Eliot, 97–9, 100, 103–7, 112, 114, 121–2, 150–1; relationship with father, 86, 89, 103, 138; relationship with mother, 58, 61, 106, 118, 131, 159; relationship with sister, 58–9, 88–9, 93–4, 117, 118, 119; sexuality, 59, 94, 147; summer homes, 81, 92, 99, 146; travels in Europe, 103–6

 PERSONAL LIFE, AFTER 1959
apartment at Charles Street, 158; apartment at East 10th Street, 267; apartment at Westbeth, 293–5, 309, 320–1; danger and risk-taking, attitude toward, 218, 257; daughters (Doon and Amy), relationship with, 159–60, 173, 186, 187, 202, 216, 223, 256, 267–8; depressions, 185, 211, 249–50, 268, 286, 290, 311, 312, 318–19; dress and appearance, 173, 210, 234, 245, 265, 288; estrangement and separation from Allan Arbus, 157–9, 171, 180, 185, 201–3; fears, overcoming of, 131, 205, 256; forty-fifth birthday, 265; friendship with Richard Avedon, *see* Avedon, Richard; friendship with Marvin Israel, *see* Israel, Marvin; friendship with Lisette Model, *see* Model, Lisette; illness (hepatitis), 239, 268, 269, 281, 283; increasing loneliness, 275; interest in literature, 178, 196–7, 211, 274; interest in sexual role changes and pornography, 250; love of flying, 283; memories of childhood, 222, 278–9; money problems, 159–60, 236, 258, 281; photographs taken of, 246, 249, 252, 293, 302–3, 313; relationship with Allan, after separation, 244, 245, 246, 269, 271, 281, 283, 284, 286–7, 310; relationship with brother, *see* Nemerov, Howard; relationship with Alex and Jane Eliot, 203, 246, 268, 289–90, 310; relationship with father, 187–8, 212–15; relationship with mother, 184, 185–6, 242, 265, 279, 316, 318; relationship with sister, 185, 201, 213, 215; sexual relationships, 205–7, 256–7, 290–1, 319; suicide, attitude toward, 200, 219–20, 309, 315–16; telephone conversations with friends, 275, 310, 316; Terkel interview, 277–80; therapy, for depression, 286, 292, 293, 311

 PHOTOGRAPHY CAREER
achievement award, 301; association with Robert Frank and Louis Faurer, 114, 124, 141; attitude toward earning money, 160, 198, 264, 279, 287; camera worn at all times, 116, 132, 241; cameras, 67, 187, 196, 223, 255, 299, 300–1; collaboration with Allan Arbus in fashion photography, *see* Arbus studio; cross-country bus trip, 218–19; darkroom development, 67, 132, 151, 237, 270, 306; dislike of fashion business, 86, 111, 119; distinctive qualities of photographic work, 227–8, 240, 275; early student photographs, 67; exploring "forbidden" subject matter, 130–1, 212, 250; gallery exhibits, 273, 274,

280, 298; Guggenheim projects, 213, 218, 236, 258; influence on photographers, 247, 275, 301; interest in history of photography, 123–4, 230; interest in news photography, 238, 299, 308; interest in painting, 100, 133–4; lack of self-confidence, 281–2; lectures, 286; London trip for *Nova*, 288–90; magazine assignments, 160, 208, 252, 287, 298; museum exhibits, *see* Museum of Modern Art; museum exhibits, public reaction to, 234–5, 247, 249; relationship with photographic subjects, 223, 224, 227, 248, 250; reputation with magazine art directors, 237; reputation as "photographer of freaks," 272, 311; teachers (Abbott, Brodovitch, Model), 67, 122–3, 129–34; teaching and students, 237, 291–2, 301–5, 307, 311, 313, 319; technical effects, 132, 235, 270, 306; technique imitated, 247, 255; unpublished portfolio of prints, 306; as woman photographer, 208, 298

Arbus, Doon: birth of, 59, 61, 62–3; childhood of, 74, 81, 82, 83, 102–3, 105, 131, 135, 136, 139; Anthony Perkins and, 149–50; photographs of, 103, 116; teen-age life of, 159, 165, 173, 185, 202, 213, 216, 217, 223; work and independent life of, 178 *n.*, 238, 256, 267–8, 271, 275, 285, 295, 310, 316, 320, 321

Arbus, Edith, 54

Arbus, Harry, 33, 54

Arbus, Lureen, 33

Arbus, Rose Goldberg, 33

Arbus studio (partnership of Allan and Diane), 68, 69–73, 86, 100, 111–12, 114–15, 119; continued after partnership ends, 121, 136, 152, 158; Diane as stylist, 108, 120–1; East 63rd Street studio, 135; East 72nd Street studio, 107; Greenwich Village studio, 157, 158

Arnold, Eve, 208

Art Forum, 311

Astaire, Fred, 190

Atkinson, Ti Grace, 295–8

Atlantic City, 230

Auden, W. H., 137, 237

Avedon, Richard, 20, 69, 115, 122, 188–93; Doon Arbus and, 267–8, 320;

books by, 228–9; exhibits of work by, 300; friendship of Diane Arbus and, 189, 190, 215, 229, 236, 268, 276, 282, 285–6, 287, 295, 299, 307, 310; at funeral, 321; Hiro and, 188, 198, 299; Marvin Israel and, 228, 242, 255; Lisette Model and, 231; at museum shows, 246, 305; owns Arbus portfolio, 306 *n.*; photographs of Viva by, 262, 263; projects trip to Vietnam, 265; seminars of, 253; successful financially, 175, 287

Baden, Dr. Michael, 320

bag ladies, 168

Bailey, F. Lee, 282

Baldwin, James, 228

Balzac, Honoré de, 123

Barr, Alfred, 32

Bassman, Lillian, 70

Beard, Peter, 312

Beck, Julian, 216, 259

Belit, Ben, 91

Bellamy, Richard, 99–100, 141, 144, 223

Bellevue, 173, 175

Bellocq, E. J., 130 *n.*, 211

Bellow, Saul, 88

Bennington College, 91, 136–7

Benton, Robert, 172, 173, 175, 198–9, 199–200; 202

Benton, Sally, 175, 199

Berg, Nancy, 112

Bergdorf Goodman, 7, 138

Berlin, Richard, 262

Bernikow, Louise, 43

Bernstein, Leonard, 246

Berryman, John, 137

Black, Algernon, 29, 246

Blake, William, 137

Blesh, Rudi, 127

blind people, 164, 275, 287

Bloomgarden, Kermit, 139

Blumenfeld, Erwin, 68

bondage houses, 311–12

Bonwit Teller, 70, 71, 110, 114, 138

Borges, Jorge Luis, 197, 275, 287

Boshung, Polly, 179, 182

Bourke-White, Margaret, 113, 208, 240

Brady, Mathew, 123, 173

Brandt, Bill, 122, 183, 307

Brassaï, Gyula Halasz, 122, 130 *n.*, 177, 183, 238, 307

Brockman, Susan, 301–2

Broday, Shelley, 309
Brodovitch, Alexey, 115, 122–3, 126–7, 128, 169
Brown, Barbara, 132, 287
Brown, James, 238–9
Brown, Robert, 136, 138–9, 146
Brown, Spencer, 52
Browning, Tod, 162
Brownmiller, Susan, 239
Bruhn, Erik, 237
Bunnell, Peter, 128 *n.*, 132, 247
Burke, Kenneth, 218, 317
Burroughs, William, 141, 229
Bush, Marcie, 199

Cage, John, 161
Calisher, Hortense, 305
Callahan, Sean, 273
Calley, John, 276, 282
Calvin Klein advertisements, 267–8, 304
cameras, 67, 143, 187, 196, 223, 255, 299
Cameron, Julia, 123, 237
Camp Arden, 28
Campbell, Winnie, 102, 108
Canfield, Cass, 209
Capa, Cornell, 229, 316
Capa, Robert, 128 *n.*
Capote, Truman, 173, 191, 225, 228 *n.*
Carmel, Eddie, 193–4, 246, 311
Carmichael, Stokely, 253
Carroll, Lewis, 219
Cartier-Bresson, Henri, 87, 114, 128 *n.*, 142, 229, 238, 240
Carton, Phyllis, 27, 30–1, 32, 49–50, 51, 54, 56, 89; adventures of Diane and, 130, 149; cards sent to, 218, 246
Cather, Willa, 74
Cato, Bob, 113, 231, 243
Céline, 169
Central Park, 287–8; Diane Arbus' childhood memories of, 10, 12, 15, 17, 23, 46, 278; Diane's children in, 62, 102, 135; 1960s events in, 252, 253, 265; photographs taken in, 15, 40, 72, 113, 114, 132, 249, 273
Cerf, Bennett, 304
Chaplin, Charlie, 192
Cheever, John, 173
Chekhov, Anton, 151, 158
Chicago riots (1968), 274, 275
children, photographs of, 15, 116, 132, 196, 219, 244–5, 277
Children in Photography, 147

Christ, Miss, 18
Christie, Julie, 285
Circle in the Square, 136
circus photographs, 165–6
Clarke, Shirley, 146, 320
Cleage, Albert, 305
Cleaver, Diane, 242
Cocksucker Blues, 144
Cohen, Marvin, 167, 216
Colliers, 160
Columbo, Joe, 198
Condé Nast, 71–2, 101, 114, 136, 252, 303
Coney Island, 79, 125, 126, 131, 166, 197, 223, 238, 284
Congo the Jungle Creep, 167–8, 239
Cook, Ethel, 41, 43
Cooper, Anderson Hays, 252
Cooper Union, 291
Corcoran Gallery, 311
Cornell, Joseph, 249
Cosmos, 294
Costello, Mariclare, 245, 276, 281, 284, 321
Crawford, Joan, 35, 173
Crookston, Peter, 255–8, 264, 288, 307; correspondence with, 265, 269, 277, 281, 294, 299, 300, 309–10
Cubism, 100, 270–1
Cummings, Nate, 26, 159
Cummington School of the Arts, 40–1, 43
Cunningham, Imogen, 127
Cunningham, Merce, 294

Dahl-Wolf, Louise, 68, 128, 208
Dali, Salvador, 76, 189
Dalton School, 58
D'Amico, Victor, 23, 32, 40, 50, 51, 271, 316–17
Dane, Bill, 304
DAR, 173, 175
Davidson, Bruce, 143, 216, 229–31, 236, 298–9
Davies, Bevan, 273–4
Davis, Bette, 102
Day, Doris, 102
Deal, N. J., 27
De Carava, Roy, 113
Decroux, Etienne, 121
de Kooning, Elaine, 145
de Kooning, Willem, 78, 100, 141, 144, 145, 293

De Larverie, Stormé, 162–3, 182, 183
Denhoff, Miki, 72
Deren, Maya, 146, 158
de Rochemont, Louis, 55
Dewhurst, Colleen, 152
Dial Press, 270
Dick, Anne, *see* Eliot, Anne Dick
Dick, Evans, 47; estate of, 59
Dick, Liberty, 55, 56, 83
Dickey, James, 184, 220
Dickinson, Emily, 74
Dickinson, Flora Knapp, 175
Dick's Folly, 75
Dine, Jim, 223, 305
Dinesen, Isak, 188, 302
Dom, 253–4
Dorso, Betty, 70–1, 73
Dovima, 115
Downey, Robert, 310
Dracula, Jack, 166, 174
drag queens, photographs of, 226–7
Drexler, Rosalyn, 146
Dundy, Elaine, 27
dwarfs and giant, photographs of, 193–4

Eberstadt, Ferdinand, 116
Eberstadt, Frederick, 11, 94, 116, 179, 206, 224, 225, 321
Eberstadt, Isabel, 116, 217, 225
Eberstadt, Nena, 116
Eberstadt, Nick, 116
eccentrics, 178–80, 181–4
Edkins, Diana, 303
Edwards, Owen, 123, 242
Eisenhower, Dwight D., 190, 228, 307
Eisenman, Alvin, 57–8
Eisenman, Hope, 57–8
Eisenstaedt, Alfred, 114, 238
Eliot, Alexander, 41–6; married to Anne Dick, 47–8, 51, 53, 54, 55–6, 58, 59, 61, 67–8, 74–6, 78, 79, 81–5, 94–5; Howard Nemerov and, 44, 91, 92; remarried to Jane Winslow, 96–100, 103–7, 112, 114, 121–2, 150–1; reviews David Nemerov's paintings, 159; travels on Guggenheim project, 151, 246, 268, 289–90, 310
Eliot, Anne Dick, 47–8, 54, 55–6, 59, 67–8, 75–6, 81–4, 95–8
Eliot, Charles W., 41

Eliot, Jane Winslow, 96–9, 103–4, 106, 107, 121, 122, 135, 151, 289–90, 310; Arbus photographs of, 97, 114
Eliot, May, 59, 73; Diane Arbus as godmother to, 74, 75, 81, 83, 96, 103, 107, 114, 131; in later years, 202, 268, 271, 289, 310
Eliot, Sam, Jr., 41, 43, 310
Eliot, T. S., 44, 137
Elkin, Stanley, 317
Ellis, Anita, 144
Empire State Building, 215
Erwitt, Elliott, 114, 128 *n.*
Esquire, 171, 202, 223, 233, 255, 260; Arbus photographs for, 172–5, 177, 181–2, 198–9, 225, 252, 280, 282
Essence, 305
Ethical Culture, 16; School, 16–17, 23–4, 29, 130; settlement house, 30
Eutemay, Loring, 145, 269
Eva (Nemerov family cook), 9, 10
Evans, Isabelle, 209, 210
Evans, Walker, 76, 126, 128, 141–2, 143, 178; Diane Arbus and, 208–12, 213, 227, 239, 246, 280, 298, 305, 311
Evslin, Dorothy, 5, 18, 19, 38, 40, 53, 184
"Exasperated Boy with Toy Hand Grenade," 15, 196, 304–5

"Family Album," 87, 233
"Family of Man, The," 113–14, 129, 240
Farrow, Mia, 225, 270
fashion photography, postwar, 68–9
Faurer, Louis, 70, 114, 124, 128 *n.*, 142, 208, 262
Fay, Irene, 246, 269, 286
Federigo, or the Power of Love (Nemerov), 137
Feeley, Paul, 317
Feiden, Margot, 283
Feitler, Bea, 203–4, 205, 219, 242, 243, 254, 307, 309, 320, 321; has received private Arbus' work, 204, 306 *n.*
Felker, Clay, 172, 173, 200, 260–1, 263, 264
Fellini, Federico, 191
feminist movement, 295–6
Fernandez, Ben, 21, 170, 215, 237
Ferrara, Eugene, 299
Fieldston School, 9, 13, 29, 31–2, 38, 40; Diane Arbus' senior year at, 49–52; Diane's sister at, 58

Fingerhood, Shirley, 49, 170, 180, 265–6, 281, 283
Fink, Abby, 179
Fink, Larry, 130, 231
Fischer, Carl, 255
Fisher, Stanley, 276
Fizdale, Bobby, 246
Flannigan, Michael, 237
Flatland, 140
Flaubert, Gustave, 211
Fonda, Henry, 188
Fonda, Jane, 184
Fonssagrives, Ferdinand, 71
Ford, Eileen, 69
Forscher, Marty, 255
Forst, Barbara, 141, 145, 147, 180, 246
Forst, Miles, 141, 147, 180
Fortune, 142, 208, 209
Fox, I. F., 7, 110
Frank, Andrea, 141
Frank, Mary, 141–2, 144, 145, 146–7, 180, 246, 254, 293, 295, 298
Frank, Pablo, 141
Frank, Robert, 70, 114, 124, 128, 160, 191, 247; Diane Arbus and, 141–6, 180, 207, 208, 228, 239, 246, 254, 298; Evans and, 209, 212; films by, 144, 161; photograph of, 303
Frank, Stephen, 291–2
Frankenthaler, Helen, 144
Frazier, Brenda, 225
Frazier, Katherine, 41, 43
freaks, 30, 31, 166–8, 170, 194, 239
Freaks (movie), 162, 168
Fredericks, Devon, 315
Fredericks, Rick, 73, 74, 99, 104, 115, 180
Fredericks, Tina, 71; at *Glamour*, 72–3, 82, 87, 99, 101, 102, 104, 106, 107, 112, 138, 140, 157, 158; at *Ladies' Home Journal*, 160–1, 169, 180, 202; on Long Island, 208, 250, 300, 307, 315, 316
Freed, Arthur, 143
Freed, Judy, 27
Freedman, Jill, 272
Friedan, Betty, 295
Friedlander, Lee, 143, 211, 234, 240, 247, 298, 313
Frissell, Toni, 208
Frost, Robert, 137, 317
"Full Circle, The," 182–3
Furioso, 44, 89

Gangler's, 165
Garland, Judy, 261
Garth, Dave, 204
Garth, Heije, 204
Gass, William, 317
Gatch, Dr. Donald E., 280
Gee, Helen, 128 *n.*
Geldzahler, Henry, 246, 293
Geller, Uri, 165
General Electric Co., 111
Gibson, Ralph, 304
Gill, Frances, 70, 101, 102, 104
Gill, Leslie, 104
Gillison, David, 294
Gimbel's, 7
Gingrich, Arnold, 172
Ginsberg, Allen, 141, 144, 220, 229, 300, 317
"Girl in the Watch Plaid Cap," 237
Gish, Dorothy and Lillian, 237, 255
Glamour, 72, 86, 100–1, 111, 112, 119, 136, 202; interview in, 102
Glaser, Milton, 263
Glazer, Alice, 223
Gold, Arthur, 246
Gold, Jay, 145, 242, 269
Goldberg, Jenny, 33
Goldberg, Rose, 33
Goldman, Connie, 300
Goldsmith, Barbara, 260, 261, 262, 263
Goodman, Andrew, 7, 53, 110
Goodman, Benny, 34, 151
Gorman, Cliff, 305
Gossage, John, 193, 194, 229, 236, 249, 312, 316
Gottlieb, Mort, 100
Gould, Joe, 176
Goya, Francisco de, 100
Graham, Susan, 144
Grant's, 166
Graves, Robert, 99
Greaser's Palace, 310
Greco, El, 104, 105, 152
Greene, Milton, 112
Greenfield, Pati, 200
Green Gallery, 99, 223
Greer, Germaine, 314–15
Gregory, Walter, 175
Greyhound Bus Company, 111
Grimes, Tammy, 139
Grossman, Nancy, 284–5, 298, 307, 312, 318–19
Grosz, George, 33
Gruen, John, 225, 235

Gunn, Thom, 184
Gutman, Walter, 144

Hall, Kenneth, 174
Hall-Duncan, Nancy, 115
Halma, Harold, 69
Halsman, Philippe, 113, 263
Hampshire College, 313, 319
Hansa gallery, 144
Happenings, 147, 224
Harnett, Sunny, 115
Harper's, 282 and *n.*
Harper's Bazaar, 69, 114–15, 122, 126–7,
 142, 143, 160, 182, 191; Arbus
 photographs in, 137, 146, 182–4, 219,
 225, 237, 241, 252–3, 255, 260–1, 270,
 271, 287; assignments for, 203, 242–3,
 252, 309; Avedon's assignments for,
 188, 190, 191; Munkacsi in, 189
Harriman, Averell, 135
Harrington, Michael, 235
Hart, Cathy, 174
Hartigan, Grace, 100, 113
Hartwell, T., 192, 300, 306
Harvard University, 44, 52, 317
Haven, Mark, 225, 301, 307–8
Hayden, Tom, 285
Hayes, Harold, 172–3, 175, 181–2, 200,
 214, 223, 246, 255, 276, 307, 309
Healy, Fran, 111
Heckler, Leroy, 166, 177
Hemingway, Ernest, 220
Henri Bendel, 7, 138, 210, 246, 277
Henry, Buck, 276
Hepburn, Katharine, 102
Hess, Tom, 246
Hesse, Eve, 298
Heyman, Ken, 114
Hill, Pati, 78, 84, 106, 116, 146, 246, 275,
 316; novel by, 202
Himmel, Paul, 70
Hine, Lewis, 123, 274
Hiro, 123, 188, 198, 223, 299–300, 301
Hitler, Adolf, 148, 228
Hoffman, Abby, 229, 285
Holiday, 160
Hollywood, 105, 198
Homecoming Game, The (Nemerov), 184,
 194
Homer, 275
Hopps, Walter, 311
Horowitz, Philip, 33
Horst, Horst P., 69

Howell, Chauncey, 247
Hubert's Freak Museum, 166–8, 194,
 218, 239
Hudson Guild Farm, 52
Hughes, Dell, 68
Hughes, Jim, 235
Hughes, Langston, 127
Hughes, Robert, 247
Hujar, Peter, 255
Hutsinger, Paula, 237
Hyman, Dick, 211
Hyman, Stanley Edgar, 137, 176, 220,
 317

I. J. Fox, 7, 110
Image and the Law, The (Nemerov), 90
Impelliteri, Vincent, 107
Impressionism, 100
Infinity, 183, 255
Ingrid Superstar, 262
International Center of Photography,
 313
International Housing Show, 119
Isles, Jill, 135
Israel, Margie, 145, 169, 203, 283–4
Israel, Marvin, 145, 169–71, 178 *n.;* as
 Art Director of *Harper's Bazaar*, 182,
 183–4, 203; assists Arbus' career, 192–
 3, 208–10, 218, 219, 237, 242–3, 246,
 268, 269, 275, 301, 306, 317; Avedon
 and, 188, 190, 191, 228, 242, 255, 300;
 Diane's dependence on, 202–3, 207,
 242, 245, 254, 295; Diane's depression
 and, 268, 282–4, 286, 318; finds Diane
 dead, 320; hears Diane's stories, 195,
 258; Lisette Model and, 232; at
 museum exhibits, 246, 305;
 photograph of, 241–2; sculpture by,
 313

Jackson, Shirley, 220
Jacobs, Jane, 198
Jamaica, 244–5
James, Charles, 112
James, Henry, 73
Janis, Sidney, 128
Javits, Marian, 261
Jay, Bill, 272–3, 276
Jay Thorpe, 138
Jeffers, Robinson, 220
Jelke, Mickey, 108

"Jewish Giant" (Eddie Carmel), 193–4, 246, 311
John Robert Powers agency, 113
Johns, Jasper, 161, 205, 293, 306 *n.*
Johnson, Buffie, 145
Jonestown massacre, 264
Joplin, Janis, 285
Journal of the Fictive Life (Nemerov), 220–2
Joyce, James, 67, 163, 178
Judy Bond Inc., 112
jugglers, photographs of, 165
Jules et Jim, 97
Jung, Carl Gustav, 74
J. Walter Thompson Co., 111

Kafka, Franz, 74, 178, 196, 211
Kandinsky, Wassily, 320
Kane, Art, 71, 111, 113, 122
Kanelos, Laura, 190
Keller, Helen, 275
Kelly, Roz, 246
Kennedy, Ethel, 271
Kennedy, Jacqueline, 271
Kennedy, John F., 161, 182, 218, 228
Keristas, 235
Kerouac, Jack, 142, 143, 144
Kerr, Joel, 199
Kertesz, Elizabeth, 126, 229
Khrushchev, Nikita, 148
King, Coretta, 271
King, Martin Luther, 253, 265
Kinski, Nastassia, 189
Kirstein, Lincoln, 209
Kline, Franz, 144–5
Kornbleè, Jill, 62
Kosloff, Max, 247
Kramer, Hilton, 311
Krim, Seymour, 269–70
Kronhausen, Eberhard and Phyllis, 277
Kubrick, Stanley, 100, 255
Kummel, Jess, 157

Ladies Home Journal, 102, 160
Laing, R. R., 277
Lamb, Barbara, 70
Lambert, Eleanor, 7
Lamkin, Marguerite, 100
Landars, Max Maxwell, 182
Lange, Dorothea, 114, 127, 237, 240
Lartigue, Jacques Henri, 230
Laurence, Steve, 268–9

Lax, Bob, 76
Lee, Sondra, 145
Leigh, Dorian, 69, 70
Leiter, Saul, 247, 268
Lenrow, Elbert, 16, 49, 51–2, 91, 138, 246, 317
LeShan, Eda, 38, 49
Leslie, Alfred, 144
Leslie, Esta, 158
Levant, Oscar, 191
Levitt, Helen, 114, 209
Levitt, Robert, 301
Levy, Alan, 196–7
Lewis, John L., 229
Liberman, Alexander, 72, 104
Lichtenstein, Ben, 7, 8, 33, 34, 35, 56, 59, 69; gives camera to Diane, 67
Liebling, Jerome, 113, 128 *n.*, 313
Life, 111, 113, 142, 143, 145, 160, 252, 314
Limelight Café, 128, 208
Lindner, Richard, 241, 250
Linquist, Roy, 223
Living Theatre, 216, 258–9
Lloyd, Kate, 101–2
Loew, Arthur, 19
London *Sunday Times*, 255, 258, 270, 282, 288, 295, 296, 309
Look, 100, 111, 126, 160, 224, 252
"love objects," photographs of, 25, 306 *n.*
Lowell, Robert, 47, 75, 233, 317
Lower East Side, 30, 130, 235
Lucas, Charlie, 239
Luna, Donyale, 285
Lunn, Harry, 277
Lyman, Mel, 309
Lynes, George Platt, 70
Lyon, Danny, 143
Lyons, Leonard, 160

MacGraw, Ali, 157
Machado, China, 115, 191
Mack, William, 181
MacLeish, Archibald, 40, 44
Macy's, 7, 110
Madame Tussaud's wax museum, 289, 290
magazine photography, 160
Magid, Marion, 248
Magnum Photos Inc., 229
Mailer, Norman, 52, 142, 172, 236, 314; photographs of, 212, 227

Malamud, Bernard, 91, 137, 317–18
Malina, Judith, 216, 259
"Mamselle" (French nanny), 9–10, 12, 17, 274, 287, 314
Manashaw, Jerry, 110
"Man in Hair Curlers," 227, 247
Mansfield, Irving, 282
Mansfield, Jayne, 198, 199
Manship, Paul, 107
Manson, Charles, 292
Mantell, Suzanne, 302, 303
Mark Cross, 110
Marlborough Gallery, 300
Marlowe, Mickey, 174
Martha's Vineyard, 81
Martin, Mary, 188
Marx, Richard, 132, 150, 178
Matisse, Henri, 95, 104, 105
Maugham, Somerset, 70, 188
Max's Kansas City, 254, 262
Maxwell House advertisements, 111
Mayer, Grace, 239, 246
McCall's, 102
McCardell, Claire, 69
McCarlson, Carole, 69
McCarthy, Eugene, 270
McCarthy, Joseph, 222
McCombe, Leonard, 113
McConathy, Dale, 178, 191, 287
McCullers, Carson, 191
McDarrah, Fred, 252
McKensie, Cheech (pseudonym), 77–80, 94, 99, 106, 119–20, 132, 133, 141, 146, 150, 153–4, 158, 169, 170–1; marriage of, 180; photograph of, 114; present from Diane to, 139–40; telephone call to, 269
McWeeney, Alen, 193
Me and My Brother, 144, 254
Melodramatists, The (Nemerov), 92
Merrill, Helen, 149–50
Meservey, Bob, 71, 78, 99, 104, 106, 133, 136, 187, 246; quoted, 157
Metropolitan Museum of Art, 293, 300
Meyerowitz, Joel, 167, 178, 241
midgets, 167, 168, 218, 239, 247, 313
Mifune, Toshiro, 198
Miller, Arthur, 139, 229
Miller, I., 53, 61
Miller, Jerry, 61–2
Miller, May, 10, 19, 36
Miller, Meurice, 10, 19, 93
Miller, Robert, gallery, 280
Miller, Wayne, 114

Millett, Kate, 295
Mingus, Charlie, 144
Minneapolis Institute of Art, 300
Mitchell, Joseph, 176–8, 181, 184, 194, 219–20, 246, 253
Model, Evsa, 126, 128, 133, 232
Model, Lisette, 122, 124, 125–34, 152, 160, 183, 208; relationship between Diane and, 231–2, 312, 320; as teacher, 187, 228, 270, 290, 305, 307
Monroe, Marilyn, 189, 220, 229, 261
Moondog, 163–4, 168, 170
Moore, Marianne, 40, 237
Moorman, Charlotte, 235
Morath, Inge, 208
Morgan, Joan, 200–1
Morgan, K. T., 174
Morgan, Thomas P., 172, 187, 199, 200–1, 204, 246, 264
Morris, Alice, 203, 294
Morse, Tiger, 211, 224, 246
Mortenson, Judith, 267
Ms. Magazine, 203, 268
Munkacsi, Martin, 69, 189
Museum of Modern Art, 20, 32, 180, 227, 229, 239, 272, 299, 300, 305; Arbus photographs in "New Documents" (1967), 239–41, 245–9, 254–5, 264, 271, 301; Arbus photographs in "Recent Acquisitions" (1965), 234; Arbus retrospective exhibit (1972), 253, 275; "Family of Man" (1955), 113–14, 129, 240; Model's photographs, 125, 126, 127
Museum of the City of New York, 278
Mydans, Carl, 113

Nabokov, Vladimir, 57, 172
Narahara, Ikko, 302
National Enquirer, 307–8
Nazi Party, in Yorkville, 21
Neel, Alice, 141, 144
Neikrug, Marge, 316
Nelson, Ozzie and Harriet, 198, 199
Nemerov, Bessie, 5
Nemerov, David, 4–8; attends Paris collections, 5, 12, 36, 105; career of, at Russeks, 11–12, 18–19, 25, 26, 39, 56–7, 86–7, 92, 93, 105, 109–10, 138; death of, 212–15, 233; Diane's recollections of, 278; family life of (1930–1940), 16–17, 19, 25–7, 32–3, 35, 38–9, 40, 45, 50, 53; family life of

Nemerov, David (*cont.*)
 (after 1940), 60, 61–2, 68, 86, 87, 88,
 89, 92–3, 103, 105, 107, 117, 138, 187–
 8; involved in scandal, 108–9; as a
 painter, 27, 33, 110, 159, 185;
 retirement of, 159, 185
Nemerov, David (son of Howard), 92
Nemerov, Fanny, 4, 5, 20, 24–5, 33
Nemerov, Gertrude Russek, 3, 4;
 children of, 5, 9–10, 15; depression of,
 36–7, 316; family life of, during 1920s
 and 1930s, 10–12, 18, 25, 27, 32–3, 35–
 7, 38, 43; family life of, after Diane's
 marriage, 53–4, 58, 60, 61, 86–7, 106,
 109, 118, 159; family relationships of,
 in later years, 184, 185–6, 212, 214,
 242, 265, 316, 318, 320, 321
Nemerov, Harold, 3
Nemerov, Howard, 5; childhood and
 adolescence of, 9, 10, 12–14, 15–18, 22–
 8, 35; depressions of, 52, 117, 137,
 317; education of, 12, 13, 20, 22;
 father's expectations of, 26, 32, 38–9,
 45, 61–2, 92; friendship of John
 Pauker and, 22, 57, 89, 185; at
 Harvard, 20, 35, 39, 44–5, 51–2;
 Jewishness of, 20, 44; Lowell and, 317–
 18; marriage and family life of, 60–2,
 89, 90, 91, 92, 108, 136, 165, 184;
 military service, in World War II, 57,
 61, 90, 283; novels by, 89, 92, 137, 184,
 194, 220; poetry of, 14, 20, 44–5, 90,
 137–8, 184, 234, 317, 321; relationship
 with Diane, in adult life, 89, 90, 91,
 92, 112, 136, 137–8; relationship with
 Diane, after father's death, 217, 218,
 220–2, 233, 234, 246, 293, 310, 317–
 18, 320, 321; relationship with father,
 in later years, 109, 138, 159, 185, 212,
 214; teaching career of, 90–1, 136–7,
 184, 310, 317; Terkel and, 277; wins
 Pulitzer Prize, 317; writing career of,
 52, 61–2, 89–92, 137–8, 184–5, 220
Nemerov, Joe, 5, 87
Nemerov, Meyer, 4, 19, 20, 24–5
Nemerov, Peggy Russell, 60, 61, 62, 67,
 89–90, 92, 108, 138, 184, 233
Nemerov, Renée, *see* Sparkia, Renée
 Nemerov
Nemerov, Willy, 5, 214
Nemerov family: photographs of, 67, 87–
 8, 92, 119, 214–15, 221, 233; at
 Russeks, 11, 25–6, 33, 38–9, 45, 60–1,
 131, 138

"New Documents," *see* Museum of
 Modern Art
Newhall, Beaumont, 126
New Jersey, 217–18
Newman, David, 172, 199, 200
Newman, Paul, 304
New School for Social Research, 129,
 229, 231, 294, 319
Newsweek, 259, 321; interview in, 81,
 133, 248; photographs for, 296–8
New York *Daily News*, 130 *n.*, 177, 238,
 299
New Yorker, 176, 184
New York Herald Tribune, 260
New York magazine, 238, 260, 263, 275;
 Viva photographs in, 261–4, 272
New York Times, 90, 92, 137, 142, 247,
 280, 300, 320, 321; *Magazine*, 203, 244,
 245 *n.*, 277
Nichols, Mike, 282
Niepce, Joseph, 123
Nixon, Tricia, 309–10
Noland, Ken, 241
Nova, 288
nudists, 194–6, 198, 247, 313
Nugget, 269
Nureyev, Rudi, 237

Ober, Bill, 44, 92, 117
O'Keeffe, Georgia, 99
Oldenburg, Claes, 241
Olga, the bearded lady, 177, 178
Opi, 157
Oppenheimer, Robert, 148
orgies, photographs of, 211–12, 256,
 276–7
Orkin, Ruth, 113, 208
Orlovsky, Peter, 144, 300
Orsini, Armando, 225
Oswald, Mrs., mother of Lee Harvey,
 225
Owett, Bud, 320

Page, Geraldine, 136
painting and painters, 100, 144–5
Palm Beach Art Institute, 185
Paolozzi, Countess Christina, 191
Papageorge, Tod, 241
Park, Clara, 39, 44
Parker, Dorothy, 188
Parker, Frank, 47, 83

Parker, Suzy, 115
Parks, Gordon, 128 *n.*
Parnis, Mollie, 53
Parsons, Estelle, 240
Parsons School of Design, 237, 291
Patino, Mrs. Dagmar, 175
Pauker, Edmond, 22
Pauker, John, 22, 25, 57, 89, 159, 184
peace march (1962), 199–200
Pearson, Sybille, 139
Peck, Seymour, 33
Penn, Irving, 114, 122, 192, 198, 229, 231
Perelman, Sid, 253
Perkins, Anthony, 149–50, 173, 184
Peterson, Gus, 244
Peterson, Pat, 244, 245 and *n.*, 246, 267, 277
Philips, Renee, 135, 246
photographers: in Brodovitch
 workshop, 122–3; fashion, 68–9; at
 Limelight Café, 128–9; magazine
 outlets for, 160; in 1950s, 111, 113–14;
 in 1960s, 224–5, 237, 292; women, 208
Photography Club of America, 286
photojournalism, in 1950s, 113
Photo League, 113
Picasso, Pablo, 95, 249
Picture Newspaper, 268
Pinter, Harold, 249
Plisetskaya, Maya, 198
Plummer, Christopher, 139
Poindexter, Basha, 265
Point of Order, 161, 222
Polk, Brigid, 262
Pollock, Jackson, 144, 145
Pop Art, 99, 223, 224, 241
pornography, 211, 250–1, 277
Potato Chip Manzini, 239
Pound, Ezra, 44, 188, 189
Power, Tyrone, 105
"Pratt, Cora" (Polly Boshung), 179–80, 182
Presley, Elvis, 120, 238–9
Presto the Fire Eater, 166, 167, 168, 239
Primus, Pearl, 126
Prince Robert de Rohan Courteney, 181
Pritzcy brothers, 110, 138
Proust, Marcel, 12, 274
Pull My Daisy, 144, 161
Putnam, John, 123, 216–17, 235, 237, 246, 252, 274–5, 290, 291

Quat, Helen, 27, 38, 212

Radkai, George, 18, 39, 70
Radkai, Karen, 70
Rahv, Philip, 91, 317
Rand, Michael, 255
Ratoucheff, Gregory, 168
Rauschenberg, Robert, 161, 293
Rawlings, John, 68
Ray, Ann, 178, 248
Ray, James Earl, 271
Reeves, Richard, 260
Rendigs, Sally, 175
RenRoy studios, 119
Resika, Paul, 146, 148
Resnick, Milton, 145
Reynolds, Charlie, 165, 197
retardates, 299, 305, 306, 312, 319
Rhode Island School of Design, 291
Ridgeway Press, 295
Rilke, Rainer Maria, 197
Rivers, Larry, 100, 113, 144, 229
Robards, Jason, 136
Robert Miller gallery, 280
Rockill, Monti, 246
Rolling Stones, 144, 198
Roosevelt, Eleanor, 60–1
Rosenberg, Harold, 91, 100
Rosenbloom, Naomi, 34, 49, 58, 59
Rosenfield, Hilda Belle, 31, 35, 39, 62–3
Rosenquist, James, 241
Rostova, Mira, 151–2, 158
Rothko, Mark, 144
Rubinstein, Eva, 231, 302–3
Rubinstein, Helena, 127
Rukeyser, Muriel, 294
Russek, Frank, 3, 4, 6, 7, 8, 18, 26, funeral of, 92–3
Russek, Gertrude, *see* Nemerov, Gertrude Russek
Russek, Harold, 3, 87, 316, 320
Russek, I. H., 3, 6
Russek, Rose Anholt, 3, 36, 60, 87, 119, 186, 212
Russek, Ruth, 87
Russek, Simon, 3
Russeks: established as Russeks Furs, 3, 4, 5–6; Fifth Avenue store at 36th
 Street, 6–8, 11, 12, 138, 159 *n.;* during
 1930s, 18–19, 25, 39; during 1940s, 56–
 7, 86–7, 92; during 1950s, 109–10,
 159; opening of Philadelphia branch,
 93, 105; opening of Savoy-Plaza store
 at 57th Street, 138, 159 *n.;*
 photography for ads, 68, 69–70; *see
 also* Nemerov family

Russell, Bertrand, 229
Russell, Hilda, 60–1, 87
Russell, Rosalind, 102

Sack, John, 172
Sainer, Arthur, 204, 216
St. Croix, 277
Salomon, Erich, 230, 237–8
Salstrom, Paul, 199, 232–3, 258–60
Salt Garden, The (Nemerov), 137
Samaras, Lucas, 241, 246
Samuelson, Andra, 320
Sander, August, 228, 274
San Francisco, 258–9
San Remo (143 Central Park West), 3, 17
Sarraute, Natalie, 287
Saturday Evening Post, 160
Scavullo, Francesco, 70
schizophrenics, 277, 290
Schneebaum, Tobias, 294
Schoenberg, Arnold, 125–6
Schoenberg, Trude, 125
Schwartz, Delmore, 52, 91, 137
Schwartz, Ted, 158
Scott (family chauffeur), 9, 11–12
Scott, George C., 136, 152
Screvane, Paul, 215
Scull, Ethel, 224, 246
Scull, Robert, 246
Sealo the Seal Boy, 166
Segal, George, 144, 223
Selkirk, Neil, 192, 254 *n.*, 276–7, 301, 302
Sellers, Bunny, 106
Seltz, Thalia, 294, 309
Seventeen, 86, 111, 119, 121, 150, 169
Seven Wonders of the World (artworks by Roy Sparkia), 215
Seyrig, Delphine, 144
Shainberg, Larry, 170, 242, 246, 254, 284, 315
Shapiro, Bessie, 16, 36
Shaw, Mark, 211
Sheehy, Gail, 275, 291
Sherman, Cindy, 264
Shining, The, 255
Show, 143, 196–7
Shriver, Eunice, 296
Siegal, Anita, 285, 318, 319
Silver, Walter, 113, 208, 320
Silverstein, Louis, 142
Simon, John, 220

Simon, Sidney, 146, 180–1
"Singer, Daisy" (Diane Arbus), 278
Sitwell, Edith, 178
Smith, Bill, 141
Smith, Eugene, 113, 240, 243, 274
Smith, Harold, 239
Smith, Jack, 179, 229
Smith, Michael, 150, 216
Snow, Carmel, 126, 127–8
Sonnemann, Eve, 264
Sontag, Susan, 174, 210 *n.*
Sparkia, Renée Nemerov, 15–16, 17, 19–20, 23, 28, 58–9; married life of, 88–9, 93–4, 108, 117–9; relationship with Diane, 184, 185, 201, 213, 215, 320, 321; quoted, 27, 34, 35, 39, 40, 50, 59, 74, 86, 87, 212, 264; sculpture by, 117, 118–19
Sparkia, Roy, 88, 93–4, 108, 117–19, 184, 185; artwork by, 215
Squilaco, Al, 295
Stafford, Jean, 47, 75
Stankowitz, Richard, 100
Starr, Blaze, 198, 199
Steckel, Anita, 145, 146
Steckel, Jordan, 145
Steichen, Edward, 68, 113, 129, 189, 239
Stein, Gertrude, 70, 249
Stein, Gertrude, gallery, 276
Steinberg, Saul, 249
Steinem, Gloria, 260
Stella, Frank, 161, 205, 223, 241, 293
Stern, Bert, 128 *n.*
Stern, Stewart, 31–2, 38, 105
Stevens, Wallace, 52, 137
Stevenson, Adlai, 148, 229
Stewart, John, 151
Stieglitz, Alfred, 99, 114, 123–4
Still, Clyfford, 144
Stout, Myron, 144
Strand, Paul, 123, 128 *n.*
"Strasberg, Vicki," 226
Stutz, Geri, 104, 246
Susann, Jacqueline, 282
Szarkowski, John, 116 *n.*, 227–8, 234, 235, 255, 272, 275, 299, 310; "New Directions" exhibit by, 239–41, 247, 248

Talbot, Dan, 162
Talese, Gay, 173, 233–4, 246, 255

Tall Story, 184, 194
Tamayo, Rufino, 59
Tate, Allen, 40
tattooed people, 103, 131, 148
Terkel, Studs, 10, 277–80
Thompson, Dorothy, 33
Thompson, J. Walter, Co., 111
Thornton, Gene, 280, 300
Thurber, James, 275
Tiffin, Pamela, 260
Time, 247, 321; Alex Eliot's career at, 76, 95, 96, 104, 105, 107, 151, 159
Time-Life Books, 146–7, 150–1, 305, 306 *n.*
Titus, Roy, 127
Tokyo Rose, 282
Tompkins, Calvin, 293
Trahey, Jane, 196
transvestites, 179, 181, 192, 210, 226–7, 247, 255
Trazoff, Sudie, 159, 202
Tree, Penelope, 285
Trefusis, Violet, 303
triplets, photograph of, 217
Trotta, Geri, 203
Troy, Carol, 277
Troy, Hannah, 53
Tucker, Anne, 302, 303
Turbeville, Deborah, 253, 301
Twiggy, 188
"Twins, The," 240, 248–9, 254 *n.*, 255, 273, 311

"Uncle Sam" (Max Maxwell Landars), 182
Unger, Arthur, 157
Ungerer, Miriam, 145
Ungerer, Tomi, 145
Updike, John, 317
Uselmann, Jerry, 264, 301

Vanderbeck, Stan, 191
Vanderbilt, Gloria, 252–3
Venice Biennale, 311
Veruschka, 188
Vidal, Gore, 172
Vietnam war, 224, 253, 254, 265, 275, 317
Village Voice, 204, 216, 239, 241–2, 252, 321

Viva, 261–4, 272
Vogue, 69, 72, 86, 104, 105, 111, 136, 151, 160, 285, 305; Viva in, 262–4
Von Ringleheim, Paul, 201
von Wangenheim, Chris, 170, 204, 241, 242, 292, 300
Vreeland, Diana, 262, 263–4

Wager, Michael, 180
Wager, Susan, 180
Waltz, Ruth, 7
Ward, Pat, 108–9
Warhol, Andy, 161, 205, 224, 226, 229, 246, 285; Viva and, 261, 262, 263
Warren, Robert Penn, 209
Washington Square Park, 236
Weber, Bruce, 304
Weegee (Arthur Fellig), 130–1 *n.*, 177, 208, 238, 270, 274
Weinstein, Anita, 109
Weinstein, Arthur, 33, 34, 92, 105
Weinstein, Bertha Arbus, 8, 33, 71
Weinstein, Lillian, 25
Weinstein, Max, 6, 8, 33, 71, 92
Weinstein, Walter, 8, 26, 109, 110
Wernick, Bob, 81
Wernick, Marian, 56
West, Mae, 197
Westbeth, 293–5, 301, 309, 315, 320
Weston, Edward, 126, 128 *n.*, 239
White, Minor, 127
White, Nancy, 169, 183, 191
White, Stanford, 4, 6
Whittemore, Reed, 44, 89, 90
Wilcox, Wilma, 274
Williams, John A., 204–5, 246, 287
Williams, Tennessee, 188
Williams, William Carlos, 44, 137, 317
Wills, Gary, 172
Wilson, Jane, 100
Wilson, Theo, 108
Windsor, Duke and Duchess of, 192
Winogrand, Garry, 21, 143, 234, 240, 241, 247, 252, 253, 255, 281, 293, 298, 313
Winslow, Jane, *see* Eliot, Jane Winslow
Witkin, Lee, 190, 273, 274, 317
Wolf, Henry, 182, 196
Wolfe, Tom, 188, 260
"Woman with a Cigar," 227, 247
Wood, Audrey, 188

Woodward, Joanne, 304
Wurlitzer, Rudi, 254
Wyndham, Francis, 288–9, 292

Yale University, 311
Yamashiro, Tod, 107–8, 111, 123, 140,
 287

Yarmolinsky, Adam, 38
Yee, Yuben, 234–5
Young, Penny, 199
Young & Rubicam Inc., 111

Zachary, Frank, 160
Zuckerman, Ben, 6, 19

PICTURE CREDITS

After page 114.

Humanities Research Center, Austin, Texas: Russeks 14th Street; Russeks Fifth Avenue; the Nemerovs returning from Europe.

Renée Nemerov Sparkia Collection: Howard and Diane; Diane at fifteen; the family collage; Gertrude; Roy and Renée.

Dorothy Evslin Collection: fiftieth wedding anniversary.

John Pauker Collection: Howard in World War II.

After page 274.

Condé Nast, *Glamour Magazine*: Mr. & Mrs. Inc.; Diane and Doon; Diane and Allan.

Alex Elliot Collection: Anne and Alex; Alex, photo by Jane Elliot; Jane Elliot.

Peter Beard Collection: Marvin Israel and Peter Beard.

Basha Poindexter Collection: anti–Vietnam War demonstration.

All other pictures belong to the author's collection unless otherwise credited in the picture sections.